ILLUMINATING THE LAW
Legal Manuscripts in Cambridge Collections

Cambridge, Fitzwilliam Museum
3 November – 16 December 2001

ILLUMINATING THE LAW
Legal Manuscripts in Cambridge Collections

Susan L'Engle and Robert Gibbs

HARVEY MILLER PUBLISHERS

HARVEY MILLER PUBLISHERS
An Imprint of Brepols Publishers
London / Turnhout

British Library Cataloguing in Publication Data
A catalogue record for this book
is available from the British Library
ISBN 1-872501-53-2

Printed and bound by Grafikon, Oostkamp, Belgium

Preface

THE RULE OF LAW is central to the ways in which societies order themselves, articulate many of their values, and establish basic principles and methods to regulate behaviour and arbitrate disputes in many essential spheres of human endeavour. In Western Europe, the study of civil (secular) and canon (ecclesiastical) law enjoyed one of its greatest periods of efflorescence in the thirteenth and fourteenth centuries with the creation of faculties of law at some of the recently founded European universities. Patterns of economic, social and intellectual life changed significantly and with accelerating pace during this period. Developments such as the rapid growth of cities and the emergence of new forms of commerce, social mobility, and religious life added immeasurably to the texture of human culture, but also introduced new strains into existing institutional frameworks. The resulting tensions between the forces of change and those appealing to tradition also promoted renewed attention to the law, for it had an essential role in maintaining social and intellectual cohesion even in the face of momentous reforms. Laws were actively collected, scrutinized, renewed and reformulated during this period, and all these activities led to the production of some of the most important and complex manuscript books that survive from the late Middle Ages.

The purpose of this exhibition is to display a representative range of the law books made during the thirteenth and fourteenth centuries and, equally important, to comment on distinctive features of their forms and contents. The material – much of it previously unstudied – is drawn from the collections of the Fitzwilliam Museum and four important college libraries in Cambridge, as well as the University of Durham. The real stimulus to the exhibition, however, was provided by the enthusiasm and learning of two students of legal manuscripts, Dr. Susan L'Engle and Professor Robert Gibbs, who first mooted the idea for preparing an exhibition devoted to this subject in autumn of 2000, during my tenure as Acting Librarian and Keeper of Manuscripts at the Fitzwilliam Museum. I encouraged them to prepare such an exhibition for the Fitzwilliam and, in particular, to introduce the material to a wide audience. That is no simple task, for medieval legal manuscripts are complexly arranged and circulated in diverse forms, understood hitherto chiefly by specialists. In a remarkably short period of time, the authors have succeeded in explicating many basic issues concerning the history, contents, and formal features of medieval legal manuscripts, while also adding significantly to our knowledge of the place of particular works within the tradition. They have been aided ably by Peter Clarke, who joined them on the project, and by Dr. Stella Panayatova, Assistant Keeper of Manuscripts and Printed Books at the Fitzwilliam, who coordinated all aspects of their work on the exhibition and catalogue. Harvey Miller Publishers have generously agreed to publish the catalogue of the exhibition in a form and format that will foster appreciation of the material and will circulate knowledge of the exhibition worldwide. To all I express my profound gratitude for helping to cast welcome light on a fascinating and little-known chapter of medieval culture, as well as for aiding us in our efforts to expand and reinvigorate the study of the manuscript holdings of the Fitzwilliam Museum.

James H. Marrow
Professor Emeritus of Art History, Princeton University
and Honorary Keeper of Northern European Manuscripts,
The Fitzwilliam Museum

Foreword

'ILLUMINATING THE LAW' is what the present exhibition is hoping to do for its visitors and the catalogue for its readers. This hope is sustained by the conviction that through displaying and interpreting the most splendidly decorated legal manuscripts in Cambridge collections the authors revive a centuries-long tradition practised by masters and students, by scribes and artists, the tradition of illuminating the law.

It takes fascinating material, specialized knowledge, an inspirational mind and an attractive venue to put an interesting exhibition together. Cambridge collections provide ample material for the history of legal studies in the medieval period. Their breadth and riches are demonstrated not only by the fact that they have already furnished an exhibition of 'Canon Law in Cambridge 1100–1540' for the Seventh International Congress of Medieval Canon Law (23–27 July 1984), but also by the almost complete lack of overlapping material in the previous and present displays. While covering civil as well as canon law, this exhibition focuses on the illustration of legal texts, and on the Italian, French and English artists and patrons who shaped its development and meaning. The richness of the material calls for specialized knowledge in numerous fields. We were fortunate to have Susan L'Engle, Robert Gibbs and Peter Clarke, whose expertise on various aspects of legal manuscript studies sparked off hot debates in what proved to be an extremely eventful process of writing. A project which is supposed to blend (highly specialized knowledge from) several academic disciplines, and is expected (at the same time) to reach out to a variety of audiences, requires broad vision, stimulating initiative and generous support. All these and much more we owe to Professor James Marrow. It was his intellectual curiosity and unfailing enthusiasm that brought the authors and the Fitzwilliam Museum together. He and his wife, Emily Rose, supported this project from its very beginning through to the end. The informed interest and kind generosity of Allison and Tom Ujejski made it possible for the rich illustrative material in the catalogue to match the splendour of the exhibits.

The involvement of various institutions and individuals transformed what was conceived as a fairly modest project into an important event. We are extremely grateful to the Librarians of the Chapter Library, Durham Cathedral, and of four Cambridge Colleges, Corpus Christi, Gonville and Caius, St John's and Sydney Sussex, for lending us some of their most cherished treasures to research, photograph and exhibit, and for helping us work in a spirit of mutual trust and wholehearted support. The Cambridge University Library, Hereford Cathedral Library, Museo Civico di Torino, the National Gallery of Art in Washington, the Pierpont Morgan Library in New York, Staatsbibliothek Bamberg and the Vatican Library allowed us to reproduce material from their collections. The British Academy's Joint Activities Award supported the work of Robert Gibbs and Susan L'Engle; Robert Gibbs's research into Bolognese illumination has also benefited from the generosity of the AHRB, the British School at Rome, the Leverhulme Trust and the Royal Society of Edinburgh. Michael Michael, Martin Bertram, Richard Rouse and Fr. Robert Ombres, O.P., gave precious and well-timed advice. All of us have to thank the team at Harvey Miller-Brepols, and to Ann Matchette in particular, whose professionally uncompromising and yet intelligently tolerant editorial work pulled together the riches of collections and the knowledge of individuals into a handsome book. To everyone else who offered fresh ideas and practical help, we are most profoundly, though, for reasons of space, silently indebted.

Dr Stella Panayotova
Assistant Keeper of Manuscripts and Printed Books
The Fitzwilliam Museum

Contents

Introduction

Susan L'Engle

THE CATEGORY 'ILLUMINATED LEGAL MANUSCRIPTS' has up to now seemed to be one of the best-kept secrets in the field of manuscript studies; as recently as 1980, Carl Nordenfalk observed that the study of juridical codices was mostly 'untilled land'.[1] Art historians and manuscript scholars have been for the most part oblivious of the illustrations in medieval legal textbooks, in many cases from an assumption that there would be nothing to illustrate in the study of law. Sustaining this premise is the reality of modern law textbooks: weighty volumes, densely written, teeming with legal concepts, definitions, case studies and cross references, expressed exclusively through the written word. Today's students feel no need for a visual representation of legal concepts since they are generally presented and perceived in the abstract.

Law in the medieval period was a new and vital intellectual discipline, critical to the development of political and social organization. The textbooks composed for its analysis and interpretation were considered at least as precious (if not more so) as the devotional and liturgical books utilized in the practice and study of religion, and as such, equally as worthy of being illuminated. And the principles behind the decoration of a legal manuscript were basically the same as for a Bible or prayer book. Ornamental details, graded sizes of penwork and painted initials, served not only to provide visual breaks along dry stretches of legal rhetoric, but also to identify for the reader at all times the type and precise textual location of each passage being studied. The physical reality of a glossed manuscript, that is, a text with its commentary placed around it on the same page, made a well ordered system of visual guideposts an imperative. The medieval legal page bears as many different types of information as some of today's dot-com web sites, but is far more logically organized and less distracting.

But above all, the law was seen as a dynamic instrument with which to organize and govern individuals and societies – made up of actual, tangible people. Thus the miniatures and historiated initials at larger text divisions were filled with human figures, often engaged in complex narratives. In addition to marking a passage, they served to convey something of the themes discussed within. The subjects of these figured compositions are as diverse and wide-ranging as the law itself, and represent an anthology of iconographic material in great need of scholarly research.[2]

Those scholars who have studied legal texts have on the whole focused on manuscripts executed north of the Alps, limiting their attention to the large miniatures at major text divisions.[3] In addition, most contemporary studies have dealt with manuscripts of Gratian's *Decretum*, probably in response to the monumental exhibition of manuscripts and incunabula held in Bologna in 1952 in celebration of the eighth centenary of the *Decretum Gratiani*.[4] Rosy Schilling's preliminary survey of the development of Gratian

iconography appeared in 1963,[5] and in 1975 Anthony Melnikas published a pioneering Gratian *Corpus* listing 480 *Decretum* manuscripts produced in Europe from the twelfth to the fifteenth centuries, containing more than 1000 illustrations from 150 manuscripts.[6] Sadly under-exploited, the reproductions in this *Corpus* provide the most extensive single source of illustrative material ever compiled on legal illustration, an invaluable tool for iconographical analysis.[7] In the area of Roman law, only Friedrich Ebel, et al. have presented a visual survey of the texts that make up the civil *Corpus*, illustrating their study with miniatures in manuscripts from German and Austrian collections.[8] Within the last decade, the themes of law and justice have generated a number of iconographic studies,[9] but most scholars have concentrated on individual manuscripts, dealing with their specific iconography rather than placing them in the context of legal illustration as a whole.

Lists and catalogues of legal manuscripts are more readily available: Gero Dolezalek's mammoth project for computer entry of codicological information from thousands of extant Roman law manuscripts was published as a four-volume computer printout in 1972[10] and is the most complete existing guide to international holdings. Stephan Kuttner's catalogues of canon and Roman law manuscripts in the Vatican Library provide detailed descriptions of their texts, with some indication of existing illumination[11]. A few libraries with sizeable collections of juridical manuscripts have published catalogues devoted exclusively to these holdings.[12] The catalogue entries however mainly provide codicological and textual information, and iconographical descriptions are rare.

This catalogue and its accompanying exhibition at the Fitzwilliam Museum were conceived with the idea of introducing the relatively unfamiliar theme of medieval legal texts to a wide audience, drawing on manuscripts and single leaves of canon and civil law in Cambridge collections and supplemented by three manuscripts from a unique and very important set at Durham Cathedral Library. For the catalogue, the chief goal of its organizers and authors was to provide something of a guidebook, a Baedekker of medieval law books, to permit readers a clear and straightforward exploration of this topic. The main title, *Illuminating the Law*, reflects this aim: derived from the Latin *illuminare*, to light up, the verb in its broader sense includes ideas of brightening, defining, explaining and clarifying. The gold and brilliant colours applied by illuminators light up manuscript pages and lighten the viewer's passage through the text, and the exercise and significance of law-making and law-giving are made clearer through the narrative miniatures that introduce legal topics. For the modern audience, the catalogue and the exhibition are intended to shed light on the production and use of medieval legal textbooks, by summarizing the literary characteristics of the texts and their commentaries, illustrating the distinctive visual aspects of their layout and decoration, and describing their academic and practical functions.

The catalogue is organized sequentially and didactically. Chapter 1 introduces the texts themselves, giving a brief description of their authors, the contents and the history of their formulation. Chapter 2 expands upon the texts, situating their creation and function more fully within their social and political contexts, with a special focus on their use by teachers

and students. Chapter 3 deals with the manufacture and distribution of legal texts and those involved with this process: the patrons who commissioned and used them, the scribes and craftsmen who produced them, the stationers who sold them and the university officials who regulated their quality and accuracy. Chapter 4 focuses on the visual aspects of the manuscript page, the manner in which glossed texts were written and the system under which the hierarchies of text passages are organized and identified. In Chapter 5, a range of iconographical compositions and motifs are discussed, exemplified and illustrated by the miniatures and pictorial compositions contained within the manuscripts on exhibit. The chapter essays are followed by the catalogue proper, with an entry for each manuscript exhibited. In this section, each entry provides basic codicological and palaeographical data, a description of primary and secondary decoration and a scholarly discussion of each manuscript in its appropriate historical, social and art historical context. A short glossary of terms relating to manuscripts and legal texts is added for reader reference.

Notes

1 Nordenfalk, 'Review', p. 318.

2 For an initial census and analysis of legal iconography, see my doctoral dissertation, 'The Illumination of Legal Manuscripts in Bologna, 1250–1350: Production and Iconography' (New York University, Institute of Fine Arts, 2000).

3 In these cases, iconography is generally given short shrift, and miniatures are described in the context of a particular artist's work.

4 See *Manoscritti e incunaboli*. This exhibition stirred historians and theologians to create the series *Studia Gratiana*, publishing studies on the *Decretum* from diverse disciplines, including art history.

5 Schilling, '*Decretum Gratiani*'.

6 Melnikas.

7 Other brief *Decretum Gratiani* studies include: Olivier-Martin, 'Manuscrits'; Pirani, 'La miniatura bolognese'; Schmitt, 'Le Miroir du Canoniste'.

8 Ebel, *et al.*

9 Among them are Jacob; Mordek, 'Gesetzgeber'; Kocher, 'Sachsenspiegel'.

10 Dolezalek and van de Wouw.

11 Kuttner and Elze.

12 Among them, see in particular García y García and Gonzálvez, for the Cathedral Library and Archive of Toledo, Spain; and Neske, for the Nuremberg State Library.

1. The Texts

Susan L'Engle

I wish someone would describe the texts of legal manuscripts
simply and clearly enough for me to remember!
I just can't keep them straight!

A GREAT MANY PEOPLE, scholars and general readers alike, have expressed the need for a simple yet comprehensive classification of medieval legal texts. The format and contents of Bibles, Psalters and liturgical manuscripts such as Missals and Choir Books are more familiar, as they have been exhaustively studied and published. Equally well known are Books of Hours which, among the laity, were indeed the best-sellers of the Middle Ages, a period in which cultural activities were dominated and defined by religion and the Church. It is often overlooked, however, that the twelfth- and thirteenth-century expansion of education and literacy included a revival of the study of law, and there was a corresponding acceleration in the book trade to provide the essential texts for this curriculum. The production of legal manuscripts from the late twelfth to around the middle of the fourteenth century was a mass phenomenon, in which thousands of manuscripts were made available to students in a relatively short period of time. One scholar has estimated the number of surviving medieval legal manuscripts at around 10,000 for civil law and seven times this number for canon law.[1]

It is ironic that the most important legal texts in use in the medieval *West*, both canon and civil, derived in concept and organization from the Emperor Justinian's (r. 527–565) sixth-century compilation of laws in Constantinople, capital of the Roman *East*. Although scholarship and learning at this time had declined in Western Europe, there were still study centres and great libraries in the Eastern Empire, and it was here that Justinian gathered a group of professors headed by Tribonian to survey and organize classical and current Roman laws into a comprehensive collection of legal doctrine. The results of this committee's work were separated into four different categories and text volumes, which today, in the form of their medieval reconstruction, are known by the name assigned them in the fifteenth century, the *Corpus iuris civilis*, the body of civil or Roman law.

Justinian's Codification – Roman/Civil Law

In 533 the legislative committee produced the fifty-book *Digesta* or *Pandectae*, meaning a complete body of law, representing a condensation of passages from the writings of classical Roman jurists (as Walter Ullmann put it, 'fragments, snippets and excerpts of varying length from the statements of the jurists of the period between the second and fourth centuries').[2] The initial books in this collection defined the law and its fundamental principles,

procedures and responsibilities. As a whole the work discussed the existing laws, why they were created and how they were enforced in the late Roman Empire, concentrating on private law and transactions between individuals, families and communities. The second major text – its revised version completed in 534 – was the *Code* or *Codex*, composed of imperial edicts and constitutions. It was divided into twelve books, subdivided first into titles and then into individual laws. The biggest difference between the *Codex* and the *Digesta* was that, instead of concentrating on general principles, the *Codex* quoted the laws themselves as pronounced by Roman emperors up to Justinian and described solutions found and measures applied in specific legal situations. Another text completed in the same year was the *Institutiones*, adapted and revised from the very popular *Institutes of Gaius* of the classical period. It was a brief exposition of the main principles of Roman law, accommodated in only four books and was intended from the start as a textbook for beginning law students. The last volume of Roman law was called the *Novellae* or *Novellae Constitutiones/novae leges* (Novels) and consisted of various compilations of Justinian's legislation following the publication of the revised *Codex*, up to his death in 565. The most complete version contained 168 new legislations and was utilized mainly in the Eastern Empire, while the collection circulating in the West and further abbreviated in the medieval period included only 134 and went by the title of *Authenticum*.

Each of the original major texts filled a particular juridical need in Justinian's time and reflected a cultural context that was already disintegrating. In the face of invasions and restructurings of the Empire over the next six centuries, Western Europe in its cultural diversity was governed by a great variety of local practices and customs, often contradictory and conflicting, more often transmitted from generation to generation by word of mouth than committed to writing. Much later, in the twelfth century, when, following a century of religious and scholastic awakening and reform, a new cultural climate encouraged the examination and application of Roman law principles to the organization and governing of societies. This was not an easy task, since many Roman legal and governmental institutions had no twelfth-century equivalents and just as many contemporary customs and practices were unknown to Roman law. These disparate circumstances were at least partly responsible for the creation of schools of law and the study of Roman law as an academic discipline, often thought to be first in Ravenna,[3] but certainly most importantly in Bologna. The corpus of Roman law was painstakingly recovered and reconstructed from scattered fragments by the earliest Roman law scholars and recopied and bound into new textual arrangements.

The medieval versions of the *Corpus iuris civilis* were completed and put into final written form between the twelfth and the fourteenth centuries. These written laws did not immediately become standards for practical use in the local courts, but as fruits of the revival of the pursuit of learning, they were utilized as textbooks in the law schools and served to encourage further intellectual commentary. The physical arrangement and method for studying these texts in Bologna was formulated by the early twelfth-century glossators, who studied and interpreted Justinian's corpus and added their comments and

interpretations in the form of glosses between the lines or in the margins of each basic text. They rearranged the original texts into formats more expedient for teaching, effected through a meticulous analysis and explication of each text passage, as carefully described in a plan of lectures written by Petrus Peregrossi, a pupil of the thirteenth-century civil law teacher Odofredus:

> First, I shall give you summaries of each title before I proceed to the text; secondly, I shall give you as clear and explicit a statement as I can of the purport of each Law (included in the title); thirdly, I shall read the text with a view to correcting it; fourthly, I shall briefly repeat the contents of the Law; fifthly, I shall solve apparent contradictions, adding any general principles of Law (to be extracted from the passage), commonly called 'Brocardica' and any distinctions or subtle and useful questions arising out of the Law with their solutions, as far as the Divine Providence shall enable me. . . . And if any Law shall seem deserving, by reason of its celebrity or difficulty, of a Repetition, I shall reserve it for an evening Repetition.[4]

The fifty-book *Digest* was separated into three volumes, of which the first and most important section was called the *Digestum vetus* or 'old' *Digest* – represented in this catalogue by Gonville and Caius MS 8/8 (Cat. No. 17) – running from the beginning of Book I through Book XXIII on dowry and then continuing for two titles into Book XXIV.[5] The second and middle part, named the *Infortiatum*, began however with the full inscription to D.24,3,2 and closed at the end of Book XXXVIII. The last of the three volumes, exemplified by the late thirteenth-century copies Gonville and Caius MS 10/10 (Cat. No. 16) and Durham MS C.I.3 (Cat. No. 13.1), was known as the *Digestum novum*, the 'new' *Digest*, opening with Book XXXIX and continuing through the end of Book L. Various ideas have been proposed to explain the uneven medieval division, one of which contends that it resulted from an accidental disbinding of a portion of one manuscript and the subsequent attempts to reconstruct the text.[6]

In the new medieval arrangement of the *Codex* the first nine books were preserved as a single volume, like Durham MS C.I.6 (Cat. No. 12) and Gonville and Caius MS 11/11 (Cat. No. 18). The final three, dealing with Byzantine public law, had been considered irrelevant in the West and for a long time were not transcribed.[7] In the thirteenth century, however, this set of books, referred to as the *Tres libri*, was joined with a series of smaller texts and called the *Parvum Volumen*, more simply referred to as the *Volumen*. It opened with the four-book *Institutiones*, which was usually followed by the twelfth-century version of the *Authenticum* (ninety-six *Novellae* grouped into nine *collationes*) and ended with the *Tres libri*. Durham MS C.I.4 (Cat. No. 11) exemplifies this arrangement.

Beginning in the thirteenth century, a non-Roman text was added to the *Corpus iuris civilis*: the *Consuetudines feudorum*, also known as the *Libri feudorum*. It originated as a collection of miscellaneous feudal law treatises, the oldest version attributed to Obertus de

Orto, a mid-twelfth-century imperial judge at the court of Milan. His discussions of feudal legislation were reportedly extracted from letters written to his son Anselmus, and these excerpts later combined with other feudal materials into the first version of the *Libri feudorum*, called the Obertina for its author. Studied and annotated by the early glossators, the text underwent two recensions that added new material and divided the work into two books. The last and standard version, known as the Accursiana, was added to the *Volumen* and sometimes classified as a tenth *collatio* of the *Authenticum*, like the unglossed example present in the Fitzwilliam Museum's *Volumen*, MS McClean 139 (Cat. No. 10).

Canon Law

The equivalent of the *Corpus iuris* for the Church, the *Corpus iuris canonici*, as it was named in 1500, was produced between the twelfth and fourteenth centuries, although it depended in its organization, as well as for many of its principles, on Roman law. It was accommodated in six volumes, the latter five representing successive updates of canon laws and decrees collected under later popes: the *Decretum Gratiani*,[8] the *Decretales*, the *Liber sextus*, the *Constitutiones Clementinae*, the *Extravagantes Johannis XXII* and the *Extravagantes communes*.

The first volume of canon law, most often referred to as the *Decretum Gratiani*, was compiled in at least two recensions between 1139 and 1158, perhaps at Bologna, by the scholar and possible teacher Gratian, sometimes considered to have been a monk, although there is no documentary evidence to this effect.[9] It was a systematic and ambitious collection of some 3,945 excerpts from patristic writings, Church councils, papal letters and other ecclesiastic sources, as well as excerpts from Roman law in the second recension. Gratian's intention was to organize the often confusing and contradictory traditions and canonical decisions into a format that would expose their inconsistencies and then reconcile them through systematic arguments and reasoning. To achieve the objective of the formal title he gave his work – *Concordia discordantium canonum* (A Harmony of Conflicting Canons) – his approach was to outline a theoretical case and then cite authorities and opinions on how it should be resolved.

Gratian's *Decretum* was an excellent classroom tool, since its dialectical presentation exposed students to the complexities of canon law and demonstrated how solutions to hypothetical situations could be resolved by applying legal concepts (discussed in more detail in Chapter 2). The popularity of this text in the medieval period is attested by the number of examples represented in this catalogue: Fitzwilliam Museum MS Marlay cuttings It. 3–11 (Cat. Nos 5 a–j); Fitzwilliam MS McClean 135 (Cat. No. 2) and MS McClean 201.f.11b (Cat. No. 9); Fitzwilliam MS 183 (Cat. No. 6); Fitzwilliam MS 262 (Cat. No. 8); Sidney Sussex MS 101 (Cat. No. 1) and Corpus Christi MS 10 (Cat. No. 3). Bolognese doctors added references, questions and comments to the margins of the copies they used in their classes and this material accompanied subsequent copies of the *Decretum*. Glosses and commentaries survive for numerous twelfth-century decretists, as

these commentators are called; Paucapalea, the earliest, had produced his glosses by 1148.

By mid-twelfth century the *Decretum Gratiani* had been given its definitive arrangement and separated into three major parts. The first, *Pars* I, was divided into 101 *Distinctiones*, each comprising canons and comments (*capitula* and *dicta*) dealing with a specific topic or related topics. *Pars* II consisted of thirty-six *Causae*, each a case study describing a legal situation and followed by related questions, thereafter discussed and reconciled by Gratian. The *Decretum* usually ended with *Pars* III, a treatise on the liturgy and the sacraments called *De consecratione*, separated into five *Distinctiones* with 396 *capitula*. Additionally, a separate treatise on penance (*Tractatus de penitentia*) is inserted awkwardly into *Pars* II at *Quaestio* 3 of *Causa* XXXIII.[10]

Further to Gratian's textbook, new laws were drawn up and circulated, stemming mainly from papal rulings on specific cases. They were distributed in the form of papal letters called decretals and were often copied and collected by individual professors of canon law. The first significant collection, amounting to nearly a thousand decretals, was compiled by Bernard of Pavia (d. 1213) between 1188 and 1192. He created the model for all succeeding decretal collections with his organization of this material into five thematic divisions: (1) ordination and ecclesiastical offices – opening with the title *De summa trinitate et fide catholica*; (2) judicial organization and civil cases – opening with *De iudiciis*; (3) matters affecting the clergy – opening with *De vita et honestate clericorum*; (4) marriage – opening with *De sponsalibus et matrimoniis;* and (5) criminal procedure – opening with *De accusationibus*.[11] Bernard's compilation and four more collections of the rapidly expanding body of new decretals, known as the *Quinque compilationes antiquae* (Five Old Compilations),[12] were incorporated into canon law curricula, supplementing and updating Gratian's *Decretum*.

In 1234 a new collection of decretals published since Gratian was promulgated by Pope Gregory IX (1227–41), compiled and arranged at his behest by the Catalonian canonist Raymond of Peñafort (1180/85–75). This new collection synthesized and superseded the previous official ones and added decretals of Gregory IX and Innocent III. Though sometimes known as *The Extravagants* of Gregory IX (for *extra vagantes*, wandering outside the *Decretum Gratiani*) or the *Liber extra* (that is, extra to the *Decretum*), it is most commonly referred to as the *Decretales* of Gregorius IX. To set an official stamp on the new publication, the Pope sent it with a letter of transmission – the papal bull *Rex pacificus* – to the universities of Bologna and Paris, proclaiming it the only legitimate version and requiring that it be taught in the canon law courses.[13] A formulaic address prefaced the bull, in which the Pope recommended his publication to the scholarly community at the various universities to which it was sent, that is: '*Gregorius episcopus servus servorum Dei, dilectis filiis doctoribus et scholaribus universis Bononiae commorantibus salutem et apostolicam benedictionem*' (Gregory bishop, servant of the servants of God, to his beloved sons, all the doctors and scholars residing at Bologna, greetings and apostolic benediction).

The major universities to which the new *Decretales* was sent were Bologna (*Bononie*) and Paris (*Parisius*), and one can sometimes find manuscripts addressed to both Bologna and

Paris at once, *Parisius bononieque*, as appears in the McClean *Decretales* (Cat. No. 14). It would be convenient if the naming of a university in this passage were a firm indication of the actual destination of a given manuscript and/or evidence of where it was produced. Unfortunately, no hard and fast rules can be established for this practice. A great volume of copies were needed and executed for students at the major universities of Bologna and Paris, making mass production imperative in these centres, but copies were also produced for smaller universities in Europe, and scribes would preface them with one or the other address. There are innumerable manuscripts addressed to *Bononie* that exhibit palaeo-graphical and codicological elements inconsistent with Bolognese scribal practices and are decorated in Northern style; additionally, many manuscripts addressed to *Parisius* were actually produced in Southern France, Spain, Germany or England. In the larger centres texts could perhaps be written on speculation and kept for sale at a stationers', leaving a blank space for the name of the university to be filled in later: in some manuscripts the added name is seen to be compressed awkwardly into an insufficient area left for its inser-tion; in others there is evidence of erasure and the substitution of another name for that originally written. Additionally, foreign students would often commission the writing of a manuscript in Bologna and then have it illustrated in their native countries upon their return. Faced with the unreliability of the published address, in some cases the script and decoration of a manuscript may aid in determining where it was physically produced, although scribes and illuminators were capable of executing various scripts and artistic styles and would employ the one(s) requested by the client who commissioned the work. Much more collaborative research needs to be done among palaeographers and art and legal historians to establish with more precision the provenance and destination of individual manuscripts.

Following the *Decretales*, a new collection of canons was commissioned by Pope Boniface VIII (1294–1303), gathering material from the first and second councils of Lyon (1245 and 1274) as well as from decretal letters of Gregory IX and succeeding popes. Organized into the same five-book format and comprising 76 titles and 359 chapters, it was promulgated by the papal bull *Sacrosancta Romana Ecclesia* on 3 March 1298 and again transmitted to the universities. Though it constitutes the third text in the *Corpus iuris canonici*, it was called the *Liber sextus* by the canonists, meaning a sixth book after the five in Gregory's *Decretales*. It is represented in this catalogue by St John's College, MS A.4 (Cat. No. 19). The last canon law text to be officially promulgated by a pope was Clement V's *Constitutiones Clementinae*, compiled in 1312 but only transmitted in 1317 by John XXII with the bull *Quoniam nulla*. It included decretals from the Council of Vienna (1311–12), one each of Boniface VIII and Urban IV and decretals from Clement's own chancery, continuing the five-book format and comprising 52 titles and 106 chapters. Between 1325 and 1327, a small collection of twenty decretals was compiled and glossed by the doctor of canon and civil law Zenzelinus de Cassanis (d. 1354) and called the *Extravagantes Johannis XXII*. This collection and a further collection of decretals, later known as the *Extravagantes communes*, were edited and published by the Paris scholar Jean

Chappuis in 1500 as the final volumes in the *Corpus iuris canonici*.

Unlike the *Decretales*, one may find a considerable number of manuscripts of the *Liber sextus* and the *Constitutiones Clementinae* addressed to smaller study centres instead of Bologna and Paris, such as Oxford (*Oxonie*), Padua (*Padue*), Avignon (*Avinione*) and Toulouse (*Tholose*). By the time these later texts were published and sent to the universities there were far more cities with established courses in canon law. There is thus a greater likelihood that a manuscript addressed to a smaller university was actually produced there, often borne out by script and decoration, but for copies directed to Bologna and Paris the address continues unreliable in this respect.

Glosses

Most surviving thirteenth and fourteenth-century manuscripts of the *Corpus iuris* are glossed. Glosses on legal texts have been defined as 'brief annotation[s] composed and written to explain a text . . . addressing either its terminology and its exterior trappings or its animating spirit and its underlying principles'.[14] They were composed by jurists and canonists, scholars and professors, either written down by the author himself (a *glossa redacta*) and closing with a siglum made up of one or more letters of the author's name, or reconstructed from class notes taken by assiduous students (a *glossa reportata*). The most compact or concise were the *interlinear glosses* placed between lines of the text. More commonly the gloss was written beside its corresponding text in a margin of the page (*marginal gloss*). Glosses could be added to the earliest manuscripts successively along the course of years, forming layers or 'strata' of commentary by different authors. Although originally these layers were added at different times and often by different hands, when the manuscript was recopied the scribe would simply transcribe all of this added material as he went, eliminating the visual evidence of successive additions. Often, however, a glossator would sign his work with a siglum at the end of some passage, which would also be copied by a scribe, in this case preserving the record of authorship.

A continuous set of glosses was called an *apparatus*; it consisted of a specific choice and arrangement of glosses by a particular jurist to be used in conjunction with specific passages of the text. Though early glosses were subject to editing by professors, students and even scribes, after 1235 most Roman law texts had been provided with a stable *apparatus* of glosses, called the *glossa ordinaria*, which was positioned on the written page around the main text, in a standard fashion (see Fig. 13, Chapter 4). An important early *apparatus* on the *Codex* was written by Azo (d. *c.* 1220–30), a much acclaimed Bolognese jurist, and his contemporary Hugolinus de Presbyteris (d. after 1233) created an extensive *apparatus* to the whole *Corpus iuris civilis*. Following these initial works of commentary the brilliant Accursius – a pupil of Azo's – composed a new gloss on the *Corpus* that assimilated over 90,000 glosses by previous commentators, analysing and synthesizing legal doctrines and principles. Adopted around mid-thirteenth century, this gloss proved so wide-ranging and valuable to practising jurists that it was given the title *Magna glossa* and was so widely dif-

fused that it was soon reclassified as the *glossa ordinaria*. All of the Roman law texts in this exhibition are accompanied by this gloss.

For canon law, the first *glossa ordinaria* to the *Decretum Gratiani* was composed by the German jurist Johannes Teutonicus (d. 1245) and was later revised and amplified by Bartholomaeus Brixiensis (of Brescia, d. 1258), this version becoming the standard. The Fitzwilliam's late twelfth-century MS McClean 135 (Cat. No. 2) has partial glosses by the former and incomplete additions by the latter, as well as scatterings of glosses by a number of other commentators. Contemporary with this manuscript, Corpus Christi College MS 10 (Cat. No. 3) is ruled for glosses alongside the text but has only sparse notations of the earliest type of commentary. The Sydney Sussex *Decretum* (Cat. No. 1) is essentially unglossed, but its margins support sporadic annotations, triangular glosses and interpretative drawings that function as visual glosses. The remaining *Decretum* manuscripts in this exhibition contain the standard *glossa ordinaria*. Around 1300 the canonist Guido da Baysio (*c.* 1250–1313), appointed Archdeacon of Bologna in 1296 and later Archchancellor of the University, wrote a scholarly commentary on the *Decretum* which he called the *Rosarium*, meant to extend and complete the *glossa ordinaria*. This rich collection of opinions and doctrines was immediately acclaimed, quickly adopted into the university curriculum and widely diffused, bringing immense prestige to its author.[15]

The *glossa ordinaria* for the *Decretales* was composed and revised more than once by Bernardus de Botone Parmensis (of Parma, d. 1266) and it accompanies all the *Decretales* in this exhibition: the Fitzwilliam Museum's two single leaves, MS Marlay Cutting Fr. 2 (Cat. No. 15) and MS McClean 201.f.12 (Cat. No. 4), MS McClean MS 136 (Cat. No. 14) and Durham C.I.9 (Cat. No. 13). In parallel to glosses that were designed to be read and studied in conjunction with the text, a great many expository glosses were composed on the *Decretales*, transcribed in a two-column format and published separately, to be studied and annotated on their own. The most important were written by the canonists Goffredus de Trano (d. 1245), *Summa super titulis decretalium*; Sinibaldus de Fieschis (Pope Innocent IV, d. 1254), *Apparatus in Decretales*; and Henricus de Segusio (called Hostiensis, d. 1271). Hostiensis's *Summa* on the *Decretales* – written in two versions, the earliest completed around 1250–51 – was highly admired and abundantly copied, its rhetoric so compelling that it became known as the *Summa aurea* (Golden Summa) in the fifteenth century. At the behest of his students in Paris he also completed a *Lectura in Decretales* just before his death in 1271.

For the *Liber sextus*, the *glossa ordinaria* taught in Bologna was composed and completed in 1304 by the renowned Bolognese lay canonist Johannes Andreae (*c.* 1270–1348), who was also responsible for the *glossa ordinaria* on the *Constitutiones Clementinae*, finished in 1326.[16] The University of Paris preferred to teach a different *glossa ordinaria* for the *Sextus*, written by the Cardinal Jean le Moine (Johannes Monachus, *c.* 1250–1313). In addition to the *glossa ordinaria*, Johannes Andreae produced a separate body of commentary on the *Decretales* and the *Liber sextus* which he named *Novella* after his mother and daughter. The *Novella* is represented in this catalogue by the Fitzwilliam's single leaf, MS 331 (Cat. No.

20) – once part of the Pierpont Morgan Library's fragmentary *Novella in Decretales* III–V bound with the *Novella in Sextum* (M.747) – comprising the frontispiece and opening passages to the *Decretales,* Book V. The *Novella in Decretales* was usually commissioned and written in two separate volumes, one for Books I and II, the other containing the last three. It seems to have been a frequent practice among medieval and early Renaissance scholars, however, to have related texts bound together in one volume, whether their transcription had been commissioned separately or together. All we can conclude about the Morgan Library's M.747 is that the two texts it contains were written and illuminated contemporaneously, since they share scribe, rubricator and illuminator, and at some time in their history an owner had them bound together.

More definitive evidence for deliberate compilation of associated material is provided by St John's College MS A.4 – written and illuminated for the same family (Cat. No. 19). This manuscript contains the *Liber sextus* surrounded by the gloss of Johannus Monachus, accompanied by three separate commentaries on the *Liber sextus,* and codicological details establish that these texts were originally transcribed in four separate volumes, to be finally bound together in the seventeenth century.[17] John Northwode's description of a book in the fourteenth-century Corpus Christi College Inventory ('*Decimus quintus est magnus liber decretalium cum libro sexto*') seems to indicate that it comprised a *Decretales* bound with a *Liber sextus,* uncommonly found together in one volume, although a very convenient arrangement for study.[18] It was perhaps a canon law professor or scholar who originally commissioned Peterhouse College MS 10, constituting precisely this combination, labelled '*Decretales cum Sexto*' in the catalogue compiled by M. R. James.[19] The two main texts appear to have been written by different scribes, but both glossed by a third, although the *Decretales* is surrounded by its commentary, while the *Sextus* very singularly is written and glossed in consecutive short passages, formatted in two columns. The rubrication and penwork articulation is consistent for both texts, reinforcing the likelihood that they were executed conjointly for the same patron. A critical study of the numerous surviving atypical juxtapositions of legal texts would broaden our knowledge and understanding of the reading and study habits of past generations.

In addition to medieval Roman and canon law texts, legal documents for professional societies and local government offices were commissioned and executed by the same scribes and illuminators, although they were decorated on a more modest scale. There are numerous extant statutes of communes, corporations (guilds) and religious societies (confraternities), as well as their registers of participation, listing members by parishes, often over several generations. These documents may be headed by a miniature or historiated initial, usually with representations of the organization's patron saint(s). The Fitzwilliam's single leaf from a Bolognese register of the Cordwainers' Guild (MS McClean 201.f.15, Cat. No. 21) opens with the blessing figure of St Petronius, patron saint of Bologna, holding a model of the city of Bologna with its leaning towers. In contrast to guild registers, statutes set out the rules and regulations under which an association was governed and, like commune or city statutes, generally take their organizational structure and a great part of

their subject matter from canon and Roman law texts. A collection of customary laws, the Southern French 1296 *Coutumes de Toulouse,* is divided into four books which discuss successively court procedures, the regulation of financial transactions, marriage obligations and rules of inheritance and municipal administration.[20] The Bolognese statutes of 1288 is a more extensive document, made up of twelve books, many with numerous subdivisions, which describe and define communal institutions and procedures. The topics covered are wide-ranging and include the election of public officers and their duties, taxes to be levied on products and services, the operations of civil and criminal courts and the assignment of penalties and punishments, financial transactions, university organization and its standards and the obligations of merchants in the practise of their trades. Unlike the Roman law textbooks studied in the Bolognese *Studium,* these statutes describe the law actually in practice in fledgling municipal governments – dependent on ancient civil law principles, but adapted to the medieval milieu.

Notes

1 Dolezalek, 'La pecia', pp. 201–17, particularly p. 205.

2 Ullmann, p. 55.

3 Ullmann, pp. 78–79; Calasso, pp. 281–82.

4 This passage extracted from Rashdall, I, p. 218.

5 Whitman, 'Division', pp. 270–71.

6 Van de Wouw, 'Zur Textgeschichte', pp. 245–46 (cited in Whitman, 'Division', p. 273). James Whitman argues that the division reflects eleventh-century social conflicts dealing with marriage laws and consanguinity; see Whitman, 'Division', pp. 273–84. Observing that many scholars have noted that the *Infortiatum* is composed of Roman law subjects that are in strict conflict with Lombard law equivalents, Whitman also cites Lodovico Zdekauer's 1890 suggestion that 'the *Infortiatum* had been divided off from the rest of the *Digestum* precisely because of its non-Lombard character and that it received its name because the Bolognese lawyers regarded it as 'rimeso in forza' – Zdekauer's proposed translation for *Infortiatum'.* See Zdekauer, pp. 25–26 (cited in Whitman, 'Division', p. 278).

7 Ullmann, p. 69

8 Often misleadingly translated as 'Gratian's Decree', which belies its status as a compilation.

9 On Gratian's identity, see Noonan, 'Gratian'; Mesini, 'Postile', and now most recently and incisively, Winroth.

10 See Brundage, *Canon Law,* pp. 190–94, for a more detailed description of the contents and Chodorow, 'Law', pp. 413–18.

11 These headings are furnished in Sayers's clear and concise description of *Decretals* development in Sayers, p. 107.

12 Described in detail by Peter Clarke in Chapter 2.

13 Innocent III established this practice in 1210 when he sent his *Compilatio tertia* to the University of Bologna, followed by Honorius III in 1226 with the *Compilatio quinta.* See Brundage, *Canon Law,* pp. 194–97 and his bibliography at pp. 235–36.

14 Bellomo, pp. 130–31. Bellomo furnishes brief and intelligent definitions of glosses and their derivatives as well as a history of their conception and application (pp. 126–35).

15 Liotta, 'Appunti', pp. 7–50.

16 See Brundage, *Canon Law,* pp. 200–01, and Chodorow, 'Law', pp. 416–17, for more details and bibliography.

17 On this manuscript, see James, *St John's,* cat. no. 4, pp. 3–5; Egbert, ch. 8 (pp. 117–20) and app. 8 (pp. 219–22, pls CXI–CXII); Sandler, *Gothic Manuscripts,* II, cat. no. 113, pp. 126–27, illus 295, 296.

18 See James, 'Inventory', pp. 88–114. Further mention of this inventory is found in Chapters 2, 3 and 5.

19 James, *Peterhouse,* pp. 33–34.

20 The most important extant version and the only one to contain a gloss is found in Paris, BNF, MS Latin 9187.

21 *Statuti.*

2. The Growth of Canon and Civil Law Studies, 1070–1535

Peter Clarke

THERE WERE MANY DIFFERENT SYSTEMS OF LAW co-existing and competing with one another in Europe by the end of the twelfth century. There was royal law, feudal law, manorial law, municipal law, mercantile law, maritime law and the two laws which are represented in this exhibition, canon (or ecclesiastical) law and civil (or Roman) law. Each of these legal systems claimed jurisdiction over particular areas of life. For example, canon law enjoyed virtually exclusive competence over marriage, wills, disputes over ecclesiastical property and taxes, and even defamation, oaths including contracts and sexual immorality among many other issues.[1] But boundaries between rival legal systems were often disputed in the Middle Ages. For example, the key issue in the famous conflict between King Henry II of England and Thomas Becket, Archbishop of Canterbury, was whether criminal clergy came under the exclusive jurisdiction of the Church courts or whether they might also be tried in the royal courts. English clergy won on this and other issues, but on some points of contention they compromised or gave way to the claims of royal law; for example, they remained under royal jurisdiction in civil cases contrary to canon law. Nevertheless, on many issues it was uncertain where the dividing line between different legal systems lay, and shrewd litigants could exploit this uncertainty and bring their case before the court most likely to favour their interests.

Among the many medieval legal systems, civil and canon law had special status. First of all, both were international systems of law recognized across Europe by the late twelfth century, whereas other laws only tended to operate within a particular country or region. Canon law was binding on all Christians, regardless of social standing, and even touched the lives of Muslims and Jews under Christian rule. An international system of Church courts had thus emerged to enforce its rules by the late twelfth century, extending from the local bishop's and archdeacon's courts in every diocese to the papal Curia, the highest tribunal in the Church, that heard appeals from all over Europe. Civil law lacked its own special courts but it served as a source of legal principles on which many other legal systems drew to some extent. The ecclesiastical courts, for example, derived most of their rules of procedure from civil law from the late twelfth century onwards. Even the two great medieval treatises on English common law, attributed to Glanvill (*c.* 1187–89) and Bracton (*c.* 1218–29) respectively, borrowed, in varying degrees, from civil law.

Secondly, canon and civil law were usually the only law that was formally taught in universities. The earliest law school in Europe was established at Bologna by the early twelfth century, although claims have been made for an earlier school at Pavia in the late eleventh century. By the late twelfth century, Bologna was attracting law students from all over Europe, and other centres of legal learning were being established at Montpellier, Paris

and Oxford, and later Cambridge and elsewhere. Graduates of these schools could and did practise their legal skills anywhere in Europe. Many found employment as judges and advocates in the church courts, or as notaries, drawing up all kinds of official records. Some rose high in the service of the Church and secular rulers. The increasingly legalistic nature of ecclesiastical administration meant that many popes and bishops from the early thirteenth century onwards were trained lawyers. Later medieval kings of England found the services of law graduates useful in international diplomacy and other business, and a college, King's Hall, was specifically established in Cambridge in 1317 and patronized by the English Crown as a source of legal personnel, particularly civil law graduates.

The medieval books of canon and civil law featured in this exhibition were hence primarily produced for and used in the teaching and study of these subjects in universities. Indeed, medieval legal learning was largely devoted to the close study of the authoritative texts in these books, and it was the recovery in *c.* 1070 of one such text, the *Digest*, which formed part of the *Corpus iuris civilis*, that had largely stimulated the subsequent growth of canon and civil law studies.[2] In the intervening centuries, only part of the *Corpus iuris* was known in the West: the Institutes and an abbreviated version of the *Code*. Despite the barbarian invasions in the West from the fifth century onwards, Roman law remained in use in Southern France and Italy after the fall of the Western Empire, and some barbarian rulers had the legal customs of their peoples reduced to written form in imitation of Justinian's *Code*. Though these barbarian codes adapted and preserved parts of civil law, close systematic study of legal texts, what we call jurisprudence, only began after the discovery of a sixth-century manuscript of *the Digest* in late eleventh century Pisa. From this sole surviving exemplar (now preserved in Florence) all subsequent copies of the text were derived, and medieval copies were divided into three parts, known as the *Digestum vetus*, the *Infortiatum* and *Digestum novum*. The full *Corpus iuris civilis* was available within a century of the *Digest*'s reappearance. The *Tres libri*, the last three books of the *Code*, were known by the mid-twelfth century. The *Novellae* (new laws) of Justinian, were known only in an abridged form in the early twelfth century but a fuller version, the *Authenticum*, was then discovered. The *Tres libri* and *Authenticum* usually circulated together in the *Parvum Volumen*, a medieval concoction that also came to include the feudal law code and legislation of the German Emperor Frederick II (1231) whose rule and law were modelled on that of the Roman Empire.

The rediscovery of the old jurisprudence in the *Digest* therefore fostered the new jurisprudence at Bologna *c.* 1100, but its beginnings are obscure.[3] Odofredus, a thirteenth-century professor of civil law at Bologna, claimed that his school was founded by a man called Irnerius, who established the classical Bolognese method of applying grammar and logic to the study of legal texts. Irnerius (or Wernerius) is a shadowy figure, however, and the few writings that can be safely attributed to him testify little to his mythical reputation as an inspiring teacher. Indeed, the glosses that he and his contemporaries wrote to clarify difficult terms and passages in civil law books are largely unsophisticated and reveal only a basic knowledge of civil law. It was the next generation of civilians, as civil lawyers are

called, who would establish Bologna as an international centre of civil law studies. This was the age of the 'Four Doctors', supposedly pupils of Irnerius, of whom Bulgarus and Martinus Gosia were the most influential for the subsequent course of civil law doctrine. They established rival schools, and that of Bulgarus became dominant in Bologna by the mid-twelfth century. Several writings can be identified as his work and they reveal a high proficiency in civil law and relatively advanced teaching methods. He conducted moots, where different students would take on the roles of defendant and plaintiff in hypothetical lawsuits, and he would act as judge and decide the case. Such exercises became a typical part of university training for lawyers, and Bulgarus's reports of these disputations are an early example of an important genre of medieval legal literature called *quaestiones*.

The mid-twelfth-century civilians tended to look down on canon law as inferior to their own discipline, although Martinus was less conservative and turned to canon law to interpret elements of civil law. Civilians prided themselves on possessing a complete and authoritative body of law, while in the early twelfth century the Church had no definitive collection of its legal authorities. The discovery of the *Digest* can be associated with the papacy's search for legal texts. The late eleventh-century papacy was in the control of a circle of reformers, who sought to free the Church from lay control, notably interference in ecclesiastical appointments, and to eliminate vices among the clergy, such as buying of ecclesiastical offices (simony), keeping concubines (nicholaism) and priests bequeathing churches to their sons. Like many reformers, they claimed to be restoring tradition, hence they looked to the old law of the Church to justify their agenda. The circle of the reform papacy thus produced several canon law collections after 1070, notably those of Anselm of Lucca and Deusdedit. The *Panormia* of Ivo of Chartres (*c.* 1090–1100) was a popular collection, but no single compilation drove the others out of use until the appearance of the *Concordantia discordantium canonum*, commonly known as Gratian's *Decretum*.

Little is known about Gratian himself except that he compiled the *Decretum*, but it is widely supposed that he was a teacher of canon law at Bologna. His text was indeed a textbook designed for teaching, not a law code. What made it attractive for use in the classroom was its 'dialectical' arrangement. The dialectical method was a popular tool of early twelfth-century scholars and consisted of assembling the authorities for and against a particular proposition. The Paris theologian, Peter Abelard, had applied this approach to contradictory passages in the Bible in his work *Sic et non* (Yes and No). Gratian likewise adduced conflicting authorities on a specific point of law and sought to reconcile them in comments called *dicta*; thus he called his book a concordance of discordant canons. The civilians had looked down on canon law because of its confusing and contradictory mass of authorities, but Gratian's method made a virtue of those contradictions and revealed that they could be resolved through interpretation. His sources included the Bible, the writings of the Church Fathers, notably Augustine, canons of Church councils and papal rulings. It is now widely accepted that his text appeared in two recensions, or versions.[4] The first was probably completed no earlier than 1139. This recension was apparently considered inadequate within a few years of its appearance, for a treatise on consecration (*De conse-*

cratione) was appended to it and numerous additional authorities were interpolated, including many from civil law, which had featured little in the original version, perhaps because civil law teaching was not so well advanced when it was compiled. It has been claimed that Gratian had little to do with this augmentation of his work, for it confusingly broke up the structure and argument of the original. None the less, it was this second recension, virtually twice the length of the first and completed no later than 1158, that was accepted as the standard textbook of canon law studies.

Evidence of the use of the *Decretum* in the Bolognese schools can be found in the glosses written on the text within twenty years of its original appearance. The earliest was probably that of Paucapalea (*c.* 1148), allegedly a pupil of Gratian. Commentators on the *Decretum* were known as decretists, and other important early Bolognese decretist works were those of Rolandus (*c.* 1150), Rufinus (*c.* 1164) and Huguccio (*c.* 1188). Schools of decretists were established in other centres by the end of the twelfth century. One existed at Paris by the 1160s, and its earliest *Decretum* commentaries included that of Stephen of Tournai (1160s) and the anonymous *Summa Parisiensis* (*c.* 1170). A Rhenish school also sprang up, and an Anglo-Norman school, which had its principal centre at Oxford by the 1190s. Lectures of two of the earliest known teachers of canon law at Oxford, Simon of Sywell and John of Tynemouth, are reported by a student of theirs in the marginal glosses of *c.* 1200 on the *Decretum* in Gonville and Caius College MS 283/676 (Fig. 1).[5]

Fig. 1

Civil law studies were also spreading outside Bologna by the mid-twelfth century. Of the 'Four Doctors', Martinus was especially influential in other centres. A *Summa*, or systematic treatise, on the *Institutes* that was written in southeast France in *c.* 1127 refers to his teachings. In *c.* 1160, Rogerius and Placentinus, followers of his school, migrated from Italy to teach in the Rhône valley. Placentinus (d. 1192) finished Rogerius's *Summa* on the *Code* and also wrote a *Summa* on the *Institutes*, both of which were influential. By the mid-twelfth century, knowledge of civil law had also reached England. It began to be taught in cathedral schools, and by the 1180s the subject was thriving. One contemporary even noted that the hitherto dominant study of liberal arts (grammar, logic, rhetoric, etc.) was being abandoned in England in favour of civil law. This dramatic rise of the subject in England is mainly associated with the *Liber pauperum*. This textbook, an anthology of extracts from the *Code* and *Digest*, was written in the 1170s by Vacarius, a Lombard trained in civil law in the age of the 'Four Doctors', who came to England in *c.* 1143 to serve the Archbishop of Canterbury. There is no proof to support the claim that he taught at Oxford, but his book was a standard teaching text in the schools of canon and civil law flourishing there by the 1180s; students trained on it were indeed known as *pauperistae*.[6]

Canon and civil law were therefore studied side by side in many centres of higher learning in the late twelfth century, notably at Bologna, Paris and Oxford. This marked the beginnings of an increasingly close symbiotic relationship between the two laws. The civilians overcame their prejudices about canon law and began to collaborate with canon lawyers, or canonists as they are known, especially on procedure. This was to lead to the growth of Romano-canonical procedure, generally adopted in the Church courts from the late twelfth century. Johannes Bassianus, who succeeded Bulgarus as the dominant figure in the Bolognese civil law school from *c.* 1160 to *c.* 1187, made notable contributions in this direction. He devised 'Trees of Actions' which classified different kinds of lawsuit (an example is illustrated in Cat. No. 10). His writings stimulated the development of a literary genre on procedure, known as *ordo iudiciorum*, that provided practical guidance to court-room lawyers. By the close of the twelfth century, the interdependence between the two laws was such that aspiring canonists had to master some civil law before moving on to the specialized study of canon law. And even civilians found it useful to learn some canon law, since many of them ended up as practitioners in the Church courts or involved in ecclesiastical administration. At Oxford in the 1190s, there were not even specialized departments of civil and canon law, as in continental universities, but simply a school of both laws, in which both the *Liber pauperum* and the *Decretum* were required reading.[7]

Canonists also adopted many of the literary methods and genres of the civilians. Both used the gloss as the main vehicle for their ideas.[8] The canonists used it to continue Gratian's work of resolving the contradictions between legal authorities by interpretation. And it served a similar function for civilians since many of their texts differed on points of doctrine, despite Justinian's assurance that his body of law contained no contradictions a subtle mind could not resolve. Primitive civilian glosses largely consisted of strings of *allegationes*, that is citations of other texts in the *Corpus iuris civilis* either analogous or con-

trary to that being glossed. Canonists applied this technique to the *Decretum* from the 1140s and increasingly cited civilian as well as canonical texts. These annotations partly originated as an *aide-memoire*, or crib, as law teachers lectured on these texts to students. By the mid-twelfth century, jurists also included in glosses comments clarifying difficult terms or ideas in the texts. Some of these summarized their own class-room teaching but others were simply borrowed from teachers with whose opinions they agreed. By the late twelfth century, jurists increasingly identified their own teachings and those of others by means of *sigla*, a letter or letters standing for a teacher's name, such as 'h.' or 'hug.' for the decretist Huguccio. Not all glosses were authored by law teachers. Some, as we have already seen with the Gonville and Caius manuscript, were based on notes taken by students on their lectures, and these are known as reported glosses. Indeed, in the early thirteenth century, the Bolognese canonist Tancred was so tired of the inferior reported versions of his lectures that were circulating that he decided to 'publish' his own glosses.

By the late twelfth century, many layers of glosses had built up around legal texts. A pupil of Johannes Bassianus, Azo (d. 1220/29), began the work of synthesizing those on the *Corpus iuris*, and this was completed by his pupil, Accursius. Azo was famous for his *Summa* on the *Code* and that on the *Institutes*, but it was the work of Accursius, compiled between 1220 and 1240, that was accepted as the standard exposition or *glossa ordinaria* on all parts of the *Corpus iuris* for centuries, superseding all previous glosses. Around the same time, a *glossa ordinaria* was also established for the *Decretum*.

By the early thirteenth century, the literary activity of the canonists was actually more fertile than that of civilians, and for one simple reason. While the *Corpus iuris* was essentially a closed system, canon law had continued to grow after the appearance of the *Decretum* with the publication of papal decretals. The *Decretum* had stimulated the demand for decretals since it had exposed the gaps in the existing law and emphasized the role of the pope as the highest judge in the Church, or 'universal ordinary'. An appeal might be made to the universal ordinary from the lowest church court without passing through any intermediate courts, hence appeals to Rome multiplied from the mid-twelfth century. Papal decretals grew correspondingly, especially under Pope Alexander III (1159–81), and canonists were quick to recognize them as a new source of law. Although decretals were addressed to the parties who had requested them, usually bishops or other ecclesiastical dignitaries, copies circulated and were collected by canonists. Early collections were haphazard, but systematic ones began to appear in the 1170s, the contents of which were organized under subject-headings, known as titles (*tituli*). A very important collection was the *Breviarium extravagantium* that Bernard of Pavia compiled between 1188 and 1192. It was divided into five books, each of which was devoted to a broad area of decretal law: the powers of ecclesiastical judges (Book I); procedure in the Church courts (Book II); the freedoms and duties of clergy (Book III); marriage (Book IV); canonical crime and punishment (Book V). Each book was then further subdivided into titles, within which Bernard arranged the decretals in chronological order, so that the reader might quickly identify more recent papal rulings that had perhaps superseded earlier ones. Bernard also

adopted the practice of editing out details in a decretal text relating to the specific case that prompted it, leaving behind only the essential legal rulings and indicating omissions by the phrase '*et infra*'. His collection provided the model for all subsequent ones and was the first of five generally adopted for use in courts and schools of canon law. It therefore became known as *Compilatio prima*. *Compilatio tertia* was the first collection officially approved by a pope. The circulation of forged decretals prompted Pope Innocent III (1198–1216) to authenticate its contents, which comprised decretals from the first ten years of his pontificate, assembled in *c*. 1210 by Petrus Beneventanus. *Compilatio secunda* actually appeared shortly afterwards, but it was so called since it contained chronologically earlier material not included in *Compilatio prima*. *Compilatio quarta* comprised Innocent III's decretals not included in *Compilatio tertia* and the canons of the Fourth Lateran Council (1215), but there is some evidence to suggest that the Pope did not approve it and canonists certainly seem to have been slow to accept it. By contrast, Pope Honorius III (1216–27) commissioned the canonist Tancred of Bologna to collect his decretals in *Compilatio quinta*, promulgated in 1226.

These *Quinque compilationes antiquae* and all other collections were superseded in 1234 by the *Liber extra*. Charged by Pope Gregory IX with its compilation, Raymond de Peñafort used the *Compilationes antiquae* as his main source, and the *Liber extra* contains many decretals of other popes, notably Alexander III and Innocent III, besides some two hundred of Gregory IX himself. But it did not remain the exclusive decretal collection for long. Appendices had to be added containing the legislation of subsequent popes, notably Innocent IV (1243–54) and Gregory X (1271–76). This new material was later incorporated in the *Liber sextus*, which supplemented the five books of the Gregorian collection; it too was divided into five books. Pope Boniface VIII (1294–1303) had charged three canonists with its compilation in 1296 and promulgated it in 1298. Many of its texts appear under his name, and although some were adapted from rulings of his predecessors, most were new law that appeared for the first time in the *Liber sextus*. More new law was later published in the *Clementinae*, a collection of legislation of Pope Clement V (1305–14) promulgated in 1317 by Pope John XXII (1314–34), and the *Extravagantes* of John XXII (1325). Thereafter, decretals ceased to be the main vehicle for legal change, and the rulings of the papal courts assumed greater prominence, especially those of the Rota, the chief tribunal where petitions to the pope were heard by judges on his behalf. Collections of these were also made, forming a body of case law. But in the late fifteenth century the last official decretal collection was compiled, *Extravagantes communes*, comprising rulings of Boniface VIII and his successors. This completed the *Corpus iuris canonici*, as its first printer, Jean Chappuis, named it after Justinian's *Corpus iuris civilis* in his Paris edition of 1500. This *Corpus* of canon law remained binding on all Catholics until 1918 when it was superseded by the *Code* of canon law, since revised twice.

Decretal law had attracted commentators since the late twelfth century, and they were consequently known as decretalists. *Compilationes prima* and *tertia* were glossed by most of the leading canonists of the day, including Tancred of Bologna who wrote the *glossa ordi-*

naria to both these collections (*c.* 1220). A new wave of decretalist writings followed the appearance of the *Liber extra*, including the *glossa ordinaria* of Bernard of Parma (d. 1266) (see Cat. No. 4). Many of these commentaries became so detailed that they could not be contained in the margins of manuscripts and had to be transmitted independently of legal texts, notably those of Innocent IV and Hostiensis (d. 1271) on the *Liber extra*. Canonists often spent a lifetime labouring on such works, revising them as new decretals appeared; this was the case with Bernard of Parma, whose *glossa* appeared in four versions representing different stages of revision between 1241 and his death a quarter of a century later.[9] Rival commentaries often competed for attention, such as the gloss to the *Liber sextus* of the Bolognese canonist Johannes Andreae, which was *ordinaria* at Bologna, and that of the French cardinal Johannes Monachus, which was *ordinaria* at Paris (d. 1313). Copies of the *Liber sextus* listed in medieval catalogues of Cambridge University and college libraries were often accompanied by both glosses, and sometimes also that of Guido de Baysio (d. 1313), Archdeacon of Bologna University.[10] For example, all three glosses appear in an early fourteenth-century copy of the *Liber sextus* addressed to the scholars of Cambridge University, now in the British Library (Royal MS 11.D.5; see also Cat. No. 19).

Many canonists were incredibly prolific. Andreae was notably productive, writing not only glosses to the *Liber sextus* and *Clementinae*, but also extensive commentaries, *Novellae*, on the *Liber extra* and *Liber sextus* (without the text).[11] He had an encyclopaedic knowledge of decretalist literature going back to the early thirteenth century and spent over twenty years condensing this in his *Novella* on the *Liber extra* (see e.g. Cat. No. 20), which appeared in its final version in 1338. As each generation of canonists had to take more and more literature into account, so the size of commentaries grew until they reached elephantine proportions by the fifteenth century; that of Nicolaus de Tudeschis (d. 1453) on the *Liber extra* ran to five volumes! From the late thirteenth century, civilians were also writing ever more expansive legal commentaries, notably the brilliant Bartolus of Sassoferrato (d. 1357) and his pupil Baldus de Ubaldis (d. 1400), who wrote commentaries on both canon and civil law. Canonists and civilians also wrote other kinds of juristic literature: the *summa* (systematic treatise on part of either *Corpus iuris*); *quaestiones* (records of classroom 'moots' or disputations); procedural manuals, notably the *Speculum iudiciale* of French canonist William Durand (d. 1296); *consilia* (advice to clients on specific cases); and treatises on specific issues. Hence, law students had to cope with a massive and constantly expanding body of highly technical reading by the later Middle Ages. The final section of this chapter will consider how they did so, specifically at Cambridge, and what motivated them.

Most historians agree that the origins of Cambridge University lie in the migration of scholars from Oxford in 1209. According to the chronicler Roger of Wendover, it was prompted by the lynching of three Oxford students by the townsfolk; this was an arbitrary and violent act of revenge for the accidental killing of a woman by a room-mate of these students. Oxford University dispersed for five years, and some of its members apparently

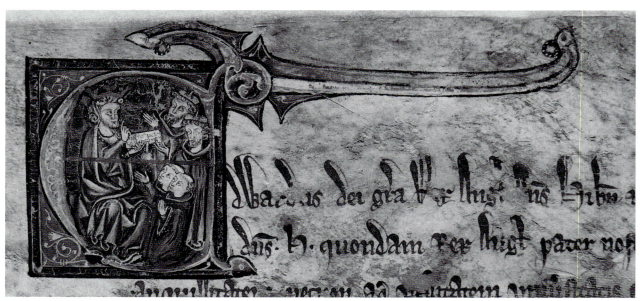

Fig. 2

never returned, preferring to remain at Cambridge. It has recently been argued that the fleeing scholars were attracted to Cambridge by the presence of church courts there that required the services of trained lawyers.[12] Law studies were well established at Oxford by 1209, and Cambridge was thus a better venue for their continuation than Reading, where other Oxford scholars settled but which had no Church courts. A canon law faculty indeed existed at Cambridge by *c.* 1250, when it is mentioned in the original university statutes, and it has been claimed that canon law was taught from the university's very beginnings. The first known Chancellor of the University, Richard de Wetheringsett, or de Leycestria (*c.* 1222–32), was a canonist, and the canon law faculty was perhaps founded under his chancellorship. A separate faculty of civil law emerged later, probably shortly after 1250, for the first known candidate for a doctorate in civil law (DCL) is recorded at Cambridge in 1256 (Fig. 2).[13] But since canonists needed to know the basics of civil law, it is probable that the subject was taught there much earlier.

The earliest statutes compiled in *c.* 1250 did not outline the canon law curriculum or even refer to civil law. Regulations concerning courses are not found till the fourteenth century, and then they parallel contemporary arrangements at Oxford in terms of entrance requirements, length and content of courses and teaching provision.[14] No arts degree was necessary to enter law, unlike theology. But, most lawyers had a knowledge of arts even if they had no arts degree, since arts provided training in grammar and logic, which were applied to the study of legal texts. Study of arts also counted towards a law degree. The course of bachelor in civil law (BCL) lasted seven years, but only five if one had an arts degree, and by the late fifteenth century similar concessions were granted to lawyers who had spent two years studying arts. The doctorate in civil law (DCL) took a further three years. *The Digest* was the key textbook for both degrees; BCLs had to spend three years

hearing lectures on part of it. Law students were also required to teach in order to qualify for their degrees. Candidates for a BCL or a DCL had to lecture on the *Digestum novum* and the *Institutes*.

As at Oxford, a training in civil law was a necessary preparation for the study of canon law. By the late fourteenth century, an aspiring bachelor of canon law (BCnL) had to spend three years hearing lectures on civil law, or five if they had no prior arts degree, and five more on canon law – eight to ten years altogether. The civil law requirement was a problem for clerics, however, since Honorius III had forbidden the study of civil law to the generality of clergy in 1219; therefore, statutes provided for exemption of clergy from this requirement, allowing years of civil law study to be commuted into canon law study. Those going on to the doctorate of canon law (DCnL) had to do further years of study on civil law, the *Decretum* and the Bible, and, like civilians, they also had to lecture as part of their course requirements. Doctoral candidates in either law also had to take part in the weekly 'moots' or disputations in the law schools and required testimonials from doctors of law regarding their learning and character in order to take their degree.

The canon law curriculum apparently evolved with the law itself. One can deduce from later evidence that, in the thirteenth century, it was based on the *Decretum* and, after 1234, the *Liber extra* too. Lectures were apparently given on the former as the 'ordinary' text in the mornings and on the latter as the 'extraordinary' text in the afternoons. By the early fourteenth century, the *Liber extra* achieved 'ordinary' status, and the *Liber sextus* and *Clementinae* were introduced into 'extraordinary' afternoon lectures. The teaching as already indicated was carried out mainly by students as part of their degree requirements. The bachelors were required to give the afternoon lectures, but by *c.* 1330 they were also encouraged to lecture in the mornings.[15] The morning lectures were normally reserved for the regent masters, those who had fulfilled the requirements for the doctorate, but change was necessitated by the teaching burden that the new decretal collections created and the shortage of regent masters. Qualified lawyers were lured away from teaching by practice in local Church courts as judges and advocates, which was far more lucrative. Teachers at Cambridge were expected to survive on fees collected from their students. The university did not maintain a salaried body of professors as at Bologna.[16] This may be a reason why it produced no jurists of international significance. Its two most eminent canonists were noted simply for work on the legislation of the English Church, William Lyndwood who compiled it in his *Provinciale* (1433), and John Acton who had glossed some of it (1334).

Teaching was probably carried out in various rooms rented for the purpose till the late thirteenth century when jurists lectured in the *domus scolarum* (house of scholars), a large building owned by a Cambridge burgess, Nicholas de Barber, that stood opposite Great St Mary's near the market place. Barber took the building back for his own use in 1309, and it is probable that teaching was carried out thereafter in several student hostels that accommodated jurists, such as the Burden Hostel, until the mid-fifteenth century. By 1420, the university began building a canon law school, completed with a library above by 1438, and it formed the west range of the quadrangle now known as the Old Schools, the pres-

ent-day seat of the university's administration. Those who lectured on canon law had to rent the school from the university, which remained responsible for its repair and management.[17] By 1458, the university acquired a site for a civil law school on the south side, and this is depicted in a contemporary sketch by John Botwright, Master of Corpus Christi College (Fig. 3). This building was finished with another library above by 1471.

Students found law hard. Formal addresses made by canon law students, probably on their assumption of teaching duties at Cambridge, *c.* 1430, speak of sleepless nights and nerves before taking part in disputations.[18] Not only was the subject intrinsically difficult, but it was hard to find the funds to stay the long courses of study. Fees had to be paid to lecturers, and the expenses of the formal ceremonies for taking a degree were substantial. Candidates for the DCnL were also required to buy or borrow for their own use copies of the *Corpus iuris civilis* and the *Decretum* and *Liber extra*. Accommodation also had to be found. Monks and friars might obtain board and lodging in a convent of their order in or near Cambridge, and some provision was made for monastic students in the town, such as the hostel set up for the monks of Ely by its prior in 1340 or the two houses bought by the Abbot of Crowland in 1428 to accommodate Benedictines studying canon law and theolo-

Fig. 3

gy.[19] Most secular students rented rooms in the various Cambridge student hostels and relied on the financial aid of friends, family and patrons. A few were lucky enough to obtain a benefice, the revenues paid to a parish priest. According to Pope Boniface VIII's constitution *Cum ex eo* (1298), they might obtain a dispensation from their local bishop to absent themselves from pastoral duties during their years of study. Law students could supplement their income from teaching and find employment in the local church courts as scribes copying the masses of documents that Romano-canonical procedure required. The more advanced students might work as advocates, and lecturers as judges.[20] It was indeed the career opportunities that made the long hard years of legal study worthwhile. During the later Middle Ages, most Cambridge graduates entered the service of the Church, and those with law degrees were generally more successful in reaching high office, especially civilians. Of the twenty-nine Cambridge men appointed bishops in the fifteenth century, for example, thirteen were civilians, three were trained in both laws, and one had degrees in theology and canon law. Many Cambridge law graduates also entered royal service. Of the ninety-seven Cambridge men with royal associations in the 1300s, fifty-two held law degrees, thirty-three of them in civil law, which was useful for judges and diplomats.[21]

Law was therefore a popular course of study. Since the law faculties at Cambridge did not require prior training in the arts, unlike theology, law was a serious rival to arts as an undergraduate degree. Of the secular scholars at Cambridge in 1340–1499, half were studying arts, a third to two-fifths, law, and only about a tenth, theology. Admittedly, the non-seculars, who made up 28% of all Cambridge students in the 1300s, were dominated by the friars, almost all of whom studied theology, but in the 1400s, the number of friars and thus theologians declined at the university. Hence, seculars and lawyers increased so that in 1458–82 law accounted for 35% of scholars, arts 58%, and theology only 8%.[22] The growth of law studies at the expense of theology was a widespread phenomenon, and it was decried by some, notably the friar John of Bromyard acting University Chancellor in 1382, as making the Church more worldly and less spiritual.[23] This way of thinking had influenced many founders of Cambridge colleges. As early as the mid-fourteenth century, some colleges' statutes placed strict limitations on the number of jurists to be admitted as fellows, notably at Clare and Peterhouse, in order to stop them swamping institutions and to favour theologians. Several colleges certainly curtailed the number of law fellows after 1400. At Corpus Christi (1352), for example, fellows mostly took law degrees in the late fourteenth century but none did so in the fifteenth century, and a similar reaction against law studies is found at Peterhouse, Clare, Pembroke and Gonville. After the mid-fifteenth century, some colleges were founded exclusively for theologians, notably Queens' (1448) and St Catharine's (1473). Only three colleges catered specifically for jurists. King's Hall (1317) was the main centre of civil law studies in the university and accounted for a fifth of its graduates in the subject. This emphasis was encouraged by royal patrons, who gave law books to its library, notably its founder Edward II and Henry VI, since they valued it as a source of trained legal personnel for royal service. Indeed, Henry VI told its scholars in 1440 that his gift of books, half of which were on civil law, was intended to assist their

studies so that they could serve the king and state better in civil law.[24] In 1350, Bishop Bateman of Norwich had also founded Trinity Hall exclusively to promote 'the growth of canonistic and civilian learning'. Its fellowship was accordingly restricted to law students and produced the second largest output of law graduates among the colleges after King's Hall before 1450. Of the fifteenth-century foundations, only King's College (1441) was prominent in law, soon overtaking Trinity Hall as the college with the most law graduates after King's Hall. College fellowships, however, only accounted for a small proportion of scholars at Cambridge. Many jurists lived in hostels such as the Burden Hostel, and some rented rooms in colleges such as Peterhouse, even if they were not admitted as fellows. A meagre college stipend, regardless of statutory restrictions, held little long-term attraction for lawyers, in any case, when more lucrative sources of income were open to them.

One major respect in which colleges contributed to law studies at Cambridge was in the provision of books. Law students had to develop close familiarity with the texts of the two laws through lectures and private study, which involved memorizing hundreds of laws. But

Fig. 4

manuscript books were dear to buy, therefore a library holding multiple copies of basic textbooks was an essential feature of any medieval academic institution. Several founders of Cambridge colleges recognized this need. Bishop Bateman of Norwich gave books to his foundation of Trinity Hall in 1352 and promised others that he reserved for his use till death, some ninety volumes altogether. The books reflected his intention that the college should be a community of jurists, for thirty-two were on canon law and thirty on civil law (Fig. 4). They included his old student textbooks and a book of case law that he probably compiled as a hearing-judge at the papal court of the Rota in the 1340s. His statutes required the commentaries of canon and civil law to be chained in a secure room to which all college members might have access, but these books were for reference only and had to be consulted *in situ*. Legal texts, however, might be borrowed for private study. Similar arrangements existed at other colleges. In keeping with its chief aim as a pool of jurists for royal service, King's Hall built up a large library collection specializing in law, especially civil law, and in 1391 four-fifths of its books were available for loan. Records of books bor-

Fig. 5

rowed by members of King's Hall survive among the college accounts from the 1380s and 1390s, and they reveal that most members borrowed civil law textbooks in accordance with their academic needs. A borrowing register also survives from Gonville for 1406–10, and a third of the seventy odd volumes that it refers to were on law.[25]

Cambridge libraries acquired many books on law, and other subjects, as gifts from alumni. The university largely formed its collection in this way since it had no founder to establish its library. Its earliest known catalogue compiled between *c*. 1424 and *c*. 1440 is indeed called a 'register of books given by various benefactors'. Twenty-three of the 122 volumes listed in it were on canon law (Fig. 5), and eleven of these had been donated by Richard Holme, DCL and Warden of King's Hall from 1417 until his death in 1424. The catalogue included no civil law books, though the university had certainly received some by then, such as those bequeathed in 1415 by William Lorying DCL. By 1473, the library had grown as a result of further gifts to include fourteen books on civil law and forty-five on canon law, twice as many as in 1440.[26] Most benefactions, however, went to college libraries. Peterhouse had thus acquired seventy law books by 1418, and Clare, forty-four by about 1440. These collections were largely built up through small gifts, but a few gifts were large, indicating the extensive private libraries that a few successful jurists amassed. For example, Thomas de Lexham, DCnL, bequeathed some thirty books to Clare in 1382, mostly on canon law. Likewise, in 1529 the Burden Hostel received as many as forty-six volumes on civil and canon law from the estate of John Dowman, DCL and Archdeacon of Suffolk (Fig. 6).[27]

Fig. 6

Gifts of books were sometimes solicited by colleges. Henry VI's gift of books to King's Hall mentioned earlier, half of them on civil law, was prompted by a petition of Richard Caudray, its warden, that claimed that the studies of its scholars were suffering since the college was poorly provided with the books that they needed, and they were too poor to buy them themselves. But most books were given freely to colleges by their old members. A college's library thus reflected the interests of the community that formed it. At King's Hall and Trinity Hall, both dedicated to legal studies, almost all the books that old members donated were unsurprisingly on law. The interests that such gifts indicated were not always those prescribed by a college's founder or statutes, however, and indeed they illustrate that initial attempts to restrict the admission of jurists to colleges were not wholly effective. Lady Clare, a thrice-widowed heiress and the foundress of the college that bears her name, had intended arts and theology as the main subjects of study in her foundation, permitting no more than two civilians and one canonist to be fellows at any one time. However, almost half of the books given to the college in its first century down to 1440 were on law, and most of them had come from fellows. Indeed, many fellows and masters of Clare College before 1440 had been jurists despite the foundress's wishes. Likewise, in 1418, Peterhouse also seems to have had too many law books. Its statutes of 1344 limited the number of jurists in the fellowship at any time to one civilian and one canonist, yet by 1418 it had received enough basic law textbooks to equip twice that number.[28] In the fifteenth century the tide did turn against legal studies in the colleges, and this is reflected in the changing character of many college libraries in this period. The earliest list for the library at Corpus mainly comprised law books, for it was compiled in the late fourteenth century when the fellows were mostly taking law degrees. But in the following century, none of the fellows did so. Most aspired to parish benefices and hence studied theology. Accordingly, by 1550 the library was dominated by works on pastoral theology, largely as a result of major benefactions from three former masters of Corpus.[29] Similar reactions against legal studies in favour of theology characterize the development of the libraries at Peterhouse, Clare and Gonville after 1400. The number of theology books at Peterhouse grew from ninety in 1418 to some two hundred by c. 1481, for example, but in the meantime it had acquired few additions to the seventy law books held in 1418 and had even sold some of them. This trend was reinforced by the foundation of the 'theological' colleges of Queens' and St Catharine's, equipped with predominantly theological libraries. The founder of the latter even precluded the study of law in his foundation and hence gave it no law books.[30]

This collegiate antipathy to law was unrepresentative of general academic trends across the university, where legal studies were in the ascendant in the fifteenth century, and indeed it was as nothing compared with the assault that was to follow Henry VIII's break with Rome. In 1535, Henry suspended the teaching of papal canon law at Oxford and Cambridge, and, despite a brief revival under the Catholic Queen Mary (1553–58), the subject disappeared from the curriculum. Some private study of medieval canon law continued since the new Anglican canon law was in large part formed out of it, but since

37

degrees could no longer be taken in the subject, its textbooks were largely discarded as useless, and indeed few canon law books recorded in medieval catalogues of Cambridge college and university libraries now survive. Civil law remained on the curriculum but its importance gradually diminished, although it is still taught in the university as part of the degree in English common law. No civil law books survive from the once-great collection at King's Hall, and few remain from other medieval libraries in Cambridge (Cat. Nos 16–18); however, this probably has as much to do with the replacement of manuscripts by printed books in most libraries during the early sixteenth century as the decline of the subject. After 1535, some private collectors preserved medieval legal manuscripts as antiquarian curiosities and gave them to Cambridge libraries (e.g. Cat. No. 19). The items in this exhibition are treasures rescued from the spoil heap of history, and from these fragments the visitor to the exhibition can hopefully begin to reconstruct the past in which they were once so important and valued.

Notes

1 Helmholz, pp. 1–27.

2 Kuttner, 'Revival', pp. 300–04.

3 De Zulueta and Stein, pp. xiii–xxi; Winroth, pp. 157–74.

4 Winroth, esp. pp. 122–45.

5 Kuttner and Rathbone, 'Anglo-Norman Canonists', pp. 317–19.

6 De Zulueta and Stein, pp. xxii–xvii, xxxiv–xxxvii; Boyle, 'Canon Law', pp. 532–33.

7 De Zulueta and Stein, pp. xvii–xix; Boyle, 'Canon Law', pp. 532–33. Boyle notes, however, that after 1234 separate faculties of canon and civil law emerged at Oxford, but that of civil law was effectively the undergraduate department of canon law.

8 Bellomo, pp. 129–32.

9 Kuttner and Smalley, 'Glossa'.

10 Especially Trinity Hall (see Libraries, UC55).

11 Kuttner, 'Johannes Andreae', esp. pp. 395, 403–06.

12 Brundage, 'Cambridge', esp. pp. 21–30.

13 Hackett, pp. 29–32, 130–31.

14 Leader, pp. 192–201; Owen, pp. 3–4; cf. Boyle, 'Canon Law' on Oxford.

15 Hackett, pp. 28n, 130–33, 136n, 138.

16 Brundage, 'Cambridge', p. 28.

17 Owen, p. 6; Brundage, 'Cambridge', pp. 28–29.

18 Logan, 'Sermons and Addresses', pp. 153, 155–58.

19 Aston et al., 'Alumni', pp. 54–57; Brundage, 'Cambridge', p. 29; Owen, pp. 5–6.

20 Brundage, 'Cambridge', pp. 30–45.

21 Aston et al., 'Alumni', pp. 67–84, esp. pp. 70, 81.

22 Aston et al., 'Alumni', pp. 57–63.

23 Cobban, 'Theology and Law', pp. 57, 67–77.

24 Libraries, UC37 (Henry VI).

25 Libraries, UC24 (Gonville), UC31–35 (King's Hall), UC55 (Trinity Hall).

26 Libraries, UC2 (c. 1424–c. 1440), UC3 (1473); BRUC, pp. 373–74 (Loryng).

27 BRUC, 192–93 (Dowman), 366 (Lexham); Libraries, UC8 (Burden Hostel).

28 Libraries, UC11–12 (Clare), UC46 (Peterhouse).

29 Libraries, UC16 (earliest list), UC17–18, UC20 (gifts of masters), UC23 (mid-sixteenth-century list).

30 Libraries, UC49 (Queens'), UC51 (St Catharine's).

3. Production and Purchase:
Scribes, Illuminators and Customers

Susan L'Engle

IT WAS A CUSTOM FOR BEAUTIFULLY designed and illuminated Books of Hours to be commissioned to commemorate a marriage, as a groom's gift to the bride or perhaps a mother's to her daughter, although wealthy members of the laity would ordinarily purchase one or more examples for themselves. A Book of Hours could be used by anyone who could afford it, to recite one's daily devotions, to seek out special prayers for fearful moments or simply to leaf through and admire. Its dimensions and appearance were user-friendly: the text was generally written in one column of fewer than twenty lines; most pages were decorated with brightly coloured initials and borders, and many others had large coloured pictures enhanced with gold leaf; the book itself was easily handled and extremely portable, often petite enough to be hung by a chain from a lady's waist. This was not so with a volume of canon or Roman law. Large and bulky, it was densely written, usually with two different texts to be considered in tandem. It was awkward to carry and needed a large surface on which to place it for consultation. Although some copies were lavishly illustrated, the majority was furnished with the minimum number of visual cues necessary for the reader to navigate the text. It is doubtful whether law books would be commissioned to commemorate a wedding, as has been suggested for the St John's College MS A.4 (Cat. No. 19), a *Liber sextus* accompanied by four of its commentaries: although beautifully decorated, this very specialized collection of texts would not have served any immediate practical or devotional use to a married couple.[1] Legal texts, decorated or not, had a specific scholarly public.

Owners and Users

The twelfth- to fourteenth-century manuscripts in this exhibition were largely produced for study, though not all of them were originally made for English owners, as some details of provenance attest. Fitzwilliam MS McClean 135 (Cat. No. 2), of uncertain origin, was owned by the Benedictine Abbey of Wiblingen, Würtemberg in the seventeenth century; MS McClean 136 (Cat. No 14), produced around 1300, has a later, partly erased ownership inscription *Domini Vuillermi de kirko[s?]* and an eighteenth-century German binding; Fitzwilliam MS 262 (Cat. No. 8) in a sixteenth-century German binding was most recently owned by John Ruskin. There are many manuscripts in Cambridge and in other parts of England, however, that have been in the possession of their church and college libraries since the fourteenth century, as can be verified in the numerous (more than eighty) medieval catalogues that survive from English monastic institutions, cathedral chapters, universities and hospitals.[2] Texts of canon and civil law were acquired for courses of study

as well as for practical applications. *Decretales* and *Summae* are listed among the required books for the Dominican houses in Humbert of Romans's *Constitutions*.[3] In the fourteenth century, Bishop Hamo Hethe of Rochester bequeathed his canon law books to Rochester Cathedral, that they might assist

> some churchmen of our diocese, [who] although commendable for their life and learning . . . have committed grievous and absurd errors for lack of books profitable to such cure or such office, especially in the matter of consultations and salutary advice to their flocks, of enjoining penances and of granting absolutions to penitents.[4]

In Europe the study of law took place under diverse circumstances. Both canon and Roman law were taught at the *Studium* in Bologna, the latter to a student population of mixed clerical and secular elements. At the University of Paris, the study of theology was foremost in the curriculum, and though a faculty of canon law was available, the study of Roman law had been prohibited by papal decree.[5] In England, as treated with more detail in Chapter 2, emphasis was on the study of canon law. This partly explains the overwhelming predominance of canon law texts that survive in Cambridge collections and which make up the exhibition described in this volume.

Some of the Cambridge Colleges possessed more extensive library resources for the study of law. This is particularly true for Corpus Christi, as evidenced by the very detailed description of the College's books found in its earliest inventory, begun in 1376 by John Botener and supplemented by John Northwode, admitted as Fellow in 1384.[6] A total of forty-one civil and canon law texts are recorded in the list. An important distinction in this inventory is the manner in which Northwode identifies the opening passages of the legal texts: in contrast to Botener's standard listing of the first words of the second leaf, Northwode describes when present the figured *decoration* that was furnished for the opening, whether a historiated initial or a miniature. By means of these descriptions it is possible to arrive at tentative dates for these manuscripts, according to the type of illustration furnished or by its iconography, and a more specific example of Northwode's iconographical observations is discussed in Chapter 5.

Legal manuscripts can be encountered in a variety of medieval collections. In the fourteenth-century catalogue of the Augustinian monastery of Lanthony (found in London, BL, Harley MS 460) we find that books are listed according to the armaria in which they were kept, and that the fourth held the volumes on law together with those of philosophy, grammar and mathematics.[7] Books were also held in private hands. Geoffrey de Lawath, rector of St Magnus, London, in the late thirteenth century, listed the contents of his personal library on the last flyleaf of a *Decretum Gratiani* in Pembroke College Library (MS 162).[8] Among a total of forty-eight books divided into five thematic sections, the first section labelled *Canonico* (canon law) contains four different volumes, the first of which, a *Liber decretorum*, is probably Pembroke MS 162 itself.[9] Library inventories, wills and lists of bequests reveal what texts were most useful to canonists and other clerics, as well as

practising lawyers. The fifteenth-century library inventory of Henry Bowet, Archbishop of York, included at least twelve books of canon law.[10]

Book Production

Where did individuals and institutions get their books? Most academic institutions in Cambridge acquired their volumes as gifts and bequests from fellows, alumni and faculty. The original provenance of their thirteenth- and fourteenth-century manuscripts, however, is multi-national. While there is evidence of university book production in Oxford and Cambridge as early as the thirteenth century, many of the thirteenth- and fourteenth-century legal manuscripts found in English libraries were executed in one of the two major centres of book production, Bologna or Paris, as revealed by their scripts and decoration. A large number was also produced in the South of France at Toulouse, Montpellier, Avignon and Orleans. In most cases they would have been commissioned and purchased on the spot by students, travelling canonists and clerics, and taken back to England upon their return. A variety of foreign clients is mentioned in Bolognese records of contracts for writing and decorating legal texts, which sometimes specify the patron's nationality and occupation: student, churchman, doctor, lawyer, teacher. For example, on 25 January 1267, Magister Andreas, scribe, promised Bernardo of Montpelier, a student, to write the gloss to a *Decretales* for the price of 15 soldi per quire;[11] also in 1267 the brothers Cardinale and Rogerius di Paganello da Forli agreed to write a pair of glossed *Decretales* for Frédol de Saint Bonnet, a canon of Maguelonne, for 134 lire;[12] and on 17 November 1288, the illuminator Zagnibonus promised Gualfredo Buticulario, a rector from Normandy, to illuminate one *Decretales* for 20 lire and two others for 22 lire.[13] A number of legal texts could also have been purchased second-hand directly from students or through a university stationer, who in both Paris and Bologna exercised the function of broker for this transaction, but was forbidden to buy and sell second-hand books directly.[14] Books, either foreign-made or domestically produced could also be obtained closer to home: the earliest record of a stationer in Cambridge is found in a note of purchase written on a flyleaf of Gonville and Caius College, MS 17, dating to 1309–10: 'Memo that I bought this book from John Haclay on the Vigil of the Apostles Saints Simon and Jude in the house of William de Nessfylde, stationer, before the following witnesses. . .'.[15]

In university towns,[16] the production of textbooks was facilitated by the *pecia* or piece system of gatherings provided by stationers to scribes on a sequential basis.[17] The *pecia* was established in Bologna as a unit consisting of two bifolia containing sixteen columns, each of sixty lines and each line composed of thirty-two letters; although in practice it has been found that the actual dimensions could vary.[18] The stationers affiliated with the university would take an official copy of each university textbook and its gloss, called an *exemplar*, and have it copied into the *pecia* format, in as many numbered units as necessary to the length of the text. Each *pecia* was carefully corrected, since the accuracy of the text copy was continually monitored by the university. Professional scribes or students copying books for

Fig. 7

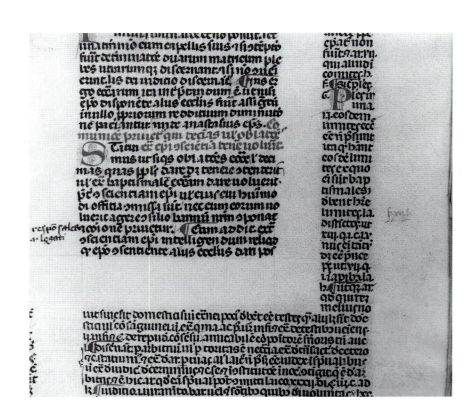

Fig. 8

42

themselves were then allowed to rent the copied *exemplar*, *pecia* by *pecia*, picking up the next in order after returning the first, and in this way it was possible for a large number of people to copy the same text simultaneously. It is thought that the *pecia* system was first established in Bologna somewhere between 1200 and 1225, and a bit later in Paris. Nonetheless, if a notation heading the second text of Trinity College MS O.7.40 is correct – '*In hoc libello continentur XXV pecie different*' – it would appear that this procedure had been in force somewhat earlier, as the script has been dated between 1150 and 1180.[19]

Scribes were paid for their work according to how many *pecie* they had copied, and thus were very careful to annotate the individual *pecia* numbers on page margins at the appropriate intervals in the manuscripts they were copying out. In Bologna the *pecia* mark was usually placed at the end of each section; in Paris scribes more commonly designated the beginning. Sometimes these marks have been cut off when the manuscript was trimmed for binding, but a great many survive: *pecia* marks are visible in Fitzwilliam MS 183, MS McClean 139 and Durham MS C.I.9, as seen in Figure 7, a *pecia* mark for the text, and Figure 8, one for the gloss. It is important to understand that though the *pecie* were written in units of a specific length, a scribe would copy them onto blank quires of eight, ten or twelve leaves in accordance with the layout specified for the particular text being written, and in his or her personal manner of execution, varying with regard to details of script, the form and frequency of abbreviations and formatting strategies. Thus, although multiple copies of the same text could be made using the same set of *pecie*, the resulting manuscripts were not physically identical, differing at the very least in length, number and size of quires and length and width of text columns.

Manuscript Production and Collaboration

The stereotype of the patient, dedicated monk bent over his writing table, copying texts day in and day out to the glory of God, persists to this day. It is true that many monasteries retained their scriptoria or at least some form of scribal activity through the fourteenth and fifteenth centuries. Nunneries in fact were responsible for a great amount of copying in Florence. But the work done by the religious was almost always of liturgical, theological or biblical texts, and usually destined to supplement or replace their institution's holdings. There was rarely a sense of urgency towards completion; religious communities had other activities and commitments to pursue in their daily routines.

Legal texts, on the other hand, were required year after year in great numbers by the students who flocked to the faculties of canon and civil law. The production of these specialized university textbooks in mass quantities required the services of professionals prepared to exercise this task on a full-time basis, adhering to the exigencies of accuracy imposed by the university, and a time schedule established by their patrons. They were for the most part lay persons, independent semi-educated individuals trained to copy texts in a variety of scripts, in Bologna working out of their homes rather than for an employer in a workshop.[20]

Scribes from all over Europe came to Bologna to learn the *littera nova*, or *littera bononiensis* as it came to be called, a fine, regular, eminently legible script developed by Bolognese scribes, so popular that it was often specifically requested in contracts.[21] A particularly accomplished example is found in the Fitzwilliam Museum's *Decretum Gratiani* single leaves (Cat. No. 5). It was highly in demand domestically and internationally in the second half of the thirteenth century. The term 'Bolognese' is sometimes assigned to a manuscript simply with reference to this distinctive script even though it was not exclusive to Bologna. In addition, scribes in all countries mastered a variety of scripts in order to guarantee a wider client base. Countless manuscripts in international collections present a mixed assortment of written and decorative elements whose pedigree often cannot be precisely determined, as can be seen in a number of the manuscripts in this catalogue. Not only Bolognese script but the decoration of manuscripts in the 'Bolognese' style was admired outside Italy, and was widely imitated during the thirteenth and fourteenth centuries by Transalpine illuminators, particularly those working in Southern France and in Catalonia. In fact, stylistic characteristics were imitated so well in some cases that only recently have a number of manuscripts long thought to be produced in Bologna been reassessed and reassigned to French or Spanish artists. Other features, therefore, including layout, number of leaves in a quire, form of the *lemmata*, *pecia* indications and iconography, must be considered to pinpoint a manuscript's place(s) of production. For example, Robert Gibbs has stressed that Italian manuscripts tend to have quires made up of eight or ten folios, whereas North of the Alps they are generally written in quires of twelve. In Northern manuscripts *lemmata* are underlined rather than alphabetically keyed, as they are in Italy.

Medieval scribes and illuminators would travel considerable distances in search of work, and their presence in foreign lands is often recorded. The same Bolognese contracts that describe the patrons also specify the nationalities of scribe or illuminator, revealing a considerable presence in Bologna of book trade professionals from a variety of locations, inside and outside of Italy. For Paris the names and nationalities of scribes, artists and booksellers can be found in tax records and university lists. Frank Soetermeer, who has done considerable work in the Bologna archives, has observed a proportionally high number of people from the British Isles involved with the production and sale of books in Bologna in the fourteenth century.[22] Richard and Mary Rouse have examined the roles foreign artists played in the book trade in both Paris and Bologna, documenting English scribes and artists working in Paris between 1279 and 1349, and others who travelled even farther.[23] A noteworthy example of book production involving the collaboration of peripatetic professionals is a very beautiful Bible now in Paris (BNF, MS n. a. l. 3189), executed in Bologna by a multi-national team of craftsmen, around the mid-thirteenth century. The Bible was first designed and written by the English scribe Raulinus, who signed his name in an autobiographical colophon recounting that he was born at Fremington in Devon, studied and worked in Paris and then became a scribe in Bologna. He adds that he wrote the Bible as expiation for his sins (some of which are spelled out in detail), and hopes to be pardoned

by the Virgin.[24] Two Parisian artists, also working in Bologna at this time, provided the Bible's illumination, as well as a contemporaneous Bolognese artist who executed the illumination of the replacement for the first quire.[25] The Corpus Master, a French artist whose work Robert Branner[26] identified in Paris from the 1240s until after mid-century, illuminated only one quire; the Johannes Grusch Master,[27] whom Branner dated working in Paris from the 1240s and 1250s, was responsible for the rest of the illumination aside from the Bolognese artist's opening quire. The Rouses suggest that the Parisian illuminators were temporarily in Bologna taking advantage of the excellent employment opportunities for skilled illuminators, particularly since Parisian illumination was so highly prized,[28] the Corpus Master also illuminating another work in Bologna, the Copenhagen *Corpus iuris civilis*.[29] In the case of the Raulinus Bible, then, we may observe an English scribe, a Bolognese and two French illuminators working together in Bologna, the first imitating a Bolognese script, the second painting in typical Bolognese 'First Style', and the last two maintaining the highest traditions of Parisian illumination, all in the same manuscript.

A similar situation is found in a fourteenth-century *Decretales* at Durham, MS C.I.10. Composed in gatherings of twelve folios (as was Raulinus's Bible), more characteristic for Northern manuscripts, text and gloss are written in either the true *littera bononiensis* or a close copy of this script, much as in MS McClean 136 (Cat. No. 14). Penwork and illumination are definitely Northern, probably French; the three-line penwork initials placed in the margins beside the text are more tall and narrow than Italian work. Furthermore, these initials are all blue, as has often been observed in English canon law manuscripts, whereas Italian and particularly Bolognese canon law manuscripts are articulated with alternating red and blue initials. Interestingly, however, at the end of the manuscript the text scribe names himself *guillermi de bononia* in the colophon on folio 269, raising the inevitable question: was William in Bologna when he wrote the manuscript, or had he travelled to England or Paris to ply his trade?[30]

The foregoing examples can serve as benchmarks by which to assess some of the problematic manuscripts in this exhibition. The Durham set, MSS C.I.4, C.I.6 and C.I.9 (Cat. Nos 11–13) taken as a whole, present especially complex features. All are apparently written in a firm *littera bononiensis*; all three contain illumination executed by authentic Bolognese artists, whose work can be found in other purely Bolognese manuscripts. Their rubrication and penwork are consonant with Bolognese work of the period, except for the C.I.9, part of whose calligraphic decoration was omitted in a first campaign and was added subsequently after the illumination had been executed. The later additions, perhaps made in France or England, are in the Northern angular and elongated style, and become even more compressed and distorted where the penwork artist tries to fit it around or between the painted decoration. Yet in two of these manuscripts illuminators of different stylistic traditions share the decoration with the Bolognese artists, in a manner comparable to the Paris Bible.

The *Parvum Volumen* (MS C.I.4) seems to be a straightforward Bolognese production and was illuminated by two Bolognese artists. In the *Codex* (MS C.I.6) the collaboration is

among at least four illuminators who alternate work in groups of quires: two Bolognese, the first working only in the manuscript's opening quire, the second artist also the main artist of the *Volumen*; the Jonathan Alexander Master, who is most likely from a Toulousan background; and a Northern French artist. The bulk of the work is shared between the second Bolognese and the Jonathan Alexander Master, for the other Frenchman only executes the illustration in two quires, the first of which is fifth from the end, the second the ultimate quire in the manuscript. From the pattern of alternation, it would be reasonable to suppose that the illumination was parcelled out among the different hands, and executed in the same locale during one campaign of illumination. The same seems true for the *Decretales* (MS C.I.9), in which work alternates between two different Bolognese artists and a French artist imitating the Bolognese style, up to the last three quires, at which point the Jonathan Alexander Master enters and executes all the illumination for the added series of *Constitutions* (fols 321–350) to the end of the manuscript[31].

What are we to make of this collaboration, and how can we determine how it was effected? Were one or more of the manuscripts written in one place, partially illuminated there, and then taken elsewhere to be completed? Or were the illuminators all based in Bologna, temporarily or permanently, taking advantage of the healthy job market, representing available labour and occasionally sharing the decoration of various manuscripts? It may never be possible to settle these questions beyond doubt in this case, for lack of concrete data and the range of alternatives, and indeed, in the face of even more complex interactions observed by Kathleen Scott:

> The permutations by which the work of English and Continental artists might be brought together within the confines of one book can take as many different forms as the divisions of labour in book decoration and illustration allow. The basic book (material, script, secondary decoration) may be an English product to which contemporary miniatures from a foreign production site were added. It may be foreign-made, with extensive English additions of text, decoration, and miniatures; or a complete text in a foreign manuscript may be fitted with a second complete text in England and designed to match the first. An English manuscript may give evidence of an English illustrator (or more than one) having worked with an alien border artist; or the book may show the work of one or more Continental illustrators together with that of native border artists or other craftsmen; or, still in a basically English book, work by an alien illustrator may appear with two different types of foreign border decoration.[32]

Apart from the enigmas of multi-national production, however, it is essential to understand the need for collaboration in the production of juridical texts, and the factors involved in its organization. It is rare to find an individual legal manuscript, particularly one with numerous major text divisions, illuminated by a sole artist. Legal texts were simply too long and could encompass more decoration than one artist could complete within a time period agreeable to the normal patron. Most, therefore, were executed by groups of

artists, craftsmen not necessarily located within the same physical confines, but sharing similar experience and expertise that allowed them to work piecemeal on the illumination of large projects.

Each project would require centralized coordination, since the normal unit of work parcelled out to artists as well as scribes was the quire, and the division of a manuscript's quires and their distribution to different artists was often extremely complex.[33] How this control was maintained and by whom is still mostly a matter of conjecture – whether it was exercised by a university stationer, a workshop master, the main illuminator or by the scribe who contracted for the work.[34] The physical proximity of residential and commercial establishments would facilitate collaborative work. Illuminators in Bologna tended to live close to each other, as can be seen in the documents that register their contracts and in the commercial transactions witnessed by fellow artists.[35] In Paris stationers and professionals of related trades were concentrated in two locations: the Left Bank around the University of Paris, and on the tiny crowded Rue neuve Notre Dame on the Ile de la Cité;[36] in early thirteenth-century Oxford they gathered in Catte Street.[37]

The term 'workshop' has been assigned to various combinations of collaborative activity. Francesca d'Arcais suggested for Bologna that the patterns of exchange and alternation of hands in some legal manuscripts indicated that these artists were probably working side by side in a workshop, not only collaborating on a particular text, but also on the decoration of other manuscripts simultaneously.[38] She considered that the task of distributing quires among illuminators fell to the scribe, who would thus be responsible for the execution of all phases of the manuscript: writing, choice of iconography and organization of the decoration. Alessandro Conti further observed that manuscript decoration was parcelled out among associates of differing experience and skills, who not only executed their own work, but were free to refine the efforts of others.[39] 'Workshop' could also signify a master and his assistants, or various family members with different skills working together in their home – such as the thirteenth- through fourteenth-century family dynasty of scribes described by Soetermeer.[40] For Paris, it has been observed that a *libraire* (the exclusive university stationer) could centralize manuscript production activities, executing one or more that fell within his areas of expertise, and contracting out for the others.[41]

In any event, manuscript illumination follows an overall design, the production and sequence of which would be overseen by a controlling force, the scribe or perhaps the main illuminator. He might have the final word on the finished illumination for the manuscript as a whole, and could re-work the compositions of others, or may simply have agreed to see to the completion of the decoration program, without vouching for its quality. This may be the case in the B 18 Master's *Decretum Gratiani* (Cat. No. 6), where the Master himself executed the opening two-column miniature and a number of the smaller ones, but delegated the rest to two or three assistants who imitated his style at varying degrees of competence. The different artists in the Marlay single leaves (Cat. No. 5) are also close in style but maintain a higher level of technical skill. In the Durham manuscripts, however, while the artists are all of high-calibre, their styles spring from entirely disparate traditions –

perhaps evidence that those who commissioned the illumination were either incapable of discriminating between styles or felt no need for stylistic consistency in their manuscripts – or, more pragmatically, simply an indication of what artists were free to take on a commission at the time. The success or failure of mass book production depended primarily on the *availability* of specialized craftsmen, over and above their national heritage or stylistic conventions.

Scribes and Illuminators

The little we know about medieval scribes and illuminators comes mainly from their appearance in contemporary documents, such as business contracts for copying or illuminating, registers or membership lists of guilds or religious associations, certification of office in political or social organizations, purchase of land or other property or service as witness to legal transactions. Another source of information can be the infrequently encountered personal signature in a manuscript, which unfortunately is rarely as descriptive as Raulinus's opus in his Paris Bible. Most signatures can be readily distinguished as pertaining to the scribe, generally placed in a colophon at the end of a major division of text or gloss. The scribe either identifies himself as such, using the term *scriptor* or the verb *scripsi*, or resorts to a conventional formula, often a rhymed jingle,[42] describing the job he has done, such as Robertus in the Fitzwilliam's MS McClean 136 (Fig. 9), who made sure he was credited for writing the *Decretales* by signing after the main text division *explicits* on folios 187v and 257v: *'Sum Robertus ego qui mea scripta rego'* – or William of Bologna's

Fig. 9

hope for eternal blessing and joy. One very chatty Italian scribe working in Padua, however, gives us almost as much information as did Raulinus. In Italy the scribe could live in the house of a wealthy patron as a family servant, as Andreas de Mutina informs us, stating that he copied three commentaries by Johannes Andreae (*scripsi totam de manu mea*) in 1359, 1360 and 1363 for the *'sapientis et discreti uiri domini domini Ioannis de Placentini, decretorum doctoris . . . in domo dicti domini Ioannis'* (for the learned and esteemed Johannes de Placentinus, doctor of decretals, in his residence).[43] He describes his patron in very favourable terms, using a formulaic phrase that might confer some reflected glory on the scribe himself for being employed by such a distinguished client. In addition to the place and dates of execution, Andreas tells us in one of the colophons how long it took him to write one volume (a year and seven months) and how much he was paid for it (40 soldi per quire).

While scribes used the verb *scripsit* to refer to the writing of a text, illuminators more often used the term *fecit* (made), which implies a more substantive graphic product.

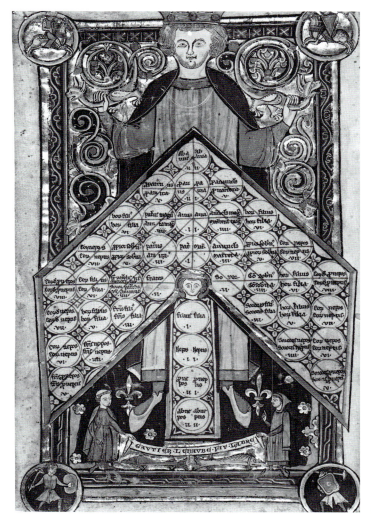

Fig. 10

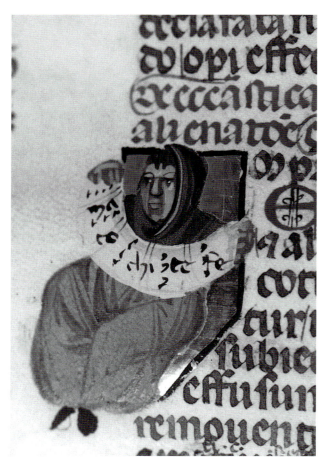

Fig. 11

Sometimes the artist signed his name in a place and in a form that made clear the work for which he was responsible. The mid-thirteenth-century French illuminator of a Tree of Consanguinity in the Morgan Library (MS G.37) revealed his identity in the best Hollywood tradition (Fig. 10). At the base of the Tree he painted the figures of a cleric and a secular official, stretching out a long white banner between them, and wrote upon it in bold letters: *'Gautier Lebaube fit larbe'* (Gautier Lebaube made this tree). Scrolls and banners were ideal media for this purpose, and we have obtained the names of a number of Bolognese illuminators who utilized them. A Byzantinizing artist signed 'Meister Guglielmo' on various scrolls held by marginal figures in an Azo *Summa* at the Bodleian Library (MS Holkham Misc. 47), and the main artist in a Paris *Codex* (BNF, MS Latin 8941, fol. 4) identified himself on the miniature page for Book I, placing an unrolling scroll in the hands of a stately prophet figure, with the inscription 'NERI[US] FEC[IT]' (Nerius made this). What may well be the real name of the B 18 Master[44] (who illuminated Cat. No. 7 and shared Cat. No. 6 with his workshop) has been recently found in a Roermond *Parvum Volumen* illuminated by him and several other Bolognese artists (Fig. 11).[45] In an initial **I** on folio 185v, a hooded, seated figure suspends a banner or unrolled scroll inscribed, in somewhat blotted fashion, in an enigmatic mixture of Latin and Italian − 'MA[R?]CO

CHI TE FE[CIT]' – which I interpret as 'Ma[r]co who made you'.[46] Although the name is uncertain, the intention to register authorship is clear from the 'FE'. Niccolò da Bologna, the first Bolognese illuminator to consistently sign his work, always employed the verb *fecit*, either written out in full or abbreviated as *f.* Only one example of his work in this exhibition is signed (Cat. No. 22); the miniature has been extensively retouched, however, and the signature is almost certainly false.

Craftsmen on the whole were not innovators but followed existing models, often duplicating the same composition from manuscript to manuscript, sometimes with exact combinations of colour or decorative details. The B 18 Master (Marco?) exemplifies this practice. He was one of the most prolific and undiscriminating of artists working in Bologna in the 1320s and 1330s, penetrating all venues and illustrating all manner of texts, which survive in great numbers.[47] His stocky figures with their broad faces, fixed, beady eyes under low straight eyebrows and doorstop noses are distinctive and unvarying, and he used the same compositions over and over, hardly varying poses or attributes. Why was he so popular? He evidently worked very quickly, to account for so many surviving works. Large and small, his miniatures dominate their pages, executed neatly in a pleasing balance of strong, clear colours and filled with massive buildings composed in dynamically shifting planes, silhouetted against combinations of solid gold grounds, and dark grounds ornamented with calligraphic gold designs. His figures, despite their sameness, transmit dignity and power, and their expressions are open and engaging. These qualities are particularly evident in the *De poenitentia* cutting (Cat. No. 7). For the patron, his pictures could be counted on to make an impact, and he was evidently a reliable worker. The last must have counted for a lot in an escalating market.

Occasionally, however, an illuminator appears who transcends the norm and puts a personal stamp on decorative details, motifs and compositions. The artist who created and executed the multi-compartment miniatures in the Fitzwilliam's MS 262 *Decretum Gratiani* (Cat. No. 8) expanded on conventional iconography and added interpretative touches of his own, particularly in his narrative and explicit representations of extra-marital sex. The Jonathan Alexander Master, whatever his origin, combines a refined sense of design with a brilliant use of colour, and above all, manifests an extraordinary imagination that allowed him to extrapolate on existing motifs to generate some of the most cleverly composed and wickedly humorous hybrid creatures ever to grace a manuscript page. Niccolò da Bologna, although his production was so vast that he relied heavily on a limited repertoire of stock compositions and figure types, nevertheless invests his figures with a strong human presence, transmitted through a sensitive modelling of flesh and eloquent facial expressions.

Most illuminators remain unnamed, particularly those considered of less than brilliant artistic vision, or of modest technical accomplishments. Yet it is impossible to speak of the evolution of layout, composition, style and iconography within the large body of extensively illuminated medieval legal manuscripts without dealing with the great majority of generally competent craftsmen who made this production possible. Although major

changes can be attributed to a handful of innovative individuals, their more conventional associates, in copying and modifying selectively, define for us the popularity and duration of certain motifs, and illustrate the mechanism of their transmission from culture to culture, over generations.

Notes

1 As suggested by Egbert in his description of this manuscript; Egbert, p. 118.

2 Wilson, 'Contents', pp. 85–86.

3 Drawn up around 1260, see *Opera de vita regulari*, ed. J. J. Berthier (Rome, 1888–89), II, p. 265.

4 Cited by Jonathan Alexander in his pivotal study of the Durham manuscripts; Alexander, 'Durham', pp. 151–52; see also Coulton, pp. 111–13.

5 Stipulated by Pope Honorius III (1216–27) in his decretal *Super speculam*, making Paris the only French university in the thirteenth and fourteenth centuries where civil law was not taught. See Brundage, pp. 342–36.

6 Briefly listed by M. R. James in the introduction to *Corpus*, I, pp. ix–xi, and fully transcribed by James in 'Inventory', pp. 88–114. A new edition is being prepared by Dr Peter Clarke for the *Corpus of British Medieval Library Catalogues*.

7 Wormald, 'Monastic', p. 25.

8 See James, *Pembroke*, no. 162, pp. 157–59.

9 The four listed books are the following: *Liber decretorum* (probably Pembroke MS 162); *Liber decretalium* (probably the *Decretales*); *Liber qui dicitur summa Gaufridi* (probably Gaufridus de Trano's *Summa decretalium*); *Liber que dicitur summa Reymundi* (probably one of Raymond de Peñafort's *Summae*).

10 Listed in Owen, p. 13.

11 '1267, 25 gennaio. Magister Andreas scriptor filius q. Dominici Isnardi de capella sancte Lutie promette a Bernardo di Montpellier scolaro di scrivere l'Apparato alle Decretali per il prezzo di 15 soldi al quinterno secundum taxationem factam per scolares'. Filippini and Zucchini, p. 9.

12 '1267, 17 maggio. Cardinalis et Rugerius fratres et filii q. Paganelli de Furlivio si obbligano di scrivere unum par Decretalium con le glosse per Frédol de Saint Bonnet canonico magalonense al prezzo di lire 134'. Filippini and Zucchini, p. 45. The same two scribes signed the remarkable Bible, Paris, BNF, MS Latin 22,

which they wrote for the same patron, perhaps a short time before the *Decretales*. See Avril and Gousset, II, cat. no. 103, pp. 85–87, pl. C, figs XLIX–L.

13 '1288, 17 novembre. D. Zagnibonus q. Aspectati de capella sancti Marini promette a d. Gualfredo Buticulario preposito Normandie di miniare un Decreto per 20 lire e due paia di Decretali per 22 lire'. Filippini and Zucchini, p. 238.

14 For a detailed description of the activities of university stationers, see Rouse and Rouse, 'Dissemination', especially p. 73, as well as most recently Rouse and Rouse, *Manuscripts*.

15 Cited in Talbot, 'Universities', p. 73.

16 Pollard lists eleven universities that utilized the *pecia* system: Bologna, Padua, Vercelli, Perugia, Treviso, Florence and Naples in Italy; Salamanca in Spain; Paris and Toulouse in France and Oxford. Although he claims that no evidence of its use has been found for any of the German or Dutch universities, or Salerno, Montpellier, Orléans, Angers, Avignon or Cambridge, Talbot maintains that it was in operation in both Oxford and Cambridge in the thirteenth century. See Pollard, 'The *pecia* system', p. 148; and Talbot, 'Universities', p. 68.

17 Literature on the *pecia* begins with Destrez; see Rouse and Rouse, *Manuscripts,* for Paris and Soetermeer, *Utrumque ius in peciis,* for Bologna.

18 In Bologna the size of the *pecia* was also directly related to the *punctum*, the amount of text a university professor was required to cover within a specified period of time, usually around a fortnight.

19 On fol. 71; see James, *Trinity*, III, pp. 376–79.

20 For the university production of legal texts in Bologna, as well as extensive bibliography, see Soetermeer, *Utrumque ius in peciis*, pp. 30–33; and Devoti, 'Aspetti', especially pp. 80–84 on the profession of scribe and contractual obligations with the university.

21 Referred to in contracts as *'littera nova'*: '12 ottobre 1268. Bonaventura qui fuit de Perusio scriptor vende a

Pietro di Giovanni un Codice *de littera nova* con l'apparato di Accursio in pergamena per lire 50' [my emphasis]. See Filippini and Zucchini, p. 40.

22 Soetermeer, 'Famille de copistes', p. 430.

23 Rouse and Rouse, 'Wandering Scribes'.

24 '[I] entered there into the wicked embraces of women and their depraved couplings – and squandered everything [I] had'. Transcribed in full in Rouse and Rouse, 'Wandering Scribes', p. 43.

25 The Parisian illuminators were identified by François Avril; see Avril and Gousset, II, p. 95. The Bolognese artist was also responsible for the illumination of another manuscript in Paris (BNF, MS Latin 3253), ibid, pp. 96–97.

26 See Branner, pp. 115–17.

27 Lately rebaptized Master of the Polyphony for his work in a music manuscript at the Biblioteca Laurenziana in Florence, MS Plut. 29.I. See the catalogue entry by Marie-Thérèse Gousset in *Duecento*, cat. no. 92, pp. 294–96, fig. 92c.

28 Rouse and Rouse, 'Wandering Scribes', p. 57.

29 Copenhagen, Royal Library, MS Gl.Kgl. S. 393,20, up to now thought to be produced in Paris but suggested by the Rouses to be entirely an Italian product; see Rouse and Rouse, 'Wandering Scribes', p. 50.

30 The colophon: 'Expliciunt decretales noue et novelle per manum guillermi de bononia cuius p[er]sona semp[er] in gaudio et bonitate regnat im p[er]petuum amen amen amen et it[er]um fiat ame[n]' (Here end the new Decretals and Novels [written] by the hand of William of Bologna, let him live forever in joy and virtue amen amen and once again let there be amen).

31 Added *Constitutions* of Gregory X, addressed to Paris; of Nicholas III and Clement IV.

32 Scott, *Gothic*, I, p. 62.

33 Within the quire, for example, the different bifolia could each be given to separate artists, as d'Arcais indicates for a Siena *Decretum Gratiani* (Siena, Bibl. Com.

degli Intronati, MS K.I.3); see d'Arcais, 'L'organizazione', p. 365.

34 In Bologna, during the thirteenth and fourteenth centuries, stationers had varied and/or multiple roles, divided into the two main functions of bookseller (*Stationarius exempla tenens, venditor librorum, stationarius librorum*) or producer and distributor of exemplars and *pecie* (*exemplator librorums, stationarius peciarum*). See Soetermeer, *Utrumque ius in peciis*, ch. 2, for definition and description of the stationers' diverse professional activities, as well as essential bibliography.

35 See Filippini and Zucchini for examples.

36 Rouse and Rouse, 'Dissemination', pp. 104–05.

37 Talbot, 'Universities', p. 71.

38 D'Arcais, 'L'organizazione', pp. 365–67.

39 Conti, *La miniatura*, p. 3.

40 See Soetermeer, and Soetermeer, 'Famille de copistes'.

41 Rouse and Rouse, 'Wymondswold', p. 65.

42 One of the most common is the basic *Qui scripsit scribat, semper cum domino vivat*. For more examples of scribes' jingles, see Thorndike, 'Final Jingles', p. 268; and Thorndike, 'More Jingles', pp. 321–28.

43 Andreas de Mutina signed three manuscripts in the Chapter Library of the Cathedral of Toledo, Spain, MSS 8–5, 8–7 and 8–10, dated 1363, 1359 and 1360 respectively. See García y García and Gonzálvez, pp. 22–26.

44 Named by Francesca d'Arcais for his illustration of a Padua *Parvum Volumen* (Padua, Biblioteca Capitulare, MS B 18), but first known as Secondo Maestro of the San Domenico choir books in Bologna.

45 Roermond Gemeente Museum, MS 3.

46 Alternative interpretations will be enthusiastically welcomed.

47 Cassee and Langezaal, 'Miniatuurkunst', pp. 86–87, listed works for the Master of B 18, and by now the list can be doubled.

4. Layout and Decoration

Susan L'Engle

A MEDIEVAL MANUSCRIPT PAGE is like a blueprint, for the arrangement of its text(s) and its descriptive components define the manner in which it is to be used. Each type of text – Bibles, romances, Missals or legal textbooks – has an individual visual profile, designed by scholars and scribes to best serve the specific needs of its readers. Books of Hours, for example, used for private devotions, are mostly found in very small formats, with one short column of text per page, like the Grey-Fitzpayn Hours reproduced in Figure 12; choir books, on the other hand, are generally huge volumes with large script and wide staves with musical notation, made to be read and sung from at a certain distance. The visual profile is thus created by the physical and spatial organization of portions of the text – called layout – and by graphic elements used to define and clarify textual distinctions – here encompassed by the term articulation. The page layout not only identifies the type of text but informs the reader how it is to be read, whether directly from top to bottom, or through a more leisurely analysis, incorporating commentary passages.

Fig. 12

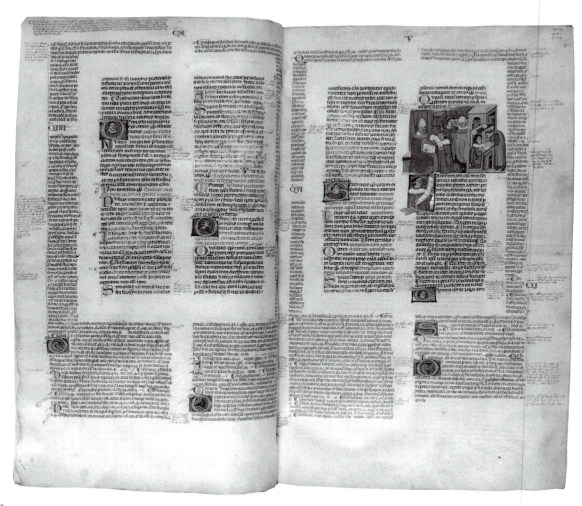

Fig. 13

Though many scholars have studied the development of canon and Roman law texts along with their discursive and exegetical commentaries, few descriptions have been made of the actual physical *appearance* of the medieval legal page, the configurations in which texts are placed and the graphic elements that articulate them. The literary peculiarities of books of law and their textual divisions and subdivisions call for a visual *ordinatio* quite different from liturgical or biblical manuscripts. Moreover, these divisions can be doubled in the same manuscript if the main text is accompanied by a gloss, which most often surrounds it and utilizes a parallel system of verbal/textual signposts, as seen in Figure 13.

The legal manuscript developed its distinctive 'look' from expediency. From the twelfth century on, resulting from the escalating study of law and a growing body of legal commentary, members of the book trade – scribes, rubricators and illuminators – were obliged to create new graphic arrangements for legal literature. The earliest legal texts were written in one column, but a two-column format was adopted in the twelfth century that made

the text easier to read and was space efficient (long lines in large books are hard to read without increasing script size and for long books like the *Codex* or *Digest*, two columns can generally hold more text per page).[1] Furthermore, after scholarly commentaries had been created, meant to be read in conjunction with the text, the physical dimensions of lawbooks had to expand to accommodate these glosses in the surrounding margins. Thus, while earlier texts of Roman and canon law can be found in fairly compact, easily handled volumes such as Sidney Sussex MS 101 (Cat. No. 1), measuring 315 x 204 mm, by mid-twelfth century, as the story goes, wealthy students would hire servants to haul their thick and cumbersome volumes to and from classes, exemplified by the more massive Fitzwilliam MS 183 (Cat. No. 6), at 480 x 300 mm.

Layout and Its Functions

For all glossed legal texts the basic layout was the same; that is, the main text was arranged in two columns and positioned upwards and slightly off centre of the white space of the page, leaving a larger space at lower and outside margins to accommodate the surrounding gloss in the manner called *textus inclusus* (Fig. 13). Space was left free in the margins outside the gloss for further commentary or annotation by scholars, as well as for written instructions to scribes, decorators and illuminators. Scribes could also manipulate this physical arrangement to fulfil the specific aesthetic requirements of patrons and institutions. A special feature of legal manuscripts produced in Bologna is the care taken by

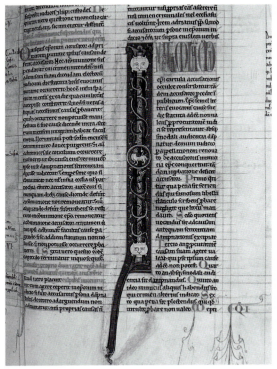

Fig. 14

scribes to maintain symmetry and uniform spacing. While the number of lines in text and in commentary might vary from recto to verso, Bolognese scribes made a great effort to produce a mirror-image layout with an equal number of written lines at every double page opening, as can be seen in Figure 13. This was a particularly complicated feat in glossed texts. The early legal texts with few or no glosses could be ruled and written in a consistent number of lines per page from beginning to end, like Corpus Christi MS 10 (Cat. No. 3) with double columns of fifty-five lines throughout, as seen in Figure 14, but once the *glossa ordinaria* was established for each text, new configurations had to be created.

Certain passages in legal texts were considered so important that they fostered a great deal of commentary, while others could be ignored or were only slightly or partially annotated. Thus in writing the gloss the scribe faced a formidable challenge: how to fit commentary to text in such a way that it matched up with its corresponding text passages, and in addition, for Bologna, maintaining a mirror effect at each opening. How could symmetrical openings be preserved in the case of two successive passages, one highly glossed and the other accorded only a few notes? How did the scribe determine his page-to-page format?

The main text was written first, and so the text scribe had the initial responsibility of establishing the working format for each manuscript, ruling his blank vellum quires as he received each *pecia* from the stationer and leaving appropriate spaces for the work of others: rubricators, penwork decorators, illuminators – and the gloss scribe. He (or she) was also responsible for keeping track of the density of the gloss for the passage he was writing, calculating how much space it would occupy, and making the appropriate adjustments in his writing of the text. In practice, the text scribe was not always so diligent, and in innumerable manuscripts the gloss is often several pages behind its corresponding text. Gloss scribes would have to resort to various strategies for controlling layout, regulating as necessary the number of lines per page, width of columns and margins, size and height of script, distance between lines, space between words, number and severity of abbreviations. The variation in width of gloss columns may be easily observed in the Fitzwilliam Museum's Marlay Cutting It. 3–11 single leaves (Cat. No. 5), all from the same original manuscript, each representing an individual solution by the scribe to the job of matching gloss to text on a given folio. The measurements range from two very narrow columns in Marlay Cutting It. 7 to the widest column facing a narrower one on Marlay Cutting It. 11.

There were other possible expedients for matching gloss to text on an ongoing basis. First of all, scribes could have access to pre-defined models, such as finished glossed manuscripts, of every text they would likely be commissioned to write. Individual and independent scribes would hardly have owned examples of all the glossed texts for personal consultation, so a collection of this type would be an essential resource for a book stationer's shop. Some scribes must have had other guidelines beyond practical experience or an actual glossed manuscript, perhaps written instructions alerting the scribe to tricky sections, or describing particular strategies or ruling patterns for a specific text. Additionally, an experienced professional could oversee the ruling and writing of a manuscript to be glossed, and might leave instructions for step-by-step ruling. As we have seen, however, in

Fig. 15

Bologna most scribes copying texts for the university worked at home, and were more likely to rely on their own ingenuity, or perhaps spend some time at a stationer's studying the equivalent gloss *pecie* before sitting down to establish the correct number of lines for a sequence of text folios.

Some unique or visually arresting textual arrangements in the gloss, probably due in part to a scribe's desire to show off his technical virtuosity, may also represent his solutions in adjusting a small amount of gloss around a portion of text for which the text scribe has provided too much available space. Along with widening and narrowing the columns, scribes would stretch out the gloss text into unconventional formats, such as geometrical shapes or letters of the alphabet.[2] The reader may have been struck by the pleasing patterns the repetition or alternation of doctored columns made on the page or across an opening, but these special effects had a functional origin.

Another space-filling activity by the gloss scribe was a ploy to simulate the achievement of a symmetrical opening, when in fact there was not enough text left to reach the bottom of the last column. This was the repetitive writing of nonsense words and syllables, or even

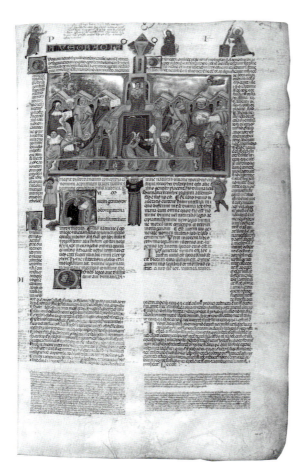

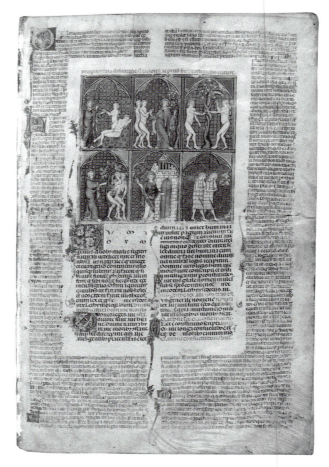

Fig. 16

Fig. 17

the name and *siglum* of the glossator, in the last one or two lines of the lower right-hand gloss column on the recto, so it would end evenly with the other three columns. The scribe who glossed the Fitzwilliam's MS McClean 136 *Decretales* (Cat. No. 14) used this device to disguise an error in calculation. On folio 257v, the end of a major text division, he tried to divide the remaining gloss into equal portions for this page, but overestimated the space he had available in the right-hand column, ending it three lines longer than what he had already written on the left. In the interests of symmetry he therefore added a neatly spaced line of gibberish to his shorter left-hand column, lining it up with the right. He used the same device at the end of fol. 187v (Fig. 15).

Additional factors that would affect the number of lines/text to be written at each opening would be the amount and dimensions of graphic and decorative devices, or the varying proportions of text to blank space on the page. The lavishly decorated, though incomplete, Fitzwilliam MS 262 *Decretum Gratiani* of Northern origin (Cat. No. 8) has, exceptionally, two-column miniatures for each of its six surviving frontispieces (out of a possible forty), no doubt requested specially by the manuscript's patron. In comparison, the Fitzwilliam's

roughly contemporary Bolognese *Decretum Gratiani* (MS 183, Cat. No. 6) was given a large two-column miniature for its initial frontispiece, but the remaining thirty-eight are one-column in width. We may analyse the different conventions followed and solutions provided by the two different scribes who planned and designed the layout for the two opening frontispieces in Figures 16 and 17. While each miniature occupies roughly half the space allowed for the central text, the dimensions and proportions of this centre block are different in each manuscript. The Bolognese miniature is wide and squat, with a short amount of text placed beneath; ample space separates text from gloss (Fig. 16). The gloss scribe had a relatively small amount of gloss to match with the text, so he stretched it out in very narrow columns around the miniature and its text. The Northern miniature in contrast is narrower and vertically longer, and the scribe placed a greater amount of the opening text beneath it than in the Bolognese manuscript. For this greater amount of text, there was a proportional increase of corresponding gloss, which now needed wider columns to accommodate it. Layout and the proportions of text to miniature may deviate from manuscript to manuscript, and improbable though it may seem, we find that each text scribe created a unique format for each manuscript he was commissioned to write.

The recognition that each manuscript has an individual design can be helpful to the scholar in identifying leaves or fragments that have been detached from their original contexts and may appear on the market, or languish in private, museum and library collections. In fact, sister leaves and fragments for two leaves in the Fitzwilliam Museum have recently been located by verifying identical configurations of layout, script and scribal notations and elements of decoration. MS 331 (Cat. No. 20) and its sister leaf in the National Gallery of Art, Washington, D.C. (Fig. 18), are frontispieces to Books IV and V extracted from a fourteenth-century manuscript of canon law commentary (Johannes Andreae, *Novella in Decretales,* Books III–V). Both leaves are written on recto and verso in two neat columns of seventy-four lines each. A striking comparison can be made between MS 331 and Pierpont Morgan Library's MS M.747, a fifty-folio fragment of the same text accompanied by the same author's *Novella in Sextum,* also written in columns of seventy-four lines, and lacking all its frontispieces but with sixty-nine historiated initials executed by Niccolò. The leaves and the manuscript have comparable dimensions: Morgan MS M.747 measures 470 x 290 mm; Fitzwilliam MS 331 is 445 x 280 mm; Washington MS B–22225 is 445 x 273 mm: the smaller dimensions of the single leaves are consonant with being trimmed after excision, perhaps for framing and display. Another point in common, present throughout the Morgan manuscript and very fortuitously on both leaves, is a scribe's very personal version of a siglum designed to call attention to important words or passages, placed in the margins alongside the appropriate text (Fig. 19). This siglum can be seen in Figure 19, and also in the right-hand margin of Figure 18, just below mid text. In addition, the text is articulated with two-line penwork initials set into the text, executed alternately in red and blue ink and ornamented with filigree penwork in a contrasting colour, blue with red, red with purple. As can be verified in the initial **P** in Figure 18 and the initial **I** in Figure 19, the filigree is executed in an idiosyncratic design peculiar to its

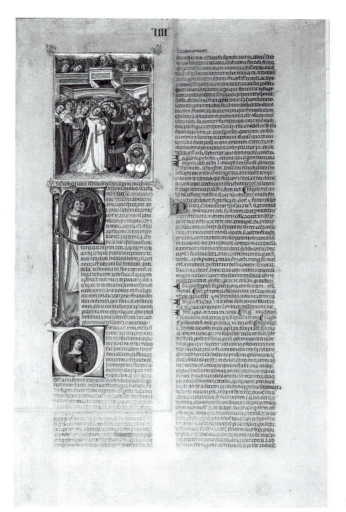

Fig. 18

Fig. 19

craftsman: it forms a square ground around each initial, which, however, is allowed to rise slightly at the upper left corner, and/or sometimes dip to a greater length at the lower left. Taken together, these analogous physical elements in the three manuscript fragments demonstrate almost without a doubt that they originally belonged together, and verification that the text on the verso of each single leaf is continued without a break on a recto in the Morgan manuscript, has completed the proof.

The linking of the Cordwainers' Guild leaf in the Fitzwilliam, MS McClean 201.f.15, with three other leaves from the original *Matricola* located in separate collections (see Cat. No. 21), was effected in the same manner. It was verified that each leaf was ruled for 34 lines of text and carried its original foliation in red ink at the upper right-hand corner. While the opening leaf was more richly illuminated the decoration of all leaves followed the same basic format, which for the section leaves (including McClean 201.f.15) was identical, and all illumination was executed by Niccolò da Bologna, working in a consistent style. Although few guild registers survive intact, a small number can be found with sixteen or more leaves. The number xx on the McClean leaf stipulates the minimum number of leaves in the original document, and some of the others perhaps still await discovery. It will profit manuscript scholars to be attentive to the many facets of format and graphic detail that distinguish individual manuscripts, which can also serve to identify missing parts. The following section will describe some of these components.

Articulation System

The pages of medieval manuscripts of canon and Roman law are excellent illustrations of the visible devices created to organize the sequence and interrelationship of text passages, according to the new scholastic methods developed in the twelfth century. While formal iconographic programmes only emerged around the middle of the thirteenth century, already in the twelfth century scribes had a wide range of graphic devices with which to make textual distinctions: type and size of script, colour, position, marks and symbols; and organizational tools such as running titles, indices and alphabetical tables. These graphic conventions seem to have had universal appeal and acceptance throughout Western Europe within particular time periods (with slight regional variations), and the fact that visual distinctions were sought implies a strong need on the part of scholars for rapid textual identification, particularly of sources and authors. The rubric *'ex concilio affricano'* directly above the miniature for Book II in the Fitzwilliam Museum's MS McClean 136 *Decretales* (Fig. 20) designates the Church council from which the following material was derived. In Justinian's *Digest*, organized as a series of extracts from the works of eminent Roman lawyers, thirteenth- and early fourteenth-century scribes placed an abbreviated version of the author's name directly before his words, so each section was differentiated by a large coloured initial, red or blue, followed by a small capital letter in the opposite colour for the first word of the passage. This is illustrated on folio 57v of the Durham *Digestum novum* (MS C.I.3, Fig. 21), where the large decorated **P** directly after the rubric *'de confessis'*

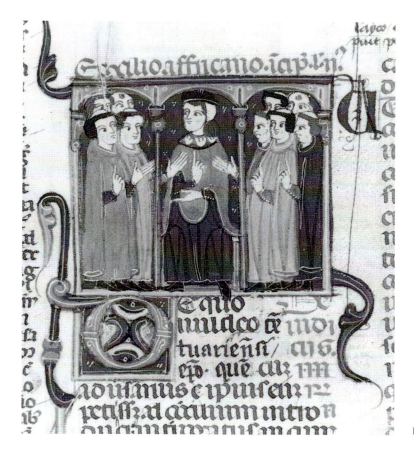

Fig. 20

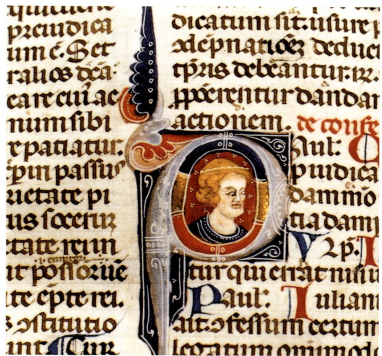

Fig. 21

identifies Paul[us], and subsequent initials distinguish extracts by different jurists in the same column: Ulp[ianus]; Paul[us]; Idem [Paulus again]; Ulp[ianus]; Idem. Somewhere in the 1330s this convention was reversed, and the larger initials were now used to introduce the first word of an extract, while the small capitals distinguished its author.

Hierarchies

It is sometimes hard to draw a line between the *articulation* and *decoration* of a manuscript, especially in deluxe productions, where even the smallest textual divisions may be elaborately defined. Practically speaking, articulating devices are those essential to distinguishing textual hierarchies, independent of their decorative content. They function under the simple principle that the larger and more complex the indicator, the larger or more important is the textual division. Late twelfth- and early thirteenth-century manuscripts (like Sidney Sussex MS 101, Cat. No. 1) were very simply articulated: as shown in the reproductions from this manuscript, major text divisions were introduced by large coloured initials, often inhabited with animal or human figures, and occasionally accompanied by an allegorical or symbolic figure. Simple coloured initials placed in the left-hand margins identified the start of secondary divisions, and one-line capitals headed sentences within them.[3] Red and blue were the most commonly used colours, and each colour would be used to decorate its opposite, sometimes with elaborate penwork flourishes, although violet was introduced and subsequently became the preferred colour for decorating red letters towards the end of the thirteenth century. Early glosses were added in layers in the margins surrounding the text, and were distinguished from each other by different shades of ink, by sigla and sometimes with a touch of colour.

Articulation became more elaborate in the thirteenth century, both in response to scholars' needs and the willingness of wealthy readers to pay for the beautification of their manuscripts. *Incipits* were distinguished by rubrics; large filigree or illuminated initials introduced books and titles; and red and blue penwork initials and capital letters of graded sizes headed smaller divisions: questions, decisions, decrees, cases, paragraphs and sentences. The smallest coloured unit was the paragraph marker or paraph, designed to head sentences within paragraphs; in addition, the first letter of a sentence could be touched with yellow wash.

Distinction of Genre: Canon and Roman Law

For Italian manuscripts, particularly Bolognese, it appears that the fact that canon and Roman law were treated as two separate disciplines in the universities created a need to make their texts visually separate as well. Around mid-thirteenth century a simple and effective mechanism was devised to quickly distinguish a glossed canon law text from one of civil law: a colour-coding system based on the red and blue penwork initials. Civil law texts, with few exceptions, were assigned blue initials decorated or flourished in red in the

text proper at secondary levels; one-line red capitals begin the subsequent sentences. The Durham *Digestum novum* (MS C.I.3) and *Codex* (MS C.I.6, Cat. No. 12) illustrate this practice; the look of the *Codex* is even more striking, due to the innumerable **I**s that punctuate the text like exclamation points, followed by their bright red one-line capitals (Fig. 22). In the gloss, the corresponding two-line initials alternate red and blue, decorated in the contrasting colours, and paragraph markers also alternate red and blue.[4] Canon law texts on the other hand, as exemplified by the Fitzwilliam Museum's Marlay It. single leaves (Cat. No. 5), were given alternating two-line red and blue initials in both text and gloss, as well as capitals and paragraph marks of alternating colours (Fig. 23). Thus, although basic layouts were the same, the visual distinction between canon and civil law texts produced in Bologna was immediately apparent: it hinged on a factor as simple as the use of alternating or single-colour initials in a given space.

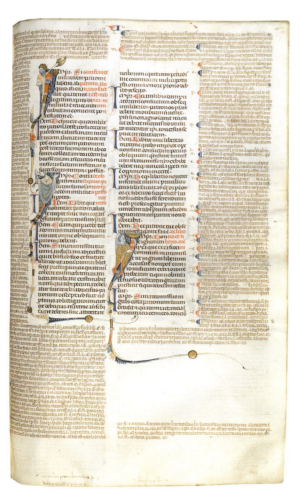

Fig. 22

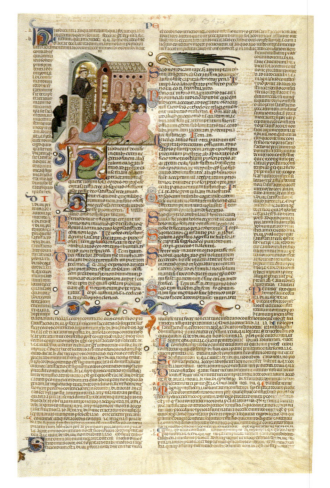

Fig. 23

The preceding conventions only hold true for Italy, however, for it can be seen that different customs were followed in other geographical regions. Little research has been conducted or statistics formulated on these variations in secondary manuscript decoration, although they can provide valuable clues for identifying manuscripts produced or decorated in a particular place, or executed by a foreign scribe or craftsman working far from his native land. The Fitzwilliam's McClean *Decretales* (Cat. No. 14) for example, had its penwork decoration been executed in Italy, would have been articulated with alternating red and blue initials in text and gloss as befitting a canon law text. Instead, the two- and three-line blue initials placed in the margins alongside the central text alert us that a different tradition is in force. A combination of other details – the double address to the universities of Paris and Bologna, the presence of two illuminators of non-Italian origin and the placing of a number of the rubrics into triangular spaces left for this purpose at the *right-hand side* of the column – point to Northern practices. A number of scholars have commented on the presence of these all-blue initials for the main text in manuscripts written by English scribes working outside their native lands, and their common use in English fourteenth-century manuscripts.[5] The English scribe Thomas of Wymondswold, who was based in Paris, is also thought to have executed the blue penwork initials flourished in red in the *Decretum Gratiani* he copied, signed and dated 1314 (Paris, BNF MS Lat. 3893). Taking this into consideration, the Gonville and Caius *Digestum vetus* (MS 8/8, Cat. No. 17), considered by M. R. James to have been written in Italy and illuminated in France or England,[6] deserves deeper analysis. Written in quires of 12, a distinctly non-Italian feature, it has all blue penwork initials in the text – the correct articulation for civil law manuscripts in Italy – but also correct for English examples in general. More attention needs to be given to these levels of decoration, long-regarded minor and even insignificant, for they can be important aids in the analysis of manuscript production.

Special Signs

Special sigla were invented by glossators and text scholars to signal abbreviations, repetition of expressions or themes or other points regarding the interpretation or discussion of texts. One particularly interesting system of notation was invented around 1140, consisting of Greek letters, signs of the zodiac or other distinguishing marks in red ink, complemented by the placement of one or more dots at specific locations around them.[7] They proliferate in the pages of the Sidney Sussex *Decretum Gratiani* (Cat. No. 1), located in the margins alongside particular text passages (Figs 24, 25). Their function was to note where key expressions or ideas were repeated throughout the text, linking these incidents with the same sign and indicating where the others were located: a dot to the right meant that a similar passage would be found further on in the text; one to the left signalled a preceding passage; dots on both sides told the reader he must look in both directions.

Graphic devices were also used to link gloss passages with the corresponding text they interpreted or discussed, similar to the tie-marks defined by Christopher De Hamel.[8] The

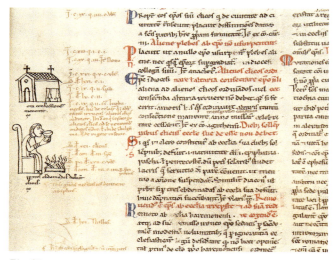

Fig. 24

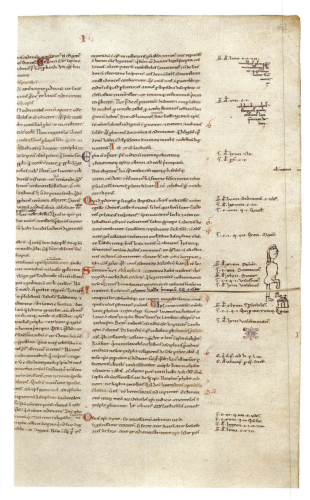

Fig. 25

earliest system utilized pairs of sigla composed of combinations of dots with horizontal or vertical curving dashes, as can be seen in an early thirteenth-century *Digestum vetus* bifolium recovered from a binding (Fig. 26). Upon finding a particular siglum beside a line of text, the reader would search for its mate in the gloss, or vice versa. For scribes, it must have been a chore to keep track of the combinations of dots and dashes utilized from one page to the other, and they soon switched to letters of the alphabet to perform the same function, clearly visible in the *Decretum Gratiani* single leaves (Cat. No. 5), exemplified in Figure 23. The letters had the advantage of following each other in an established order, and if the alphabet was exhausted on a given page, it would simply be repeated. This alphabetical keying, characteristic to Italian manuscripts, was effected during the writing of the gloss, and it can be observed in many Bolognese-produced manuscripts (see Cat. Nos 5, 6, 11, 12, 13) that scribes usually neglected to add the matching letter of the alphabet to the appropriate spot in the text. One may conjecture that this omission was not prejudicial to the reader. Another device for matching gloss to text, practised by French and English scribes, was the underlining in the text, often in red, of *lemmata* – key words or

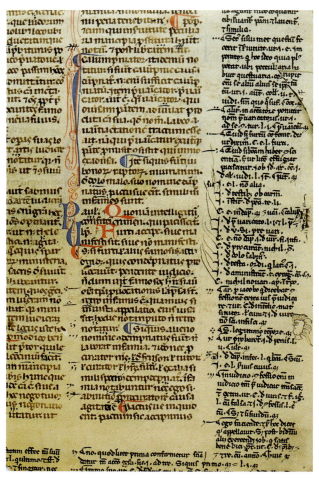

Fig. 26

Fig. 27

titles – and their repetition in the gloss, exemplified in the Fitzwilliam's *Decretales* single leaf for Book V (MS McClean 201.f.12, see Cat. No. 4 and Fig. 56).

Scholars themselves were not only aware of the functions of graphic devices, but composed their commentaries envisioning their use. The renowned Bolognese canonist Johannes Andreae (d. 1348), in one of the chatty passages he sprinkled throughout his commentaries, discusses the three different types of glosses he will furnish for each chapter of his commentary to the *Decretales*, called the *Novella*, and describes the different forms of paragraph marks by which he will distinguish them.[9] They may be seen in the Fitzwilliam's MS 331 (Cat. No. 20), the frontispiece to Book V of this text. An ordinary paragraph marker is a simple rounded C-like form, one line in height, used to separate the sentences in a passage of text. In the lower right-hand column of MS 331 (Fig. 27) and in the right-hand column of the Washington, D.C. leaf as well (Fig. 18) we may note the simple yet effective differentiating devices created by Johannes Andreae: to the rounded side of the simple marker are appended one, two or three spikes (he called them teeth, *'dentes'*), each corresponding to an individual kind of gloss: *casus summarii, divisio, literalis prosecutio.*

68

Special Layouts

The addition of so many new and different texts to the repertoire of scribes and artists as a result of burgeoning legal studies at the various *Studia* may have made specialization an attractive enterprise. Just as particular skills were called into play for copying a glossed text, the execution of tables and diagrams too required special knowledge and experience. The most common diagrams associated with legal manuscripts are the Trees of Consanguinity and Affinity (illustrated in Chapter 3, Fig. 10, and Cat. Nos 1, 2, 8)[10] and the lesser known Tree of Actions (*Arbor actionum*) (Fig. 28). They are composed of circles inscribed with titles and concepts, and arranged within geometrical configurations, inter-connected by various graphic devices, and in the case of the *Arbor actionum*, additionally

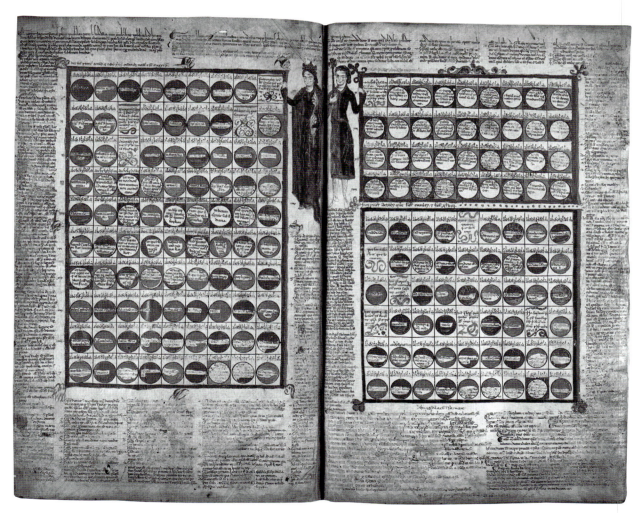

Fig. 28

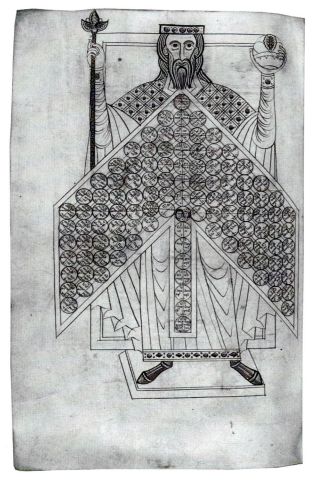

Fig. 29

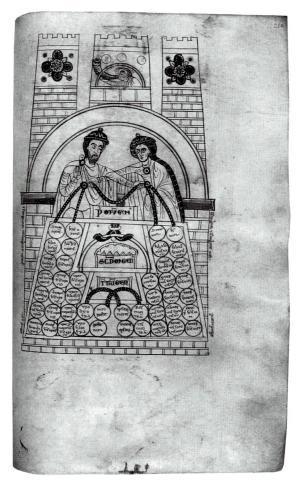

Fig. 30

furnished with an esoteric system of alphabet letters surmounted by a coded arrangement of dots – more fully described and explained in the catalogue entry for this manuscript (Cat. No. 10).[11] Occasionally one encounters diagrams so poorly executed that it is proba-ble the scribe had little idea of their function or significance, or had had insufficient prac-tice with constructing them. The majority, however, are neatly drawn and inscribed, very likely by specialists who generated them by the dozens.

The Trees of Affinity and Consanguinity were placed in canon law texts to accompany Church rules governing marriage and to define the eligibility of marriage partners. The diagrams on Consanguinity, like those found in Sidney Sussex 101 (Fig. 29) and Fitzwilliam MS 262 were usually organized into an arrow-like format and superimposed onto the body of a standing, frontal, male figure, thought by some to represent Adam, the First Man. Jonathan Alexander points out that twelfth-century examples present the male figure in an almost subservient posture, 'uncrowned and sometimes almost impaled on the tree, as if an unwilling victim of these constraints', contrasting with the thirteenth- and

fourteenth-century versions illustrated in this catalogue, where he is visually more assertive, upright and crowned.[12] Within the circles are named the blood relatives with whom marriage was prohibited. The Affinity diagrams, in contrast, usually headed by the figures of a betrothed or married couple, listed the relatives by marriage who could not fulfil the role of second spouse upon the death of the first (Fig. 30). These Trees can be found in early copies of the *Decretum Gratiani*, but their use was phased out in this text after successive decretal collections (*Decretales, Liber sextus, Constitutiones Clementinae*) modified or updated the canons of marriage. Thereafter the Trees were transferred to the later texts as a visual complement to Book IV, on Betrothal and Marriage. Walter Cahn speculates that the notion of putting together a diagram with a figure originated in Italy, at least as early as the eleventh century, since the combination can be found in early Italian manuscripts of Burchardus of Worms's *Collectio canonum* composed between 1007 and 1015. He suggests the standing, frontal figure originates with the author portraits in Italian Bibles of the eleventh and twelfth centuries.[13]

Most fourteenth-century versions of the Trees, unlike the examples in this catalogue, are accompanied by a descriptive *Summa* or treatise, often written around them as a frame. It can be observed that these diagrams were almost always executed independently – usually as a separate bifolium or single leaf – for insertion at the appropriate textual location, as they are often preceded and/or followed by blank pages. We also find manuscripts furnished with Trees executed at a different time or location than the text and its general decoration, such as the Vatican Library's Vat. lat. 1390, a *Decretales* written and illuminated in Bologna around 1280–90, in distinctly Bolognese style, whose Trees were designed and illuminated by a fourteenth-century Northern, most probably French, artist. Perhaps they were created and inserted at the same time a later scribe Johannes de Clugny of Autun wrote and signed many of its *additiones*.

Book Divisions

In late twelfth- and early thirteenth-century codices, the opening to book divisions, or *causae* in the case of the *Decretum Gratiani*, could be prefaced by a variety of decorative elements. Purely calligraphic decoration was used in simple or inexpensive commissions, such as the arrangement of coloured display capitals on folio 3 of Sidney Sussex MS 101 (Fig. 31). In this early *Decretum Gratiani* the words represented correspond to the section's first line of text: *In prima parte*. Here an indented space was left blank at the left side of the left-hand column for the long unexecuted initial **I**; to its left alternating red and blue display letters spell out the rest of the text. The decoration continues at the *bas-de-page*, where the lower extremity of a large red and blue initial **I** sprouts a beaked head, which spews out a small coloured spray that soon narrows to a single horizontal line and then once more bursts into multiple filaments, embellished with organic motifs. In contrast, the decoration of the Corpus Christi *Decretum* (MS 10, Cat. No. 3) was far more costly, its major divisions and *causae* introduced by elegantly painted foliate or historiated initials set into

Fig. 31

coloured frames (Fig. 14), occupying the width of a column and accompanied by display capitals to complete the opening word or words of the text.

Though penwork decoration and articulation still represented an inexpensive solution for textual differentiations throughout the thirteenth and fourteenth centuries, from around mid-thirteenth century, most book divisions were designed to open with a painted miniature, followed directly below by a painted initial, usually three to eight lines in height, to initiate the text. Depending on the size of the commission, the scribe could plan for larger or smaller painted elements, leaving blank spaces for the illuminator's work. In numerous manuscripts some or all of the planned decoration was never completed, for reasons that can only be conjectured. For the Gonville and Caius *Digestum vetus* (MS 8/8, Cat. No. 17), only the miniatures and painted initials for the Prologue and Book I were executed, and the latter miniature has been excised. The manuscript was possibly commissioned by a student who, after text and gloss had been written and rubricated, may have found himself with insufficient funds to pay for its complete decoration.

72

For most of the thirteenth century legal miniatures were laid out in a one-column format, and were generally slightly higher than they were wide. A rectangular field, painted in tones of blue and often ornamented with white tracery designs, or in more costly commissions laid with gold leaf, served as background for an iconographical composition. Architectural elements were essential as framing devices and for delimitation of spaces within compositions. In the last quarter of the thirteenth century, exemplified by the Durham *Parvum Volumen* (Durham MS C.I.4; see Cat. No. 11 and Figures 32, 37, 45, 63, 64) and the Fitzwilliam McClean *Decretales* (MS McClean 136, Cat. No. 14), round or pointed arches at the upper border of the miniature segmented the background into two or three compartments, these further separated into bays by thin vertical bands simulating columns, topped with capitals constructed of small balls sandwiched between thin blocks. In several of the Fitzwilliam Marlay It. cuttings (Cat. No. 5, particularly Pls 5b and 5e) the Bolognese artists have followed the Byzantinizing tradition of projecting the upper segments at different levels, imitating rooftops and draping swags of cloth in the antique manner across the entire architectural stretch, allowing them to dip between dissimilar heights, and to fall gracefully down the upper sides of the miniature. Within the miniature, figures are grouped in structured compositions and confined within their spaces. After 1300 compositions began to become more fluid, and though architectural constructions still mark spatial boundaries, figures assume more credible positions in the picture plane.

In legal manuscripts the most complex layouts were reserved for major text divisions, usually two for each text, the second generally representing the manuscript's midpoint. Further distinction could be made by initiating these sections on a recto, and by preceding them with a blank page or folio. Around the end of the thirteenth century artists began to utilize two-column miniatures for the most important frontispieces, which allowed them more space to create dramatic and narrative compositions. The Fitzwilliam's MS 262 *Decretum Gratiani* (Cat. No. 8) is unprecedented in having a two-column, multi-level miniature for each of its six surviving frontispieces, with the likelihood that the missing thirty-three or four would also have been this size. This represented not only a tremendous cost to the manuscript's patron, but a challenge for both the scribe and the illuminator: the former to plan and devise the format; the latter to create and execute so many complex compositions for themes previously expressed in single scenes. The placement and function of human figures in legal miniatures will be discussed more fully in the chapter devoted to iconography.

Notes

1 See Bozzolo *et al.*, 'Noir et Blanc', pp. 216–20, and also the important essay on 'readability' in Bergeron and Ornato, 'La lisibilité', pp. 521–54.

2 Soetermeer observes that this irregular shaping was practised by non-Bolognese scribes, chiefly Southern French. See Soetermeer, *Utrumque ius in peciis,* p. 220.

3 I differentiate between the words *initial* and *capital* as follows: by *initial* I refer to an ink or painted letter that signals a major change in textual hierarchy, opening a division and located either at the extreme left-hand side of the column or in the left-hand margin; I use *capital* to indicate the first letter of the first word of a sentence or phrase – usually one line in size and either executed in coloured ink or in brown ink touched with wash – located *within* the text.

4 Within the category of Roman law, those various texts bound together in the *Parvum Volumen* – the *Institutiones*, the *Tres libri*, the *Authenticum* or *Novellae* and the *Libri feudorum* – are distinguished one from another by similar means.

5 See particularly Rouse and Rouse, 'Wymondswold', p. 64, with regard to this Paris *Decretum Gratiani*. Adelaide Bennett in her description of Walters Art Gallery MS 134, written in August 1991, asserts that initials only in blue flourished with red penwork are characteristic of English work, originating most probably in Oxford in the second quarter of the thirteenth century and becoming widespread by the beginning of the fourteenth.

6 James, *Caius*, I, p. 8.

7 For a full explanation and illustration of these signs, see Dolezalek and Weigand, 'Das Geheimnis', pp. 143–99, illustrations at pp. 150–51. Sidney Sussex MS 101 however is not among the listed manuscripts, and was perhaps unknown to the authors at this time.

8 De Hamel, *Glossed Books*, pp. 30–31.

9 Kuttner, 'Johannes Andreae', pp. 405–06.

10 The most complete description and analysis of the Trees of Consanguinity and Affinity is found in Schadt.

11 For the Tree of Actions, see most recently Errera, with full bibliography on previous literature.

12 Alexander, *Medieval Illuminators*, p. 16.

13 Cahn, 'Fragment', p. 55.

5. Legal Iconography

Susan L'Engle

WHY ILLUSTRATE A LEGAL TEXT? Most people today, art historians included, find it logical to encounter pictures in a Bible, a volume of Dante or even a medical encyclopaedia: the first two tell stories, and the latter must deal with anatomical characteristics and perhaps surgical techniques that need to be visually described. But the field of jurisprudence is generally considered to be a repository of abstract ideological concepts and endless regulations, and laymen and legal professionals alike find it hard to conceive of a body of illustrations in textbooks for the study of law. What could be pictured? And, furthermore, if one could conjure up a series of images to represent laws, their enactment and enforcement and punishments for their infringement, what would be the point? What would they contribute to the practice of law?

Medieval illuminators probably asked themselves the same kind of questions. We can surmise that after the study of law was revived, and courses in canon and Roman law attracted students by the thousands, scholars or professors with money to spend were just as eager to possess elaborately decorated legal texts as clergy and laymen were their Bibles, Missals, Choir Books, and Books of Hours. The pictorial compositions placed in books dealing with religious narratives or rituals for private and communal devotions often functioned as place-markers, to identify a specific reading for a particular time of the year or hour of the day. Additionally, they could depict important events in religious history, and also evoke for the reader the essence of doctrinal passages. Legal manuscripts were handed over to the same artists who decorated biblical and liturgical books, craftsmen whose livelihood depended on the number of jobs that came their way. Those who accepted commissions in the new field of law, having no experience with its literature and hardly a notion of what it encompassed, faced the difficult task of illustrating unfamiliar texts with no established iconographic tradition. For the first collections of written law, therefore, artists very ingeniously borrowed and adapted compositions and motifs from religious, secular and antique sources, until they were aided by legal specialists to devise more text-specific scenes. We can often recognize an earlier context in thirteenth- and fourteenth-century legal compositions – particularly scenes of betrothal and the celebration of marriage – deriving from the depiction of Biblical events like the Marriage of the Virgin, or the Wedding at Cana. The figure of Christ enthroned in Judgement – this composition itself originating from representations of emperors and other rulers in antiquity – was an ideal model for the authority figure presiding over legal proceedings that is the basis of most juridical scenes, exemplified by the crowned and enthroned Justinian flanked by lawyers, with a note-taking scribe at his feet, in the Durham *Volumen* (Cat. No. 11, Fig. 32).

Simple pictorial compositions for legal manuscripts were in use as early as the 1240s, and standard iconographic cycles had been devised by the last quarter of the thirteenth century. Illustrators did not provide a very profound or extensive visualization of the text:

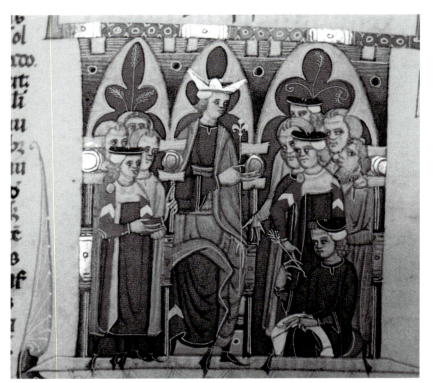

Fig. 32

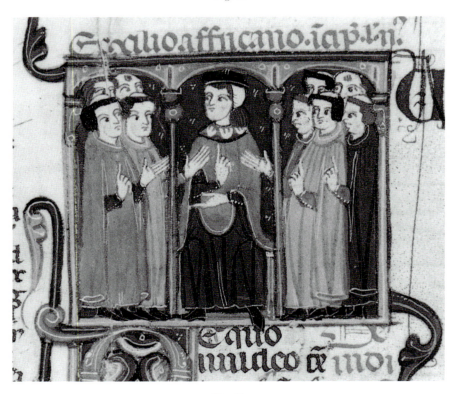

Fig. 33

while multiple topics may be covered and discussed in individual books, miniatures and historiated initials rarely refer to more than the first few titles or cases, and most often only to the opening phrase. This implies that the creators of the early illustration cycles were not experts in law, but rather in illustration, that they were literate but did not read beyond the initial paragraphs to seek inspiration for a composition. And much depended on the opening phrase: if it were very abstract or did not contain verbs of action to evoke a narrative situation, artists would supply a generic 'judicial' or 'discussion' scene applicable to any juridical context, such as the miniature placed at Book II of the Fitzwilliam Museum's McClean *Decretales* (Fig. 33). Here tonsured figures flank a civil judge, their static poses and formal gestures suggesting no more than a consultation on general legal issues.

The main task fulfilled by legal illustration was a visual representation of the rulings and decisions by civil and ecclesiastic courts of law, described and interpreted by the written words on the manuscript page. A starting point for artists was an emblematic image found in all media throughout the history of art – a figure of authority, standing or seated, usually in a frontal position. In biblical and liturgical manuscripts it is used to depict Christ or God the Father, Old Testament prophets and kings, Christian saints and other holy figures; in legal manuscripts this individual represents the codifiers and purveyors of the law, emperors, kings and popes, and their associates – bishops, priests and monks; judges, jurists and lawyers. In all contexts these figures hold or display objects – scrolls, books, swords, staffs and orbs – symbolic of their identity, rank or power. Just as the written word itself signified authority, a human figure placed at the beginning of a text served to confirm or authenticate this newly copied version of the text and the ideas it contained. We may guess that the richly dressed figures who accompany the Trees of Actions in the Fitzwilliam's MS McClean 139 (Cat. No. 10, Fig. 28) certify the importance of these tables by their regal presence and by the physical act of touching the frames.

Early thirteenth-century artists placed single, standing figures as personifications of law and justice at the openings of juridical texts. Invested with either sceptre and crown or tiara and crozier, they are further distinguished by formal, iconic qualities: rigidity of posture, total or nearly total frontality and a limited range of hand positions. An example is the simple sanguine-coloured drawing of the Emperor Justinian at the opening of a commentary on the *Institutiones* at the Morgan Library (Fig. 34). Heading the declaration '*Iustiniani est in hoc opere*', this figure evokes the presence of the Emperor in his capacity as promulgator of the text while graphically standing in for the letter **I**. When miniatures were created to head book divisions around the middle of the thirteenth century, the single authority figure was joined by secondary characters in secular or ecclesiastic dress, plaintiffs, defendants, lawyers, counsellors and judges, actors in the elaborate ceremonial of law. Legal rituals were now enacted within a scenario formulated for each particular case, framed by coloured bands or architectural devices and set against coloured or gold leaf backgrounds.

The legal miniature is essentially a mini-stage, and artists sometimes used very complex devices to construct their sets. Bolognese artists in particular deployed physical elements

Fig. 34

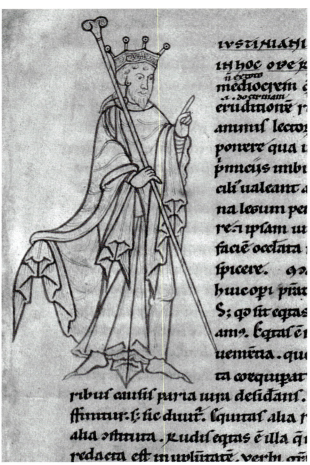

Fig. 35

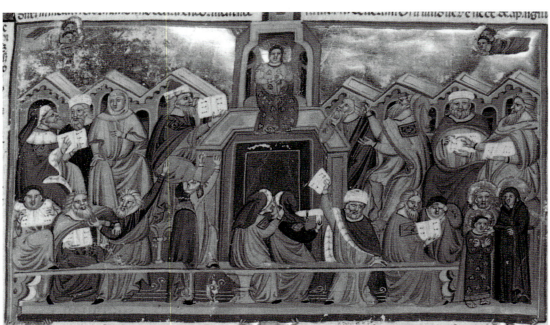

with great enthusiasm, varying the size and shape of living and working spaces, furniture, clothing style and fabric types. An excellent example is the large opening frontispiece to the Fitzwilliam's Bolognese *Decretum Gratiani* (MS 183, Cat. No 6, Fig. 35), where the B 18 Master with his customary verve tucked a great many figures wearing a variety of garments in, on and around a precarious-looking arrangement of benches and stalls, grouped around a central platform topped by a throne. Thirteenth-century scenes are flatter and more linear but can often be just as intricate, as demonstrated by the marriage ceremony in the Fitzwilliam's McClean 136 (Cat. No 14, Fig. 36), where the Jonathan Alexander Master managed to fit in a kneeling bride and groom, the officiating cleric, acolytes and attending clergy and a sizeable wedding party, each group apportioned its own space.

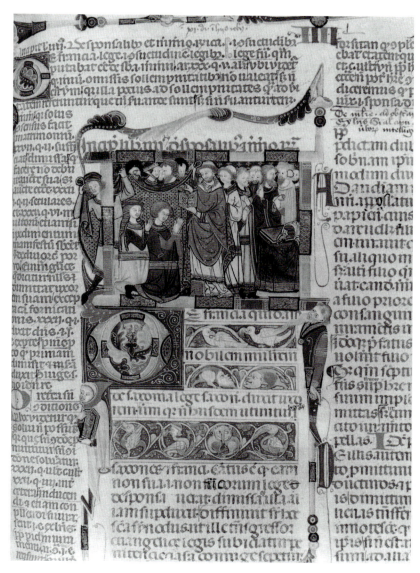

Fig. 36

As noted above, essential to most legal scenarios is a standing or enthroned figure, representing authority – secular, ecclesiastic, or divine. In manuscripts of canon law the authority figure is most often a pope or a bishop, although representations of Christ or God the Father can be included to convey supreme authority, divine intercession or the authorization of a text, particularly with regard to Church doctrine. In Roman law the figure often represents the Emperor Justinian, considered the father of civil law. Regardless of the particular text or type of law, this authority figure is generally situated at centre or to one side of the miniature, occupying some type of formal seat, or throne, whose rich detail underscores the occupant's importance and level of authority. In three of the Fitzwilliam's Italian Marlay Cuttings (Cat. No. 5; nos It. 6, It. 8, It. 10), a pope presides from his comfortable perch on a throne, feet resting on another plump cushion; the cardinal in Fitzwilliam MS 331 (Cat. No. 20), splendid in his fur-lined *cappa*, is enthroned beneath an elaborately carved baldachin, flanked by standing and kneeling figures, with a table of scribes recording proceedings at his feet.

Legal proceedings in juridical scenes are accompanied by postures and gestures often interpreted as indicating query or response, discussion, controversy, assent or negation.[1] In the Fitzwilliam's McClean 136 'discussion' miniature (Fig. 33), the secular judge at centre points upwards and gestures to the left, flanked by groups of serious-looking tonsured clergy, also pointing and gesturing. Many scholars have tried to read complex dialogues and distinguish nuances of inflection in these fluttering exchanges of hand positions. It becomes evident, however, after analysing a body of thirteenth- and fourteenth-century manuscripts, that these gestures rarely signify a specific ruling or have intrinsic meanings as such, but function more as signals that court is in session, so to speak. As Bernard Hibbitts has pointed out, 'Legal gesture is a physical and corporeal sign which can indicate that a legal change or relation is being effected . . . historically [serving] as a sort of semiotic shorthand. . . .'[2] Hands and fingers point at or point out figures, objects, animals or written material in book or scroll. They serve as directional devices, to guide the viewer in his comprehension and assessment of a composition and its areas of action. The few gestures that are situation-specific are connected with rituals or with the fulfilment of tasks, such as those used in ceremonies like the celebration of the mass, consecration of an altar or the uniting of man and wife; the clasping of a vassal's hands in acceptance of fealty – or counting gestures, used in business transactions.

Although civil and canon law were taught as separate university courses, they shared many legal topics, and illuminators would use the same compositions for textbooks of the two laws. Often the only distinguishing factors between civil and canon law miniatures on a common subject are the protagonists' clothing, headgear and attributes. The emblematic Justinian may be crowned as an emperor and dressed in Roman robes or military garb, and much of the time is metamorphosed into a medieval doctor of law or a jurist. His various symbols of authority include a sceptre or globe and a wand, flowering staff or, most often, an upright sword; in his guise as the figure of Justice he will suspend a set of scales as well. In court scenes he may hold an open or closed book or extend a scroll, and is

usually surrounded by secular professional figures: jurists, magistrates, lawyers, scribes and notaries. Flanked by lawyers in the miniature for Book IV of the Durham *Institutiones* (Fig. 37), the crowned Justinian holds a wand-like sceptre as he sentences a thief brought before him by officers of the law. In the composition for the Durham *Codex,* Book III, On Judgements (Fig. 38), the Emperor's right hand now clasps the hilt of a thick upright sword; he raises his left hand, forefinger pointing upwards, to rule on the case presented by

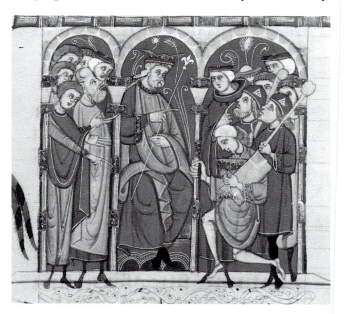

Fig. 37

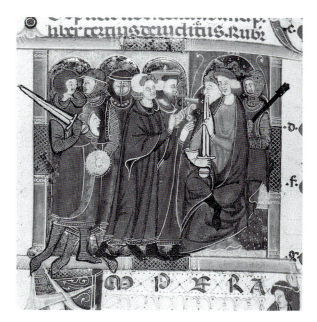

Fig. 38

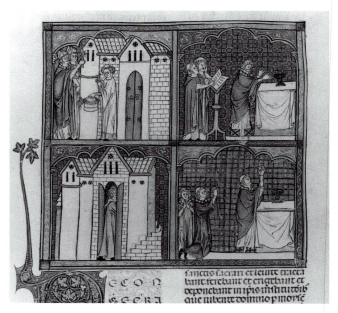

Fig. 39

the two secular judges who gesticulate before him. Here his right leg is crossed over the left, a formal, ceremonial posture for authority figures associated with Northern artistic traditions and revealing the illuminator's Transalpine roots; in Italian versions rulers generally have both feet firmly planted on the ground.

In the ecclesiastical sphere, hierarchical rank is distinguished by characteristic liturgical clothing. Popes, bishops and cardinals wear the hats and robes pertinent to their office, and sometimes full ceremonial costume. Clerics and monks may be tonsured, and their dress often refers to specific religious orders. These religious figures interact with liturgical objects and equipment, as vividly depicted in the large miniature for *De consecratione* in Fitzwilliam MS 262 (Fig. 39): here celebrants elevate the Host and cover chalices at the altar; canons and deacons carry processional crosses and monstrances and wave fans or censers; acolytes carry tapers and ring bells.

Legal Themes

Further to the general aspects described above, illuminators placed their civil and clerical protagonists in appropriate settings, to express a range of legal themes. The most complex and artistically elaborate compositions were reserved for major text divisions, particularly the first, and it is for this reason that so many medieval manuscripts have been robbed of their opening frontispieces, like the Durham *Decretales* (MS C.I.9). Often associated with a prologue or some sort of prefatory material, introductory miniatures in canon and civil law manuscripts perform a variety of functions: they may honour the author or sponsor of the text, establish the text's authority and transmit a general idea of law and justice. The first objective is accomplished with what is called a presentation miniature, exemplified by the Prologue composition in the Fitzwilliam's *Decretales* (Fig. 40) where the kneeling figure of the text's compiler, the Dominican Raymond of Peñafort (garbed mistakenly as a Franciscan friar), presents his completed book to the standing Pope Gregory IX, who commissioned the work. The sponsoring figure, in receiving and accepting the offered volumes, symbolically authenticates and authorizes the written law. It is this composition that John Northwode describes for the opening of a book in the inventory of the Corpus Christi College goods, a *Decretales*, bound together with a *Liber sextus*:

> Decimus quintus est magnus liber decretalium cum libro sexto cuius prima littera textus capitalis est G. supra quam sedet papa uno sacerdoti genuflectente coram eo et inter manus librum tenente, altero sacerdote stante a dorso genuflectentis

> (The fifteenth is a large decretals book with the *liber sextus* whose first text letter is a capital G above which sit a pope [with] a genuflecting cleric in his presence (before him) [who has] a book between his hands, with another priest standing behind the kneeling cleric).[3]

Fig. 40

Fig. 41

Fig. 42

The simple miniature with only three protagonists indicates that it was probably a thirteenth-century manuscript, since compositions became more spatially complex and were given supplementary figures in the fourteenth century, as can be verified in the Master of 1328's multi-levelled, multi-scened rendition in Figure 52. It is telling that this visual interpretation merited a written commentary by John Northwode, proof that the presence of illustrative material in legal manuscripts was not only familiar to him but that he easily recognized the iconography.

A similar presentation ceremony takes place in the Durham *Codex* (Fig. 41), and here a secular lawyer offers a stack of books to Justinian, who is dressed as a medieval judge. The textual source of this composition for civil law is found in the Prologue to the *Digestum vetus*, which relates how Justinian commanded his lawyers and jurists to sift through and extract the essential points of law from hundreds of legal texts, subsequently rearranged into the fifty books of the *Digest*, the four of the *Institutes* and the twelve of the *Codex*.[4] Most illustrations, like the Durham miniature, picture Justinian receiving into his hands

84

the end result of the lawyers' labour, by this act certifying its authenticity and approving its use. The most ambitious and narrative illustration of this passage is found in the Turin *Digestum vetus* (Turin, Bibl. Nazionale Universitaria, MS E.I.1, fol. 1), a multi-scene narrative sequence executed in the 1330s by an extraordinarily talented Bolognese illuminator, the Master of 1328, which describes the entire process of research, analysis and reconstruction by the Roman lawyers.

A variation on this theme is offered in the Prologue miniature to the Gonville and Caius *Codex* (Fig. 42), a composition most often found in the *Decretum Gratiani*. Here the enthroned Justinian, crowned as Emperor but garbed as a secular lawyer, enacts a variation of the Division or Distribution of Powers, an allegorical ritual in which legislative authority is granted to both secular and ecclesiastic entities, who will share it in harmony. Symbolized by two books, or a book and a sword, in the *Decretum* these powers are handed over to representatives of Church and State. In this *Codex*, Justinian hands a book to a kneeling secular figure at left, accompanied by a standing lawyer with black pileus; the kneeling soldier at right, mailed like his standing companion, receives an upright sword. The composition evokes the opening words of the second *Codex* prologue: 'The maintenance of the integrity of the government depends upon two things, namely, the force of arms and the observance of the laws'.[5] While here it is implied that the source of power is a secular ruler, even the earliest canon law versions make it clear that earthly rulers, secular and ecclesiastic, are subordinated to the divine authority, Christ. Twelfth-century opening compositions for the *Decretum Gratiani* depict a pope and a crowned sovereign in positions of equality, standing or enthroned side by side in a single space, or occupying the upper and lower tiers of the initial **H** of the opening phrase, '*Humanum genus*'. In thirteenth- and fourteenth-century miniatures, chiefly Italian, the figure of Christ or God the Father is added to the composition, sometimes portrayed in the act of personally handing over the temporal and spiritual powers to their earthly representatives or presiding over the distribution effected by heavenly delegates – winged angels. This motif was elaborately pictured by the Bolognese Master of 1328 (Fig. 53) in an allegorical composition for Book I of the *Decretales*, discussed further on.

Additional dimensions to this iconography appear in two Fitzwilliam *Decretum* manuscripts, MSS 262 and 183, where both miniatures are given a two-column format. In the first and earlier of the two, dated around 1300 and attributed alternately to English and French illuminators (Fig. 43), the artist presents in six compartments God's creation of the human race (summarized by the extraction of Eve from Adam's side), the introduction of Adam and Eve into the Garden of Eden, the Fall and the Expulsion from Eden. This narrative sequence sets a Christian allegory to interpret Gratian's opening phrase to the *Decretum*: '*Humanum genus duobus regitur, natuali videlicet iure et moribus*' (The human race is ruled by two things, namely, natural law [divine ordinance] and custom [human ordinance]) – emphasizing the higher authority of the divine. Use of this Biblical story to open the *Decretum* seems to have been popular among Northern illuminators in the early fourteenth century, although most summarized it with the single scene of the Creation of Eve.[6]

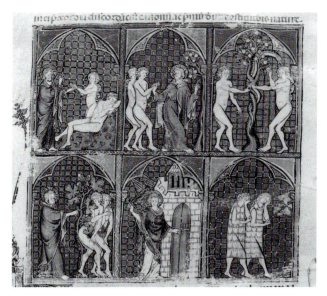

Fig. 43

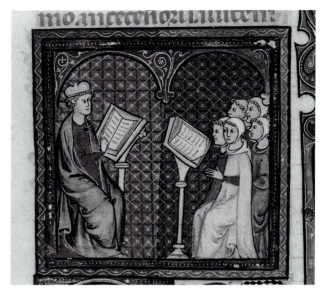

Fig. 44

In the 1330's the Bolognese B 18 Master utilized for MS 183 (Fig. 35) the image of Christ as Teacher, portraying the young Christ during his discussion of the law among the Doctors in the Temple. His role as source of the law and its highest authority is emphasized by his physical position in the miniature, enthroned at centre on a pedestal above the other protagonists. The popularity of this flexible motif is confirmed by its continued use in Bologna by contemporary and later generations of artists, to illustrate a variety of texts. The B 18 Master virtually duplicated the Fitzwilliam configuration to open a *Decretales* in Lucca (Bibl. Capitolare, MS 236, fol. 1). The Master of 1328, who may well be credited with the first use of this composition in a legal context, employed it as the opening miniature for two copies of a *Liber sextus*,[7] and for a *Decretum Gratiani* in Spain as preface to the section *De poenitentia* (Madrid, BN, MS Vitr. 21.2, fol. 263); the Master of 1346 placed it in a *Decretum* at *Causa* II (Vatican City, BAV, MS Urb. lat. 161, fol. 107); and as late as 1378 Niccolò da Bologna adopted it for the headpiece of a commentary on Roman law.[8] Another device used to expressing the importance and authority of the text was to depict its use in an actual university classroom, as seen in the opening miniature to the Gonville and Caius *Digestum vetus* (Fig. 44). Here the master, a doctor of law, presides at left, lecturing from the open book on the stand before him, while a seated group of five coiffed students accompany his words in their own volume, venturing a question or a comment from time to time.

Although the *Institutiones* is usually found in the larger context of the *Parvum Volumen*, its opening miniature – as, indeed, the beginning illustration to each separate *Volumen* section – is specific to its text alone. Illuminators drew directly on the text for the iconography of the Prologue, as Robert Branner first noted,[9] focusing on the phrase, '*Imperatoriam maiestatem non solum armis decoratam, sed etiam legibus oportet esse armatam*' (Imperial

Fig. 45

Majesty should not only be graced with arms but also armed with laws').[10] Most artists provided visual reference to both arms and the law, utilizing the formulaic presentation of books to Justinian for the latter, and alluding to the former with military figures and their trappings. A typical composition is found in Durham's MS C.I.4 (Fig. 45 and Pl. 11a), depicting Justinian frontally enthroned at centre, flanked on the left by a group of mailed and armed warriors, and on the right by lawyers and jurists, spatially giving equal weight to arms and the law.

Canon Law Themes

Papal decrees and the decisions of Church councils provided directives that regulated clerical life and the performance of ecclesiastical duties, and established the jurisdiction of canonical courts over clerical crimes and offences, as well as control over a variety of lay behaviours. Gratian's *Decretum*, in whose largest text division are found detailed discussions of the legal and religious questions raised in thirty-six separate cases, furnished illuminators with the widest range of possible compositions, although some topics were more suggestive of visual interpretation than others. Themes may be identified by particular iconographical features, such as a moneybag in illustrations to *Causa* I, which deals with simony. In this case Gratian takes up the question of a father's dispensing funds to ensure his son's admission into a monastery, and the later supplementary paternal contributions to further his rise in the ecclesiastical hierarchy. This practice is strongly denounced in canon law, and miniatures most often depict the father in the inappropriate act of offering a bribe to a bishop or monk as he presents his young son. The bribe is sometimes sym-

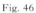

Fig. 46

Fig. 47

bolized by an precious object, such as the golden vessel offered in the historiated initial **Q** in Corpus Christi MS 10 (Fig. 46), but in most manuscripts the father holds up a heavy sack or fringed purse, as in the Fitzwilliam's MS 183 (Fig. 47). Simony is also treated in Book V, Title 3 of the *Decretales* and the *Liber sextus*, with a discussion of the penalties incurred by clerics accused or convicted of this crime; Niccolò da Bologna's illustration for this title in the Morgan Library's M.747[11] pictures a furtive-looking, red-hatted cardinal clutching a weighty sack against his chest (Fig. 48).

In cases dealing with Church ceremony, clerical authority, regulations of Church property or the responsibilities of parishioners, artists would juxtapose architectural elements with liturgical furnishings to establish a churchly setting. A spare but effective composition is found in the early Corpus Christi *Decretum* (Fig. 49), in the initial **A**[*bbas*] that opens *Causa* XVI, which discusses conflicts of authority between abbots and priests. The church exterior is evoked by the tower and rectangular structure in the upper section; an interior bay is constructed within the initial by thin columns that support a simple arch, from which hangs a votive lamp directly above the seated figures of tonsured priests and hooded monks. In the Fitzwilliam's Marlay It. 5 leaf for *Causa* XIII (Cat. No. 5c) that discusses the obligatory payment of tithes to one's baptismal church, clerics in two separate apses

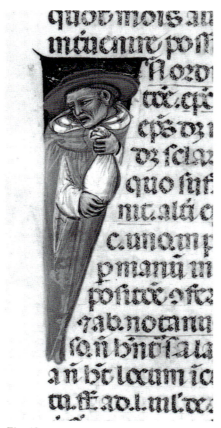

Fig. 48

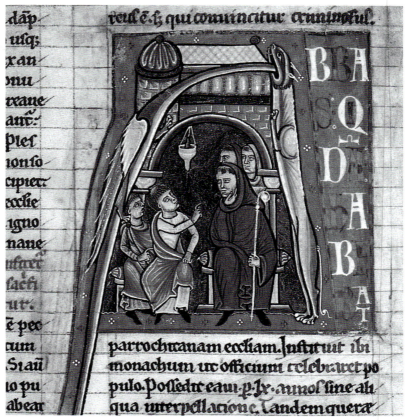

Fig. 49

preside behind draped altars, while a procession of church members enters bearing goods as their oblations. We have already seen the very elaborate four-part miniature in Fitzwilliam MS 262 illustrating the section *De consecratione*, which deals with the physical and symbolic functions of a church building (Fig. 39). In the first compartment two bishops are shown consecrating the newly completed building with holy water sprinkled by aspergilla; the second and fourth picture the church interior and two phases in the ritual of the mass; in the third compartment a figure enters a similar but incomplete or partially ruined edifice, perhaps seeking sanctuary.

Some of the most dramatic illustrations were made for cases concerning marriage and the sexual debt owed to each other by husband and wife. The illuminator of the Fitzwilliam MS 262 *Decretum Gratiani* provides perhaps the most explicit extant medieval representations of sexual activity in his compositions for *Causae* XXXIII and XXXVI. The first case describes a husband who has become temporarily impotent, his wife's denunciation of this situation in a Church court, her subsequent adultery with and marriage to another man and, finally (upon the first husband's recovering his potency), the wife's forced separation from the second (and illegal) husband and her return to the first. This is pictured in sequence on folio 86v (Fig. 50), where in the upper right compartment

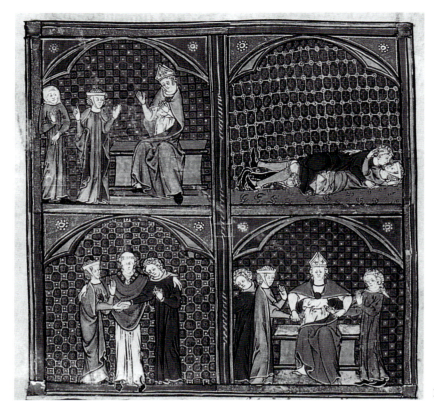

Fig. 50

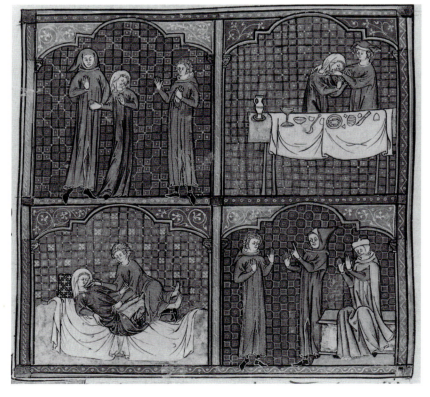

Fig. 51

the adulterous coitus takes place in a tangle of clothing and limbs. The vigorous activity exposes the woman's elegantly shod feet, her slim legs clad in gartered stockings and a glimpse of bare knees; her enfolding arms betray her willing submission to the figure above her. The second case, pictured on folio 137, involves the question of whether and how, under Church law, the sacrament of marriage may be granted to a couple who have already had sexual relations. The Fitzwilliam artist here illustrates a familiar situation, today called 'date rape', where a young man invites a young woman to dine without her parents' knowledge, plies her with drink and then takes advantage of her inebriation to violate her sexually (Fig. 51). Once again the artist presents the story in a narrative cycle: the first episode, where the young woman is accompanied by her father, perhaps depicts the young couple's covert agreement to a tryst; the second pictures the seduction at the feast; and in the lower left-hand compartment we see the young woman's rape. In this scene domination and aggression are conveyed by various details: the woman's entirely bare legs, stockings removed and her dress being roughly pushed up by her attacker to expose her pudenda, while she fruitlessly tries to push him away with her left hand; the young man's rampant position with penis exposed, and his right hand extended to chuck the woman's chin, in a long-recognized gesture of male possession.[12]

The *Decretum* – divided into two major sections, the latter subdivided into thirty-six *Causae*, with two additional treatises on penitence and liturgy – could incorporate as many as thirty-nine or forty miniatures. The *Decretales*, however, more modestly conceived in Bernard of Pavia's five-book format and occasionally supplemented by the more newly published decretals (*Novellae*) of Innocent IV (1243–54) or Gregory X (1271–76), were rarely given more than a total of six or seven miniatures. Around mid-thirteenth century, specific compositions were created to preface each book, drawing on visual themes suggested by the words in the first title. As we have seen in Chapter 1, most manuscripts of the *Decretales* open with a short prologue, comprising Pope Gregory's address to the university community followed by the text of the bull *Rex pacificus*, representing the legitimization of this particular collection and its official transmission for use in universities and in Church courts. In Italian manuscripts the space assigned the prologue is normally a page, written in two columns, Book I then beginning on the following page. In late thirteenth- to mid-fourteenth-century Bolognese examples this arrangement was often carried out very grandly over a double-page opening with facing miniatures, very likely having been the case in the Durham *Decretales* (MS C.I.9, Cat. No. 13), where both the Prologue miniature on folio 1v and all but a stub of folio 2 – with a remnant of vinescroll signalling a probable miniature for Book I – have unfortunately been excised. From the style of the surviving fragments of decoration, the work seems to have been executed by the true Bolognese artist, and could have provided an early example of the double page Italian tradition. The fourteenth-century version is represented by one of the Master of 1328's most striking creations: two single leaves at the Morgan Library, datable to the early 1330s (Figs 52, 53). These facing two-column miniatures with their subsidiary marginal vignettes, once the opening to what must have been an abundantly illuminated *Decretales*, not only

91

make strong ideological statements but also testify to a very happy collaboration of scribe with illuminator. It is to the credit of the scribe or scribes, that text and gloss are laid out, ruled and written symmetrically and cleanly, leaving equally clean and symmetrical spaces on each page for the illuminator to carry out his work. The Master of 1328 indulged himself by filling in his arena completely, up to the edge of the inner gloss margins, even appropriating the space usually left blank (Fig. 52) between the end of the Prologue and the *incipit* of Book I, in the right-hand text column.

Fourteenth-century Prologue miniatures subtly convey ideas of hierarchy, legal jurisdiction, not the least through spatial distinctions. In Figure 52, the elevated Gregory presides at centre, while at right seated ecclesiastics occupy a lower tier of his platform. The secular figures at left, however, among them soldiers, jurists and lawyers, are placed at ground level, clearly given less importance. In a neutral zone below the throne, writing busily within their tiny compartments, scribes and notaries legitimize the activities above. Tucked into and around the initial **G**, representing the name of Gregory himself, a lecturing master and his attentive students symbolize the importance of the teaching and study of the law.

When Book I of the *Decretales* was given an illustration, it was usually treated allegorically, since the first title embodied Church doctrine: *De summa trinitate et fide catholica* (On the Exalted Trinity and the Catholic Faith). To represent the basic Catholic beliefs, thirteenth-century Bolognese miniatures portray the enthroned, blessing Christ, often flanked by the Virgin on his right and John the Baptist on his left. Around 1300 this began to be alternated with an elemental Trinity composition of the *Gnadenstuhl* type – which transformed the enthroned Christ into God the Father, whose outstretched hands supported the Crucified Christ, as the white Dove of the Holy Spirit hovered somewhere in between. The Master of 1328 used this Trinity in the right-hand miniature of the Morgan Library double page spread (Fig. 53) to continue his essay on hierarchy, presenting it in the guise of doctrine. In the right-hand miniature he placed the Trinity at the same level as Pope Gregory on the left, visually endowing the earthly representative equal status with the rulers of heaven. Gregory's secular and ecclesiastical retinue is correlated with the holy figures that accompany the Trinity: the Virgin at left and John the Baptist at right, attended by kneeling angels; at the second level sit the haloed twelve apostles in two groups of six. In the foreground, we see the enactment by two angels of the symbolic Division of Secular and Ecclesiastic Powers, consigning a sword to a king and a book to a pope, who, like the Virgin, is on the right, or favoured side, of the Trinity.[13] The lower marginal vignettes are then given over to an elaboration on the articles of Catholic faith. A warrior saint stands at centre, exemplifying the militant defence of Christianity. At left and right Gabriel and the Virgin portray the Annunciation, representing the conception of the Son of God for the salvation of humankind, and just above the rubric two monks in attitudes of prayer evoke the contemplative life. The artist did not leave it at that: on the verso of this leaf, what began in the Annunciation takes place in the flesh: the initial **F**[*irmiter*], converted into a small miniature, depicts the Nativity and the Annunciation to the Shepherds,

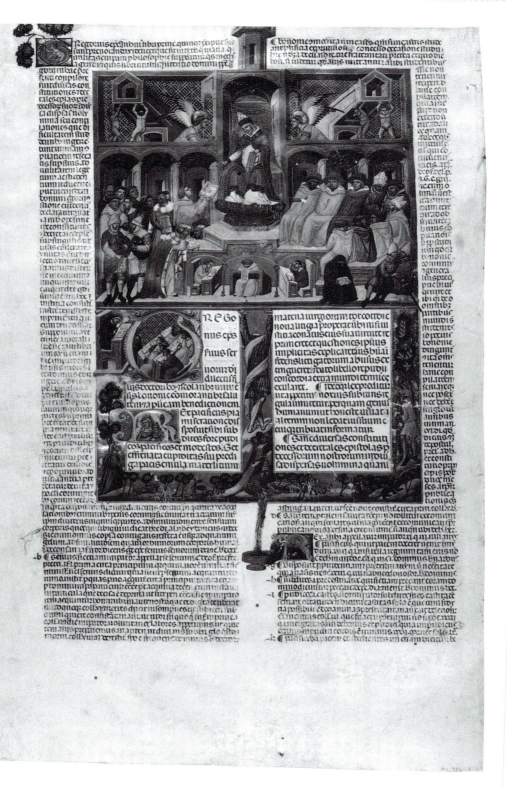

Fig. 52

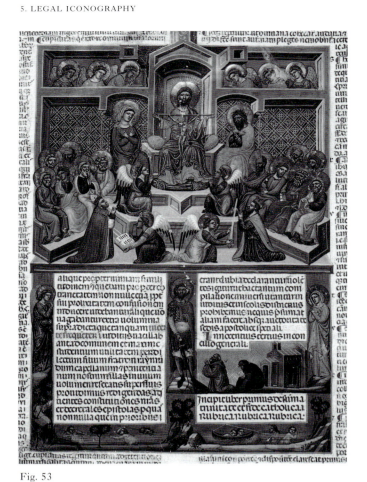

Fig. 53

Fig. 54

heralding the Saviour's birth. The fulfilment of God's promise of salvation is then enact-
ed in the large two-column miniature by the crucified Christ, who sacrificed his life to this
end. This complex visualization of Catholic doctrine, realized in the 1330s, testifies to the
Master of 1328's creativity and interpretative powers, along with his artistic skill.

Illuminators working in Northern traditions were more likely to forego a miniature for
Book I, opening it more simply with a rubric and a large penwork or painted initial **F** for
the opening phrase, '*Firmiter credimus*', as indeed was done in MS McClean 136 (Fig. 40)
and in the much later Smithfield Decretals (London, BL MS Royal 10.E.IV) as well. A
Decretales at Hereford Cathedral Library, however, addressed like the McClean manuscript
to *parisius bononieque*, was given two large historiated initials for the Prologue and Book I
on the opening page, conveying the appropriate iconography with great economy of space
and detail (Fig. 54). Within the **G**[*regorius*] at top left column the seated Gregory receives
a book from the kneeling Raymond; in the **F**[*irmiter*] at lower right-hand column the illu-
minator placed a Trinity composition more common north of the Alps: God the Father
and Son face the viewer on side-by-side thrones, the upside-down Dove of the Holy Spirit
poised above, its head interposed directly between the other two. These fluctuations in

94

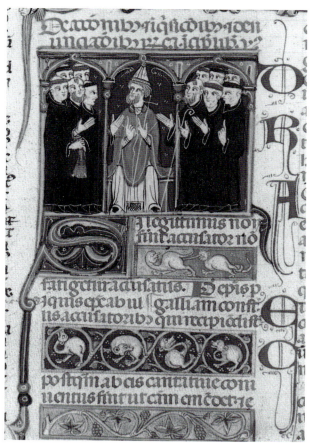

Fig. 55

Fig. 56

iconography and composition are often the only clues we have to identify regional trends and traditions.

Book II, On Judgements (Fig. 33), and Book V, On Clerical Crimes (Figs 55, 56), were usually given generic court scenes featuring an enthroned pope as judge and an offending ecclesiastic undergoing judgement. The miniatures for both in Fitzwilliam McClean 136 are virtually identical, although a secular judge presides for Book II, while at Book V (Fig. 55) a pope renders judgement over the flanking groups of sombre, black-robed clerics, one of whom conspicuously clutches a money purse and is probably guilty of simony or money lending at interest. In the single leaf (MS 201.f.12, Cat. No. 4) (Fig. 56) the pope is joined on the left by a kneeling secular judge, backed up by a group of laymen, who appears to be participating in the adjudication. For Book III, which distinguishes correct and improper clerical behaviour and describes ecclesiastical duties, illuminators pictured the clergy performing the rituals and procedures of the celebration of the mass, beautifully captured in the Fitzwilliam's single leaf with a two-column Southern French miniature (Fig. 57). The miniature is segmented into two principal areas by a centre column, but three distinct groups of figures are defined. In the right-hand section the celebrant raises the Host before

the draped altar; acolytes kneel behind him holding lighted tapers. Directly left of centre, in what is meant to be the choir, standing clerics cluster around a tall bookstand, singing from an open choir book. Behind this group at left kneel the laity, separated in principle if not in fact from direct participation in the eucharistic ceremony. In the one-column McClean *Decretales* version (Fig. 58), the composition is highly truncated but also abounding with figures. The celebrating priest at right elevates the Host as customary, but at the centre a worried-looking deacon faces an invasion of the laity and tries to persuade them to return to their proper location in the nave. Infrequently depicted,[14] this confrontation seems to be the artist's deliberate emphasis on the need to segregate the secular from the ecclesiastical.

Marriage in Book IV was represented by differing iconographic components according to regional traditions. The simplest compositions picture a betrothal or marriage ceremony, usually symbolized by the giving of a ring or joining of the couple's hands in front of witnesses, as takes place in the Durham *Decretales* (Fig. 59), presided over by an official figure, a secular judge or a cleric. The Jonathan Alexander Master created a splendid ver-

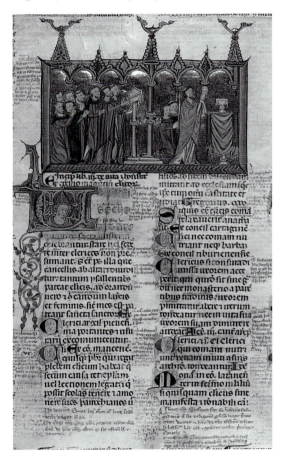

Fig. 57

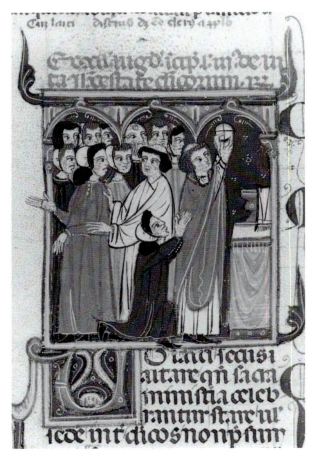

Fig. 58

sion for the McClean *Decretales* (Fig. 36), which depicts the betrothed couple in an unusu-al kneeling position before the officiating priest, set off by the golden cloth of honour stretched behind them by an acolyte and a member of the wedding party. Book V of the *Codex* is also concerned with betrothal and marriage, albeit as a lay transaction, and in most Italian manuscripts this secular aspect was conveyed by the officiation of a civil judge. In the Northern tradition a cleric usually officiates, whether in civil or canon law manuscripts. In the Jonathan Alexander Master's miniature for the Durham *Codex* (Fig. 60), a tonsured ecclesiastic supervises the ceremony in which the groom places a ring on the bride's finger.

Questions of legacies and inheritance are also common to canon and Roman law.[15] The most elementary civil discussions are found in Books II and III of the *Institutiones*, defin-ing wills and those who are eligible to make them and describing legacies and those who are eligible to inherit, according to degrees of blood and family relationships and other legal conditions. Although the textual material spans two books, iconography is summa-rized in the miniature that prefaces Book III, where the basic visual components are a man dictating a will from his deathbed and a scribe annotating the bequests. The miniature for

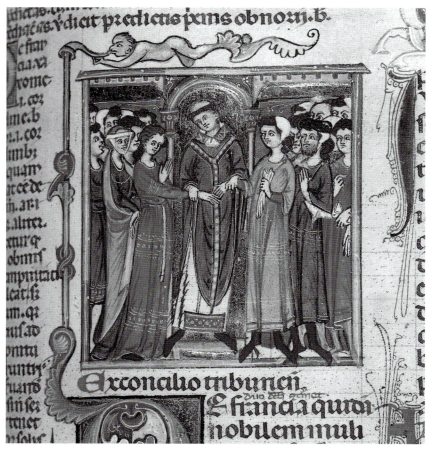

Fig. 59

this book in the Durham *Institutiones* (Durham C.I.4) has unfortunately been excised, but there are two canon law equivalents from the Fitzwilliam's collection (see MS McClean 201.f.11b, Cat. No. 9 and Marlay It. cutting 4, Cat. No. 5b), which depict recumbent clerics in the act of expressing their last wishes to a variety of bedside attendants. In the fourteenth century, compositions become more narrative, and the act of dying becomes an event.[16] Other characters may crowd around the bed or occupy secondary spaces: lawyers and judges, the dying man's wife, a grieving young heir, a doctor who examines a urine flask and a cleric to administer the last rites. Taken together, these genre details describe the hustle and bustle of different activities and rituals that accompany the ending of a life.

Civil Law Themes

More specific to civil law manuscripts are illustrations of criminal sentencing and punishment, usually with relationship to theft. These are most often found at the *Institutiones*, Book IV, concerning delictual obligations, and the *Codex*, Book VI, which involves the punishment due a fugitive slave whose flight is treated as theft, as expressed in the opening paragraph: '*Servum fugitivum sui furtum facere*' (The runaway slave commits a theft of himself, causing prejudice and loss to his master). The thief/slave/criminal is easily identifiable by his dress and physical appearance and by the figures that accompany him, as we may discern in the miniature for *Institutiones*, Book IV in the Durham *Volumen* (Fig. 37). Usually short and stumpy in stature, he is often given crude features such as a huge pouting lip, pug nose and pop eyes. In contrast to the lawyers and jurists' long robes, he is clothed in a short garment with bare legs and feet, occasionally lacking a limb, the sign of a recidivist. Thieves and other criminals are bound and taken into court for sentencing by lawyers or soldiers – or sometimes, as in Figure 37, by what appears to be a police squad, its members distinguished by their red caps – and ushered into the presence of Justinian, who is dressed as a judge or crowned as a ruler. Rather than entering with bound arms, here the thief is pictured carrying the objects he has stolen, probably to signal his being caught in the act. In Bolognese manuscripts, the two objects with which the thief is usually pictured are either a golden chalice or a book (infrequently both, as in the Durham miniature), each representing an object of commercial and social value.[17] In the English tradition, it appears that other items could be used as well. Canon law manuscripts, specifically the *Decretales* and the *Liber sextus*, deal with the judgement and sentencing of crimes and offences in Books II (*De iudiciis* – On Judgements) and V (*De accusationibus, inquisitionibus et denunciationibus* – On Accusations, Inquisitions And Denunciations). In St John's College, MS A.4, vol. 4 (Johannes Andreae's gloss on the *Liber sextus*), the historiated initial at folio 61 for Book V (Fig. 61) pictures a bound criminal being brought before the judge, a sheep draped around his neck like a stole, its fore and hind legs trussed together under his chin, testimony to his attempted poaching of livestock.

Punishments for civil crimes may also vary according to Northern and Southern traditions. In thirteenth- and fourteenth-century Italian miniatures artists favoured decapita-

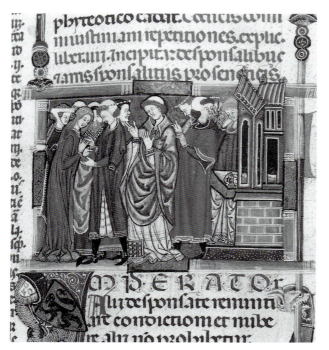

Fig. 60

Fig. 61

tion and foot amputation – the latter by far the most common, usually performed by a team of executioners who divided the job: one positioned a hatchet-like blade on the victim's leg, the other wielded a heavy mallet to pound on the blade and drive it through bone. Another alternative was hanging, this method was most popular in the North, stemming from a long visual tradition and perhaps initially modelled on representations of the suicide of Judas, portrayed in Gospel Books from at least the sixth century on.[18] Below the opening *Institutiones* miniature in the Durham *Volumen* (MS C.I.4, Fig. 45), a nude figure dangles from a stylized gallows, most probably exemplifying the enforcement of laws by the use of arms (that is to say, punishment). A similar hanged figure is found in the St Johns MS A.4 (Fig. 61), beside the rubric, illustrating the punishment for theft. Hanging was considered one of the most degrading forms of punishment since the human body was exposed to the ridicule and contempt of the populace for an extended period of time. In Northern illustrations this punishment can be given a very narrative interpretation, sometimes picturing the criminal at the gallows as he climbs up a ladder to the noose, followed by the executioner who will make sure the job is properly done. Bolognese illuminators in general seem to have preferred the more violent forms of execution, and when they depicted a hanging it was almost always in conjunction with decapitation and amputation.

Books VII of the *Codex* and XL of the *Digestum novum* are concerned with the act of freeing slaves, according to Roman practices, and the miniatures created for this subject depict the Roman ritual of manumission by a wand or staff,[19] one of the symbolic objects often used as props in legal miniatures. In early medieval rites of vassalage, objects used for the investiture of vassals included swords, sceptres and staffs of command,[20] all of

which are wielded in varying situations by the authority figures in manuscripts of canon and Roman law. The ritual is illustrated very simply in the Gonville and Caius *Digestum novum* (Fig. 62) where three witnesses look on as the authority figure taps a prostrate individual with his staff. In reproducing these historically conventional forms and customs, illuminators re-enacted and reaffirmed the past, and proclaimed its continuity in the present. Whether or not these gestures and actions were actually performed in their time, 'this is how such actions were imagined in the Middle Ages'.[21] Most compositions picture the crowned and enthroned Justinian who touches a rod to the shoulder of a figure who kneels before him, hands often placed together in a gesture of fealty. A similar secular ceremony takes place in the miniature for Book XII of the *Codex* in the *Tres libri* division of the Durham *Volumen* (Fig. 63). The first text passage after the opening Title, *De dignitatibus* (Concerning Dignities), awards the title of consul to an individual whose father and grandfather have held the same rank. The illuminator ingeniously represented this status-upgrading ceremony by depicting a lay professional kneeling in obeisance before the enthroned and crowned Justinian, the secular figure stretching his hand around to pluck off his own biretta and exchange it for the crown that Justinian is extending.

The small proportion of civil law manuscripts in the exhibition has made it expedient to devote most of this chapter to iconographical interpretations of canon law. One last civil theme, however, allows a dynamic and amusing conclusion to this section. The Durham

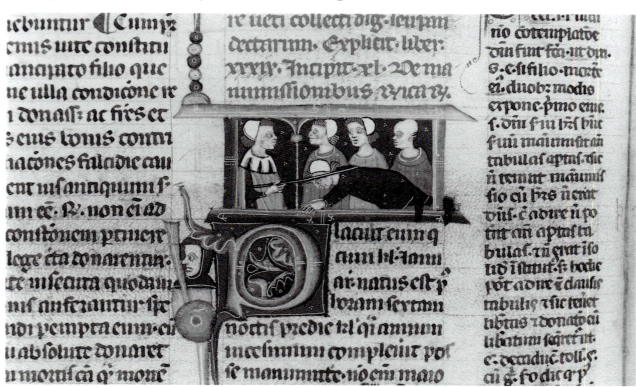

Fig. 62

Fig. 63

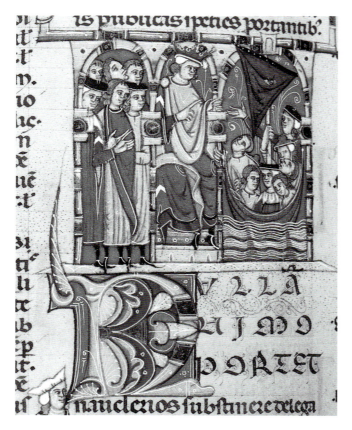

Fig. 64

Volumen, at *Codex,* Book XI of the *Tres libri* (Fig. 64) is illustrated with a miniature described by Jonathan Alexander in 1980 as 'a picture of a sailing ship which looks dangerously overloaded!'.[22] Here we see the crowned Justinian presiding at centre, accompanied at left by a group of lawyers, and apparently making a legal comment on the comportment of the indeed jam-packed vessel at right. The first five titles in the *Tres libri,* Book XI, and the first two in the *Digestum vetus,* Book XIV, are textual locations dealing with maritime travel: ships, shipping and ship owners, which gave artists an opportunity to display their talents at painting water and describing the effects of translucency, as well as placing into water a sailing vessel that seemed convincingly afloat. The composition is one of the earliest to be established in legal iconography, adapted from the long-existing Bible illustration to the book of Jonah, which generally portrays the body of Jonah being jettisoned from a sinking ship.

Illuminators used the same compositions and iconography for both maritime text locations, with no differentiation given for the slightly different focus presented in their opening extracts. The iconography pictures the transportation of cargo and passengers in maritime crafts, which may vary in size and model. Some are powered only by oars and resemble casks, tubs, canoes or cat claws; others have in addition masts, sails, rigging and crows' nests. At times there is an allusion to shipwreck with the inclusion of objects bobbing in the water near the vessel.

102

Thirteenth-century miniatures for this subject are composed in two or three spaces, usually with Justinian enthroned at left, sometimes accompanied by other figures, as in the Durham miniature. The vessel may be rowed by a figure standing in the prow, or powered only by sails, or, as in the Durham version, displaying both methods of propulsion, although here, while the oars are visible beneath the waves, no one seems to be operating them. There is often a steersman or oarsman who appears to receive instructions from the gesturing Justinian as he prepares to depart from the harbour; in this case he is trying to steady the ship by clutching the column next to Justinian's throne. One of the earliest text-specific compositions on a legal theme, the iconography of this miniature was maintained in fourteenth-century versions, which acquire more convincing spatial projection and a progressive elaboration of details: the ship is shown anchored in port, its sails usually furled, being loaded by figures who carry sacks and packages up a gangplank.

Although the number of manuscripts brought together in this exhibition is relatively small, the quantity and quality of their illuminations have permitted a fair sample of the immeasurably fertile and relatively unexplored field of legal iconography. It is the hope of the organizers and the host of scholars, legal, art historical and textual – who have contributed their time and expertise to the preparation and writing of this catalogue – that this exhibition will engender more interest in the medieval legal manuscript as an illustrated text, a historical artefact and as a repository of many palaeological, codicological and iconographical mysteries yet to be solved.

Notes

1 On varieties of legal gesture and their functions, see two important essays by Bernard Hibbitts: Hibbets, 'Coming to our Senses'; and Hibbets, 'Making Motions'.

2 Hibbits, 'Making Motions', p. 57

3 See James, *Corpus*, pp. 88–114.

4 The passage begins, 'Omnem rei publicae nostrae sanctionem iam esse purgatam et compositam tam in quattuor libris institutionum seu elementorum quam in quinquaginta digestorum seu pandectarum nec non in duodecim imperialium constitutionum quis amplius quam uos cognoscit?'.

5 'Summa rei publicae tuitio de stirpe duarum rerum, armorum atque legum veniens vimque suam exinde muniens'. Translated by Samuel P. Scott in Scott, *Law*, XII, p. 4.

6 For these and all other *Decretum* compositions, see the rich comparative collection of reproductions from this text in Melnikas.

7 Padua, Bibl. Capitulare, MS A.2, fol. 1; New York, Pierpont Morgan Library, MS M.821, preserved as a single leaf.

8 Vatican City, BAV, MS Vat. lat. 2598, fol. 1, Bartolus de Saxoferrato, *Lectura in primam Infortiati partem*.

9 Branner, '*Corpus*', p. 106.

10 Some illuminators, however, seem to have classified the opening to the *Institutiones* along with those for the *Digestum vetus* and the *Codex*, because a number of miniatures merely depict the presentation of books to Justinian, ignoring the 'graced with arms'.

11 The mother manuscript from which Fitzwilliam MS 331 was excised.

12 See Wolfthal, 'Rape Imagery'.

13 A similar composition was often given to the *Codex* at Book I, since its prefatory title began with the same words as the *Decretales*, immediately followed by a passage in which three Roman emperors exhorted the people under their rule to accept the Trinity as an article of faith: *De summa trinitate et de fide catholica et ut nemo de ea publice contendere audeat* (Concerning the most exalted Trinity and the Catholic faith, and providing that no one shall dare to publicly oppose them).

14 This scene appears to be more common to Northern iconography.

15 Discussed in the *Decretum Gratiani* at *Causae* VII, VIII, XII and XVII and in the *Infortiatum* in Books XXVIII–XXXV, the *Institutiones* in Books II–III, and in *Collatione* 9 of the *Authenticum*.

16 See particularly, for the *Infortiatum*, Book XXX, Cesena, Bibl. Malatestiana, MS S.IV.2, fol. 111 and Paris, BNF, MS Latin 14340, fol. 111.

17 It is significant that illuminators used a book to exemplify a stolen good, especially in the context of the Bologna book trade, demonstrating the economic value of this commodity.

18 A well-known image of the hanging Judas is found in the sixth-century Rossano Gospels, where on fol. 8 it concludes the illustration of Christ's trial before Pilate on this page. Illustrated in Weitzmann, pl. 30.

19 Scott notes that 'Manumission by *vindicta*, or *festuca*, a wand or staff, ordinarily took place before the Praetor, but could be effected by any other magistrate legally authorized to grant it. The master brought the slave, whom he wished to liberate, before the proper official . . . and after having stated the reason for his emancipation, gave utterance to the formula: *'Hunc hominem liberum esse volo more quiritium'*, whereupon the magistrate placed the wand upon his head; he was then turned around either by the lictor or his master, and the latter, after having given him a box on the ear, sent him away'. Scott, *Law*, XIV, p. 113, no. 1.

20 On vassalage and performative rites, see Le Goff, pp. 237–87; and Hibbits, 'Coming to our Senses', pp. 910–34.

21 Barasch, p. 7.

22 Alexander, 'Durham', p. 150.

Cat. No. 1
Cambridge, Sidney Sussex College, MS 101

Gratian, *Decretum*

Manuscript, parchment, 234 fols, 315 x 204 mm, in two columns, *c*. 220 x 120 mm, with occasional marginal glosses, in 8s, the first gathering in 10 of which fols 1–2 contain an index, the last leaf cropped to allow the prologue to face the opening of the text; a bifolium containing the *Arbores* inserted as fols 209–210. The manuscript is too tightly bound to confirm all the details of M. R. James's collation: i[10](10 cancelled), ii–v[8], vi[10] (2 cancelled), vii–ix[8] (3 can-celled), x–xiv[8], xv[12] (10 cancelled), xvi–xxii[8], xxiii[10], xxiv–xxvii[8].

PROVENANCE: Durham Cathedral: fol. 3 is head-ed in a 15th/16th-century hand, *Decreta non glosata. lib. sci. Cuthberti*; bequeathed in the 17th century to the college by the master, Prof. Sam Ward, 1610–43, a native of Bischip Middleham in the county and friend of the Dean of Durham.[1]

TEXT: Italian, late 12th century.

It is written in a very regular Carolingian minis-cule with much of the roundness of *littera bononiensis*, rather than a Gothic pointed forma-tion of letters.

Pl. 1a. Sidney Sussex College, MS 101, Gratian, *Decretum*, fol. 3: the opening of the Summary

Pl. 1b. Sidney Sussex College, MS 101, Gratian, *Decretum*, fol. 10: the opening of Part I

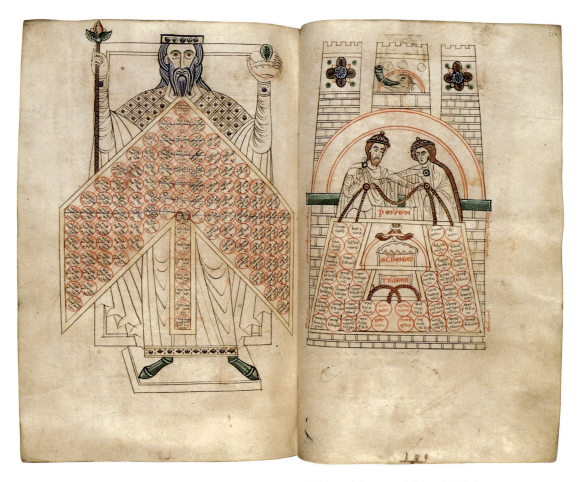

Pl. 1c. Sidney Sussex College, MS 101, Gratian, *Decretum,* fols 209v–210: Trees of Consanguinity and Affinity

The manuscript is exceptionally small for a *Decretum*, being a largely unglossed copy as the library heading indicates. However, it does have broad margins allowing for a gloss of Kuttner's second type, including triangular rubric glosses with initials not executed. Although there are some later additions, the original glosses have never been erased or replaced and remain exceptionally sparse, giving a remarkably clear impression of an early copy of the text. A summary typical of early copies, *In prima parte agitur,* occupies fols 3–9. The *Distinctions* are headed **I P** or **P I** variously from fol. 10 as far as fol. 44v; Part II opens at *Causa* I on a new gathering, a division typical of early Gratians but not found in later Bolognese manuscripts.

ILLUMINATION AND DECORATION: Italian, *c.* 1175.

The manuscript has very fine display lettering and decoration in a rich scarlet red and a fine powdery blue, probably ultramarine; the major initials were intended to be illuminated but were never realized. The opening of the summary and of each *Causa* is written in display capitals. Each section of the summary has a red or blue initial **I** with contrasting filigree pattern. The opening of the text proper and various subsequent initials in the text proper, not inset, are in red and blue alternately with a line of contrasting colour through them, the simplest form of filigree letter decoration typical of the pre-1250 period. Many of them have filigree

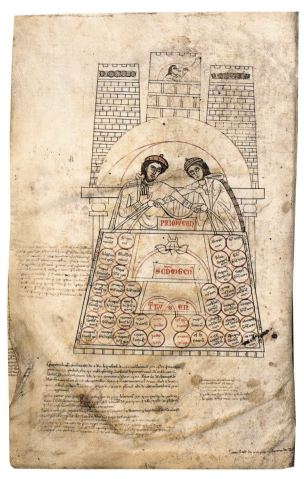

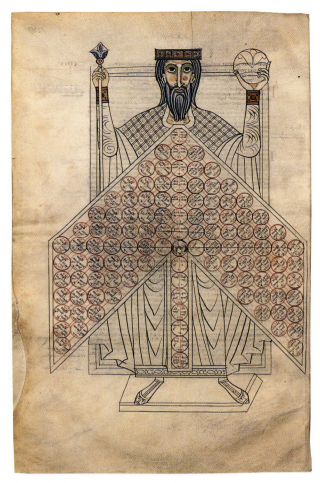

Pl. 1d. Bamberg, Staatsbibl., msc. Can. 14, Gratian, *Decretum,* fol. 3v: Tree of Affinity

Pl. 1e. Bamberg, Staatsbibl., msc. Can. 14, Gratian, *Decretum,* fol. 169v: Tree of Consanguinity

sprays with heads of barley and zoomorphic features reaching into the *bas-de-page* (Pls 1a-b).

The Trees of Consanguinity and Affinity inserted into *Causa* XXXV, fols 209v–210, are illustrated in a linear Romanesque idiom probably typical of the earliest stages of Bolognese illumination. The Consanguinity tree belongs to Hermann Schadt's seventh type, which still represents the Church's proscription of marriage within seven rather than the five degrees of interrelationship proscribed by Roman law (Pl. 1c). Other examples of this type are datable to the third quarter of the 12th century and the 13th century.

This pair of tables is virtually identical to that in a copy in Bamberg, Staatsbibl. msc. Can.

14, and is by the same workshop, if not by the same artist (Pls 1d, 1e). It is closely related artistically to a wider group of manuscripts, including Bamberg, Staatsbibl. msc. Can. 15; Baltimore, Walters Art Gallery MS 777; Venice, Bibl. Marciana IV 117 and Vercelli, Bibl. Capitolare XXV (118). Bamberg msc. Can. 14 is a larger (406 x 252 mm overall) copy of Gratian, extensively glossed but without the preliminary summary. Its opening letter **H**[*umanum genus*] with the characteristic combination of pope and emperor was illuminated by the artist of the Cambridge copy (Pl. 1f). Its other decoration is less refined than the Cambridge manuscript. The Cambridge and Bamberg tables are notable for the very firm

Pl. 1f. Bamberg Staatsbibl., msc. Can. 14, Gratian, *Decretum,* fol. 4: the opening of Part I

Pl. 1g. Sidney Sussex College, MS 101, Gratian, *Decretum*, fol. 38v: men cutting down a tree

Pl. 1h. Sidney Sussex College, MS 101, Gratian, *Decretum*, fol. 95v: a priest dines

Pl. 1j. Sidney Sussex College, MS 101, Gratian, *Decretum*, fol. 97v: a bishop in his sickbed

Pl. 1k. Sidney Sussex College, MS 101, Gratian, *Decretum,* fol. 109: a man of doubtful character

contours of the figures, their round eyes echoed by high round eyebrows and the concentric circles composing their heads and crowning hair. Eyebrows are shaded in green, and a thicker peach tone defines the cheeks. In the Bamberg illumination these colours are built up in layers of paint, whereas the parchment provides the basic tone in the Cambridge manuscript. Consanguinity is presented by the First Man, crowned as king, a frequent but not universal detail of such trees. He wears a very broad pallium or stole with a diaper pattern, as in Bamberg, over a tunic and cloak falling in long single lines and V-folds, without any other modelling, unlike the related manuscripts. The Cambridge manuscript develops the fold lines on the upper arms of the Bamberg Adam into more natural pleats, and the head is developed into the double circle with hollow cheeks typical of Byzantinizing Romanesque art.

The Affinity table depicts a married couple holding cords that lead to the proscribed

degrees above the prohibited second and third degrees. Their dynastic role is expressed by the arch and towers that surround them, all seen in purely frontal graphic presentation. The celebrated Marciana version of this scene is artistically very close but more conventional in its architecture.

In the Cambridge manuscript the blue hair of the Adam figure and the red circles of the tabulation relate these pages to the decorative scheme of the rest of the manuscript. The severe lines and minimal modelling of the figures have a counterpart in the murals of the Benedictine monastery of S. Vittore outside Bologna and may represent the presence of a modest pictorial tradition in the city before illumination became a major concern in the 1250s.[2]

The Sidney Sussex Gratian has no other illumination, but it is also notable for an extensive series of marginal drawings that appear to act as an extra gloss. They are of some pictorial complexity and are of considerable artistic quality. The drawings clearly reflect an understanding of the text and act as an index to certain passages, and in some cases they prefigure the more formal illustration of late 13th- and 14th-century illuminated Gratians. They include a sword (fol. 16, Dist. XVII, c. v); church towers and churches (13, 24, 57); birds, particularly storks (96, 103, 117); profile heads, perhaps alluding to Manichean renunciation of marriage and children (24v, Dist. XXX, c. xiv); men cutting down a tree, probably referring to the discussion of brothers cutting trees (38v, Dist. L, c. li) (Pl. 1g); a mother with her dead child, related to the discussion of children who had been found dead after sleeping with their parents (77v, C. II, q. V, c. 20), a bishop squatting in his church with another bishop above, illustrating the text on bishops expelled from their sees (84v, C. III, q. II, c. 3); and a January-like scene of a supping clergyman, conspicuously absent from the church whose sanctuary is shown empty above, in reference to the absence of clergy on solemn feasts (95v, C. VII, q. I, c. 30) (Pl. 1h). Other images include a bishop in bed (97v, C. VIII, q. I, cc. 3–4), which becomes a normal feature of the illumination of this *Causa* in later manuscripts (Pl. 1j); a man with a winged hood, a fantasy figure common in late 13th century illumination probably with ironic or heretical connotations to 'those who set themselves against God' (109, C. XI, q. III, cc. 100–02) (Pl. 1k). Occasional examples of such illustrative drawing can be found in other early manuscripts,[3] but they are much more rare than random grotesques or humorous profiles, and the consistency of this set is exceptionally programmatic and visually effective.

Despite its limited painted decoration, this is a very fine early Gratian, given the high quality of its script, especially the red and blue decorative flourishing, as well as the sophistication of the vivid marginal drawings.

BIBLIOGRAPHY: James, *Sidney Sussex*, pp. 123–24 (attributing the tables to the 'first English annotator'); Kuttner, *Repertorium*, pp. 3–9, 24–25, 27, 29, 234; Schilling, '*Decretum Gratiani*', pp. 30–32; Pink, 'Decretum', pp. 247–48; Ker, p. 62 (Durham Cathedral); Schadt, pp. 144, 161, 180–81, 382, fig. 62.

RG

[1] See Nicholas Rogers, 'The Early History of Sidney Sussex College Library', *in Sidney Sussex College Cambridge: Historical Essays in Commemoration of the Quatercentenary,* ed. D. E. D. Beales and H. B. Nisbet (Woodbridge: Boydell, 1996), p. 84.

[2] Bentini *et al.*; P. Angiolini Martinelli in *Duecento,* pp. 143–44. The association of the murals with Bishop Enrico della Fratta who retired to S. Vittore in 1240 appears too late for the Prophets and St Victor, though not for the narrative scenes; however, the former may be archaic representatives of a well-established tradition.

[3] Bamberg, Staatsbibl. msc. Can. 13, fols 30, 35a, 46v, 61v, a Gratian with similar bird-beaks and barley sprays.

Cat. No. 2
Cambridge, Fitzwilliam Museum,
MS McClean 135

Gratian, *Decretum*

Manuscript, parchment, 252 + 1 fols, 362 x 225 mm, cropped at the head, written in parts in 4 columns including later glosses, 310 x 220 mm, the text itself 2 columns, *c.* 260 x 140 mm, in 8, fols 113–121 in 9 with fol. 119 added to the gathering, fols 146–149 in 4, fols 222–231 in 10, the 31st, 33rd and 34th gatherings missing, fols 250–252 in 3 of 6, the last 3 leaves cut back to stubs, and missing most of *De consecratione*. The gatherings have a roman numeration between dots at the centre of the foot of the first leaf. The original text appears to have been blind ruled; many of the glosses, including most of the *glossa* of Johannes Teutonicus, are on separate lines heavily ink-ruled. Pink gives the binding size, 410 x 250 mm, as the page size. Catchwords in the lower right corner are plain and unframed. The case appears to have been made for a larger volume, perhaps in the 17th century, and is labelled *CORPVS GLOSS JVRIS CANON. MSS/ TOM. JJ.* The manuscript has not been cropped: it preserves the pricking holes for its ruling. It has been sewn on tall flat bands at head and foot to adapt it to the larger case.

PROVENANCE: Fol. 1 records ownership of *Monaster. Wiblingensis*, the Benedictine monastery of Wiblingen, Würtemberg; the last guard leaf has a list of monastic names on the recto and a 16th/17th-century inscription *V.a/ Corpus Iuris Canonici* on the verso. It was formerly in the Phillips Collection, MS 1076, sale at Sotheby's, London, 27–30 April / 1–2 May 1903, lot 294; bought and bequeathed by Frank McClean (d. 1904).

TEXT: Italian, later 12th century.

The text is written in various small and fairly regular protogothic miniscule hands, probably Italian. It opens with the words of Gratian's text, *Humanum genus*, rather than the summary common in manuscripts of this early period. It lacks the opening to *Causa* XV. The *De consecratione* text is later and differently decorated; it breaks off at *'dist. i. c.liv'*.

The repeated reworking of the glosses suggests that the manuscript is early and circulated in the schools of Bologna before being taken to Wiblingen. The original gloss is of the earliest type, consisting of isolated comments on individual passages. It has largely been replaced with an incomplete copy of the *glossa ordinaria* of Johannes Teutonicus, supplemented on fols 141v–147v, 227–233v, 239v–249 with earlier material datable to Stephen Kuttner's third phase of the gloss, *c.* 1160–1215, and on fols 250–252 with another late addition of non-*ordinaria* material. There are additions of passages from the revised *glossa ordinaria* by Bartolomeo da Brescia, based upon Johannes's version, and from subsequent commentators. These are generally in a smaller version of the text script but rounder in shape and developing towards the *littera bononiensis*.

ILLUMINATION AND DECORATION: Probably Bologna or Emilia, possibly south Germany, late 12th century.

Small red and blue initial letters are variously set in the margin or into the text; those of the main text are in darker red and blue than the ones in *De consecratione* which are decorated with simple line of filigree in contrasting colour.

The illumination consists of animal and foliate letters set off against washes in pale green and darker turquoise or in darker blue with yellow and vermillion. The artist using the greener blues appears to be the predominant one, executing the opening and larger initials. His drawing is less firm and rhythmic than that of the second artist, who frequently emphasises plant rather than animal forms dominant in the first hand's initials. A third hand provided capitals with bright red filigree flourishing.

There is a tradition of coarse drawing with tinted washes in manuscripts from Bologna.[1] Illuminated law manuscripts with initials of

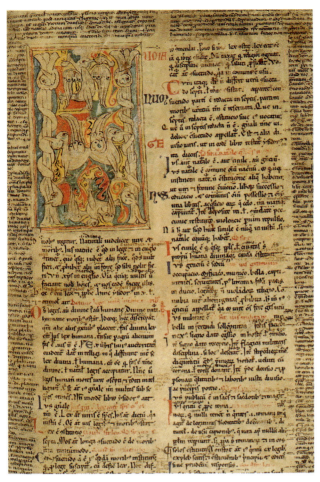

Pl. 2a. Fitzwilliam Museum, MS McClean 135, Gratian, *Decretum*, fol. 1: the opening of Part I

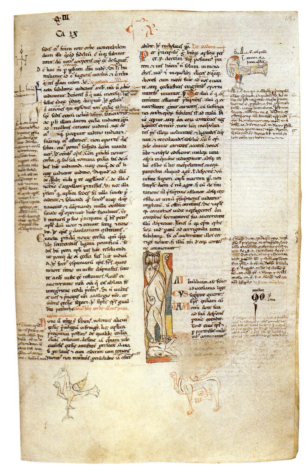

Pl. 2b. Fitzwilliam Museum, MS McClean 135, Gratian, *Decretum*, fol. 118: *Causa* X

irregular draughtsmanship drawing on Tuscan motifs may also be attributed to the city. However, these could have been inserted in Wiblingen: the majority of late 12th- and early 13th-century manuscripts from Bologna left the city without the initials being realized. Space for the major initials and often the rest of the opening words were normally left blank for the patron to have them completed at home.

The text begins on fol. 1, Part I: **H**[*umanum genus*], with the letter composed of stems or trees, double-headed snakes, and birds (Hand 1) (Pl. 2a).

Fol. 65, Part II, *Causa* I: initial **Q** inhabited by a pair of lions (Hand 1).

Fol. 82, *Causa* II: initial **Q** composed of snake-and stem-forms (Hand 2).

Fol. 96, *Causa* III: plant-form initial **C** (Hand 2).

Fol. 102, *Causa* IIII: red initial **Q** (Hand 3).

Fol. 104, *Causa* V: plant-form initial **I** (Hand 2).

Fol. 106, *Causa* VI: red opening word **Duo** (Hand 3).

Fol. 108, *Causa* VII: red initial **Q** and title (Hand 3).

Fol. 113v, *Causa* VIII: plant-form initial **I** (Hand 1).

Fol. 116, *Causa* IX: plant-form initial **S** (Hand 1).

Fol. 118, *Causa* X: initial **L** composed of a rampant lion standing on an animal head; two birds and a griffin in the margins, damaged by erasure (Hand 1) (Pl. 2b).

Fol. 121v, *Causa* XI: initial **Q** composed of biting animals (Hand 1).

Fol. 132, *Causa* XII: initial **Q** composed of biting birds (Hand 2).

Fol. 149, *Causa* XVI: initial **Q** composed of plant-forms and a biting beast (Hand 2).

Causae XIII, XIIII, XVII, XVIII have blank spaces; the heading for *Causa* XV is missing.

Fol. 167, *Causa* XIX: initial **Q** inhabited by an eagle (Hand 2 or an assistant).

Fol. 168, *Causa* XX: foliate initial **Q** (Hand 2 or an assistant).

Fol. 170, *Causa* XXI: initial **Q** composed of biting beasts (Hand 2 or an assistant).

Fol. 171v, *Causa* XXII: plant-form initial **E** (Hand 2).

Fol. 178, *Causa* XXIII: initial **E** composed of a bird and foliage (Hand 2).

Causae XXIV–XXXIII, initials not realized; *Causae* XXXIV–XXXV, frontispieces missing. Fol. 248v, *Causa* XXXVI: foliate initial **F** (Hand 2).

In addition to the initial letters of many *Causae*, there are numerous grotesque or purely decorative drawings scattered through the margins that are often more convincing in execution than the letters. They precede the later glosses which were written around them where necessary. The majority of the drawings show animals or birds with a few human heads. These include birds (8, 17, 23, 44, 66, 104v a), a fox (10), human profile heads typical of early 12th-century Italian legal manuscripts with oval eyes framed like a budgerigar's and long pointed beards (25), a double horse-head (30), a forest of pointing hands (31), foliate scroll (45), a twin bird-headed creature contemplating itself (68 and 90), a frontal head of a bearded man (96). Rather more elaborate drawings, often coloured, are scattered through the *Causae,* many of them birds or winged animals (e.g. 174v and 175). A pair of wings, a double-headed bird and a lion or griffin on fol. 109 have been coloured by the first of the illuminators in his typical yellow, red and dull green, as have the birds and griffins that accompany the initial on fol. 118.

Fols 178–217 are liberally decorated with marginal animals, though the initial letters to the *Causae* were not realized in this part of the manuscript: e.g. a griffin devouring a worm (200), a trio of animals (200v), a bearded head shown both frontally and in profile (209), and an animal devouring a human arm (213). These drawings appear, however, to be by the main decorator or by users of the manuscript with a similar training.

This is an anomalous manuscript. Its reworked glosses are normal for an early copy of this vital text, whose commentary needed to be current. The cost of a manuscript both in materials and writing made revision a better option than replacement. But the manner of its decoration, lacking any specific reference to the text, is also too crude to belong to a major artistic tradition that might securely locate its origin. The type of controlled marginal drawing in early Romanesque style found here is common, however, and may precede or coexist with the more illustrative drawings abundant in Sidney Sussex MS 101.

BIBLIOGRAPHY: Kuttner, *Repertorium*, pp. 3–9, 24, 105; Pink, 'Decretum', pp. 239–40; James, *McClean*, pp. 282–83, at no. 135.

RG

[1] Garrison, 'A Gradual', pp. 93–110.

Cat. No. 3
Cambridge, Corpus Christi College, MS 10

Gratian, *Decretum*

Manuscript, parchment, 363 fols, 434 x 282 mm, the text in two columns, 304 x 152 mm, with two columns ruled for glosses on either side, 310 x 54 mm, all firmly lead ruled with three pairs of horizontal rulings across top, bottom and centre of the text and gloss columns to control the line rulings, in 8s, numbered at the end of each gathering rather than connected by catchwords, the first in 5 of 8 with the first 3 leaves cut (probably lost guard-sheets and indices), the second 6 of 8 with the last 2 cut, probably before the text, fol. 363 reduced to the fragment completing the text; not written in parts.

PROVENANCE: A 15th/16th-century heading, *Decretum aurei D. Gratiani*, is on fol. 1. It was bequeathed to the College by Matthew Parker, Archbishop of Canterbury (1504–75), who generally acquired his manuscripts from English sources.

TEXT: Northern French or English, *c.* 1190–1200.

It is written in a well-spaced Gothic book-hand, *textualis rotunda*, with a similar, smaller hand for the glosses. Folios 1–11 open the manuscript with the summary, *In prima parte*, common in manuscripts of this early period. The gloss is of the earliest type, extended with numerous comments in triangular layouts by two hands contemporary with the text. The glosses are sparse, however, compared with later copies, though the whole manuscript, including the introductory summary, has been designed to allow generous provision for them. The glosses opening the *Causae* have *Continuationes* identical to the *Summa* of Paucapalea, an exceptionally early example of its incorporation into the gloss, noted by Stephan Kuttner.

ILLUMINATION AND DECORATION: Northern French or English, *c.* 1190–1200.

The prefatory summary, the opening of the text and each *Causa* opens with an illuminated initial, historiated or foliate. The initials to Questions and Distinctions, set tightly into the text, are in pale red and blue with leaf or feather filigree. The filigree also forms spectacular symmetrical cascades from the marginal inscriptions and other features breaking with trefoiled spikes. These seem coordinated with or dependent upon the illumination.

The style of the illumination has been associated by Nigel Morgan with the 12th-century tradition at St Albans and related manuscripts like the Copenhagen Psalter. Most other scholars have considered the illumination to be French. Michael Gullick has recently reported (in correspondence) that he considers the parchment and script to be English, and has drawn attention to another Gratian from late 12th-century Reading (London, BL, royal 9.C.III), previously said to be 'Paris origin'. The iconography shows the strong influence of the group of North French illuminated Gratians studied by Rosy Schilling: the former Dyson Perrins copy (subsequently Cologne, Ludwig XIV, 2; and Malibu, J. Paul Getty Museum MS 83. MQ 163) and others in Cambrai (Bibl. Mun. MS 967), Douai (Bibl. Mun. MS 590) and Troyes (Bibl. Mun. MS 103). Related manuscripts include Berlin, Staatsbibl. Lat. fol. 1; Paris, Bibl. Mazarine MS 1287; Vatican City, BAV, Pal. lat. 625, in which some of the figures are closer to the Bury-Canterbury Romanesque idiom than to the later French counterparts; Paris, BNF lat. 3884 and Siena, Bibl. Com. MS G. V.23,[1] attributed to the north of France. Schilling included the Cambridge manuscript within the French Channel group, but considered the Troyes copy, which has an early Clairvaux provenance, to have originated there and the Dyson Perrins copy to have been produced in Sens. She claimed a strong Cistercian interest in Gratian's text,[2] and the close affinity of all these manu-

scripts might reflect the copying of a common Cistercian or other monastic manuscript throughout the houses of the order.

Walter Cahn cites the Cambridge manuscript as an example of the influence of French production on that of England and Germany, while reserving judgement as to whether it is actually English or French. He distinguishes the Dyson Perrins copy and perhaps the Cambridge version from the rest of the Schilling group, and he rejects Schilling's suggestion that it was produced in Sens in favour of Carl Nordenfalk's view that they were all produced in Paris. Perhaps the clearest explanation for its design and artistic character is suggested by Christopher de Hamel, who, like Nordenfalk, compares it to the Parisian glossed copies of the books of the Bible. This model might explain the lavish provision for the Cambridge copy's very exiguous collection of brief glosses.[3] In this view the North French Gratians would be an academic Parisian production rather than a monastic one.

It is remarkable that these mainly French manuscripts dominate the early illumination of Gratian's text. The established early academic production of Bibles in Paris, where the fine illumination of religious manuscripts was probably already established, would provide a better explanation for this than the former attribution to an unspecific or Cistercian monastic tradition.

No similarly monumental programme of historiation can currently be associated with Bologna at this date, though the programme of historiated initials may have originated there: several less refined programmes of small initials, usually drawn rather than painted, survive in Italian manuscripts of the late 12th and early 13th centuries. The summary to a Gratian (BAV Ross. 595) and a *Codex* (BAV lat. 11598), probably produced in Bologna, have initials with biting masks similar to that of *Causa* IV in this manuscript, though they may simply reflect a common origin in Romanesque convention.[4] However, most of the earlier initials are characteristically foliate rather than historiated.

Pl. 3a. Corpus Christi College, MS 10, Gratian, *Decretum*, fol. 1: the opening of the Summary

The Corpus Christi Gratian has some of the richest narrative imagery among the Channel School group, though it shows a tendency, especially in the opening cases, to revert to foliage rather than figuration compared with the others, a trait Walter Cahn notes also in the Dyson Perrins copy. It is notable for its calm and majestic figures, belonging to the '1200 Style' with its light classicism in drapery treatment.

The Parts into which the *Decretum* is normally divided, even in many 12th-century manuscripts (Cat. Nos 1–2), are not structurally distinguished here; this may represent the beginning of different codicology traditions in Northern and Italian copies. The introductory summary, the opening of the Distinctions and each *Causa* has a single-column frontispiece

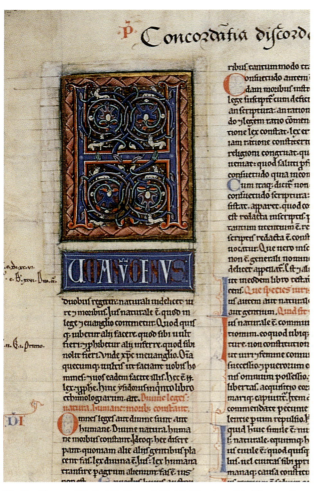

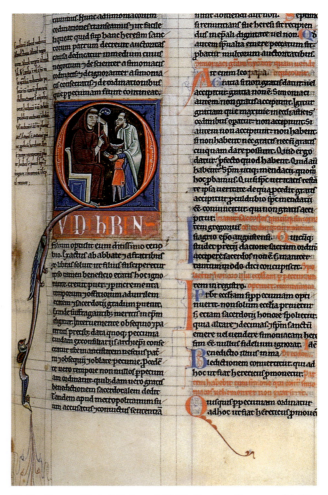

Pl. 3b. Corpus Christi College, MS 10, Gratian, fol. 12: opening of main text

Pl. 3c. Corpus Christi College, MS 10, Gratian, *Decretum*, fol. 92: *Causa* I, the simoniac admission of a minor to a monastery

composed of an initial, foliate or figured, generally with a painted panel below against which the rest of the opening word is illuminated in white.

Fol. 1, the introductory summary of early Gratians, *In prima parte agitur,* is introduced by a foliate initial **I** (Pl. 3a).

Fol. 12, Part I, *Distinctiones*: a one-column initial **H**[*umanum genus*] with foliate spirals and white lions (Pl. 3b). The two powers, pope and emperor, already widely represented in this initial by 1200 (e.g. the Troyes, Berlin and Cambrai manuscripts), are not represented.

Fol. 92, *Causa* I: the initial **Q**[*uidam habens*] contains a seated abbot, blessing a boy presented by his father along with a bowl of gifts (Pl.

3c). The case concerns the simoniacal admission of a minor to a monastery. The iconography may come from Italian sources (see Siena, Bibl. Com. MS G. V.23); the enthroned abbot is otherwise unusual. In the extraordinarily confrontational Dyson Perrins version he seems to wrestle with the child; in the Troyes, Berlin and Douai manuscripts he is standing, as in subsequent iconography.

Fol. 113, *Causa* II: a foliate mid-column initial at what becomes a major break in later Gratians. The related manuscripts illustrate the case, the accusation by a doubtful witnesses of a bishop charged with fornication.

Fol. 130v, *Causa* III: a foliate initial **Q**[*uidam episcopus*] with a tail composed of a dragon bit-

116

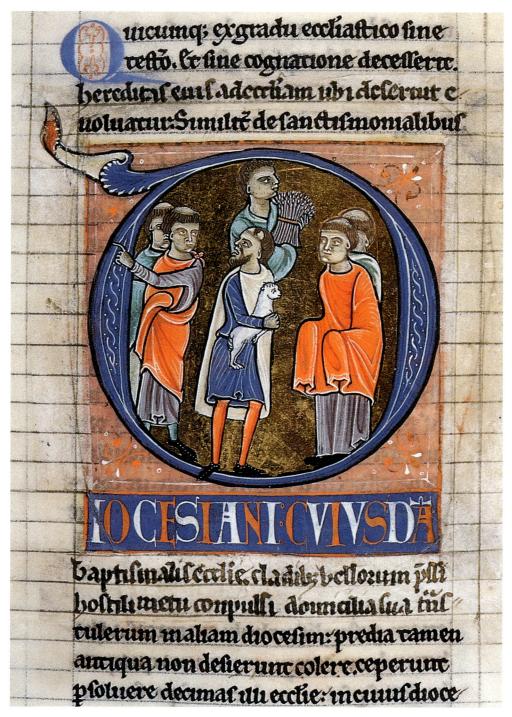

Pl. 3e. Corpus Christi College, MS 10, Gratian, *Decretum*, fol. 181: *Causa* XIII, disputed tithes

ten by a snake. Cambrai and Troyes have one or two seated bishops; in the Berlin copy a knight with shield defends himself from a lion.

Fol. 138, *Causa* IV: foliate initial with a lion and a snake; the Dyson Perrins copy has a man wrestling with a lion in the centre and a dragon forming the tail of the letter **Q**[*uidam in excommunicatione*], perhaps implying a demonic struggle; Italian copies show the bishop and his accuser.

Fol. 140, *Causa* V: a foliate initial **I** with human/leonine white masks and a green-headed monster (Pl. 3d). The Dyson Perrins copy also has a foliate initial; the Troyes copy, following a

common illuminators' convention, treats the **I** as a figure, the bishop of the case, which later becomes the standard iconography.

Fol. 142v, *Causa* VI: a bishop is charged with simony by notorious fornicators. He is shown enthroned, holding his crook, and arraigned by a pair of men of lower class. His larger size indicates his status; he is a classic figure of the English St Albans/Westminster style. The Dyson Perrins copy shows an aged bishop severely frontal and impassive; the Berlin, Douai and Troyes copies are close in design to the Cambridge manuscript.

Fol. 145v, *Causa* VII: a bishop suffering

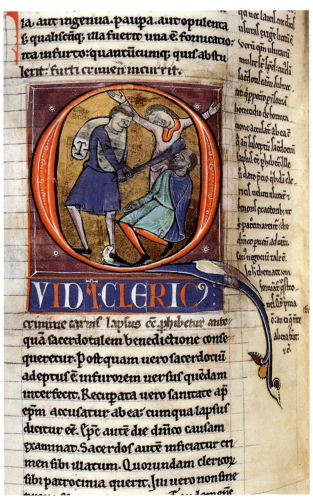

Pl. 3d. Corpus Christi College, MS 10, Gratian, *Decretum*, fol. 140: *Causa* V

Pl. 3f. Corpus Christi College, MS 10, Gratian, *Decretum*, fol. 187v: *Causa* XV, clerical murder

118

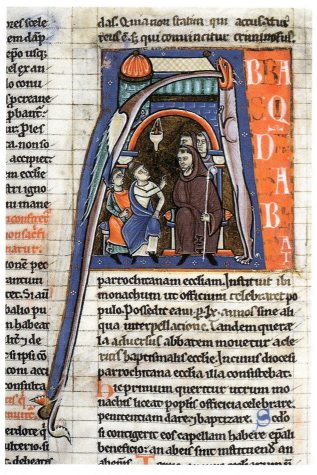

Pl. 3g. Corpus Christi College, MS 10, Gratian, *Decretum*, fol. 192: *Causa* XVI, a dispute between a monastery and parish clergy

the Cambrai, Douai and Berlin manuscripts tend to prefer narrative illustrations.

Fol. 181, *Causa* XIII: this case deals with tithes claimed by rival parish clergy. Two peasants holding a lamb (which looks like a lion) and a sheaf of corn are caught between two pairs of priests: those on the right hold out their chasubles to receive the offered tithes, while the leader on the left points back to his own church (Pl. 3e). Cambrai's version is very similar, while the Dyson Perrins copy has a bishop addressing a layman.

Fol. 185, *Causa* XIV: foliate initial as in the Dyson Perrins copy; Troyes' copy has two merchants before a bishop probably complaining of the clerics.

Fol. 187v, *Causa* XV, concerns clerical murder: a tonsured cleric strikes down a man with a club, while an animal head extending from the letter, perhaps representing his insanity, bites his ankle (Pl. 3f). The cleric's wide smile and displaced eye and eyebrow seem to be a later retouching in place of an abrasion in the centre of the illumination: such erasures are a common pietistic form of vandalism often applied to executioners. The Berlin and Cambrai manuscripts have similar imagery; the Corpus Christi manuscript differs in the space around the figures and their attitude. Clearly, the Cambridge, Berlin and Cambrai copies all used the same model. The Dyson Perrins copy reverts to a foliage initial at this dramatic point.

Fol. 192, *Causa* XVI relates that 'a certain abbot had a parish church and installed a monk there to celebrate mass for the people'. Eventually the clergy of the baptismal church for the parish brought an action against the abbot. The scene, framed by the letter **A**[*bbas*], is set within a church, under an arch, with its clerestory, belfry and dome depicted above, and shows the abbot with his brethren listening to a couple of clergy (Pl. 3g). This is one of the richest compositions of the manuscript, perhaps an indication of a special interest in the subject; the Troyes manuscript merely shows a seated abbot reflecting, while the Dyson Perrins copy has a foliate initial.

from a long illness requests a replacement, but then seeks reinstatement on recovery. The bishop lies in bed, while another bishop, presumably his replacement, stands over and blesses him; two grieving laymen stand at the head and foot of the bed. The Douai copy has a similar composition, though it is framed within a **Q**[*uidam longa invalitudine gravatus*]; where most copies omit the *Quidam*; the Dyson Perrins copy has a non-specific battle between a knight and monsters.

Causae VIII–XII are accompanied by foliate initials, often decorated with griffins, lions or snakes. The Dyson Perrins copy also contains foliate initials for most of these cases, whereas

Survey, I, no. 6, pp. 24, 52–53, ills 18–19; Cahn, *Romanesque Manuscripts*, I, p. 26, p. 35 n. 75, II, pp. 110–11; De Hamel, *Parker Library*, p. 34.

RG

[1] Melnikas, *passim*; G. Vailati von Schoenburg Waldenburg, in *Lo studio*, pp. 39, 97–100. Less close is London, BL MS Royal 9. C. III (Melnikas, C. I, fig. 16).

[2] Schilling, '*Decretum Gratiani*', pp. 36–37. Her claim that Bernard of Cîteaux was a personal friend of Gratian is unsubstantiated, given the lack of clear historical evidence for Gratian himself.

[3] De Hamel, *Glossed Books*.

[4] See, for example, the Barcelona copy of the first recension of Gratian's *Decretum*, Arxiu de la Corona Ripoll 78 (illus. as cover fig. on Winroth); the summary prologue of titles to the *Decretum*, Vatican City, BAV, Ross. 595 (Tietze, no. 83, MS IX 285, pp. 57–58); Melnikas, I, fig. I-1, III, Appendix I, fig. 3, pp. 1205–08; Assisi. *Libri miniati*, pp. 50–51, 83–88, figs XXXII–XXXIX, 49–55; and a very early, probably 12th-century, largely unpublished *Codex*, Vatican lat. 11598 (Dolezalek and van de Wouw, II, *ad loc.*). Vatican City, BAV Vat. lat. 11598 came from the Società del Gesù, also the owner of the Rossiana collection, and was illuminated by the same workshop as the Rossiana *Gratian*, originally from S. Francesco. It has a complete programme of grotesque illumination including an emperor incorporated into the initial to Book I; this seems to provide confirmation that this represents the mainstream of Bolognese illumination around 1200.

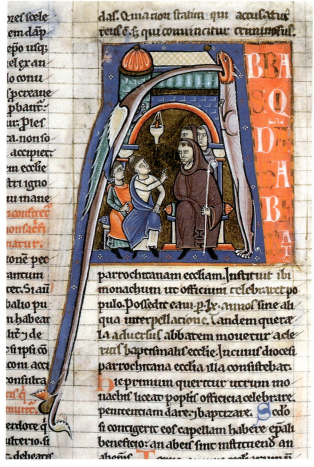

Pl. 3g. Corpus Christi College, MS 10, Gratian, *Decretum*, fol. 192: *Causa* XVI, a dispute between a monastery and parish clergy

the Cambrai, Douai and Berlin manuscripts tend to prefer narrative illustrations.

Fol. 181, *Causa* XIII: this case deals with tithes claimed by rival parish clergy. Two peasants holding a lamb (which looks like a lion) and a sheaf of corn are caught between two pairs of priests: those on the right hold out their chasubles to receive the offered tithes, while the leader on the left points back to his own church (Pl. 3e). Cambrai's version is very similar, while the Dyson Perrins copy has a bishop addressing a layman.

Fol. 185, *Causa* XIV: foliate initial as in the Dyson Perrins copy; Troyes' copy has two merchants before a bishop probably complaining of the clerics.

Fol. 187v, *Causa* XV, concerns clerical murder: a tonsured cleric strikes down a man with a club, while an animal head extending from the letter, perhaps representing his insanity, bites his ankle (Pl. 3f). The cleric's wide smile and displaced eye and eyebrow seem to be a later retouching in place of an abrasion in the centre of the illumination: such erasures are a common pietistic form of vandalism often applied to executioners. The Berlin and Cambrai manuscripts have similar imagery; the Corpus Christi manuscript differs in the space around the figures and their attitude. Clearly, the Cambridge, Berlin and Cambrai copies all used the same model. The Dyson Perrins copy reverts to a foliage initial at this dramatic point.

Fol. 192, *Causa* XVI relates that 'a certain abbot had a parish church and installed a monk there to celebrate mass for the people'. Eventually the clergy of the baptismal church for the parish brought an action against the abbot. The scene, framed by the letter **A**[*bbas*], is set within a church, under an arch, with its clerestory, belfry and dome depicted above, and shows the abbot with his brethren listening to a couple of clergy (Pl. 3g). This is one of the richest compositions of the manuscript, perhaps an indication of a special interest in the subject; the Troyes manuscript merely shows a seated abbot reflecting, while the Dyson Perrins copy has a foliate initial.

from a long illness requests a replacement, but then seeks reinstatement on recovery. The bishop lies in bed, while another bishop, presumably his replacement, stands over and blesses him; two grieving laymen stand at the head and foot of the bed. The Douai copy has a similar composition, though it is framed within a **Q**[*uidam longa invalitudine gravatus*]; where most copies omit the *Quidam*; the Dyson Perrins copy has a non-specific battle between a knight and monsters.

Causae VIII–XII are accompanied by foliate initials, often decorated with griffins, lions or snakes. The Dyson Perrins copy also contains foliate initials for most of these cases, whereas

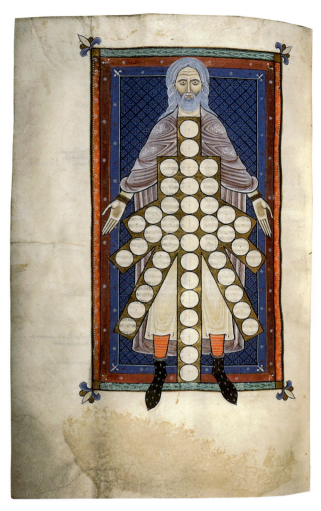

Pl. 3h. Corpus Christi College, MS 10, Gratian, *Decretum*, fol. 330v: Tree of Consanguinity

Causae XVII–XIX have foliate initials, some composed variously of dragons, snakes and foliage spirals. The Dyson Perrins, Berlin, Cambrai and Douai manuscripts have historiated initials for *Causa* XVII, the Dyson Perrins showing the priest on a sickbed, the others showing him leaning on a crutch. The Troyes copy has a historiated initial for *Causa* XIX.

Fol. 212, *Causa* XX deals with the rights of a novice to confirm or abandon the monastic vocation. Two novices are kneeling before their abbot, but the second at the back turns to his father who lays his hand on his shoulder to imply his re-acceptance back into the family,

while the abbot seated on the right blesses the other. The Berlin and Cambrai manuscripts have foliate initials with grotesque beasts, with Berlin copying *Causa* XII of the Troyes manuscript in which a knight holding a shield spears a human-headed dragon.

The initials to *Causae* XXI–XXVI are all foliate, like several of the other copies at this point. For *Causa* XXI, the Dyson Perrins, Berlin and Douai copies all have a version of the **A** found in *Causa* XVI of the Cambridge manuscript, which is composed by a lion biting a dragon. All the other copies are historiated at *Causa* XXII; the Dyson Perrins copy shows arguing bishops at *Causa* XXIII; the Berlin copy is historiated at *Causa* XXVI.

Fol. 268, *Causa* XXVII. The case deals with a woman who rejects her original suitor because of his vow of chastity. A young woman in the centre embraces her young husband who holds a broad-sword aloft on the right, while she fends off the agitated advances of her original fiancé on the left, now that he has rejected his vow of chastity. The Cambrai, Douai and Troyes copies show the same figures in an architectural setting and with a less marked contrast of gestures; the Dyson Perrins copy has a foliate initial.

Causae XXVIII–XXX are foliate, as in the Dyson Perrins copy. Other manuscripts, particularly the copies in Cambrai, Douai and Berlin have historiated initials for some of the cases.

Fol. 283v, *Causa* XXXI involves a cuckolded husband whose wife marries her seducer after his death and a dispute over the choice of husband for their daughter. An older man restrains a younger man laying his hands upon a woman who is embracing a third man, presumably the adulterer, his daughter and her two suitors. The Dyson Perrins copy has a foliate initial, the Berlin copy a centaur-like figure among foliage, but the chain of figures shown in the Cambridge manuscript is also found in the Munich version, Bay. Staatbibl. MS Clm. 17161, perhaps Italian, showing another source for the iconography of this group of manuscripts.

Causae XXXII–XXXIV are foliate as in the Dyson Perrins copy; several contain grotesques, lions, dragons, snakes and griffins. There is no separate display treatment for *De poenitentia*.

Fol. 326v, *Causa* XXXV: a widower marries a close relative of his deceased wife. A young bride is handed a bowl of food at table by her husband; below he and a servant lay his first wife into a grave. The Cambrai treatment is similar. The Dyson Perrins copy has the new couple together; the Berlin copy has an elaboration of the burial scene with a priest present. The Douai manuscript has a variant of *Causa* XII of the Troyes manuscript in which a knight holds a shield against a human-headed dragon, though without a defensive weapon.

Fol. 330v, contains a Tree of Consanguinity, showing a patriarch, Adam as the First Man perhaps (Pl. 3h). He stands with his arms outstretched to display the table whose circles lack inscriptions. The fine shading of his complexion matches the historiated initials of the manuscript, but his drapery is treated more archaically, as is often the case with these historiated tables, in the style of the Bury Bible and its English Romanesque followers. The Dyson Perrins copy has a broadly similar but more classicizing treatment of this table, with softly modelled draperies. It also includes the Table of Affinity, with a husband and wife holding branches and a seated patriarch below, and all inscriptions of the table are included.

Fol. 333v, *Causa* XXXVI concerns what is now called daterape. Above a youth entertains his fancy while servants on either side of the table hold out cups to her; below they lie in bed. The Dyson Perrins copy is confined to the supper scene, like most of the later interpretations.

Fol. 335, *De consecratione* is treated in the rubrication as *ultima pars* but only given a foliate initial as in the Dyson Perrins copy.

It can be seen from the comparisons above that none of the related copies is consistently close to the Corpus Christi Gratian in its treatment of individual *Causae*, though they undoubtedly share sufficient iconographical and decorative elements to form a coherent group. While the Dyson Perrins copy is closer to the Corpus Christi Gratian more often than the other members of the group, the non-specific figured motifs of one manuscript recur between the other members of the Berlin, Cambrai, Douai, Troyes group, clearly signalling their common origins. There are probably at least two degrees of recension between their programmes, therefore, which may argue for an insular origin of the Cambridge copy and a French origin of all the others. The rather square jaws, strong contours dominating the soft drapery folds, and the square-cut hemlines in the Cambridge manuscript are perhaps more characteristic of the English than the French manuscripts of the 1190–1220 period. Alternatively, they might represent a different and perhaps later Parisian workshop, given the importance of university production for all law texts and the considerable number of related manuscripts associated with Paris. However, conclusive evidence for the Corpus Christi Gratian is still lacking.

It is notable that scenes that would later become some of the more colourful episodes of the true picture cycles (C. XV, XXIII, XXVI) are still treated as abstract or grotesque initials in most of these manuscripts. Despite the artistic refinement of this manuscript, therefore, it is still far from the pictorial consistency of a less sophisticated 14th-century exemplar of the same text, like Fitzwilliam MS 183 (Cat. No. 6). Nevertheless, this group is of great importance for its artistic quality, superior to any other group of Gratian manuscripts of this date.

BIBLIOGRAPHY: James, *Corpus Christi*, pp. 30–31; Kuttner, *Repertorium*, p. 23; omitted from Pink's list; Boase, p. 280, pl. 92a; Schilling, 'Dectretum Gratiani', *passim*; *Mathew Parker's Legacy*, no. 17, pl. 17. Melnikas, at C. I, fig. 13; C. VI, fig. 16; C. VII, fig. 11; C. XIII, fig. 17; C. XVI, fig. 15; C. XX, fig. 12; C. XXVII, fig. 10; C. XXXI, fig. 10; C. XXXV, fig. 12; C. XXXVI, fig. 12. Nordenfalk, 'Review', pp. 326–28; Von Euw and Plotzek, pp. 41–48, figs 1–12 for the Dyson Perrins copy; Morgan,

Survey, I, no. 6, pp. 24, 52–53, ills 18–19; Cahn, *Romanesque Manuscripts*, I, p. 26, p. 35 n. 75, II, pp. 110–11; De Hamel, *Parker Library*, p. 34.

RG

1 Melnikas, *passim*; G. Vailati von Schoenburg Waldenburg, in *Lo studio*, pp. 39, 97–100. Less close is London, BL MS Royal 9. C. III (Melnikas, C. I, fig. 16).
2 Schilling, '*Decretum Gratiani*', pp. 36–37. Her claim that Bernard of Cîteaux was a personal friend of Gratian is unsubstantiated, given the lack of clear historical evidence for Gratian himself.
3 De Hamel, *Glossed Books*.
4 See, for example, the Barcelona copy of the first recension of Gratian's *Decretum*, Arxiu de la Corona Ripoll 78 (illus. as cover fig. on Winroth); the summary prologue of titles to the *Decretum*, Vatican City, BAV, Ross. 595 (Tietze, no. 83, MS IX 285, pp. 57–58); Melnikas, I, fig. I-1, III, Appendix I, fig. 3, pp. 1205–08; Assisi. *Libri miniati*, pp. 50–51, 83–88, figs XXXII–XXXIX, 49–55; and a very early, probably 12th-century, largely unpublished *Codex*, Vatican lat. 11598 (Dolezalek and van de Wouw, II, *ad loc.*). Vatican City, BAV Vat. lat. 11598 came from the Società del Gesù, also the owner of the Rossiana collection, and was illuminated by the same workshop as the Rossiana *Gratian*, originally from S. Francesco. It has a complete programme of grotesque illumination including an emperor incorporated into the initial to Book I; this seems to provide confirmation that this represents the mainstream of Bolognese illumination around 1200.

Cat. No. 4
Cambridge, Fitzwilliam Museum,
MS McClean 201.f.12

Gregory IX, *Decretales*, Book V,
De accusationibus
Bernardo da Parma, *Glossa ordinaria*

Manuscript, parchment, a cutting from a single folio, *c.* 400 x 280–300 mm originally, smaller than the original complete written area and cropped of most of its gloss, written in 4 columns, 310 x 205 mm, irregular, lightly or blind ruled, the text in 2 columns, 223 x 130 mm. Mounted with the recto as verso, X.4.20.5–8; 4.21–5.5 on verso, now forming the recto.

PROVENANCE: Frank McClean; bequeathed to the Fitzwilliam Museum in 1904.

TEXT: Italian, probably Bolognese, *c.* 1260–70.

The main text is written in a gothic hand showing some of the roundness and wide spacing of *littera bononiensis*; the gloss is in a smaller, squarer hand and a darker ink closer to the mature rotunda in layout, but with glossing script characteristics such as the closed italic '*a*'.

The gloss is keyed to the text with red underlining rather than the alphabetical sequence typical of Bologna. Underlining is normally a Transalpine practice, but the use of red, as here, is not. Since the rubrics seem to be written in a genuine Italian hand, they may record the manuscript's transfer to another university centre.

ILLUMINATION AND DECORATION: Bolognese, *c.* 1260–70.

Chapter initials are alternately red and blue with filigree of the Bible style of spirals and trailing palmettes. The rubrication followed the illumination, which was not an infrequent practice, perhaps due to the impatience or imperatives of the patron.

The frontispiece is in an idiom typical of early Bolognese Bibles and academic texts: it is a three-bay composition with the pope in a red tiara, or perhaps a bishop with a mitre, enthroned in an arched aedicule forming the central compartment (Pl. 4). He receives a plea from the leader of a group of clerics in the right compartment, while a lawyer or nobleman kneels with a plea before three secular companions in the left compartment. In 13th-century copies of the *Decretales*, Books II and V usually have relatively similar trial imagery.

The palette of copper green and pale umber is typical of the formative stages of the so-called 'First Style' of Bolognese illumination, though it would be more appropriate to associate it with Academic illumination, particularly before this was substantially influenced by the 'Second' or Paleologan Style of Bolognese manuscripts. The figures are clad predominantly in a red vermillion and a warm azurite blue matching the background. Their close-set eyebrows are shaded distinctly in bright blue; a brown shadow continues back along the top of the cheek to create a helmet effect, a mannerism typical of much Italian painting from 1250 to 1275. A similar treatment can be found in some of the opening leaves of the Bolognese Abbey Bible, *c.* 1260–65, the Paduan Epistolary of Giovanni Gaibana, 1259, and the Sienese *Madonna of S. Bernardino,* 1262.[1] The use of blue and vermillion or green and brown/pink with a rather free painting technique also recall the Bible of Lanfranco da Cremona (Oxford, Bodleian Library, Canon. Bibl. Lat. 56), dated to 1265.

The cutting is related to two other copies of the *Decretals*, Lucca, Bibl. Capit. MS 137, and Piacenza, Archivio Capit. MS 59, that Gigetta Dalli Regoli considered together. They share many iconographic features, as well as the 'helmet' shading of the brows and cheeks, with this cutting, and together they constitute a notable group of early *Decretals*. The Cambridge illuminator is probably the third hand in the Gratian at Princeton (University Library, MS Garrett 97), illuminated by Bernardino da Modena or his finest assistant and two other artists not associated with Bernardino.[2]

Allessandro Conti considered the second Master of the Princeton Gratian to have execut-

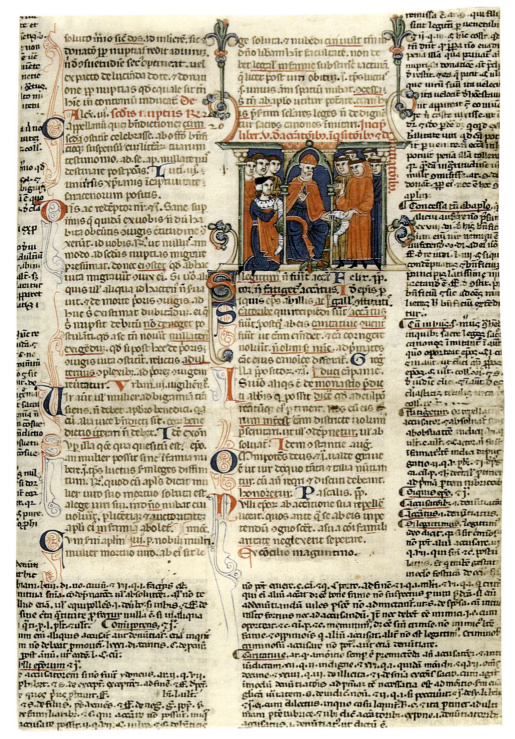

Pl. 4. Fitzwilliam Museum, MS McClean 201.f.12, Gregory IX, *Decretales*, Book V,
On Accusations, Inquisitions and Denunciations

ed the Piacenza *Decretals,* but his formation is much more classical in character than any of its artists. The third Princeton Master, responsible for the frontispiece to *Causa* XXI and this cutting, is clearly an altogether more conservative artist than the others working in the Princeton Gratian.

The figures in the Cambridge cutting and the Princeton *Causa* XXI have various similarities. They have much shorter, squatter bodies than related figures in the Lucca and Piacenza *Decretals,* favour green as a dominant colour in the setting and decoration and give prominence to lawyers' fur collars. The faces have a broad straight nose, rigidly set above a frowning mouth and wide round chin; the brows curve up from the nose around big eyes with dominant black pupils. The general appearance of the two pages is very different, however. The Cambridge cutting is a characteristic Academic Style production, while the Princeton frontispiece, with simpler bolder leaves to its foliate ornament and a hint of three-dimensionality in structures, reflects the grander patronage and more formal, classical qualities of both its major artists. The Princeton page shows the artist at a later stage of development.

The Piacenza frontispiece, which has a simple three-bay colonnade without the central arch, shows a layman being brushed aside in a grand gesture by the presiding bishop. Lucca MS 137 depicts a calmer hearing, framed under three arches, with towers rising between them into the margin above, a precocious feature.

The type of broad-featured face found in the Cambridge cutting recurs in a couple of the manuscripts associated with the Bolognese Dominican nuns of Sta. Maria Maddalena di Valdipietra: Museo Civico, MSS 517 and 518, choir books inscribed by them, and MS 514, a lectionary of finer quality but of less certain provenance.[3] The filigree decoration of the choir books shows them to be late, probably

after 1280, and conservative in style; seed circles replace the open forms of MS 514 and the Cambridge cutting. By this late date the style had also evolved into the simpler execution but with similar facial proportions found in the pictorially very different Turin *Infortiatum*, Bibl. Univ. MS E.I.8, where these Academic Style artists emulate the complexities of the Paleologan Style manuscripts of Jacopino da Reggio.

The McClean cutting is perhaps the epitome of a fair Bolognese academic illumination at the moment where book production and teaching converged. The script has the majestic breadth and clarity that unite Carolingian and Italian Gothic rotunda, while the illumination has something of the daintiness of French Gothic illumination enlivening the rather heavy forms of the Italian Romanesque. However, the relatively economic idiom with the vermilion, blue, green and brown palette of an academic workshop and solemnly rigid figures give the characters a *gravitas* appropriate to the law.

BIBLIOGRAPHY: James, *McClean*, p. 364

RG

[1] For the Abbey Bible, see most recently C. de Hamel in *Abbey*, lot 3013, pp. 31–45; for the Epistolary of Giovanni da Gaibana and related works, see Bellinati, *Gaibana*, and *Parole dipinte*, pp. 47–60. For the *Madonna of S. Bernardino*, attributed to Guido da Siena by most Italian critics and to a separate artist by Stubblebine, see among many other entries, Stubblebine, *Guido*, pp. 62–63; Torriti, *Siena*, pp. 22–23; White, *Duccio*, pp. 26–27. While the S. Bernardino Master is a leading protagonist of this mannerism, Guido da Siena is not; the change of idiom may reflect stylistic evolution but expressive differences between them suggest otherwise.

[2] Melnikas, *passim*; Conti, *La miniatura*, pp. 25, 39–40.

[3] Conti, *La miniatura*, pp. 26, 35, figs 22–23; and Medica, *Pieve*, pp. 9–11, though not dealing with this particular aspect of the Valdipietra style; see also Lollini in *Duecento*, no. 71, pp. 251–53.

Cat. Nos 5 a–j
Cambridge, Fitzwilliam Museum,
Marlay Cuttings It. 3–11

Gratian, *Decretum*
Bartolomeo da Brescia, *Glossa ordinaria*

Manuscript, parchment, 9 detached folios, various sizes 440 x 295 to 460 x 295 mm, written in 4 columns, 410–430 x 240–255 mm, the text in 2 columns, 150–290 x 160–165 mm. The folios have been mounted to display the frontispieces, not necessarily in their true relationship to the original manuscript: in these descriptions recto and verso refer to the original codex rather than the present mount.

PROVENANCE: Charles Brinsley Marlay; bequeathed to the Fitzwilliam Museum in 1912.

TEXT: Probably Bolognese, *c.* 1320.

The text and gloss are in a round *littera bononiensis*; the gloss is written in a slightly tighter script.

ILLUMINATION AND DECORATION: Bolognese, the Marlay Gratian atelier.

The chapter initials are alternately red and blue with contrasting seed circle and palmette filigree characteristic of the 'Second Style' and finer Bolognese manuscripts of the first third of the 14th century.

The *Causae* and *De poenitentia* have single-column frontispieces of moderate pictorial complexity, though of quite refined execution. These are extended by elaborate foliate sprays and full length marginal figures to form fairly rich opening pages to each section of the manuscript. The opening to the Distinctions and to *Causa* II may have had two-column frontispieces, such as those in two related manuscripts in the Vatican, BAV Vat. lat. 1368 and Vat. lat. 2492. A third copy from this group of illuminators in Venice, Bibl. Marciana MS lat. Z.175 (=1599), is somewhat simpler and only has single-column frontispieces.[1] Each *Causa* is divided into questions arising from the complexities of the case as put by Gratian and raising specific points of law. Each *questio* has an illuminated initial, generally containing a bust-length figure and enriched with foliate sprays for the text itself, and foliate for the gloss.

The closest affinity of the Marlay artists is with Vat. lat. 1368. Its third artist is present here, with an assistant able to reproduce his facial types accurately, and perhaps its fourth artist too. These three hands from Vat. lat. 1368 are probably the first and dominant hand of Vat. lat. 2492, as well as the second and third hands which illuminated the frontispieces for Part I (*Causa* I), and for Part II (*Causa* II) respectively in Vat. lat. 2492.

One may form some idea of the original frontispiece to this manuscript from that of Vat. lat. 2492 (Pl. 5k), which represents the iconography typical of a 14th-century Gratian; it replaces the separate representations of the pope and emperor in earlier copies, like Bamberg Staatsbibl., msc. Can. 14 (Pl. 1f), with a unified composition. Christ enthroned in Majesty gives the keys of the Church to the pope as St Peter's heir and the sword of temporal justice to the emperor as his viceroy on earth, accompanied or replaced by two volumes representing the two laws, canon and civic. Since this is a canon law text, the pope is at Christ's right hand, the privileged position. This composition can probably be traced back to the mosaics of Leo IX's triclinium in the Lateran Palace in Rome.[2]

Marlay Cutting It. 3: (recto) *Causa* II: 'A certain bishop is accused by a layman of sins of the flesh. Two monks, a subdeacon and two Levites testify against him. He feels the case against him to have been prejudged by his archbishop. Three of the witnesses against him, suborned by false promises or disproved by canonical examination, fail to hold up. The bishop is, however, deposed, because his crime is notorious' (Pl. 5a).

This is a single-column frontispiece to the opening of Part II; richer manuscripts, such as Vat. lat. 2492, have a second double-column

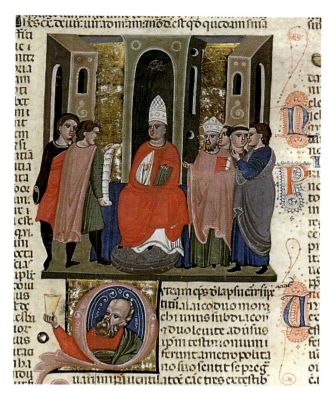

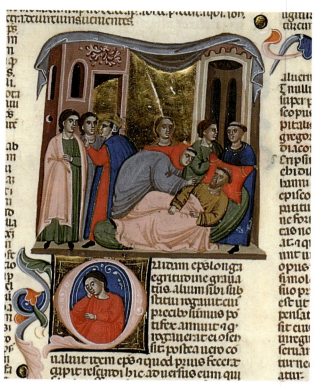

Pl. 5a. Fitzwilliam Museum, Marlay Cutting It. 3, Gratian, *Decretum*, *Causa* II: a bishop accused of fornication

Pl. 5b. Fitzwilliam Museum, Marlay Cutting It. 4, Gratian, *Decretum*, *Causa* VII: a bishop seeks a substitute because of ill-health

illustration. While the page here is elegantly and elaborately presented, it lacks a narrative focus. The pope is addressed by a petitioner and his companion; the rear view of the accuser is specific evidence of the influence of Giotto. On the right a bishop with a cleric and two other supporters respond. The scene is articulated by three towering structures depicted in the vertically receding perspective of the 13th century. An old man occupies the first text initial, a priest the second title initial. This is the work of the first hand of the Marlay leaves, the third artist of Vat. lat. 1368 or, more probably, a very close assistant.

Marlay Cutting It. 4: The recto shows a girl in the text initial and a bird-headed grotesque and two foliate initials to the gloss.

On the verso is a single-column frontispiece to *Causa* VII: 'A certain bishop worn down by long illness asked that another should take his

place. The supreme pontiff agreed to his pleadings and granted his request. The bishop recovered, however, and wished his request rescinded. He took action against his successor and demanded that his see be returned to him by right' (Pl. 5b).

On the left, a lawyer addresses a couple of bystanders; centre and right, a monk bends over a cleric lying in a bed (the bishop without any of the attributes of his office); a group of three people, including a cleric, stand above them. Given the emphasis on the pope's approval of his replacement, it is unusual that this scene shows neither a papal tribunal, nor a mitre upon the bishop's head. Although one would not expect a sick bishop to wear his mitre in bed, this is usually represented to distinguish this subject from other similar ones; clerical legacies and dispositions are the concern of several *Causae*. In Vat. lat. 2492 the second hand (probably the author of Marlay It. 3) includes the tri-

127

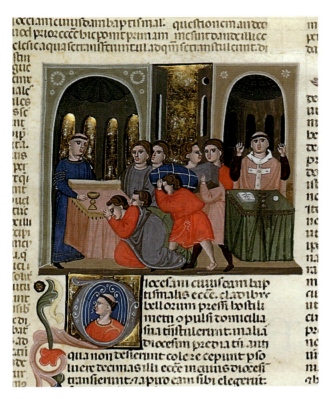

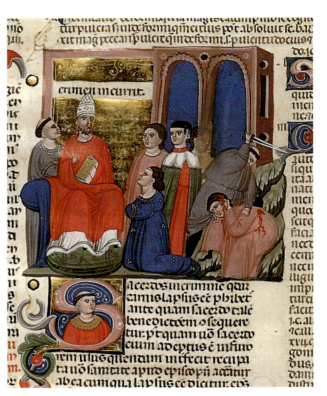

Pl. 5c. Fitzwilliam Museum, Marlay Cutting It. 5, Gratian, *Decretum, Causa* XIII: parishioners change churches, and their original parish seeks to recover their tithes

Pl. 5d. Fitzwilliam Museum, Marlay Cutting It. 6, Gratian, *Decretum, Causa* XV: a cleric commits murder

bunal but also shows the sick man without a mitre. The Marlay scene is framed by a pair of buildings with the Veil of the Temple over them, a stray from 13th-century Byzantinizing manuscripts into a scene otherwise governed by frontal pictorial space and Giottesque buildings. In the text initial is a sleeping girl.

This is by a second artist, perhaps the fourth hand of Vat. lat. 1368, whose work shows a more emphatic roundness to the heads, more obvious pallor in complexion and a tendency to exaggerate the width of the forehead. The vigorous but untidy foliate carving on the palace at left recalls the ornamented bridge on which a necromancing priest sits in *Causa* XXVI of the Vatican manuscript.

Marlay Cutting It. 5: On the recto is the initial to the last title of *Causa* XII depicting a young man; the gloss has a foliate initial.

On the verso is a single-column frontispiece

to *Causa* XIII: 'The parishioners of a baptismal church, harassed by the disasters of war and fear of the enemy, moved to another parish without abandoning their original lands, to pay tithes and to be buried there. Fifty years later the clergy to whom they formerly paid their tithes took legal action against the clergy to whom they now paid their tithes' (Pl. 5c).

The scene depicts the apses and altars of two churches. Four peasants, two bearing sacks, approach the altar on the left. They are received by a priest behind the altar, while four onlookers lead to the deserted church on the right, where its priest raises his hands above a well-furnished altar. The windows of his church are dark, while those on the left let the gold ground shine through. The central figure bearing a blue bale probably derives from Joachim and Anna's servant in Giotto's *Presentation of the Virgin in the Temple* in the Scrovegni Chapel. The text initials show a priest in profile and a youth.

This is the first hand of the Marlay leaves, probably an assistant to the third artist of Vat. lat. 1368.

Marlay Cutting It. 6: The recto has a man in a red hood in the text initial and a foliate gloss initial.

On the verso is a single-column frontispiece to *Causa* XV: 'A cleric was known to have lived in sin before being ordained as a priest. After his ordination, however, he killed a man in a fit of wrath. Recovering his sanity, he was accused by his former mistress' (Pl. 5d).

The pope on the left, with a priest in grey behind him, is addressed by a kneeling woman accompanied by a lawyer and another figure. On the right, the priest raises a short sword to strike a man seated on a rocky bank. Behind is a palace whose scalloped arches develop from a cable motif in *Causa* XXI of Vat. lat. 1368 by the same artist and are reduced to the scalloped pattern in the subsequent *Causae* XXII and XXVI by this and the other hands of the workshop.

The accusing mistress was originally represented a second time behind the murderous priest; she has been almost entirely erased, without extensive smudging, probably by the artist himself. On the other hand, her second depiction might have been erased by the owner or another legally trained mind to prevent confusion, since the two episodes of the case are not explicitly connected. This is, the first hand in the manuscript, perhaps an assistant to the third artist of Vat. lat. 1368.

Marlay Cutting It. 7: On the verso is a single-column frontispiece to *Causa* XVIII: 'A certain abbot who had brought much wealth to his house was consecrated bishop, and subsequently acquired many further riches. When his brothers sought a successor, the bishop wished to be involved in the election so that the new abbot should be ordained in the monastery by the bishop himself; the monks refused' (Pl. 5e).

A bishop is crowned by another to the left, while a third stands behind him. A row of clergy, perhaps his former monks, stand across the

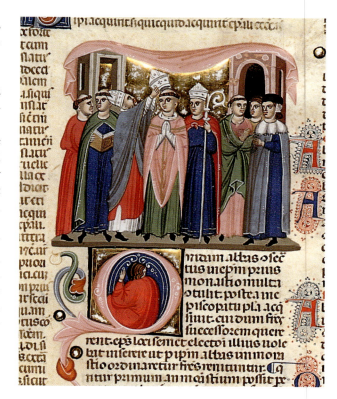

Pl. 5e. Fitzwilliam Museum, Marlay Cutting It. 7, Gratian, *Decretum, Causa* XVIII: an abbot consecrated bishop seeks to ordain his successor

scene behind them, with a lawyer on the right. The scene is framed by a pair of aedicules, perhaps standing for churches, with the Veil of the Temple draped across them. A green dragon addresses the scene from the upper right text margin; this is a distinctive motif common in Bolognese manuscript borders from 1280 up to 1325. The three text initials show two young men and a man seen from behind, a derivation from Jacopino da Reggio's Toledo Gratian widespread between 1295 and 1325. The third artist of Vat. lat. 1368 appears to have executed this and the next *Causae*.

Marlay Cutting It. 8: On the verso is a single-column frontispiece to *Causa* XIX: 'Two clergymen wished to transfer to a monastery; each requested permission from their bishop. One left his church without the bishop's approval, the other after renouncing his orders as a regular canon' (Pl. 5f).

On the left, a bishop is enthroned before a palace, represented by a high side window and open arches. A cleric standing behind the bishop is addressed by a bowing and a kneeling cleric. One of the clergy is welcomed on the right by a pair of monks. Their monastery, unlike the bishop's palace, is a relatively late example of clashing perspectives.

The vigorously shaded wings of the lion in the upper margin are characteristic of Bolognese illumination between 1315 and 1335, and associated in particular with the 1328 Master and the illuminator of the Padua Cathedral Antiphonaries, the major illuminators of this period. A figure seen from behind appears in the text initial. This is by the third artist of Vat. lat. 1368.

Marlay Cutting It. 9: The recto contains the text of *Causa* XIX; Marlay Cutting It. 8–9 are consecutive folios of the manuscript. The top

initials show a red-hooded man and a youth holding an amphora, a characteristic survivor of the classicism of Jacopino da Reggio and Nerio Bolognese. A third initial has a lively profile of a man in a green hood.

On the verso is a single-column frontispiece to *Causa* XX: 'Two youths were handed over to a monastery by their parents. One took the habit unwillingly, the other of his own choice. On reaching puberty the unwilling youth returned to secular life, while the other sought a more strict monastic regime' (Pl. 5g).

On the left a protesting child in dark blue is led away from the monastery by his mother and two companions, while in the centre the father presents the boy's brother to four monks and their bearded abbot who holds out the black habit. The first text initial shows another figure seen from behind, the second has a cleric in red. This is the work of the third artist of Vat. lat. 1368.

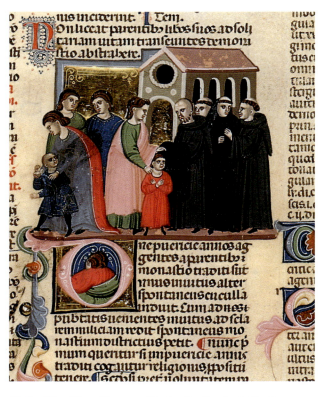

Pl. 5f. Fitzwilliam Museum, Marlay Cutting It. 8, Gratian, *Decretum*, *Causa* XIX: two clergymen transfer to a monastery

Pl. 5g. Fitzwilliam Museum, Marlay Cutting It. 9, Gratian, *Decretum*, *Causa* XX: a willing and an unwilling novice go their separate ways

Marlay Cutting It. 10: On the verso is a single-column frontispiece to *Causa* XXI: 'The archpriest of a certain church accepted ordination as the provost of another but refused to surrender his first living. He also agreed to act as procurator in secular business affairs. Dressed in inappropriately flashy attire he was disciplined by his bishop. He abandoned his office and sought refuge before a secular judge' (Pl. 5h).

The scene is set notionally within a palace. The pope is seated in the centre listening to a lawyer or layman on the right with the procurator of the abandoned parish and a group of clergy or hooded laymen. On the left, another group of clergy listen to his case: the foremost, who is aged and balding, is perhaps the pluralist archdeacon. Another hooded figure in green listens attentively from within the text initial. An aged bearded figure appears in the previous *quaestio* of *Causa* XX in the first column. This folio was illuminated by the third artist of Vat. lat. 1368.

Marlay Cutting It. 11: On the recto is a single-column frontispiece to *De poenitentia* (On Penance): a preacher in black addresses a congregation (Pl. 5j). The preacher is in a tall rectangular pulpit; his companion is sitting on the steps, his back to the crowd, while another seated figure in the text initial raises his hand to the group. Two church structures are shown behind the pulpit. A young man or woman occupies the initial to the second *quaestio*. This is the work of the third artist of Vat. lat. 1368.

This workshop is one of the finer Bolognese ateliers of the period around 1320, familiar from other, complete Gratians (Vat. lat. 2492 and Venice, Bibl. Marciana, MS lat. Z.175 [=1599]), as well as *Causa* XXXII of the Teplá Gratian (Prague, Narodni Knihovna Clementinum, MS Teplá 18, fol. 222v). The workshop also collaborated with the 1328 Master on the Paris *Digestum novum* and *Volumen* (BNF lat. 14341 and 14343). It appears to have formed

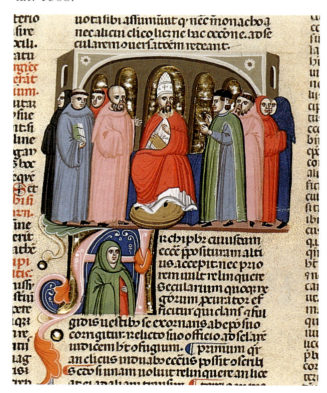

Pl. 5h. Fitzwilliam Museum, Marlay Cutting It. 10, Gratian, *Decretum, Causa* XXI: a pluralist archpriest is disciplined

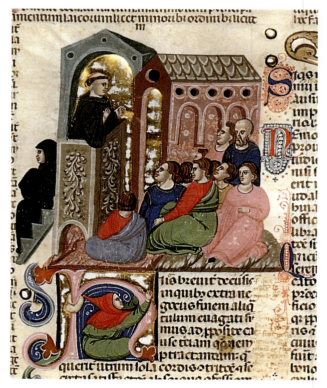

Pl. 5j. Fitzwilliam Museum, Marlay Cutting It. 11, Gratian, *Decretum, De poenitentia* (On confession)

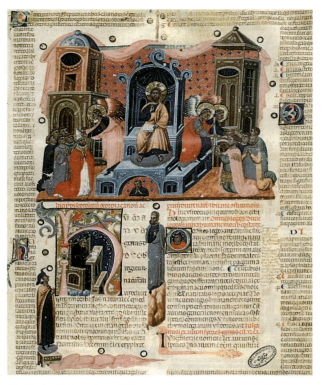

Pl. 5k. BAV, Vat. Lat. 2492, Gratian, *Decretum*, fol. 1: Part I, The Distribution of Powers

alongside and perhaps under the influence of the 1328 Master towards 1315–20, emulating his relatively complex architectural structures articulated with emphatic pilaster mouldings, Lombard banding (corbel-tables) and foliate relief, in which views of contrasting niches and windows in shady interiors provide a sense of pictorial space. The artists never acquired the geometric mastery of the 1328 Master's architecture. They remain consistently fond of draping the Veil of the Temple of the Paleologan illuminators across their Giottesque buildings for which it is hardly appropriate. This was probably inspired by the principal artist of Vat. lat. 1368, who is a very different and older illuminator, deriving his compositions and, albeit greatly simplified, his pictorial technique from Jacopino da Reggio.

The manuscript from which the Marlay leaves come was a less lavish undertaking than the Vatican copies. There appear to be two or three hands present: one responsible for Marlay Cuttings It. 7, 8, 9, 10; his close assistant for Marlay Cuttings It. 3, 5, 6 and a slightly different hand for Marlay Cutting It. 4. There is a considerable coherence in style and execution between the Marlay cuttings. It is likely that Vat. lat. 2492 is later than Vat. lat. 1368 and the Marlay leaves, and the same artists may be present in all three, though a number of mannerisms in their characterizations have become more marked. The assistant to the third Vat. lat. 1368 hand illuminated Marlay Cuttings It. 3, 5, 6. Marlay Cutting It. 4 is probably by the third hand of Vat. lat. 2492. The best of our three illuminators may be the leading illuminator of Vat. lat. 2492, but his palette has been greatly modified there; the bright reds and greens that dominate our leaves are largely replaced by pinks and blues in the opening frontispiece. It is striking that, although the figure types and architectural elements are shared among each of these manuscripts and participating artists, who form a more cohesive group than normal among Bolognese illuminators collaborating on a manuscript, their compositions are not repeated from Gratian to Gratian; there is even a sense of individual hands deliberately working on different frontispieces. In short, far from Bolognese illuminators working from cartoons like the exemplars of their associated scribes, they seem frequently to have preferred to reinvent familiar subjects.

BIBLIOGRAPHY: Wormald and Giles, *Descriptive Catalogue*, pp. 107–08.

RG

[1] For the other Vatican Gratian, BAV Vat. lat 1368, with major two-column frontispieces by a follower of Jacopino da Reggio, the Third Collegio di Spagna Master, and extensive contributions by these artists, see Melnikas, *passim*; Conti, *La miniatura,* pp. 65–66, 69–70, 74, figs 191–97; Kuttner and Elze, I, pp. 143–44, II, pp. 61–62.

[2] Melnikas, I, pp. 27–41; Waetzoldt, *Kopien*, p. 40, cat. nos 208–28; figs 120–22.

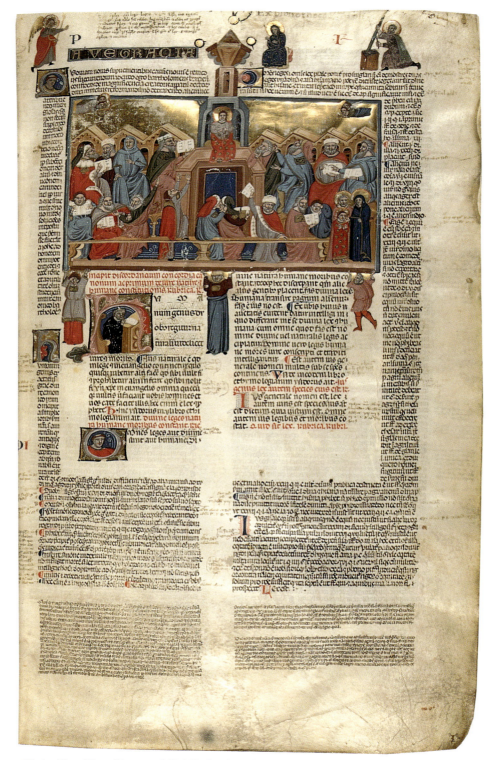

Pl. 6a. Fitzwilliam Museum, MS 183, Gratian, *Decretum*, fol. 1: Part I, Christ in the Temple

Cat. No. 6
Cambridge, Fitzwilliam Museum, MS 183

Gratian, *Decretum*
Bartolomeo da Brescia, *Glossa ordinaria* (with
 sigla of Laurentius)

Manuscript, parchment, 341 fols (339 + 274 bis
+ 291bis), 480 x 300 mm, written in 4 columns,
390 x 245 mm, the text in 2 columns, 270 x 170
mm, in 10s, Part I ending fols 91–99 in 9 of 10,
fol. 99v blank and the 10th leaf cropped; Part II
ending fols 270–274 bis in 6, fols 274–274v
blank; Part III ending fols 304–311 in 8; Part
IV ending fols 332–339 in 8, written (unusual-
ly) on smaller leaves 478 x 285 mm, originally
foliated by gathering; a *pecia* manuscript, 32
pecie to the gloss of Part II, 6 to the gloss of *De
consecratione* (5 to fol. 337v).

PROVENANCE: Part I ends with the inscription
dominus Hertmndus (Pink) or *Bertmndus* =
Bertrandus (Kuttner), either the scribe or the
owner (fol. 99); a 17th-century inscription, *Ex
bibliotheca V....li,* is on fol. 1; William Bragge,
engineer and antiquary of Sheffield; purchased
at his sale at Sotheby's, London, 7–10 June
1876, lot 149.

TEXT: Bolognese or North Italian, early 14th
century.

The text is written in a range of bookhands sim-
ilar to *littera bononiensis*, but more angular than
most Bolognese scripts. It is more informal than
the script used for major texts and closer to a
secondary academic script used for glossing and
for minor texts. The gloss in Part I is more
irregular than the text it accompanies; the
scribes may have exchanged roles in Part II.
Despite the insufficient space left for the initial
of the opening title (*Distinctionis* I) and the
asymmetrical column length on the opening
page, the regularity of the text block expected of
a Bolognese manuscript is generally main-
tained. A copy of a Gratian in Cesena (Bibl.

Malatestiana, S. II. I), although written by a
different scribe or based on another exemplar,
shows the same tentative script and suggests
that both manuscripts belonged to a milieu out-
side Bolognese production practice.

ILLUMINATION AND DECORATION: Bolognese *c.*
1320–30, by the B 18 Master (Second Master of
the S. Domenico Choir Books).

Remarkably, the rubrics, which are in a hand
similar to the text in Part I, were executed
together with the illumination. In some places
the illumination is smeared with red ink from
being laid against wet gatherings, though not
necessarily in textual sequence (e.g. fol. 61).
This suggests that a non-specialized workshop
produced the manuscript from start to finish.
Treatment of specific elements, such as the
papal tiara, beards and facial modelling, show
the involvement of three or four hands. The
range in technique may help explain why the
workshop of the B 18 Master was so successful:
its simple and easily imitated figurative style
facilitated rapid collaborative execution, econo-
my and swift delivery.
 Fol. 1, Part I: A major two-column fron-
tispiece opens the text (Pl. 6a). The main fron-
tispiece diverges strikingly from the normal
iconography of the period, including the B 18
Master's frontispiece for the Gratian in Cesena.
It shows Christ not as the mature God convey-
ing the twin laws of Church and State to pope
and emperor but as the twelve-year-old boy
conversing with the Doctors of the Temple. He
is seated on the podium normally reserved for
the Distribution of Powers and argues with
councillors and scholars, while at bottom right,
he is gathered up and taken home by his dis-
traught parents. The upper row of sedate law-
yers is derived from *Decretals* imagery and was
also adopted as the normal imagery for *Causa* II
of Gratian's *Decretum*. This is contrasted with
the lower bench, where the irate confrontations
of contemporary academics are equated with
the presumed ire of the Jewish elders over-
whelmed by the divine insights of the boy

Jesus.[1] This contrast is neither biblical nor typical in non-academic pictures of this subject.

The main illustration is surrounded with unusually disparate imagery. Above the text the Annunciation is represented, including the words of Gabriel. The old, haloed man, sharpening a pole with an axe, is presumably Joseph as a carpenter, and may be a reference to the wood of the Cross. Three different figures act as caryatids for the main scene. Gratian writes his book in the text initial, and a priest introduces the first of the questions into which the opening section is subdivided. The gloss has smaller illuminations: the first marks the importance of the opening with a figure of a priest, the rest consists of leaf motifs and reflect the economical treatment of the secondary parts of the manuscript.

This is the only double-column frontispiece in the manuscript. The illuminator's other known copies have two-column frontispieces at Parts I, II (*Causa* II) and III (*De poenitentia*) in the Cesena copy; and at Parts I, II (*Causa* II), III (*De poenitentia*) and IV (*De consecratione*) in Vatican Pal. lat. 623. (In the latter, however, a later artist associated with Stefano Azzi provided Parts III and IV, while the lesser frontispieces were unrealized). In each of these the first frontispiece depicts the Distribution of Powers, but the variety of their composition shows that the B 18 Master, while combining elements of the other copies, changed his view of the scene considerably.

Illuminated initials accompany the *Distinctiones* of the opening treatise on Church law. Each of the *Causae* has a single-column frontispiece and a large opening initial with a bust-length figure whose red and green clothing is an early example of the distinctive palette of the 1325–50s. The questions of the cases have illuminated initials with foliate designs to the gloss and with bust-length figures to the text, including priests, bearded and young men, civilians and occasionally a disembodied 'moon-face', a motif typical of 13th- and 14th-century Bolognese illumination. The titles into which each distinction and question is divided have

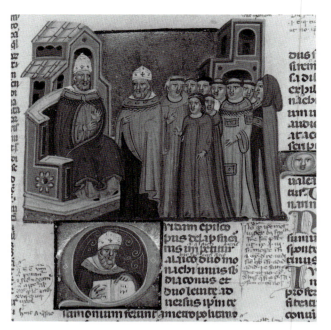

Pl. 6b. Fitzwilliam Museum, MS 183, Gratian, *Decretum*, fol. 100: *Causa* II, a bishop accused of fornication

alternately red and blue initial letters set into the text and enriched with 14th-century elaborated academic line and loop filigree in dull purple and red ink.

Fol. 78v, *Causa* I concerns the admission of an under-age child into a wealthy monastery through the payment of a bribe, but the artist has confused the case with *Causa* XX (Fig. 47). It shows a child grabbed by his mother while another is presented by his father in noble or academic dress to monks standing beside their altar under a simplified church. A similar representation appears for *Causa* XX by an assistant less concerned with stylistic refinement or the representation of a third dimension. This is the work of the Master or a close assistant.

Fol. 100, *Causa* II shows the pope enthroned and addressing a bishop accused of fornication (Pl. 6b). The bishop's accuser, a girl in blue, stands with a companion before a throng of clergy. While sometimes the sexual indulgence of the bishop is made more obvious, the more impartial treatment here is appropriate since the main concern of the case is the fair conduct of such an accusation. In the Cesena manuscript

135

the artist shows an accuser before the pope and the bishop arraigned before his archbishop; in the Palatine copy the bishop appears before the pope and another judge. The representation of the pope in many of these cases is a convention for a higher judicial authority, and on occasions is inappropriate, as in *Causa* V below. This is by the Master or a close assistant.

Fol. 117v, *Causa* III: This case concerns a bishop who loses his see, but because of the questionable nature of the accusations and of those making them he will eventually be reinstated. The scene shows the bishop, accompanied by a throng of clergy, who appeals to the pope to reinstate him. The action takes place in a minimal room supported by corner posts, not unlike Giotto's settings for many scenes in the Arena Chapel in Padua. However, the arbitrary addition of a great veil draped over the structure is derived from the finest Bolognese illuminators of 1270–1300, who transferred the depiction of the Veil of the Temple in scenes of the Annunciation and Presentation by contemporary Byzantine artists to other subjects. This frontispiece was illuminated by a rather more mannered assistant.

Fol. 125v, *Causa* IV: An excommunicated man and a fourteen-year-old boy accuse a bishop who refuses to respond to charges brought improperly. The artist shows two young clerics kneeling before the pope, while an older cleric, perhaps the accused bishop, without his mitre, turns away.

Fol. 128v, *Causa* V: A bishop condemned over a secret accusation brought in his absence is subsequently exonerated. A lawyer kneels before the pope with an accusation against a bishop, who is shown behind with a group of girls. On the right is his accuser, a man of infamy shown as a clergyman, secretly instructing the lawyer who is drawing up the accusation. The lawyer or scholar at his desk is a typical Bolognese figure in a wide range of legal and academic subjects. Since the bishop appeals successfully against being sentenced in his absence, it is inappropriate to show the pope, the ultimate authority, as the original judge of

the case. The instruction of the advocate is a typically vivacious invention of the Master.

Fol. 130v, *Causa* VI: The case involves two infamous fornicators who accuse a bishop of simony. A pope enthroned is addressed by them on the left, while on the right the bishop and his clergy listen to the charges. The pope perhaps represents the metropolitan of another province to whom the bishop wrongly refers the case.

Fol. 133v, *Causa* VII: A bishop suffering from long illness is replaced by a younger man, shown standing in front of the pope. On the right, the recovered bishop, sitting up in his sickbed, instructs a lawyer, with an altar and a priest behind him, to request his reinstatement.

Fol. 138v, *Causa* VIII: This case deals with a dying bishop who unlawfully determines his own successor. The bishop, shown bedridden appoints a successor who is duly elected through the patronage of friends. Though subsequently accused of simony, the new bishop is shown being crowned with his mitre behind his predecessor's sickbed and then standing before the pope. Since the last will and testament is a legal matter of universal concern, representations of a man lying sick are frequent in both civil and canon law. *Causae* VI–VIII are in the style of the Master but are probably by a faithful assistant.

Fol. 141v, *Causa* IX: A pope blesses two clerics kneeling before him, while another pair bring a bishop before him. It illustrates the case of an excommunicated bishop who has improperly ordained clergy within a different province and deposed others in his own. Such situations might often occur during the conflict between Roman popes and German emperors between the 12th and 14th centuries, given the national and local loyalties involved. The incoherence of the architecture and the old man's face suggest the work of a weaker assistant.

Fol. 144, *Causa* X: This is a rather vague representation of the dispute over a church withdrawn from episcopal control by its lay patron. The scene depicts a pope addressing a layman while two clergy address a civil judge. Usually, the bishop, who wrests the church back

into his control by force of arms, is depicted. The treatment of the faces suggests a hand different from that of the main artist and his assistant.

Fol. 147, *Causa* XI: A cleric sues another in a civil court, in violation of ecclesiastical prerogative. The pope addresses a cleric holding a long plea; behind him a pair of clergy address a civil judge. The cleric on the right succeeds in having his clerical adversary dispossessed by the civil judge but will be suspended from office by his bishop for doing so: recourse to civil courts was a major breach of Church discipline, since the medieval Church's immunity from civil or criminal process was a jealously guarded privilege. A bishop occupies the initial to the text. This and the next case were probably illuminated by the Master or the leading assistant.

Fol. 157, *Causa* XII concerns certain clergy who draw up wills bequeathing church property as well as their own, but the scene is conflated with *Causa* VII. It shows a mitred bishop in his sickbed accompanied by a sitting cleric and two companions, while two more clerics hand a plea to the pope seated before a curtain.

Fol. 167, *Causa* XIII regards a dispute over the tithes of parishioners fleeing their baptismal church in time of war. A soldier in vaguely Roman armour stands over a mother and child; two other women lay offerings on an altar attended by a priest. Often soldiers appear plundering the receiving church, or the congregation are shown carrying their chattels to it. An inferior assistant of the B 18 Master intervenes here, perhaps already responsible for parts of *Causa* X. The figures have slit-eyed triangular faces, cruder and less expressive than the Master's.

Fol. 171, *Causa* XIV: The involvement of canons in commerce and lawsuits to recover debts, raising discussion of usury and monetary interest, is the subject of this case. It shows the pope seated centrally and approached by two clergy holding a plea, while a lawyer and a girl look on. The same assistant exaggerates his own mannerisms, particularly in the priest of the text initial.

Fol. 174, *Causa* XV: Concerning a priest who committed a 'sin of the flesh' before his ordination and then murder, this case is more specifically illustrated (Pl. 6c). The weak artist of the preceding scenes shows the priest brandishing a bloody cudgel over his victim; a bishop seated under a large arch with gold ground listens to the mistress denouncing the priest. Gratian poses a wide range of conflicting issues on proper juridical procedure, the use of torture and the responsibility of the insane and the impenitent, in the context of clerical exemption from civil process and the death penalty, which was one of the most delicate issues for the Church in its dealings with the secular world.

Fol. 178v, *Causa* XVI concerns the conflict between an abbot's church to which he has appointed a monk as parish priest and the local baptismal church subject to the bishop. The scene depicts an abbot consecrating an altar while a priest celebrates mass at an altar behind him. The composition reflects Book III of the *Decretals* and *De consecratione* of Gratian's text. The weak assistant's use of grass green for the second altarcloth is a characteristic preference, where the B 18 Master uses a blue- or grey-green in this manuscript.

Fol. 192, *Causa* XVII: An ailing priest on his sickbed expresses the wish to become a monk and resigns his benefice, a decision he tries to reverse on recovery. The use of the same design for a church and a domestic scene shows this workshop's limited attention to representational precision.

Fol. 195, *Causa* XVIII: An abbot newly ordained as bishop wishes to be involved in the appointment of his successor to the abbacy; notwithstanding his success in enriching the house, the monks refuse. Rather effectively this is represented by a bishop and two clerics approaching a conspicuously abandoned altar table. The artist's rendering of space is less effective.

Fol. 197v, *Causa* XIX: Two clerics who wish to become monks, one against the will of his bishop, the other having renounced his canonry, are the subject of this case. They approach the

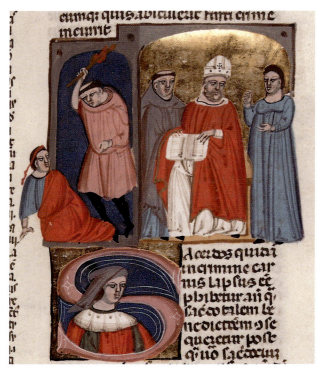

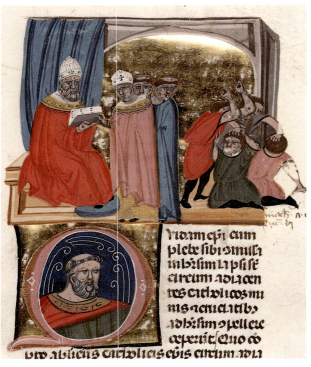

Pl. 6c. Fitzwilliam Museum, MS 183, Gratian, *Decretum*, fol. 174: *Causa* XV, the murderous priest

Pl. 6d. Fitzwilliam Museum, MS 183, Gratian, *Decretum*, fol. 209v: *Causa* XXIII, the execution of heretics

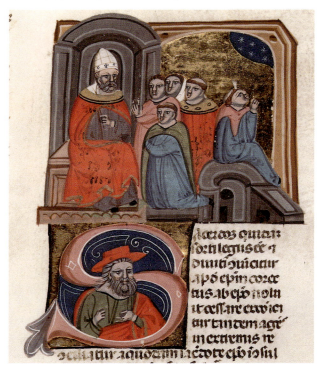

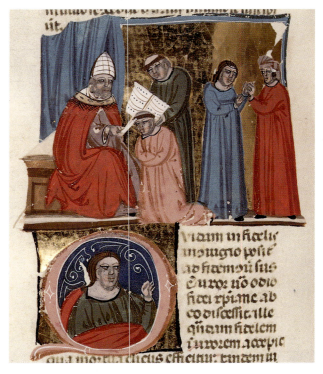

Pl. 6e. Fitzwilliam Museum, MS 183, Gratian, *Decretum*, fol. 240: *Causa* XXVI, a necromantic priest

Pl. 6f. Fitzwilliam Museum, MS 183, Gratian, *Decretum*, fol. 253v: *Causa* XXVIII, an infidel is converted to Christianity

pope, who holds open the book of laws. On the right, one cleric buries his head in his new monastic habit as three other monks look on. The simple frame, as in *Causae* XIV and XVIII, betrays a conservative artist, perhaps the weakest hand with the right-hand figures painted by a better one.

Fol. 198v, *Causa* XX: This is the case of two brothers who were made novices by their parents; one took the habit unwillingly, the other of his own choice. On reaching puberty the unwilling youth returned to secular life, while the other sought a stricter monastic regime. A mother bends over her reluctant infant fleeing a monastery while his proud father presents his brother to the monastery as a confirmed novice. The children are supposed by Gratian to have reached the age of puberty, while the illuminator (like many others) emphasizes their childish age.

Fol. 201, *Causa* XXI: A pluralist archpriest involved in secular business affairs and wearing flashy attire is disciplined by his bishop; he abandons his office and seeks refuge before a secular judge. The firm drawing and tonally contrasted planes in the architecture characterize a more experienced assistant. The pope is opposed to a secular judge on the right; a cleric with two companions stands between them, but his appeal to the latter will be unacceptable to the Church.

Fol. 202v, *Causa* XXII concerns a bishop who has committed perjury and compels his clergy to an oath of obedience. The artist here clearly confuses the iconography and shows a pope conducting the oath. The illumination has the assurance of the assistant's work in the preceding *Causa*.

Fol. 209v, *Causa* XXIII, one of the most momentous cases of the *Decretum*, concerns the violent acts of a heretical bishop and his community against their orthodox neighbours and the subsequent retaliation endorsed by the pope; the case then discusses the legitimate role of force in realizing Church aims (Pl. 6d). One of the bishops appears with his clergy before the pope; the massacre takes place on the right

where a couple of peasants club two others kneeling on the ground. As in the previous case, the illuminator's drawing is more convincing than the narrative interpretation.

Fol. 226v, *Causa* XXIV: A bishop, on the right, who has 'fallen into' heresy sacks some of his clergy; on the left they appeal to the pope. This rather low-key representation is not unusual, though the bishop's posthumous condemnation sometimes causes another sickbed to be introduced in the scene or a tomb in the initial. The weak assistant of *Causa* XIII illuminated *Causae* XXIV–XXV.

Fol. 236v, *Causa* XXV discusses the conflict between the clergy of a church and the monks, whose monastery is exempt from tithes, who have partially acquired the parish. The pope receives long pleas from two groups of clergy in monastic habits, each led by a kneeling brother in blue; the illuminator fails to distinguish between the two different parties. The range of colours for the habits of the two communities, pale blue, pink and grey or red, shows that in most Bolognese manuscripts, colour is decorative rather than descriptive.

Fol. 240, *Causa* XXVI discusses the prohibitions on sorcery and divination. Two priests and two women appear before the pope (Pl. 6e). On the right the priest, who has been convicted of fortune-telling, is shown gazing up at the stars and seated on a bridge over water, an image associated with necromancy. A tree with a bird is also often included, but the gazing priest is the crucial feature of 14th-century Bolognese treatments of the subject; previously the priest was shown holding an owl in a round glass bowl. This scene and the following are probably by the assured hand of *Causa* XXI.

Fol. 246, *Causa* XXVII opens ten cases concerning sex and marriage. A man vowed to chastity is rejected by his intended wife for another. The scene here shows the pope, right, looking on as the suitor points to his vow and is rejected by the bride; then in a different dress she is embraced by her new husband. A marriage, says Gratian, is constituted by mutual agreement, not by the deflowering of the virgin

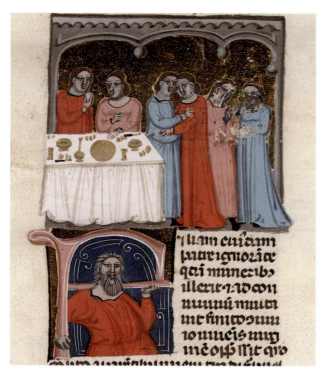

Pl. 6g. Fitzwilliam Museum, MS 183, Gratian, *Decretum*, fol. 310: *Causa* XXXVI, a young man invites his girl-friend to dinner

bride, but it is not constituted without sexual union.

Fol. 253v, *Causa* XXVIII: An infidel is converted to Christianity and is left by his wife who hates the religion (Pl. 6f). On the right his wife marries a new husband, shown wearing a prosperous merchant's long gown and hood wound as a hat. A scene on the left marks a later stage of the narrative, when, after the death of his second Christian wife, he becomes a cleric and is shown kneeling before the pope, who is cutting his tonsure. This and *Causae* XXIX–XXXIII are illustrated by the weakest hand of the manuscript. Unlike most of the earlier scenes this and the next are repeated quite closely in the Cesena manuscript, suggesting that the Master passed a model to his assistant and retained it for later use.

Fol. 256v, *Causa* XXIX concerns a noblewoman who agrees to marry the son of a nobleman but an impostor of servile rank takes his place at the marriage; she therefore seeks a divorce so she can marry the original suitor. A man kneels in suit before a noblewoman; on the right she is wedded to a man standing before a priest.

Fol. 258, *Causa* XXX discusses the results of exchanging two babies during their baptism. Two mothers, one holding her child, an old man and a younger man approach a priest bending over a font; the younger man receives a baby from the priest. The child the man receives is his own son, while his wife will receive the child of another by mistake, creating a series of improper spiritual relationships.

Fol. 261, *Causa* XXXI: Gratian's case involves a cuckolded husband whose wife marries her seducer, after her husband's death, and the disputed marriage of their subsequent daughter. A woman grabs a young man by the waist; an older man addresses a woman differently dressed, and the former woman kisses the hand of the first man, now in longer robes.

Fol. 263, *Causa* XXXII: The case involves 'a certain man who had no wife and married a sterile prostitute'. He seeks to have children with a servant, to have his wife raped and dismissed and to remarry a non-Christian. Gratian's case inspired the illuminator to a distinctly incongruous set of images. A young man jumps upon a lady, while another man and woman are conducting a union between two children, male and female.

Fol. 271v, *Causa* XXXIII: A man affected by witchcraft becomes impotent; his wife therefore takes a lover. Her husband regains his virility, but his wife has since married her lover. A man stands beside his wife; she embraces another man. The first husband recovers his virility and his wife, but turns from impotence to spiritual abstinence: to the right there is a curtain with a male figure making a gesture of rejection, flanked by the returned wife, centre, and another woman, probably again his wife expressing her dismay and rejection of him.

Fol. 275, *De poenitentia*: Gratian introduces a treatise on penance into *Causa* XXXIII. By the 14th century this is usually treated as a third major break in the manuscript, and its impor-

tance is signalled by the illumination's placement at the beginning of a new gathering. The scene depicts a bishop preaching from a pulpit to a group including a scholar or nobleman in miniver hood, while on the right a young woman is given confession by a Dominican. He sits outside the aedicule framing the scene and raises his hand to his head as if sitting in a confessional. The spirited gestures are typical of the Master. However, the formulaic and cursory setting suggests that this may be the work of an assistant (as in *Causa* III), given its marked contrast to the grander treatment in the Master's cutting (MS 400-2000, Cat. No. 7).

Fol. 303, *Causa* XXXIV: a woman's husband is taken captive; thinking him dead, she remarries, but he returns and seeks to reinstate his marriage. A captive is shown behind bars on the upper storey of a tower on the right. On the left he appears after his liberation, presenting a plea to the pope, while in the centre of the scene his wife and her new lover are shown embracing.

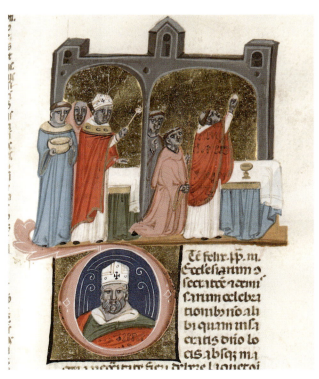

Pl. 6h. Fitzwilliam Museum, MS 183, Gratian, *Decretum*, fol. 312: *De consecratione*

Causae XXXIV–XXXVI are by another assistant of moderate ability.

Fol. 304v, *Causa* XXXV involves a widower who remarries, but his second wife is too closely related to his deceased wife, and he feigns ignorance of this. A bishop addresses a group of women and the husband gathered around the body of his first wife on a bier.

Fol. 310v, *Causa* XXXVI deals with what is now called 'date rape'. A young man and woman dine in a double-arched aedicule transformed by the artists into a palatial setting (Pl. 6g). In the middle of the scene the couple embraces; the subsequent marriage takes place on the left.

Fol. 312, *De consecratione*: This constitutes the fourth part of the 14th-century manuscript; the major break again begins a new gathering, but written on smaller leaves. On the left a bishop sprinkles the first altar, attended by an acolyte and another cleric; on the right a priest raises the host in celebration of the mass with two more clerics (Pl. 6h). It is the work of a distinctive hand close to the Master but whose work is distinguished by painting black eyes.

The *notname* we have preferred for this artist derives from a *Volumen* in Padua, Bibl. Capit. B 18; his alternative title, the Second Master, refers to the illuminated choir books of S. Domenico in Bologna.[2] He appears to have learned his art working with the Seneca Master (alias the First Master of the S. Domenico Choir Books), and their art not only has many similarities but occurs in related contexts; on at least one occasion they worked in succession on the same manuscript.[3] Their work is frequently confused with each other's, and occasionally, with that of other artists.[4] Susan L'Engle has pointed out the signature of Marco found in the Roermond *Volumen* (Gemeente Museum, MS 3, fol. 185v) partially illuminated by the B 18 Master (see Chapter 3). Unfortunately, no illuminator of this name has to date been discovered in the limited Bolognese documentation surviving for this period.

He is the most reductive, and possibly the

most productive, Bolognese illuminator of the second and third decades of the 14th century. Faced with the ruthlessly effective illustrative economy of this volume, M. R. James's description, 'Italian probably Florentine, the text better than the miniatures which are rough though clever and show in a striking way the inferiority of Italian work to that of France or England in the 13th century', epitomizes several of the reasons why both illumination in general and legal illumination in particular have failed to be given their due recognition. It is hard to object to James's rather patronizing term 'ingenious' for this cycle. The artist reduces complex and intense issues to a minimal pictorial language. The elegantly drawn figures of the Northern Gothic style whose dainty gestures suggest a remote world of refined manners are replaced with a strong sense of the immediacy of the action and the reality of a heated legal conflict. This manuscript invites comparison with the other copies of Gratian's *Decretum* attributed to the B 18 Master, those in Cesena and the Vatican, mentioned earlier. Elements of Paleologan Style architecture in some of the scenes and the absence of the foliate backgrounds suggest that the Cambridge manuscript is the earliest of the three.[5] In the Cesena manuscript the B 18 Master's associates responsible for most of the initials and the later *Causae* are not from his own workshop, unlike the several very weak hands in this manuscript.

The extraordinary range of assistants is a significant feature of the Cambridge manuscript. It would appear that the Master had a close associate working on the opening twelve *Causae* and from *De poenitentia* to *De consecratione*. Another assistant was responsible for *Causae* I, XXVI, XXVII; a weaker hand executed parts of *Causa* X, and *Causae* XIII–XX, XXIV–XXV. The secondary initials in gatherings 5 and 7 (41–50, 61–70) were the work of a fine assistant. A most inexperienced assistant illuminated gathering 10 (91–100) and the frontispieces and gatherings of *Causae* XXVIII–XXXIII.

The vast quantity of illustration and decoration needed in a fully illuminated Gratian normally required the efforts of several artists. Occasionally a small group of artists with similar or compatible styles are consistently found working together: the workshop responsible for the Marlay Gratian leaves, the Marciana Gratian and another Gratian in the Vatican (BAV Vat. lat. 2492) is a good example. But more often the work is quite disparate as in the Marlay atelier's Gratian BAV Vat. lat. 1368. The involvement of a single artist, found in the Paris Gratian (BNF, nouv. acq. lat. 2508), is rare. In the Fitzwilliam Gratian the artist responsible has a team of closely related assistants but with recognizably different limitations. Given their entire dependence upon his artistic idiom and the modesty of their contributions, it is very likely that they were members of his family or personal servants.

BIBLIOGRAPHY: James, *Fitzwilliam*, pp. 388–91 as *'Decretals'*; Kuttner, *Repertorium*, pp. 105, 116; Pink, 'Decretum', pp. 235–36.

RG

[1] Though certainly untrue, the legends that the great legist Azo killed Hugolinus and that Accursius had him banished indicate the ferocity of the rivalry between the Bolognese masters and their followers; Bellomo, p. 169.

[2] Barzon, no. 26, pp. 28-29, pl. XXIX; 'Manoscritti italiani' in Abate and Luisetto, *Codici e manoscritti*, no. 177, p. 725, figs 39–40; D'Arcais, 'Le miniature'; D'Arcais, 'Manoscritti giuridici', pp. 249–54, with extensive reproductions of the comparable Cesena Gratian illuminated by the B 18 Master; Alce, *La biblioteca*, pp. 160–69, and pls opp. pp. 96–97, 112–13; Canova, *Fondazione Cini*, pp. nos 6–25, 3–16, figs 6–25; Canova, 'Nuovi contributi', pp. 371–93; Gordon, 'Calendar Cycles' (New York, Pierpont Morgan Library M 511: *Dominican Calendar*); Pächt and Alexander II, no. 122, p. 13 (*Decretals* frontispiece); J. Langenzaal in Cassee, 'La miniatura italiana in Olanda', pp. 164–67, with a preliminary catalogue of works; Peintner; *Neustifter Buchmalerei*, pls 39–40 (Durandus, *Speculum*); Gibbs, 'Bolognese Manuscripts in Bohemia', pp. 73–74, fig. 15 (St Ambrose, *Commentaries*); *Miniatura a Brera*, nos 22–23, pp. 152–67 (Jacopo Bottrigari, Dante, *Paradiso*).

[3] Vatican BAV, Vat. lat. 5929, a *Liber Sextus* with frontispiece and initials by the Seneca Master combined with a *Clementines* with initials by the B 18 Master.

4 See a series of roundels of similar size: a tondo of *St John* by the Seneca Master (Sotheby's, *Western Manuscripts*, London, 17 December 1991, lot 24); two *Genesis* tondi by the B 18 Master (Bober, *Mortimer Brandt Collection*, no. 14, pp. 33–34; Fliegle *Blackburn Collection*, nos 10–11, p. 18); four by the B 18 Master from the John Pope-Hennessy Collection wrongly given to the First S. Domenico (Seneca) Master: *St Peter Martyr Preaching* and three other scenes of perhaps the same martyr (Hindman and Bollati, no 3, pp. 16–17); the Martello *Adoration of the Magi* from a Choir Book by the B 18 Master is attributed to the very different 1328 Master (Boskovits, *Martello*, pp. 114–15; Christie's, *Valuable Manuscripts*, London, 24 November 1993, lot 4).

5 A manuscript particularly close in style to the Fitzwilliam Gratian is the Jacopo Bottrigari, *Lectura digesti veteris* (Milan, Bibl. Naz. Braidense AE XIV 15), which shares its simple arched frame at the opening and the same team of assistants for the secondary frontispieces; G. Vanoli in *Miniatura a Brera*, no. 22, pp. 152–57.

Cat. No. 7
Cambridge, Fitzwilliam Museum,
MS 400-2000

Gratian, *Decretum, De poenitentia*

Manuscript, parchment, a cutting from a single folio the width of the two-column text, 101 x 182 mm, mounted.

PROVENANCE: An accompanying typescript indicates a Zurich provenance; purchased at Sotheby's, London, 5 December 2000, lot 12.

TEXT: A fragment of the *De poenitentia* beginning *Sin autem aliquid quoquo modo in quadam machinatione...* (Dist. I, c. 7).

ILLUMINATION: The B 18 Master (Second Master of the S. Domenico Choir Books), *c.* 1325–30.

This is the frontispiece to the *De poenitentia* (On Penance) of a lavishly illuminated copy of the *Decretum Gratiani* (Pl. 7). The scene shows a bishop preaching and a Dominican giving confession to a woman on the right. The iconography is typical for this subject. It is found in other copies of the *Decretum Gratiani* illuminated by the artist, notably in the Fitzwilliam copy, MS 183 (Cat. No. 6), although that has a single-column frontispiece with a schematic setting behind the main action.

The cutting's quadripartite vaulting was probably inspired by Giotto's illusionistic chapels painted on the flanking chancel walls of the Arena Chapel in Padua. There is clear evidence that several major Bolognese illuminators, including the 1328 Master who dominated Bolognese illumination in the 1320s and 1330s, knew Giotto's frescoes. They also knew those in the Lower Church at Assisi showing the Presentation in the Temple, and Christ and the Doctors, which is the most likely alternative source for this complex Gothic architecture among Giotto's surviving works. A hint of uncertainty in the representation of such structures is shown in the conflicting perspective of the towers that flank the three main gables and the unvaulted spaces below them. The blue band suggesting an altar-cloth in the bay furthest on the right is derived from the scenes of churches and sanctuaries common in other copies of Gratian's *Decretum*. A blue ground appears below the pulpit to the left but the dominant gold ground reaches to the floor of the central bay: these inconsistencies show the dominance of pictorial conventions even when the artist is at his most attentive and creative.

The B 18 Master's other complete copy of this text is in Cesena, Bibl. Malatestiana, S. II. I. It has a major two-column treatment like this cutting, but it is further developed, with its architectural setting formalized into a series of separate structures. Its illumination is enlarged to occupy the full text borders and introduces a gold foliage scroll, features suggesting a date in the late 1330s or 1340s. The pulpit is moved to the far left, with a curtain now hanging as a tester from the picture frame. Below, the seated Dominican is accompanied by a standing Franciscan who also addresses the congregation. Behind the congregation and the confession, complete churches appear on a background divided into gold and foliate compartments. This treatment is clearly a development of the same ideas as the Fitzwilliam cutting, but losing some of its vitality of characterization and the clarity of its setting in the process.

The prominence of Dominicans in this artist's presentation of Penance is surely not only a reflection of their role as penitential preachers but also of his close association with them. Since we have at least three different copies of choir books with the Feast of St Thomas Aquinas illuminated by the B 18 Master, he was clearly active in Dominican commissions in Bologna around the time of Aquinas's canonization in 1323. The feast was inserted into the S. Domenico copy that the artist was already working on (see Cat. No. 6).

The Fitzwilliam cutting is a particularly sophisticated composition for the artist. Its measured grouping of figures and expressive faces and gestures show his art at its most effective, while

its simplifications add a cartoon-like vitality to
the most serious of subjects.

BIBLIOGRAPHY: Sotheby's, *Western Manuscripts,*
5 December 2000, lot 12.

RG

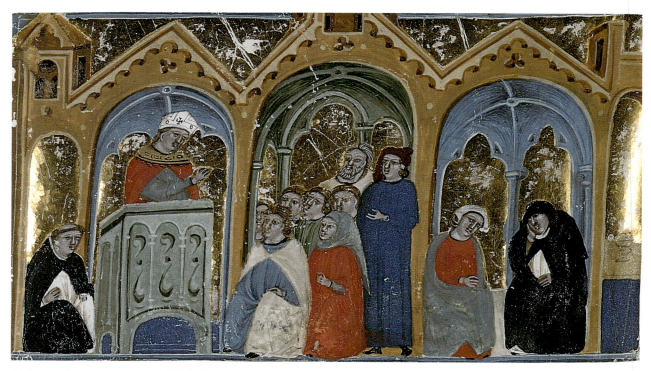

Pl. 7. Fitzwilliam Museum, MS 400-2000, miniature by B 18 Master (Marco Bolognese?): *De poenitentia*

Cat. No. 8
Cambridge, Fitzwilliam Museum, MS 262

Gratian, *Decretum*, incomplete, Part I, *Causa* XXXIII–end (Ruskin's Gratian)

Bartolomeo da Brescia *Glossa ordinaria*, incomplete, Part I, *Causa* XXXIII, q. ii, c. viii, *litigare*

Manuscript, parchment, incomplete, in 12s, i + 174 fols, 435 x 285 mm, written in 4 columns, 300/370 x 240 mm where glossed, the text *c.* 240 x 155 mm, in 12s, ending in 6 on 173v a, the last leaf a guard-sheet integral to the gathering with a couple of 14/15th-century notes; lightly pen ruled for the columns, blind ruled for the text; missing many gatherings, including Part I, Distinctions LI–LXX, XCVII to the end of Part I and most of Part II. A German 16th-century pigskin binding with a half-length stamped portrait of Luther close to Cranach's type (Wormald and Giles), subsequently rebacked.

PROVENANCE: There are illegible owner's marks of the 14th or 15th century, erased, on fol. 174. Formerly owned by John Ruskin, whose Brantwood bookplate survives on the inside cover. Purchased in 1902 from Alexander Denham & Co, cat. no. 67.[1] Ruskin's acquisition of the manuscript is unrecorded.

TEXT: French, *c.* 1300.[2]

The text is in a very regular hand emulating the round *littera bononiensis*. The gloss is in a variety of hands; the first is close to Bolognese gloss hands, but others are very irregular. The 12-leaf gathering structure, however, is French or English; the alphabetical keying of *lemmata* found in Bolognese manuscripts is absent except for a random appearance on fol. 7v, presumably due to a later owner. The half-page allowance for frontispieces to all the *Causae* is unprecedented in Italian or Southern manuscripts. The absence of a break at *De poenitentia*, normally constituting a Part III with a

major frontispiece in Italian manuscripts by 1300, surely indicates that it is a Northern manuscript. The scribe omitted most of *Distinctiones* LXXXIII–LXXXIV, and failed to leave spaces for the initials of numerous other *Distinctiones*.

DECORATION: French, 14th century.

The secondary chapter rubrics have alternating red and blue initials more evidently Northern than the text, with fine purple and red spiral filigree. Its small scale is characteristic of 14th-century Southern French manuscripts, though it is rather looser and simpler in its loops and spirals than normal.

ILLUMINATION: England, *c.* 1310–30, related to the Tickhill Psalter group of manuscripts.

The narratives of the opening frontispiece are set under trefoiled Gothic arches with spandrels alternately blue and pink or vermillion and contrasting diaper backgrounds; this arrangement is continued for the simpler four-part frames of the other frontispieces, though with increasingly irregular arches.

In addition to the frontispieces, a large foliate initial opens each Part or *Causa*, and smaller foliate initials open each Distinction or Question. Their leaves in rust and green shaded with white highlights is characteristically early 14th-century English. The gloss has initials clearly inspired by Bolognese folded leaf patterns in a distinctive palette of light and dark blue, crimson and pink, with gold leaf at the centre. However, its busy white lobing and spines of white ringlets are characteristic of the Tickhill Psalter group prominent in English legal illumination and appear also in the text initials.

Fol. 1, Part I: Instead of the usual representation of the Distribution of Powers or a ruler, there is a large two-column frontispiece subdivided into six scenes depicting the Fall of Man. In the top row: the Creation of Eve, the introduction to the Garden of Eden, the Eating of the Apple; in the lower row: God reprimands

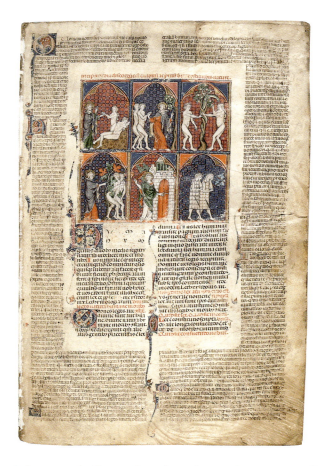

Pl. 8a. Fitzwilliam Museum, MS 262, *Decretum Gratiani*,
fol. 1: The Fall of Man

Adam and Eve; the Angel at the gates of Paradise, the expelled couple leave Paradise. Since sin is a central issue in Church law, and Gratian's opening words can refer to divine rather than natural law, the choice of subject is not inapposite, but it is highly unusual. Anthony Melnikas provides modest examples of the Creation in Douai, Bibl. Mun. MS 588, and Barcelona, Archivo del al Corona de Aragon, MS S. Cugat. 8; and as secondary decoration to the frontispiece of Brussels, Bibl. Roy. MS 7451 (2564). None of these, however, are close to the large scale or the refinement of the Fitzwilliam manuscript, let alone its emphasis upon the sexuality of Adam and Eve (Pl. 8a).

The figures are tall and slender, with particularly small heads, confidently and elegantly drawn within stronger flowing contour lines in black; the flesh tone is created with an even layer of white body colour. The mantles of God

and the angel fall in broad folds breaking into tighter pleats at the waist, which are quite strongly modelled in body colour. The intense expression of the archangel and the broad miniver-patterned furs worn by the expelled Adam and Eve in the final scene are a feature of English illumination, notably the De Lisle Psalter, a Westminster manuscript of the early 14th century.[3]

Two large and rich Trees of Consanguinity and Affinity appear on a leaf left blank by the scribe, resulting in the omission of half of *Distinctiones* LXXXII, c. 5 and the rest of the text up to LXXXIV, c. 5 (Pls 8b–c). The inclusion of the Trees (or *Arbores*) is not common in 14th-century Italian Gratians. By 1300 the Trees are normally included in the *Decretales*, rather than in the *Decretum Gratiani*, and are usually accompanied by Giovanni d'Andrea's treatise and represented more effectively on fac-

147

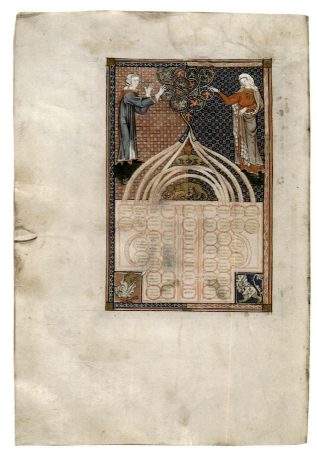

Pl. 8b. Fitzwilliam Museum, MS 262, *Decretum Gratiani*, fol. 71: Tree of Consanguinity

Pl. 8c. Fitzwilliam Museum, MS 262, *Decretum Gratiani*, fol. 71v: Tree of Affinity

ing pages, a layout preserved in early printed copies. It is revived here from the earlier practice exemplified by the Sidney Sussex Gratian (Cat. No. 1). The placing on a leaf integral to the text of the *Distinctiones* is quite exceptional, however, and is surely a response to an accidental gap in the manuscript, probably evidence that the illumination was independent of the writing of the manuscript.

The Trees appear on fol. 71. The Tree of Consanguinity shows Adam as a king holding two palm-like branches in each hand above the arrow-shaped table typical of the Tree of Consanguinity, while his feet rest on seated lions. The Tree of Affinity shows a young nobleman and lady on either side of ivy or vine scrolls rising from the intersecting arcs of the

table. The emphatic humour of the exquisitely drawn grotesques evokes the various artists of the Durham lawbooks (Cat. Nos 11–13) whose foliate decoration is similar to the Italianate gloss initials here.

Fol. 86v, *Causa* XXXIII: The case concerns a woman who takes a lover because her husband has become impotent. The husband regains his virility, but his wife has since married her lover. The first husband forces the dissolution of this marriage and the reinstatement of his own, only to then take a vow of chastity without his wife's approval (Pl. 8d). In the first scene, the wife complains to a bishop of her impotent husband. Her adulterous affair is depicted in the next scene, remarkable in its directness and detail. In the 13th and 14th centuries, sex is usually rep-

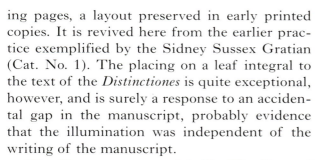

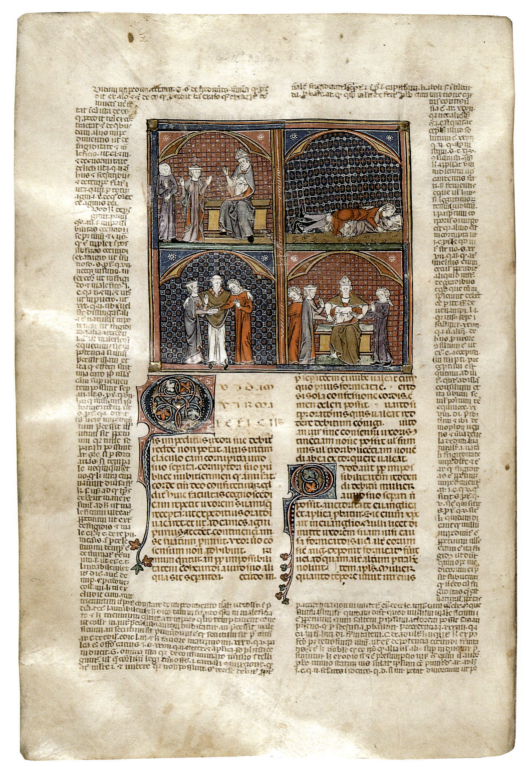

Pl. 8d. Fitzwilliam Museum, MS 262, *Decretum Gratiani*, fol. 86v: *Causa* XXXIII, an impotent husband and an adulterous wife

resented by couples hidden under bed clothes, even in medical books. In the lower left compartment the woman and her lover are united by a priest. The last compartment shows the wife re-united with her first husband by a bishop, while the lover leaves the scene.

Fol. 126, *Causa* XXXIV: This frontispiece illustrates a case that also deals with a woman's remarriage. The scene opens as a husband takes leave of his wife. He is taken captive and ushered into a castle. At the lower left he appears, after his liberation, with his wife who bows her head and removes his hand from her shoulder; thinking him dead, his wife has remarried. Rejected, the husband appears with a companion before a bishop. The companion is in olive yellow, identical to the castellan above; perhaps both represent an advocate presenting the story of the husband's imprisonment to the judge, in the same way that St John accompanies the individual scenes of an Apocalypse manuscript.

Fol. 127v, *Causa* XXXV: The case involves a widower who marries a close relative of his deceased wife. The first scene depicts a husband holding the hand of his wife; in the second scene he waves his hands agitatedly over her bier; in the third scene he holds hands with his second wife who is too closely related to his deceased wife. In the final scene he is arraigned by a lawyer before a seated bishop. The man is identified by his consistent garments. In contrast, his two wives are distinguished by their appearance: the first, with flowing dark hair and a circlet, wears a gold gown revealing green sleeves; the second is veiled by a white head scarf and wears an orange sleeved gown.

Fol. 137, *Causa* XXXVI: This scene depicts the case of a young man who rapes a girl he has invited to dinner; he later gives her a dowry, and her parents give her to him in marriage (Fig. 51). A girl, dressed in grey, is held by her father and appears to withdraw from a young man at right. In the second scene, the two youths embrace rather awkwardly at the table, the pitcher of wine and the chalice perhaps helping explain the action that follows. The rape scene in the third compartment is very explicit,

though the girl's pose seems more coy than defensive. In the final scene the angry father admonishes the youth before a seated judge.

Fol. 139, *De consecratione*: In the first scene two bishops consecrate a church, sprinkling it with holy water (Fig. 39). Below a man enters a similar church whose apse is still incomplete. In the upper right compartment, two choristers at the lectern accompany the priest beginning mass; this is celebrated with the raising of the Host before two kneeling lay worshippers in the fourth scene. The set of scenes and particularly the two stages of the mass make this an exceptionally complete account of the sacrament.

The manuscript is highly unusual in providing for double-column frontispieces of unusual size and complexity. Colour and garments are used to identify individuals through the various episodes. The iconography, though related to the normal treatments of the *Causae,* is not only more elaborate but also more explicit than usual.

The curiously fragmentary structure of the surviving manuscript is to some extent original; its gloss was always incomplete in contrast to its comprehensive illustration. Its subsequent Lutheran owners may have cut out the missing gatherings. The surviving material, apart from the opening sections, has been reduced to a treatise on marriage, though some of the *Causae* relevant to this are also missing. All issues of monasticism and heresy are missing, as well as aspects of the priesthood, other than the Consecration treatise at the end.

The illuminator's emphasis on sexuality is already evident in the choice of the Adam and Eve scenes with their nakedness as the opening illustration. On the other hand the spine appears relatively recent, and the loss of the intervening material might be due to John Ruskin himself, who is known to have cut up manuscripts. Given the public humiliation of Ruskin's divorce on grounds of non-consummation, it is particularly poignant, and perhaps historically significant, that he should have owned a manuscript containing the highly

unusual representation of the subject at *Causa* XXXIII and that this should be the first *causa* to survive in the manuscript. Since Ruskin was also actively interested in Church matters from a non-conformist viewpoint, rather than the liturgical emphasis of most members of the Gothic Revival, the Lutheran rebinding may well have also been of particular interest to him. M. R. James noted that the manuscript had been considered English but thought it more likely to be northern French; Anthony Melnikas considered it French.[4] Francis Wormald and P. M. Giles suggested that it was illuminated by German artists perhaps in Cologne, identifying two hands and comparing their style to the illumination of Johannes von Valkenburg in 1299. The angular faces of the well-known Visitation of the Cologne Gradual, Diocesanbibl. nr. 173, are quite different; the architecture of the 1299 Gradual, Cologne, Diocesanbibl. Hs. 1b, is altogether more linear and refined.[5] Wormald and Giles distinguish four artists in the Fitzwilliam copy: the first was responsible for Part I, fol. 1, and the Trees of fol. 71; the second for the other frontispieces; a third for the larger text initials and a fourth for the gloss initials, which they consider Italian. The frontispieces are from a single workshop, also responsible for the illuminated foliate initials, while the Trees may be the work of the first, finer hand working in a more monumental manner, or the third hand. The frontispiece to Part I is clearly finer in drawing and sharper in its rhythms than those of the *Causae,* which appear to be by an assistant probably working to the Master's drawings.

The figure style probably derives from the circle of the presumed Master Honoré, whose style is exaggerated both in the modelling of draperies and the elongation of figures and their facial expressions. Several manuscripts show stylistic similarities: a Book of Hours significantly for English use (Nuremberg, Stadtbibl., Solger MS 4.4), the Breviary-Missal of St-Etienne de Châlons-sur-Marne (Paris, Bibl. de l'Arsenal MS 595) and a copy of Honoré's *Somme le Roi* (Paris, Bibl. Mazarine MS 870).[6] The small heads on slender bodies, their alert, wide-eyed expressions and the architectural framing of these manuscripts recall the Fitzwilliam copy quite closely. Some aspects of our Gratian are undoubtedly rougher than these refined manuscripts: the simplicity and irregularity of the framing arches and the irregular treatment of the background diaper, particularly noticeable at *Causa* XXXV and *Causa* XXXIII.

However, comparison of the secondary features of the style show at the least a generic relationship between this Gratian and the 'Grey-Fitzpayne Hours' which should be probably called now the 'Pabenham-Clifford-of-Frampton Hours' (Cambridge, Fitzwilliam Museum, MS 242):[7] the narrow head of the patriarch in the Tree of Consanguinity, the broad and softly modelled shields of the miniver cloaks of Adam and Eve or the linings of the figures of the Trees and the pale copper green and orange-rust-coloured foliage of the text initials. Other features show the same generic relationship to the Tickhill Psalter group of early 14th-century English manuscripts, most of them produced for patrons in the English Midlands, often from Nottinghamshire and the southern parts of the diocese of York. The small heads on long bodies compare with the Queen Isabella Psalter (Munich, Bayr. Staatbibl. Cod. gall. 16), perhaps the first member of the same group. The pronounced white scalloping on the edges of the foliage and strings of small white circles at the centre of the leaves of the illuminated letters, particularly to the gloss, are highly characteristic of the Tickhill group, as well as of the Jonathan Alexander Master, whose deep interest in Italian decorative features and apparently widespread influence on English legal illumination may explain the Italianism of the gloss initials.

The structure of the manuscript layout, its Italianate text and the Italian influence on the shape of its foliate initials, particularly in the gloss, suggest the influence of Toulouse on its general design. François Avril has shown that fine manuscripts with an essentially Parisian elegance of style but clearly Bolognese-inspired

humorous traits were produced for the clergy of Languedoc.[8] But the unusual illustrative design is clearly original and due to the scribe. The emphasis on illustration and the lack of extensive academic apparatus and annotation suggests an ecclesiastical rather than a legal patron, as well as an origin outside the principal European centres of legal study.

BIBLIOGRAPHY: Kuttner, *Repertorium*, p. 105; Pink, 'Decretum' pp. 235–36, including an unpublished description by M. R. James; *CBS*, Pt I, no. 22, p. 201; *Ruskin and his Circle*, no. 179, p. 46; Dearden, 'Ruskin', no. 35, pp. 141; Melnikas, at Dist. I, fig. 51; C. XXXIII, fig. 23; C. XXXIV, fig. 17; C. XXXV, fig. 19; C. XXXVI, fig. 35; *De consecratione*, fig. 21. Wormald and Giles, *Descriptive Catalogue*, pp. 196–98.

RG

[1] For Ruskin's manuscript collecting, see the section 'Discovery of Medieval Art', in *Ruskin and his Circle*, pp. 45–46, this manuscript at no. 179; Treuherz, 'Pre-Raphaelites', pp. 153–69, 252–53; Dearden, 'Ruskin', pp. 124–54, this manuscript at no. 35. We are grateful to Stephen Wildman, Curator of The Ruskin Library, University of Lancaster, for his advice on Ruskin's manuscript collection.

[2] A number of leading scholars in the field have confirmed the French origin of the manuscript, though there is some uncertainty as to whether its layout and rubricated decoration are Parisian or Southern in origin.

[3] Sandler, *De Lisle*.

[4] Sandler omits it from her *Gothic Manuscripts* and *Omne Bonum*.

[5] Wallraf-Richartz, I, nos 69–70, pp. 126–31, 187–89, for this group of manuscripts; and G. Plotzek-Wederhake, 'Zur Stellung der Bibel aus Groß St. Martin innerhalb der Kölner Buchmalerei um 1300'; and J. Kirschbaum, 'Ein Kölner Chorbuch des frühen 14. Jahrhunderts', in Wallraf-Richartz, II, pp. 62–80.

[6] For Honoré, see Vitzthum, pp. 46–61, 218; Millar, *Honoré, passim*, citing the Nuremberg MS at p. 13; Avril in *L'Art au temps des rois maudits*, pp. 275–80.

[7] J. A. Goodall, 'Heraldry in the Decoration of English Medieval Manuscripts', *Antiquaries Journal*, 77 (1997), 179–220, at pp. 180–81.

[8] See Avril in *L'Art au temps des rois maudits*, nos 229–30, pp. 329–32, for the Bible of Jean de Cardaillac, Archbishop of Toulouse, 1379–90; a Toulousan or Albigensian Breviary, Baltimore, Walters Art Gallery MS W. 130, and Paris, BNF MS Nouv. acq. lat. 2511 are also discussed in Avril, 'Un element retrouvé', pp. 123–34.

Cat. No. 9
Cambridge, Fitzwilliam Museum,
MS McClean 201.f.11b

Gratian, *Decretum, Causa* VIII
Bartolomeo da Brescia, *Glossa ordinaria*

Manuscript, parchment, a single detached folio headed [*Causa*] VII on recto, 448 x 295 mm, written in 4 columns, 365 x 240 mm, the text in two columns, 280 x 160 mm.

PROVENANCE: Frank McClean; bequeathed to the Fitzwilliam Museum in 1904.

TEXT: Southern France, Toulouse or Provence, *c.* 1320–30.

It is written in a French version of the round *littera bononiensis*, but with a much more vertical script; essentially Gothic black-letter, for the gloss.

ILLUMINATION AND DECORATION: Southern France, Toulouse or Provence, *c.* 1320–30.

The page comes from a richly illuminated manuscript decorated with the small-scale Southern French version of Bolognese Academic line and loop filigree in contrasting red and blue to the initials of each chapter, with the Bolognese loops changed to tiny circles (Pl. 9).

A space is left at the end of *Causa* VII on the original recto to allow the next frontispiece to appear on a new page. The initial to *Causa* VII, q. ii, has the head of a bearded old man, red-haired and drawn in a firmer line than the following principal illumination.

On the verso (mounted as recto) of *Causa* VIII is a single-column frontispiece and extended foliate initial letter. The opening initial has French vine-scroll culminating in a bearded, human-faced dragon at the top, while the next initial has a small dog, probably directly related to the gloss initial at the top of the page showing a hare wearing a cloak.

The frontispiece depicts the case of an aged bishop appointing his successor, who is duly elected through the patronage of friends but subsequently accused of simony. In the lower right corner, the bishop is shown on his sickbed, attended by a doctor and a hooded assistant. In the main scene a bishop stands with his lawyer before the pope, enthroned on the left. Behind him another bishop addresses a couple of laymen; there is a suggestion that the artist is confusing the successor with the original bishop. These scenes are set before a triple arcade and a range of diapered backgrounds, while church towers and castellated walls rise above.

The cleric on his sickbed is a feature of *Causae* VII–VIII, XII and XVII; the separation of the episode from the main part of the illumination with a semicircular enclosure or part of an arch appears in Bolognese Academic Style manuscripts in the 1280s. Among these are the copy from Roudnice (Prague, Nar. Mus. MS XII. A. 12) and two in Reims (Bibl. Mun. MSS 678 and 679). It is found in French copies around 1300, including a group from Toulouse or Avignon: Vatican City, BAV Vat. lat. 1373; Florence, Bibl. Laurenziana, MS Edili 97 and Avignon, Bibl. Mun. MS 659. Spanish examples of the same date may perhaps also be included, such as a related pair of manuscripts, Bibl. Real del Escorial, MSS ç. I. 4–5. Avignon MS 659 has been attributed to Toulouse on the basis of comparison of the illumination with a Breviary of the Dominicans, Toulouse, Bibl. Mun. MS 77.[1] The distinction between Avignon and Toulouse manuscripts is an important question still to be resolved in a broader context.

The dainty and hesitant drawing of the figures and faces, as well as their slightly pinched features, are shared with the Toulouse/Avignon group. So too are the general features of the composition, such as the group before the pope; the laymen in a pulpit-like structure is particularly close to the Avignon manuscript itself, though the artist here is slightly more refined. The palette also suggests an Avignon origin. The use of olive green, pale pink and vermillion, with quite bright blue and pink diaper in

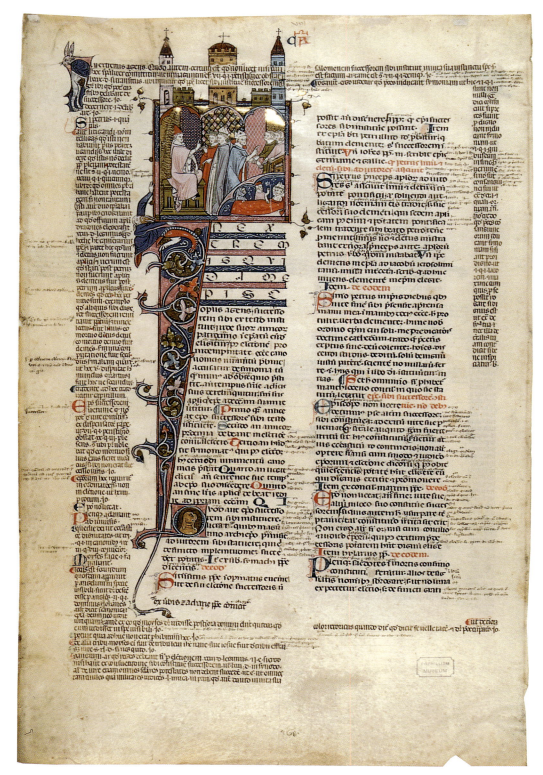

Pl. 9. Fitzwilliam Museum, MS McClean 201.f.11b, *Decretum Gratiani, Causa* VIII

the background, is perhaps derived from the luxurious manuscripts of Jacopino da Reggio and his imitators, which may have circulated among the members of the papal curia. The Toulouse/Avignon group of Gratians have a related emphasis on pale and raspberry pink and dull deep green, though the faces of the Fitzwilliam leaf are daintier than most of these, its architectural setting more ambitious and the foliage closer to Parisian style, which is more modelled and altogether finer.

BIBLIOGRAPHY: James, *McClean*, no. 7, pp. 364–66. Melnikas, I, p. 313, C. VIII, fig. 13; and C. VII–VIII, XII and XVII, *passim*.

RG

[1] Reynaud, 'Le recours', pp. 293–319; Nordenfalk, 'Review', pp. 318–37, at p. 335 for this group. Reynaud notes the misplacing of several frontispieces but misattributes it to a desire to illustrate the ends of the relevant preceding *Causae*; in fact the defective sequence of frontispieces affects all three manuscripts but to a greater degree in some, confirming error rather than intention.

Cat. No. 10
Cambridge, Fitzwilliam Museum,
MS McClean 139

Justinianus, *Volumen*
Accursius, *Glossa ordinaria*
Tree of Actions (*Arbor actionum*)

Manuscript, parchment, i–iiii + 307 fols, 398 x
250 mm, 4 columns, 360 x 230 mm, text in two
columns, 210 x 120 mm, surrounded by gloss,
quires of 10 folios, lightly ruled in lead; bind-
ing: gold tooled Russia.

PROVENANCE: Notes by previous owners on folio
i a: *Dom. Nicholaus vopetrus da lichanagh. Pro.
m. Roncino pro xx flor[. . .]*, also *d. grimaldus . . .
libr. Xxxiiij - f - xl.*; two cancelled inscriptions
in Hebrew. An 18th- or 19th-century owner has
added ornamental touches at intervals through-
out the manuscript, primarily in tones of green-
ish blue and muddy ochre. Purchased from
Hoepli.

TEXT: Italian, *c.* 1300.
All texts have one or more surviving *pecia* anno-
tations, marking the ends of *pecie* and outlined
with a fine wavy line, most including the abbre-
viation *cor* (corrected). Each text is articulated
with penwork initials, the *Tres libri* following
the characteristic Italian *Codex* model, featuring
three-line blue penwork initial **I**s at titles, fol-
lowed by one-line red capitals.

ILLUMINATION:
Spaces were left for small unexecuted minia-
tures and large initials at book divisions. The
Tree of Actions (*Arbor actionum*) occupies two
full pages, fols iv and ii, lacking the gloss or
Summa that generally surrounds it (Pl. 10).[1]
These two added folios, composed earlier than
the text itself, were probably retained from a
previous, out-dated manuscript, to avoid the
complex task of composing new versions.
Tables of this sort would be executed separate-
ly by specialized craftsmen, experienced with
unique physical formats and the exigencies of

aligning text coherently within a geometrical
structure. Their backgrounds have suffered the
attentions of the same later owner who added
painted ornament to the manuscript in various
places; paint has been crudely applied to the
spaces around the cells.

The McClean *Volumen* contains the full
complement of the texts that may compose this
volume of the *Corpus iuris civilis*. It opens with
the *Institutiones* on fol. 1; the *Authenticum* occu-
pies fols 74–211v; followed by the *Tres libri* on
fols 212–283 and concludes with the *Libri feu-
dorum* on fols 284–304. Although the painted
decoration was not executed for the text proper,
the manuscript begins with the complex Tree,
divided into two tables, sometimes inserted in
copies of the *Volumen* and usually falling direct-
ly after Book IV of the *Institutiones*, with which
it is associated.[2]

This little-known and infrequently de-
scribed Tree of Actions was chosen to represent
MS McClean 139 in the exhibition and in this
catalogue. Its visual aspect is intriguing and not
immediately comprehensible, embodying a
form of code: areas inscribed with letters of the
alphabet are topped with mysterious Braille-like
arrangements of dots, in rows of one to four.
Like other Trees, such as the Trees of Consan-
guinity and Affinity present in the Sidney
Sussex, Corpus Christi and Fitzwilliam *Decre-
tum Gratianis* (Cat. Nos 1, 3 and 8), they arran-
ge information into a format defined by divi-
sions and subdivisions which serve to explain
certain legal relationships.

The Tree of Actions represents a pictorial
and literary genre created to organize and clas-
sify lawsuits in their multiple forms, fruit of the
dialectical methodology employed by the
Bolognese glossators, and drawing on their ex-
tensive knowledge of Justinian's texts and of
the categories utilized by the classical Roman
jurists. The glossators applied the diagramming
vehicle of the tree, with its divisions and subdi-
visions, to create a structure that would arrange
and explain the greatest possible number of the
lawsuits described in the texts of the *Corpus
iuris civilis*.[3] The layout of the *Arbor actionum*

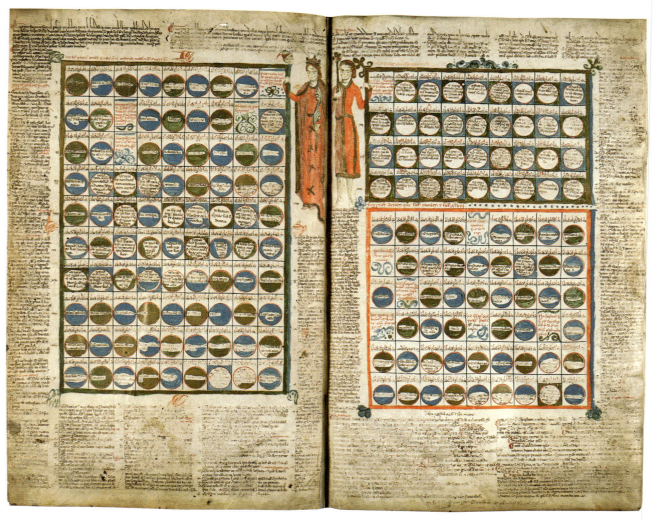

Pl. 10. Fitzwilliam Museum, MS McClean 139, fols i v–ii: Table of Actions

was composed by the Bolognese civilian Johannes Bassianus in the last years of the 12th century. Physically the *Arbor* is contained in two tables of varying sizes, each occupying a full page, generally placed facing each other on verso and recto of two different manuscript leaves. The tables together consist of 180 circular cells of equal size – usually with a larger number grouped in the left-hand (verso) table than on the right (recto) – distributed so that praetorian suits occupy most of the left-hand table, while the fewer civil suits are all contained in the table on the right. The name of a lawsuit is inscribed within 169 cells, the remaining eleven containing glosses that comment on the suit they immediately precede. Above each cell in a separate space, the letters **a–m** (omitting the letter **j**) represent twelve categories under which each suit is classified. The status of each suit is further categorized by placing vertically above each letter one, two, three or four dots, each option denoting a variation. One hundred and eighty lawsuits in their varying contexts are thus presented in an ingenious and neatly packaged format which, for the trained medieval civilian, defined them at a glance. The key to interpreting the alpha-dot coding above each cell is as follows, according to the number of

dots placed above it and the status accorded the lawsuit by this configuration:[4]

a one dot = praetorian (*pretorie*)
two dots = civil (*civiles*)

b one dot = real (*in rem*)
two dots = personal (*in personam*)
three dots = hybrid (*mixte*)

c one dot = restorative (*rei persecutorie*)
two dots = penal (*pene*)
three dots = hybrid (*mixte; id est utriusque et rei et pene*)

d one dot = for single damages (*in simplum*)
two dots = double (*in duplum*)
three dots = threefold (*in triplum*)
four dots = fourfold (*in quadruplum*)

e one dot = based on good faith (*bone fidei*)
two dots = based on strict law (*stricti iuris*)

f one dot = perpetual (*perpetue*)
two dots = temporary (*temporales*)

g one dot = transitory to heirs (*transitorie ad heredes*)
two dots = not transitory to heirs (*non*)

h one dot = suits incurring *infamia*/disgrace (*infamant*)
two dots = not incurring disgrace (*non*).

i one dot = direct (*directe*)
two dots = profitable (*utiles*)

k one dot = straightforward (*directe*)
two dots = contradictory (*contrarie*)

l one dot = universal (*universales*)
two dots = unique (*singulares*)

m one dot = simple (*simplices*)
two dots = double (*duplices*)

However these intricate diagrams were actually used, the mechanism of their conception and elaboration is an impressive testimony to medieval scholarship.

Many 13th-century versions of these tables are accompanied by a feminine figure placed in the space between them, usually in the upper right-hand margin beside the left-hand tree. According to Andrea Errera, this figure, which he refers to as *domina actionum,* was added as a purely decorative element, irrelevant to the clas-sification of lawsuits, 'an ornamental artifice devoid of any utility'.[5] One such *Arbor action-um*, however, anomalously inserted into a 13th-century *Decretum Gratiani*,[6] bears an inscription between the two tables – *Juris prudentia est mater actionum* (Jurisprudence is the mother of suits) – that accompanies a drawing of an atten-uated, long-haired female figure, uncrowned, clothed in a bi-coloured gown, holding up a flower in her right hand and a sceptre in her left. In the light of long-established pictorial per-sonifications of concepts such as Justice, the Virtues and Vices, Philosophy, Fortune and the Liberal Arts, it seems natural to suppose that medieval illuminators might have been asked to supply a representation of Jurisprudence as well, to accompany a set of tables in which the exercise of this concept was so adroitly described. The present tables were quite unusu-ally given *two* personifications, male and female, perhaps executed by an illuminator unacquaint-ed with the usual conventions for the *Arbor actionum*, and conceivably confusing it with the Trees of Affinity and Consanguinity, each of which have figured decoration.

BIBLIOGRAPHY: James, *McClean*, pp. 286–88.

SL'E

[1] Among them are the *Summa arboris actionum* by the Catalan Ponzio da Ylerda, written between 1213 and 1217, and the *Prologus ad arborem actionum*, signed with the siglum *Jo* and variously attributed to Iohannes de Deo and Iohannes Egitaniensis.

[2] The most important lawsuits and their variations are described and classified in the *Institutiones*, Book IV, Title 6: *De actionibus* (Actions/Lawsuits).

[3] Errera, p. 75.

[4] I have included the Latin terms in parentheses, to provide for specialists a clue to my layman's English equivalents.

[5] Errera, p. 292, n. 62.

[6] Bamberg, Staatsbibl., MS Can. 13, fols 270–271, repro-duced in Nordenfalk, 'Review,' p. 320, fig. 1, but erro-neously assumed by him to be a typical feature of *Decretum* illustration.

The Jonathan Alexander Master

AREMARKABLE ILLUMINATOR who appears to have had a crucial role in the development of 14th-century English manuscript taste and technique, the Jonathan Alexander Master is represented in the Cambridge collections by an important copy of Gregory IX's *Decretals*, Fitzwilliam MS McClean 136 (Cat. No. 14). His most substantial surviving work is the decoration he completed in an important set of later 13th-century manuscripts brought back from Bologna by a family of Durham lawyers (Cat. Nos 11, 12, 13, 13.1), and he also contributed to the illumination of the Vaux-Bardolf Psalter (London, Lambeth Palace Library, MS 233) for an aristocratic English family.

The origins of his style belong with Southern French manuscripts such as the *Decretals* of Florence Cathedral (Florence, Bibl. Laurenziana, MS Edili 86) and the *Digestum novum* of Gonville and Caius College, MS 10/10 (Cat. No. 16) in which similar foliage and leaf masks appear.[1] The artist responsible for Book II of the Florence *Decretals* also illuminated the opening and closing texts of an older, composite *Parvum Volumen* in Durham, Chapter Library MS C.I.5.[2] The Florence *Decretals* shows a strong influence of Bolognese elements in the compositions and the division of frames and initials by gold bars characteristic of the main artist of the Durham *Decretals* (MS C.I.9, Cat. No. 13). A distinct feature of the Jonathan Alexander Master's work in the Durham *Digestum novum*, the overpainting of original capitals with flag-shaped ones, seems to be of Toulousan origin: the same flag-shaped capitals appear in a *Digestum vetus* with glosses by Toulousan legists; though their illumination is very different, they probably share a common origin.[3]

If the Jonathan Alexander Master can be identified with the artist of Book II in the Florence *Decretals*, his figure style evolved in the transition to the Durham *Codex*, not only in adapting to Bolognese composition and its tighter definition of foliage but also to the daintier figure style of the Parisian illumination prominent in Toulousan manuscripts. He appears to have had some familiarity with the Durham *Volumen* (MS C.I.5), since he includes the Bolognese artist's distinctive round-eyed yellow rabbits (116v, 123), not otherwise represented in the Durham manuscripts, in his own repertoire of grotesques (cf. MS C.I.6, fol. 248; Cat. No. 12).

Much of the Jonathan Alexander Master's legal illumination is likely to have been executed in Toulouse or another important Southern French university, but he also worked in England. He illuminated the Fitzwilliam *Decretals* either in France or in England with the collaboration of another artist from Languedoc. Characteristics of his style such as the deep modelling of faces and the highlighting of facial features with firmly defined white lines are shared with the now largely destroyed painting on the base of Edmund Crouchback's tomb in Westminster Abbey. While the possibility that he started his career as a monumental painter cannot be ruled out, his important influence on English painting around 1295 is more easily explained by manuscripts he brought to England or illuminated for English patrons, such as the Vaux-Bardolf Psalter.

Michael Michael drew our attention to the multiple serrations of the Jonathan Alexander Master's foliage and the strings of white circles along the spines of the leaves as typically English and particularly characteristic of the Vaux-Bardolf Psalter.[4] The artist illuminated the right-hand border of the *Beatus* page (fol. 15) which has several Bolognese-style interlace motifs not commonly found in English illumination. There appear to be several hands in this manuscript which point to its relationship with other manuscripts of the Tickhill Psalter group: the closest of these are the Grey-Fitzpayn Hours and a Bible (Fitzwilliam Museum, MS 242 and MS McClean 15), and a cutting from a Psalter of remarkably academic iconography (Bodleian Library Lat. liturg. d.

40).[5] The Master's earlier work anticipated and probably inspired both the elaborate foliage and the particularly vivid grotesques in manuscripts of the Tickhill Psalter group. The strength of Bolognese influence on the Jonathan Alexander Master suggests that his legal works and the subsequent Tickhill Psalter manuscripts with which he was involved represent the origin of the Italianism frequently noted in English 14th-century illumination.

RG

[1] Several hands have been distinguished in this manuscript: Fabbri and Tacconi, p. 125, pl. 33; see also *Duecento*, no. 93, pp. 297–300.

[2] It includes an illuminated Bolognese *Tres libri*, *c.* 1250, and an unilluminated *Authenticum*, as well as the *Institutes* and *Consuetudines feudorum* illuminated by this artist. All these texts are Italian, *c.* 1250, in *litteras bononienses* but in gatherings of 8 leaves with alphabetical *lemmata* except for the *Authenticum*, which has the earlier system of dots and dashes; the *Institutes* is either early or non-Bolognese.

[3] The *Digestum vetus*, Frankfurt, Stadt- und Universitäts-bibliothek, MS Barth. 9, was illuminated *c.* 1300 by a Toulousan artist: Swarzenski and Schilling, no. 83, pp. 89–92, pls xli–xliii; Powitz and Buck, pp. 22–24.

[4] Personal communication.

[5] Sandler, *Gothic Manuscripts*, pp. 31–38, esp. nos 28, 30 at pp. 34–36, figs 52–78; Millar, *Lambeth Palace*, pp. 5–11, pls XXXV–XL; James and Jenkins, pp. 373–79; Harrison, pp. 13, 19–21, pls XII–XIV; Egbert, esp. pp. 189–204, pls CI–CVIIIa; Pächt and Alexander, III, no. 548, p. 50; Rickert, *Painting*, p. 146; Rickert, *Miniatura*, pp. 6–7, 12, pl. 23; Randall, *Images*, figs 149, 422.

The Durham Cathedral Set of Bolognese Law Texts

SINCE AT LEAST 1391, Durham Cathedral has possessed a remarkable set of illuminated legal texts written in Bologna in the later 13th century. These volumes belonged to three brothers, Henry, Richard and John de Insula, of whom we know very little. At least one and possibly two members of this family called John (or J) de Insula were associated with the cathedral from 1299 to 1334, and were probably related to Bishop Robert de Insula, a former monk of the cathedral priory from Holy Island who was elected in 1274 and died in 1283.[1] A Henry de Insula graduated in Oxford by 1295 and was licensed to study at the Roman Curia or elsewhere in 1315; he became vicar or rector in various parishes of Northamptonshire and Somerset and was still living in 1330.[2] There are, however, several recorded clerics and friars of this name which, if it includes de L'Isles, might derive from various islands around Britain and even Europe.[3] The original owners were surely at university in Bologna in the 1270s or 1280s.

The set comprises a *Decretals* (MS C.I.9, Cat. No. 13) and three volumes of civil law, the *Volumen,* the *Codex* and the *Digestum novum* (MSS C.I.4, C.I.6 and C.I.3; Cat. Nos 11, 12, 13.1). It is notable that the set lacks the first volumes for both civil and canon law, which may have been provided by earlier copies.[4] A record of their ownership also appears in a Bolognese(?) copy of the first part of Odofredo's *Summae in Codicem* (Durham Cathedral, MS C.I.12).

The manuscripts were the subject of an important study by Jonathan Alexander in 1977 but have received little attention since. Alexander dated the writing of the texts to *c.* 1300; this is certainly a few years too late. The Durham *Decretals* was supplemented with the *Novella* of Innocent IV, 1253, and, separately, constitutions of Popes from Gregory X, 1274, to Nicholas III, 1277–80, with glosses of Garcia Hispanus composed by the early 1280s. The added constitutions are not in chronological sequence; their glosses are similar in hand to the rest of the manuscript, but they were certainly illuminated later. This suggests that it was the availability of the gloss texts that determined the additions in the 1280s, providing a *terminus ante quem* for the dating of the rest of this manuscript. In 1298 Boniface VIII replaced the supplements to Gregory IX's *Decretals* with his *Liber sextus* and annulled all the intervening legislation not incorporated into his work, making it inconceivable that the Durham *Decretals* were written after that date.[5]

The set was taken from Bologna before the lavish illumination could be finished, probably because the owners had finished their studies. Decoration of the *Decretals*, the *Codex* and the *Digestum novum,* were subsequently completed by Northern artists, including the Jonathan Alexander Master. The manuscripts have been extensively robbed of frontispieces and some borders, the *Digestum novum* having lost all but the last minor frontispiece, but they preserve most of their extensive and very inventive secondary decoration.

The *Volumen,* probably the earliest of the manuscripts to be written, is relatively well preserved and was entirely illuminated in Bologna. As it contains the students' introduction to the civil law, the *Institutes,* which was sometimes copied separately by students,[6] it is a natural opening for the set. In its general character the *Codex* is quite similar to the *Volumen,* but had secondary glosses added. Several of its gatherings including frontispieces to Books III, V and VIII were left undecorated and were subsequently illuminated by the Jonathan Alexander Master. Its last gatherings were illuminated by a later 13th-century artist with a generically Northern French technique, though probably working in Toulouse or Oxford.[7] The Jonathan Alexander Master played a greater role in the *Digestum novum* since the Bolognese artists only illuminated the first gatherings of each part. This was a different Bolognese workshop, which also illuminated much of the *Decretals.* Another possibly English artist illuminated the frontispieces to Books II and IV of the *Decretals,*

in places covering earlier initials, and the Jonathan Alexander Master illuminated the appended constitutions. The original scribe of the *Decretals* may have been the artist of the *Volumen*. The sequence of work suggests that the *Decretals* was prepared concurrently with or slightly before the *Codex*, since its secondary illumination and the decoration to the added *Novella*, was completed by Bolognese artists.[8] Its last section of additional constitutions and the secondary glosses added to the *Codex* share the same script and distinctive purplish brown ink; they also mark the intervention of the Jonathan Alexander Master into both manuscripts' illumination.[9] We may conclude that his work is contemporary with or prior to that of the other Northern artists.

There are several distinct Bolognese workshops involved in the manuscripts, though they are similar in their general qualities and likely dates. They all represent the Bolognese Academic (First) Style at the stage around 1275 when it had evolved a mature figurative style strongly influenced by French 13th-century art, although the round foliage and linear emphasis of the Romanesque is still present. The three-arched frontispiece design predominates, and there is little or no pictorial space; the influence of the Bolognese Paleologan style has not yet intervened. This suggests an earlier dating than such manuscripts as the celebrated 'Pseudo-Oderisian' *Infortiatum* in Turin, Bibl. Naz. Univ. E. I 8.

The work of five artists is particularly notable. It is the *Volumen* Master, the dominant artist of the civil manuscripts, whose angular drawing style and fraught figures haunt the imagination. His figures have small, pale faces with broad foreheads, eyebrows gabled about the nose and shaded blue, and sharp, often frowning, features. His work is a development of the first stage of the Academic Style represented by a *Codex*, Paris, BNF lat. 4527, which might be attributed to the same artist at an earlier date.[10]

The *Volumen* Master's greater affinity with Parisian Gothic contrasts with the classical traits of the artist who opens the *Codex*. He has a sketchily classical idiom of drawing, notable principally in his taste for naked figures and profile or upturned faces. He uses a distinctive orange-vermillion and a paler pastel blue than the *Volumen* Master; his frontispiece frames and foliage staves lack the punctuating gold bars characteristic of the *Volumen* and of the rest of the *Codex*. The *Codex* Master's style is related to that of the antiphonary from the Dominican convent of S. Agnese, Bologna, Museo Civico, MS 510, but is much more refined.[11]

A third Master, technically sound but less inventive, appears in a minor role in both the *Codex* and the *Volumen*. He favours a deeper palette, a heavier and firmer line for his foliate ornament and bigger, more classical faces. This is the artist of the additional texts in the Lucca *Decretals*, Bibl. Capit. MS 137, fols 284–97.[12]

A fourth Master dominates the illumination of the *Decretals*; he is probably the artist responsible for one of the better-known Bolognese illuminated law-books, the Vatican *Volumen* (BAV, Vat. lat. 1434).[13] His technique has a monumental classicism, his majestic faces given calm, rather sweet expressions in complete contrast to the angular intensity of the Durham *Volumen* Master's. Parchment and white are used as the main complexion tone while broad bands of pale pink and blue/grey create a firm modelling. He shares some characteristic grotesques such as the blue eagle-beaked bird-heads with the other Bolognese artists. The *Decretals* Master was also responsible for the opening gatherings of each part in the *Digestum novum*, largely completed by the Jonathan Alexander Master.

The Jonathan Alexander Master appears to have acquired his distinctive style and imagery in the course of illuminating these manuscripts. His grotesques largely develop those already executed by the Bolognese artists, and a couple of gatherings in the *Codex*, perhaps the artist's first contributions in the manuscript, show a more tentative technique and sketchy drawing closer in figure style to the *Volumen* Master. At times he works in a Northern idiom with dainty figures and faces

lightly drawn, but frequently he adopts an Italian style of modelling, using a strong flesh colour, a fantastic blue or yellow with a white line or strip of tone shadowing its contours. Sometimes his faces have the Italo-Byzantine *verdaccio* as a base tone with certain features emphasised with white contour or flesh lines. It is notable that while the Bolognese artists in these manuscripts generally give their humans white faces, the Jonathan Alexander Master sometimes gives them blue complexions, inspired by the animal-headed grotesques and leaf-masks and particularly the 'Easter Island' mask on fol. 99 of the *Codex*.[14]

The Jonathan Alexander Master appropriates most of the features that typify Bolognese illuminators but employs them in a distinctive manner. While he sets his figures against a blue ground as the Bolognese artists do, he fills the whole area with the foliate spirals in the fine white filigree the Bolognese normally reserve for the border. His foliage tends to have smaller, rounder and far more numerous lobes than their Italian models. The spine of little white circles to his leaves has French and Italian origins, but he makes it more pronounced: this combination comes to typify the English Tickhill Psalter group of manuscripts (and the associated legal manuscripts: Cat. Nos 8, 14, 19). His obsession with turning leaves into faces, beards and hair into leaves and sprouting faces from the backs of animals and other human figures is a distinctive feature of his own fantasy, though inspired by the Italian grotesqueries.

The Durham set are of great importance for several reasons. They have a long provenance in the ownership of a major ecclesiastical institution and they include both civil and canon law manuscripts, demonstrating the value of both for a religious house. They are among the finest Bolognese Academic Style manuscripts with some of the most vivid examples of their characteristic secondary decoration. But they also demonstrate through the inspired imitation of the original work how Bolognese illumination influenced French and perhaps English artists who had unfinished Italian manuscripts or Northern European copies of legal texts to illuminate. Frequently they emulated and developed the kind of grotesques represented here in even richer programmes, though rarely with such humorous effect. All the successive stages of this set, Italian and Northern, were realized by artists of considerable skill; the principal Bolognese artists are among the finest of their period, while the Jonathan Alexander Master perhaps surpasses them in his range of pictorial technique and flair for observation, parody, exaggeration and surreal, sometimes obscene, visual conceits and juxtapositions.

BIBLIOGRAPHY: Rud, pp. 254–58; Raine, *Catalogi veteres,* pp. 34–37; Ker, p. 69; Alexander, 'Durham', pp. 149–53, pls XXVId–XXVIId; Watson, *A Supplement,* pp. 88 (Corbridge), 91–92 (Insula), 93 (Lumly).

RG

[1] See Greenwell and Hunter Blair, II, no. 3124, pp. 449–50, pl. 49 for Bishop Robert's two seals.

[2] References to students of this name occur in Bologna: the English William de Insula, witness to a payment by Bernardo Anglico, *cives bononiensis*, in 1265; and John de Insula, 'Henmericus, filius qdam Guilielmi de Insulis' in 1269. See *Chartularium Studium Bononiensis*, V (1921), pp. 5, 15, 27, 34, 52, 69; X (1936), pp. 99.

[3] Cf. *BRUC*, p. 370; *BRUO*, I, no. 1437, p. 170, no. 1615, p. 193, and pp. 191–94; II, p. 1003.

[4] Durham still has an unglossed Gratian, a *Digestum vetus*

and an *Infortiatum* while the Sidney Sussex Gratian came from Durham Cathedral too (see Cat. No. 1).

[5] A comparable case is the *Decretals* illuminated by Jacopino da Reggio, Vatican City, BAV, Pal. lat. 629, with similar supplements; the *Cupientes* of Nicholas III, 1277–80, with the apparatus of Garcia Hispanus, before 1282, has later illumination. *Bibliotheca Palatina*, B 6.3, I, pp. 52–53, II, p. 32; Berschin, pp. 76–78; Burkhart, 'Die Dekretal handschrift', pp. 33–51, pls 1–13 (Burkhart's chronology confuses the sequence of Jacopino's earlier, middle and later work). Martin

Bertram has stressed to me that without evidence of use in the gloss one cannot be certain that the manuscript must date before Boniface's *Liber sextus* which made it redundant; however, it seems unlikely for such an expensive production that it should have been produced in ignorance of current legislation, and the evolution of its illumination precludes a late date.

6 This is quite often found as a separate volume sometimes written by a less experienced hand; see e.g. Vatican City, BAV, Vat. lat. 1432, written by a German in Bologna, *R. rector in Lunsen*…(Lenzen near Potsdam?), but with a Bolognese gloss and illumination by the Crucifixion D Master, *c.* 1335–40, and Vat. lat. 10221, probably written and certainly illuminated in Perugia, *c.* 1330–40.

7 See Cat. No. 12 **at note 4.**

8 It is not uncommon for secondary illumination to precede that of the frontispieces, since in numerous Bolognese manuscripts the latter was never realized, particularly those for foreign students; see e.g. Nerio's copy of the *Decretum Gratiani* (Prague Castle, Metr. Capit. Library MS I), and many of the manuscripts of the Rossiana collection, formerly of the *Cardinalis Firmensis*, and now in the Vatican Library.

9 Another copy of the *Decretals* at Durham, C.I.10, was written by the Bolognese scribe Guillermo de Bononia; see Rud, p. 258, and L'Engle, Chapter 3 in this volume. C.I.10 incorporates the *Novellae* and *constitutiones* of Innocent IV and Gregory X within the text, which is written in distinctive inks, in Northern gatherings of 12, but in a purely Bolognese hand and layout. It is likely that Guillermo or another Bolognese scribe in Toulouse, or possibly in England (Oxford?), was responsible for the additions to MSS C.I.6 and C.I.9. The attention in each Durham copy of the *Decretals* to the 1253–80 legislation suggests a distinctive academic tradition, probably unlikely in Durham itself despite the continuing strength of its artistic production.

10 Avril and Gousset, II, no. 94, pp. 79–80, pl. XLV: the facial type of Justinian as well the distinctive finch-billed bird-head in the Paris work recurs in the Durham manuscripts.

11 *Duecento*, no. 74, pp. 255–56. The artist of the S. Agnese manuscript was also responsible for the *Institutes*, Bamberg Staatsbibl. msc. Iur. 8; Pfändtner, *Illuminierte bologneser Handschriften*, no. 2, pp. 15–17.

12 Dalli Regoli, 'La miniatura', pp. 175–79, figs 206–10, and figs 201–05 for the other artists related to the Durham *Volumen* Master; for this manuscript see also Cat. No. 4.

13 As observed by Susan L'Engle; for the Vatican *Volumen*, see also Conti, *La miniatura*, pp. 27–28, figs 19–20, 26. In addition to Vat. lat. 1434, the artist, and particularly his assistants present in the Durham manuscripts, illuminated the Denstone Bible, formerly of the Glazier Collection, now New York, Pierpont Morgan Library MS G38. I think it possible that the Master himself may have developed his style under the influence of the Paleologan Style masters to produce the manuscripts associated with the Vatican Bible, BAV, Vat. lat. 20, which have a similar decorative taste for elaborate foliate knots and gold flourishes, though these represent a substantial evolution of painting technique: the others include the *Decretals*, BAV, Vat. lat. 1390, a Bible gathering and a *Summa* of Ramon de Peñyafort, Paris, BNF n.a.l. 3189, fols A–10v and lat. 3253 (Avril and Gousset, II, nos 118bis–119, pp. 94–97), the latter pair intermediate between the Durham-Denstone group and BAV Vat. lat. 20.

14 The blue-faced figures in the Luttrell Psalter that Camille claimed to represent Scots (Picts) might well derive from his artist having a knowledge of manuscripts like these, particularly in view of Sir Geoffrey Luttrell's legal connections through his son's marriage to the daughter of the Chief Justice, Geoffrey le Scrope, and his experience of border wars; Camille, particularly at pp. 55–70, 284–89. Durham itself was heavily involved in the Scottish war of Independence, being burned in 1312 and paying indemnities thereafter. Parallels in the Luttrell Psalter and the Durham manuscripts include the blue fish-head of fol. 173 of the Psalter with that in fol. 9 of the *Volumen*, and the cow-head of fol. 173v in the Psalter with the Jonathan Alexander Master's figure in the *Codex*, fol. 60 (cf. Camille, figs 84–85; Gibbs, 'Camille').

Cat. No. 11
Durham Cathedral, Chapter Library, MS C.I.4

Justinian, *Parvum Volumen (Institutiones + Authenticum + Tres libri)*
Accursius, *Glossa ordinaria*

Manuscript, parchment, 289 (3 + 286) fols, 457 x 284 mm, the text written in 4 columns, 350 x 240 mm, the text in 2 columns, *c.* 240 x 140 mm, blind or very lightly ruled, in 10, the *Institutiones* on fols 4–74; the *Authenticum* on fols 74v–215, fols 114–125 in 12, ending in 10 on fol. 215, 215v blank; Books X–XII of the *Codex* on fols 216–287, ending in 12, with two added folios of notes at the end. No *Consuetudines feudorum*. Fols 1–3 added, with an early index on fols 2v–3v.

PROVENANCE: Durham Cathedral since at least the 14th century. Fol. 2 inscribed: *Istud parvum vollumen est trium puerorum de Insula, scilicet Henrici, Ricardi et Johannis fratrum.* Magister J. de Insula appears in the Durham accounts in 1299 and 1333–34, while Magister Johannes de Insula was presumably buried at the Cathedral's expense in 1324–35. Fol. 3v: *liber sci. cuthberti parvum Volumen de comuni libraria monachorum dunelmensis*; fol. 4: *2B: parvum Volumen de comuni libraria monachorum dunelmensis in le spendiment*, both are probably 15th-century inscriptions. Notes on 1v: *Parvum volumen* and *Cautio Willielmi Lumly, Willielmi Hamsyterly et Thome Spens expense in cist⁰ de Gyldeford.+ ii martii in fastio sci johannis baptiste anno domini M⁰ ccc⁰ lxx⁰ viii⁰.* The reference to the Oxford Guildford chest indicates that the volume, or at least its index, was in Oxford then, but this and two of its sister manuscripts were precisely catalogued in Durham in 1391. Neither scholar is certainly recorded at Oxford, but a canon of Durham was supporting a student called Thomas de S. at this period,[1] and the Cathedral also sent manuscripts to Durham College at Oxford.[2]

TEXT: Bolognese, or Paduan, *c.* 1275–85.

It is written in a broad *littera bononiensis*; the gloss is slightly tighter in proportion and spacing, but both scripts are of mature character. *Lemmata* are alphabetically keyed to the text. The catchwords are framed in boxes or by light foliate ornament.

ILLUMINATION AND DECORATION: Bolognese, *c.* 1275–85, by two related workshops.

The rich illumination allowed little scope for decorative penwork, though the blue initials to the chapters of the *Tres libri (Codex,* Books X–XII) have simple red line filigree. Unusually, the gloss does not have decorated initials.

Each major section originally had a single-column frontispiece, with *bas-de-page* enrichment when the gloss left space. All titles to the text have illuminated initials, often with figures; some initials are extended into the lower margin. The **I**s are treated as human grotesques.

Fol. 4, *Institutiones,* Book I, The Emperor Justinian Establishes the Rule of Law in the Reconquered Empire. The frontispiece shows Justinian enthroned between a group of soldiers and lawyers with their clients in 13th-century dress (Pl. 11a). A hanged man provides the initial **I**[*mperator*], expressing more bluntly than usual the imposition of Roman law on conquered peoples. A dragon leads into asymmetrical foliage scrolls set within the text; they hold birds and a scene of a fish being hooked by an angler, perhaps a reference to the hunting of wild creatures at Book II. The sketchy and lively style of the *bas-de-page* contrasts with the main scene, which is tightly packed with angular figures.

The secondary illumination to the opening book includes a bearded man turning into a leaf mask (4v) addressed by a bird-headed priest with chalice (5); composite figures of men and dragons (6); dome-heads (6, 10v) including a squatting one (9); a striding naked man (6v); a lawyer with a girl accompanying *De tutelis* (on tutelages) (10v); several fish-heads (9v, 11v) and a dog-head (11v).

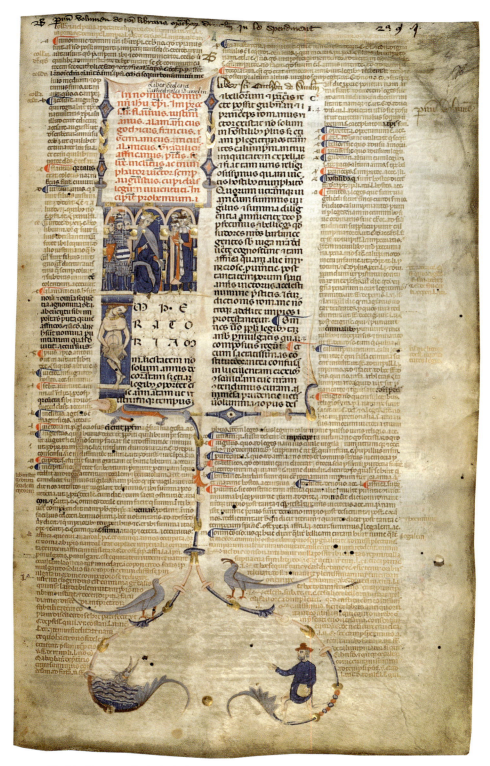

Pl. 11a. Durham Cathedral, Chapter Library MS C.I.4, *Parvum Volumen*, fol. 4:
The Emperor Justinian Establishes the Rule of Law in the Reconquered Empire

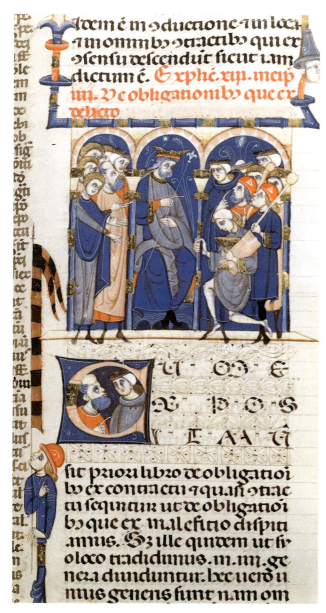

Pl. 11c. Durham Cathedral, Chapter Library MS C.I.4, *Parvum Volumen*, fol. 136: lion-mask grotesque

Pl. 11b. Durham Cathedral, Chapter Library MS C.I.4, *Parvum Volumen*, fol. 56: Book IIII, Obligations Arising from Wrong-doing

Fol. 15, Book II: frontispiece cut out; the remaining initial has a human-headed dragon with a pointed cap. Distinctive features of its illumination include a pair of moon-faces frontal and profile (19), a squatting dome-headed man (20) and a succession of *bas-de-page* foliate scrolls with magpies, blue-birds, kite-shaped knots and a moon-face (34–37).

Fol. 37, Book III: frontispiece cut out; what remains is a blue-headed monster with a dog leaping between lion-masks. A dome-head and

a giant severed head of Goliath are particularly striking (46v).

The following gathering (54–63) was illuminated by another artist, whose secondary imagery is largely confined to serious male figures, aged men in profile (54) and monks and lawyers in three-quarter view (55, 58).

Fol. 56, Book IIII, Obligations Arising from Wrong-doing: The frontispiece depicts Justinian enthroned between a group of courtiers and a kneeling thief, holding a chalice and a book,

167

Pl. 11d. Durham Cathedral, Chapter Library MS C.I.4, *Parvum Volumen*, fol. 197v: a large moon-face

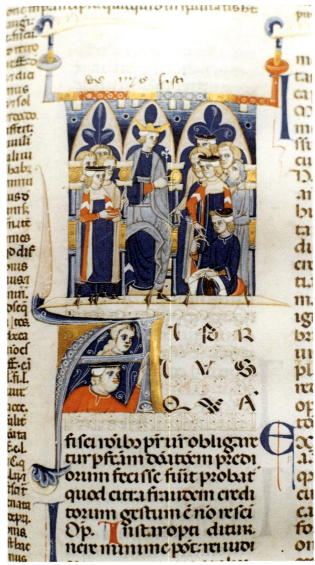

Pl. 11e. Durham Cathedral, Chapter Library MS C.I.4, *Parvum Volumen*, fol. 216: Book X of the *Codex* (*Tres libri*)

with sergeants and bystanders above (Pl. 11b). A soldier holds a pennant in the margin. In the initial a bearded man instructs a lawyer. The *bas-de-page* has been stolen.

Fols 67v, 69v, 70v have bird-inhabited scrolls at the foot of the page and hooded human-dragons above (68v, 69v), by the main artist.

Fol. 74v, *Collatio* I (*Authenticum*), Concerning Heirs and the Falcidian Reservation: Justinian is shown enthroned between courtiers; he is addressed by a lawyer on the right with a youth on the other side. A blue horse-headed grotesque frames the text on the left,

and a youth occupies the text initial. The *bas-de-page* has been partly robbed, leaving twin foliage scrolls and an ink drawing of feathers.

There are no frontispieces for *Collationes* II–V; *Collatio* VI (145) has had three areas of decoration cut away, leaving a double-bodied bird in the centre. The remaining illumination of these gatherings, however, is enlivened by numerous grotesques. Notable figures include a grimacing long-necked figure revealing a naked leg (78); a standard bearer and a strutting horned deer (80v, 160v); a menacing soldier (82v, 103) translated into a grinning grotesque

168

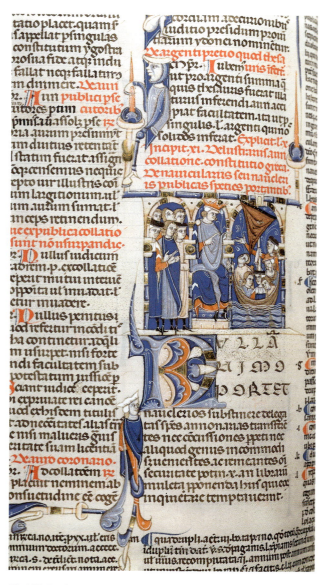

Pl. 11f. Durham Cathedral, Chapter Library MS C.I.4, *Parvum Volumen*, fol. 236v: Book XI of the *Codex:* On the Transportation of Public Goods

on fol. 41 of the *Codex* (MS C.I.6). Other grotesques include a half-naked figure with flowing hair (85v, 134v); a sermonizing dog-headed man (89); a bird pecking at the foliage scroll from an armed figure (99v), matched by another soldier (100); a naked dome-headed man with a bladder-like hat (101v); a lawyer and a snarling dog (103); a blue horse-headed soldier (127); and among several bird-headed grotesques (106, 108, 111, 114, 131) a stork-billed soldier with a smirking moon-face (130).

The *Volumen* Master's grotesques have dialogues occurring between several initials: a doghead is addressed by a pseudo-clerical soldier holding a chalice (132v–133), and a man mimicked by a swan or goose is matched by a lion-mask putting out its tongue on the opposite page (136v–137, Pl. 11c).

Fols 137v–197v contain more spirited grotesques. A leaf-face blows a trumpet towards a despairing figure (138); a priest holds up a large dripping candle (142); and a man presents a book to a dog-headed grotesque (143v–144). Traces of a tower and two-bodied dragon and bird remain on fol. 146. Other figures include a bird holding a banner (156v); an archer (158v); a man holding a cross (180v) and another who blows three trumpets (194v). On fol. 197v a remarkably large moon-face with a desperate grin is set in foliage emanating from a man holding a sword (Pl. 11d). There are a variety of birds (142, 153v, 175, 194); their highly rhythmic placing in pairs on the *bas-de-page* (144, 175) is characteristic of the *Volumen* Master.

Fol. 216, Book X of the *Codex* (*Tres libri*) depicts Justinian, enthroned between lawyers and courtiers, directing a lawyer who instructs a notary (Pl. 11e). A girl and a clerk occupy the text initial. The titles have many beak-headed and dome-headed grotesques (218v, 234), long-nosed (227v) or flat-nosed faces (234, 242) and a series of grinning orange cows (232v, 233).

Fol. 236v, Book XI, On the Transportation of Public Goods: Justinian, enthroned with lawyers and courtiers, instructs the captain of a ship, in which a lawyer is seated amongst its passengers (Pl. 11f). In the margin is another

169

Pl. 11g. Durham Cathedral, Chapter Library MS C.I.4,
Parvum Volumen, fol. 246: lower tumbler, shouting figure and
bas-de-page

Pl. 11h. Durham Cathedral, Chapter Library MS C.I.4,
Parvum Volumen, fol. 268: Book XII, On Dignities

lawyer. The book is preceded by several titles
with grotesques: half-length martial figures,
squatting naked figures and a long-necked bird
holding a falchion.

Among the grotesques in the gathering are a
vermillion cow-headed figure mocking the
lawyer (241); a double initial with a naked tum-
bler opening the prohibition on gladiators; a
shouting and gesticulating dome-headed man;
and a large crow pecking at foliage (Pl. 11g).

Fol. 268, Book XII, On Dignities: Justinian
is shown enthroned, placing a consular crown
upon a kneeling courtier. In the *bas-de-page* a

man fires an arrow at a cockerel, and an eagle is
in the centre (Pl. 11h). A typical group of
grotesques, especially blue animal-heads, con-
clude the decoration of the volume.

This is the work of two related workshops or
perhaps a principal artist aided by close assis-
tants; a finer but more cautious hand close to
the Master may have been responsible for the
later frontispieces. The *Volumen* Master is the
second hand in the *Codex* (MS C.I.6, Cat. No.
12) and was perhaps also responsible for writing
the *Decretals* (MS C.I.9, Cat. No. 13); drawings

of fish that decorate catchwords in the *Decretals* are similar stylistically to the fish on fol. 4 of the *Volumen*.

In the first pages of the manuscript the *Volumen* Master uses a more painterly technique, with a light raspberry pink flesh tone and emphatic red lips. His eyebrows are arched towards the centre of the forehead, unlike his associate who uses eyebrows that arch concentrically. In the Master's other work, or possibly the work of an outstanding associate, the drawing dominates, and the eyebrows are large and angular with a strong blue shadow. Animal heads crisply shaded in two-tone blue are another notable trait of this artist/workshop.

The *Volumen* Master's figures, characterized by bony and jerky limbs, point emphatically. Their animation gives way to the wild humour seen in the grotesques. No artist demonstrates more clearly how the humour of Bolognese illumination of the later 13th century could capture the imagination, and helps explain why it was widely emulated in academic art across Europe around 1300. His distinctive dome-heads prob-

ably directly inspired those by the Jonathan Alexander Master in the *Decretals* (333–334v).

The second artist, who was also responsible for fols 184–193 of the *Codex*, is a close, presumably younger, colleague despite a clearly distinct drawing style and expressive tone. His technical treatment of complexions and the layout of his illustrations is entirely compatible with the principal artist. Both artists share grotesques and a common decorative idiom, notable in the framing of frontispieces and in the foliage staves punctuated by gold bars.

The illumination shows the intensely expressive possibilities of a humorous decorative system that is also elegant in its good quality pigments and general command of linear rhythm.

RG

1 Cobban, *Medieval English Universities*, p. 175.
2 One of the 14th-century Durham inventories lists manuscripts sent by the Chancellor John Wessington, the Prior John Barton and William Poklington; Raine, *Catalogi veteres*.

Cat. No. 12
Durham Cathedral, Chapter Library, MS C.I.6

Justinian, *Codex*
Accursius, *Glossa ordinaria*

Manuscript, parchment, 315 (309 + 20 bis, 27 bis, 250 bis, 254 bis, 290 bis, 304 bis) fols, 455 x 285 mm, the text written on fols 3–305, in 4 columns, *c.* 360 x 245 mm, the text in 2 columns, *c.* 240 x 140 mm, blind or very lightly ruled, in 10s with 2 added folios of indices at beginning and a gathering of 4 fols added at the end; the opening gathering in 9 of 10, fol. 6 bis robbed. Part I ends in 6 on 175va; Part II opens in 8 of 10, the first and last leaves of the gathering have been robbed; fols 214–222 in 9 of 10, the last leaf robbed, and ends in 10 on fol. 305. The later sheets have been cropped at the foot and occasionally robbed. The gatherings are irregularly foliated, the first ending at fol. 11, the second fols 12–20 bis, the third fols 21–29 (with 27 bis); fols 1–2 added, with 14th-century indices, fols 306–309, 4 smaller 15th/16th-century leaves added from a manuscript in a bastard script.

PROVENANCE: Durham Cathedral since at least the 14th century. Fol. 3: *A. Codex glo de comuni dunelmensis in le spendiment*; *A. Codex glo de comuni monachorum*, both probably 15th-century inscriptions.

TEXT: Bolognese, or Paduan, *c.* 1275–85.

It is written in a broad *littera bononiensis*; the gloss is slightly tighter in proportion and spacing, but both scripts are of mature character. *Lemmata* are alphabetically keyed to the text. The catchwords are framed in irregular penwork borders or occasionally by grotesque animals. The original scribes allowed considerable space for the addition of later glosses, which have been added extensively from the opening page onwards.

ILLUMINATION AND DECORATION: Bolognese, *c.* 1280–85, by two related workshops or artists; completed in (Southern?) France and perhaps England, *c.* 1290–1300, by the Jonathan Alexander Master and a second Northern illuminator.

The rich illumination allowed little scope for decorative penwork. The blue initials to the chapters of the *Codex* have simple red line filigree, which was originally plain but was elaborated with extra loops in the parts worked later; in some of the gatherings illuminated by the Jonathan Alexander Master this was executed after the illumination. Unusually, the gloss does not generally have decorated initials; on fols 8–14, however, the gloss, rather than the text, has both rubricated titles and illuminated initials, and is extensively framed in red and blue ink with foliate flourishing.

Each book was probably given a one-column frontispiece, but several of the opening pages to the Books have been robbed. There are *bas-de-pages* to the Preface and Book IV. Almost all titles to the text have illuminated initials; these are generally **I**s (*Imp., Idem*) with human-based grotesque figuration.

Fol. 3, The Promulgation of the Law Code: Justinian enthroned addresses a servant carrying books while lawyers look on (Pl. 12a). One lawyer holds on to the border, a distinctive illusionistic touch of this artist. In the *bas-de-page*, a magpie is threatened by a winged putto with a giant axe, while on the other side a naked youth clutches foliage.

The frontispiece and the rest of the first gathering are illuminated by the *Codex* Master. His sketchy but confident drawing of foreshortened faces is striking in the naked warrior holding a buckler (3v) and the priest holding out a book (7). On the opening folio he gives his marginal figures a ruddy flesh tone also present in the frontispiece. On fol. 10 a naked youth holds a large shield and a weapon that confuses a poleaxe and a spear.

Book I: There was probably a major frontispiece; the leaf originally between fols 6 and 7 has been robbed.

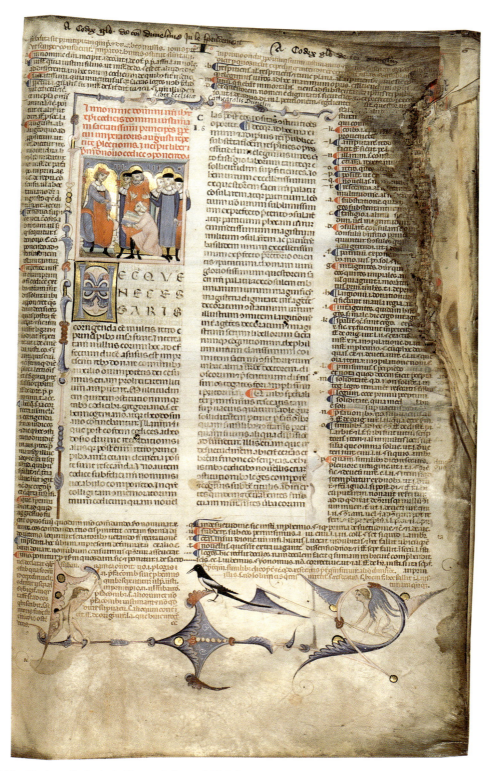

Pl 12a. Durham Cathedral, Chapter Library, MS C.I.6, *Codex*, fol. 3: The Promulgation of the Law Code

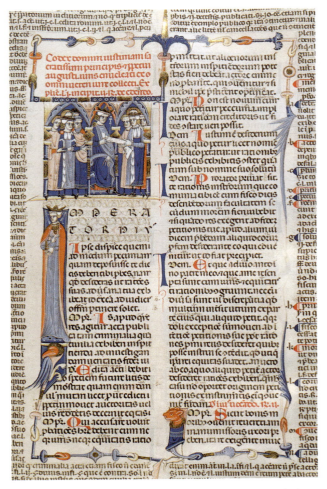

Pl. 12b. Durham Cathedral, Chapter Library, MS C.I.6, *Codex*, fol. 44: Book II, Bringing an Action

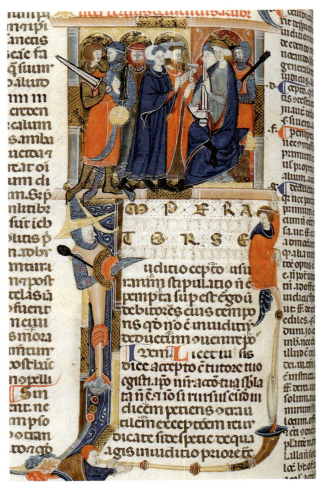

Pl. 12c. Durham Cathedral, Chapter Library, MS C.I.6, *Codex*, fol. 68v: Book III, On Judgements

Most of the Bolognese work in the rest of the manuscript is by a second artist, who was also the main hand of the *Volumen* (MS C.I.4). His work is evident in the gatherings from fol. 12 on. Characteristic images of this artist follow: animal-headed figures addressing each other (17v–18); a youth in a tall pointed hat holding his penis (18v); a bird devouring a blue fish and a scowling man introducing *De hereticis, manicheis 7 samarithiis* (on the removal of civil rights from heretics, Manichees and Samaritans) (19v) and a menacingly armoured figure (20v) like those in the *Volumen* (82v, 103).

A merchant wearing a hood extending like branches or antlers (21) introduces the next gathering, followed by several soldiers (22,

23v–24). It is this point, on fol. 23v where a secondary gloss was added, that marks the beginning of the illumination by the Jonathan Alexander Master. He opens with a smirking old man wearing a summer hat, intended to echo the other profile figures in the text above (23v). His linear face suggests more of a Parisian/Toulousan style than most of the Master's work. A number of foliate letters to the secondary gloss by the Jonathan Alexander Master appear in the following pages.

A series of martial and other figures by the *Volumen* Master appear on the following pages, including a woman with wimple (26v), a woodcutter (33); and a striking figure (36v), reprising an earlier motif (25v), who holds his hand to his

brow as if surveying the horizon. A knight with a nasal guard holds a begging bowl (37); a group of figures in pointed hats and a crowned figure splaying his naked legs are joined by two bird-headed warriors (39v–40). The wildest of them all is an orange grinning moon-faced warrior, biting the hood that forms his shoulders (41). A man wearing a leg for a hat and a king follow (42), and a bird with a long beak and a soldier with wings for a cloak anticipate the frontispiece to Book II.

Fol. 44, Book II, Bringing an Action, shows Justinian enthroned and flanked by a pair of lawyers, in miniver-lined robes and hoods, each leading a group of laymen (Pl. 12b). Justinian receives a plea from the leader on the right. A crowned figure of Justice stands above an eagle with hooves in the text initial. A lion-headed cleric introduces the second title, and the whole of the text is framed with foliate staves. In the added gloss on fol. 51v the Jonathan Alexander Master imitates the bird beaks which abound in the preceding gatherings.

Fols 60–89 comprise three gatherings illuminated throughout by the Jonathan Alexander Master in a softer palette and in a manner distinct from any Bolognese artist. Fol. 60 has a blue cow-headed cleric obviously copied from the Bolognese master, but given a distinctive simpering expression. There are numerous bird- and hog-headed creatures, duck-beaks and human figures, including a blue-faced merchant, a soldier with blue mail, blue-faced humans with domed heads or pointed hats and snake-like necks.

Fol. 68v, Book III, On Judgements: A two-part composition, by the Jonathan Alexander Master, shows a group of lawyers and soldiers gathered before the Emperor. Flanking soldiers holding a mace and a sword enforce the martial tone of the scene (Pl. 12c). In this gathering, the Jonathan Alexander Master provides mainly human grotesques interplaying with animal monsters. For the following gathering, which has few titles, he offered no new inventions; the *Volumen* Master introduces some distinctive figures into the next gathering: a man brandish-

Pl. 12d. Durham Cathedral, Chapter Library, MS C.I.6, *Codex*, fol. 99v: On Hereditary Actions

ing a leg (90v), a gurnard-headed humanoid (91v) and a dome-headed male sphinx (93).

Fol. 93v, Book IV, On Sworn Oaths: The Bolognese *Volumen* Master shows Justinian enthroned in the centre, flanked by a pair of lawyers, each leading a group of laymen, and receiving a plea from the leader on the right. A vermillion bird-headed grotesque, a parody of the imperial eagle, introduces the text. In the foliate spirals of the *bas-de-page*, a naked youth spears a red boar with a white band around its midriff, suggesting a heraldic association.

On fol. 99 the work of both artists is vividly

175

combined. In the text the *Volumen* Master painted a blue frontal donkey-face and a blue angular dome-head, rather like an Easter Island sculpture. Below, in the secondary gloss the Jonathan Alexander Master painted a grey bird-head with a sun hat (Pl. 12d). The *Volumen* Master provided several vivid inventions to inspire the later artist in the following pages: a severed leg confronted by a bodiless dome-head, like Humpty Dumpty (99v); a soulful knight (100); a bird wearing a blue face for a chest (101); a pointed dome-head (104v); a blue horse-headed dragon (106v) and a profile face whose extremely long nose is used to point out the title (107).

Fols 110–119 form another gathering illuminated by the Jonathan Alexander Master and open with a trumpeting blue-faced figure. Across fols 116v–117 a man in a hood admonishes a donkey-headed figure.

Fols 120–129 are by the *Volumen* Master: another Humpty-Dumpty figure (120v); a remarkably restrained bishop (121); a priest confronted by beak-heads and a soldier (121v–122); a pink-pig-faced grotesque, accompanied by a lawyer and a youth (123), and the familiar cast of trumpeting youths, dome-heads and biting beak-faces which follow to the end of the gathering. The blue fish-headed monster trailing naked legs on fol. 129v is addressed by a hairy cleric on fol. 130 that opens a gathering by the Jonathan Alexander Master.

Fol. 133, Book V, On Betrothals and Marriage: The frontispiece by the Jonathan Alexander Master depicts a wedding, with the groom placing a ring on the finger of his bride (Pl. 12e). Women behind look at the men standing in front of a church. A figure on the right, a father or perhaps a lawyer, turns aside to comment. In the centre a priest oversees the marriage, making it an ecclesiastical union in contrast to Bolognese iconography which in a civil law text would show a lawyer creating a civil one. The scene is compositionally very different from the Fitzwilliam *Decretals* (MS McClean 136, Cat. No. 14) by the same artist, in which the couple kneel before a marriage pall.

A knight leaning on his sword decorates the initial, his body tapers to become a foliate swag that connects him to a trumpeting soldier in the margin. The *bas-de-page* has been cut out.

Notable grotesques in this gathering by the Jonathan Alexander Master include an eagle-headed figure bitten by a cat looking up at a juggler (133v); a blue-faced witch holding up a scroll accompanying *De incestis*, on incestuous and invalid marriages (138v); and another blue-faced figure (139v) whose foliate tail is designed to match the dragon-headed grotesque by the Bolognese artist (140).

The gatherings of fols 140–149, 150–159, 160–169 are illuminated by the *Volumen* Master, interspersing bird-heads of all colours with naked, martial and crowned figures. The Jonathan Alexander Master emulates Bolognese fish initials in the glosses on fol. 161.

Book VI: The frontispiece originally between fols 175 and 176 is missing, along with the first and last folios of the gathering (176–183); it was presumably by the Jonathan Alexander Master.

Many of the grotesques in this gathering by the Jonathan Alexander Master show the influence of the Bolognese illuminators. The *Volumen* Master's cow with long blue horns like antennae on fol. 165v is followed by the Jonathan Alexander Master's version (178). Warriors, a griffin-headed priest and a human follow (178v–179). Snake-necked grotesques include a figure with a dome-head corrugated in a manner typical of the artist but not his Italian models (179v).[1] A lively group of bending humans include a man holding a human mask framed by leaves (180), a favourite motif of the artist, with a foliate tail held by a squatting naked soldier with hooves. Armed soldiers, knights and animal figures battle between the initials (181v–182).

Fols 184–193 are by the second Bolognese artist of the *Volumen*, fols 54–63 (Book IIII). His profiles with round shaded eyes are distinctive and his particularly effective begging grotesque with a long shark or dolphin beak on fol. 192 (Pl. 12f) reappears in the Jonathan Alexander Master's version on fol. 205 of the

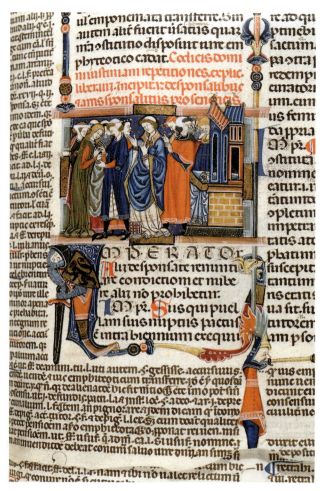

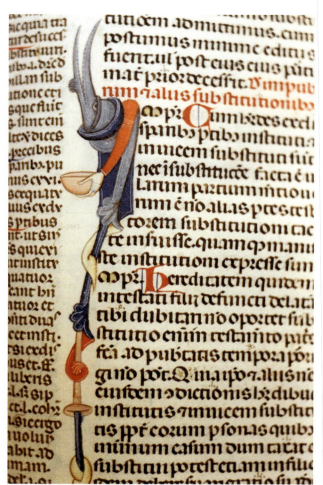

Pl. 12e. Durham Cathedral, Chapter Library, MS C.I.6, *Codex*, fol. 133: Book V, On Betrothals and Marriage

Pl. 12f. Durham Cathedral, Chapter Library, MS C.I.6, *Codex*, fol. 192

next gathering. The hoofed soldier with pointed helmet on fol. 190 is copied by the Jonathan Alexander Master on fols 194, 200 and 220v. Again certain Bolognese figures probably inspired the work of the Jonathan Alexander Master in the secondary gloss. The Bolognese artist's walrus-like version of the bovine head on fols 185v and 193, in particular, seems to have motivated the Northern master, who provided a bird-head to the secondary gloss on fol. 185v and added a linear version of the cow-headed dragon on fol. 202. In the gathering of fols 194–203 the Jonathan Alexander Master appears to be consciously copying the narrow faces of the Bolognese artists, especially the second. However, he uses a different palette of

bright reds with modelling in pale washes unlike his own or the Bolognese artists' normal technique. The tentative execution suggests that this was perhaps the first gathering on which the artist worked; there are gaps in the finished Bolognese illumination, and there is no strong evidence that he worked through the manuscript from the beginning forwards.

Fols 204–213 have illumination more typical of the Jonathan Alexander Master's mature work, while that on fols 214–223 is similar to the previous gathering. The figures are restricted to some extent by the narrow spaces left for the initials; elsewhere the artist expanded them into the margins. Notable grotesques include youths with horse's hind quarters (204v–205); blue

177

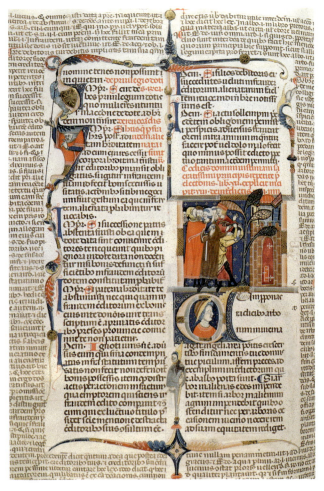

Pl. 12g. Durham Cathedral, Chapter Library, MS C.I.6, *Codex*, fol. 257v: Book VIII, On Interdicts

horse-headed priests (207, 211v), similar to the Bolognese sources; a master and donkey (209v); a beaked fish-head with fins like dragon wings on its head (215v), a characteristic invention of the Jonathan Alexander Master; and a soldier (217) with a shield similar to one on fol. 41. There are many bearded, middle-aged men holding a book and looking to the previous column. Various playing figures, including a crowned man riding his own horse-legs (222), strongly recall Michael Camille's view of grotesques as mumming figures.[2]

Book VII: The frontispiece, originally between fols 222 and 223, the last leaf of its gathering, has been stolen. Much of the remaining illumination has slender figures and the paler colour washes of fols 194–203 and 214–223. Characteristic touches of the Jonathan

Alexander Master also appear: a profile leaf-mask as half-man, half-goat with similar figures following (243v, 244v–245), and sphinx-type creatures (245v). A classic confrontation between a knight and a rabbit is given the artist's distinctive mumming treatment with the special twist that the rabbit (or hare) is holding up the blue head of a greyhound (247v–248). Blue faces dominate the gathering.

The Jonathan Alexander Master's last gatherings, fols 252–260, 271–296v, have the same large fleshy figures found in fols 176–183. A trumpeting youth baring a donkey's tail towers over a naked mother and child (252v); angry old men with falchion and sword confront younger men, while a lion gnaws a bone and an ox sounds a trumpet and a bell (254 bis v–255).

Fol. 257v, Book VIII, On Interdicts: The

178

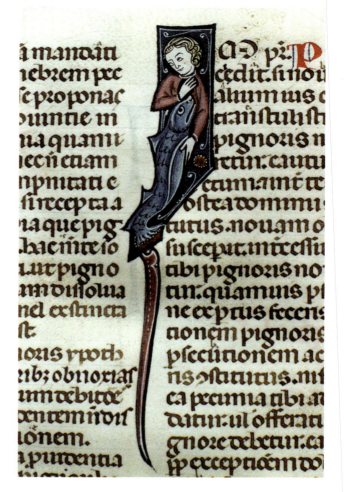

Pl. 12h. Durham Cathedral, Chapter Library, MS C.I.6, *Codex*, fol. 267v: the holding of pledges

frontispiece by the Jonathan Alexander Master depicts a man chopping down a tree threatening a castle (Pl. 12g). The clearance of trees around defences was a real concern but not a feature of Italian iconography where the threatened building is usually less military in character. Amongst the group of onlookers, a couple argue with a man in a berretta who is probably a judge or lawyer responding to their dispute. A bust of a youth in profile, wearing a peasant's hat, occupies the text initial. The text is framed with foliage at the top and bottom of the page, linking up with a warrior giving a sermon for the previous title.

Fols 252–261 contain the Jonathan Alexander Master's most mature, comic and fantastic, or even obscene, nudes. A succession of these gesticulating or squatting figures appear on fol. 258, including one who pulls off not only his shirt but also his head. An old man with a book has a swan-necked winged youth as a helm-crest (259). On fol. 259 the first figure, holding his own head and a hawk, has an eagle head emerging from the neck of his shirt; the second figure plays a harp; the third figure bows a bagpipe like a violin; the fourth, naked except for a hood, clutches his helm and a lance, and rides a bird; the fifth, wearing only a cloak, sprawls back into the text.

Fols 261–270 make up a gathering illuminated by a completely different artist, Northern French in style though perhaps working in Toulouse or Oxford. His figures often have lion- or dragon-like legs and claws. Notable figures include a priest drinking from a bowl (262); a leering cat, the artist's most characteristic

179

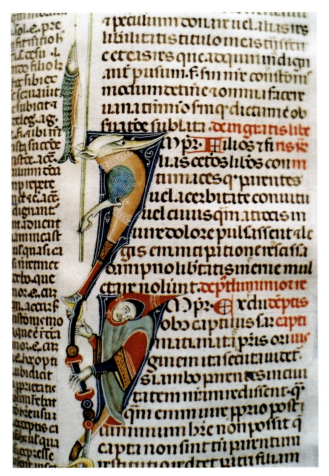

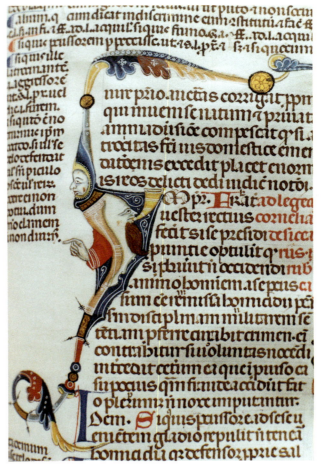

Pl. 12j. Durham Cathedral, Chapter Library, MS C.I.6, *Codex*, fol. 281: on ungrateful children

Pl. 12k. Durham Cathedral, Chapter Library, MS C.I.6, *Codex*, fol. 294: the Cornelian law on assassins

motif (266v, 270); and figures brandishing swords (264v) or leaf stems with a phallic-shaped tip (266v). On fol. 267v a sentimental youth embraces a fish (Pl. 12h).

Book IX: The leaf with the frontispiece has been robbed from between fols 287 and 288.

Fols 271–296v make up the last gathering illuminated by the Jonathan Alexander Master with some of his most extravagant imagery: a wild youth with flying hair reads from a scroll (280v); a fish-headed, horse-hoofed monster has caught a fish but is himself held by a man forming the next initial (281, Pl. 12j); and a series of monstrous bending figures brandish falchions, clubs, even a book (293v–294), including one with a huge horn-blowing moon-

face with a hoof for a chin on its behind (Pl. 12k).

Fols 297–305 close the manuscript altogether more quietly, with initial figures and limited foliate flourishes by the North French Master. Certain figures, however, seem influenced by the imagery of his more disorderly colleagues such as a bishop with a triple-pointed mitre (300v), perhaps a reflection of the earlier triple-horned cow (178), and a dragon-tailed trumpeter (304v).

This is the richest manuscript of the whole Durham set for its variety and fantasy of invention, the product of five fine artists of different traditions. Three Bolognese artists were in-

volved. The artist responsible for the opening gathering, the *Codex* Master, has a distinctive palette and a classicizing taste for nude figures and profile faces. The second artist, the *Volumen* Master, was responsible for fols 12–59, 90–109, 120–29, 140–69, and may have been the scribe in the *Decretals* (MS C.I.9, Cat. No. 13). The third one, who also illuminated fols 54–63 (Book IIII) of the *Volumen*, decorated the gathering of fols 184–193, presumably at a similar date.

The manuscript is probably the first of the set on which the Jonathan Alexander Master worked, illuminating the added glosses and moving on to complete substantial sections omitted by the Bolognese artists.

The North French or English artist who completed the manuscript with two gatherings does not appear in the other volumes of the set. His style and palette are very different from both the Bolognese artists and the Jonathan Alexander Master. Firm neat lines define compact figures with small faces and daintily drawn, unmodelled features, as in 13th-century Parisian and North French work. The dress is drawn in vertical tubular folds more typical of the 1240s and 50s, and coloured in brick red, dull blue-green and cool dark blues. These are features found in certain Toulousan manuscripts and also in English illumination of William de Brailes and William of Devon, whose Bible (London, BL MS Royal I. D. 1) is notable for its grotesques. Several of the manuscripts associated with the latter have been attributed by Nigel Morgan to the 1260–80 period in Oxford,[3] and he attributes others in a similar style to the North of England and as late as 1290.[4] The 'Parisian' artist's figures fit neatly into the text space, and their vertical lines emphasize the text columns in a manner very different from either the Bolognese or the Jonathan Alexander Mas-

ter. His humorous faces and their attributes, however, clearly reflect the work of the other artists in the manuscript.

The relative sequence of the work of the two Northern artists is not entirely clear. Since the gloss of the two gatherings illuminated by the 'Parisian' artist is not balanced with those of the preceding gatherings, they were written separately, though in a similar hand; the rest of the manuscript had presumably already been passed to the illuminators. They have had some secondary glosses added to them like the Bolognese gatherings, but these are illuminated by the same artist as the text. The sequence of the various artists' styles would suggest that this preceded the final completion of the illumination by the Jonathan Alexander Master, but the consistency of these secondary glosses suggests that the two artists, though of different generations, were working at around the same time.

RG

[1] It also appears on fol. 295 and is a motif shared by the Master's Southern French associate in the Fitzwilliam *Decretals* (MS McClean 136, Cat. No. 14).

[2] Camille, pp. 239–75; Camille's reading is not as yet sufficiently grounded in the wider European (or legal) context to go unchallenged (Gibbs, 'Camille'), but the affinity between the Durham grotesques and the work of the best known artist in the Luttrell Psalter is unmistakable, as is their theatrical effect.

[3] Lilian Randall suggested an affinity to work in a Toulousan or Albigensian Breviary, now divided as Baltimore, Walters Art Gallery MS W. 130 and Paris, BNF MS n. a. lat. 2511; Avril, 'Un element retrouvé'. On the other hand, both Michael Michael and Paul Binski have suggested to me that this artist might be English. The manuscripts associated with Oxford by Morgan, *Survey*, nos 156–64, pp. 148–62, ills 274–318, including the Bible of William of Devon, provide perhaps the closest affinities both for the style and the distinctively firm drawing of the grotesques.

[4] Morgan, *Survey*, nos 172–76, pp. 173–80, ills 359–72.

Cat. No. 13
Durham Cathedral, Chapter Library, MS C.I.9

Gregory IX, *Decretales*
Bernardo da Parma, *Glossa ordinaria*

Manuscript, parchment, 350 fols (2 + 348), 465 x 277 mm, the script in 4 columns, 380 x 235 mm, the text itself in 2 columns, *c.* 230 x 115–125 mm, blind or very lightly ruled, in 10s, the first in 11 leaves of which fol. 4 almost entirely stolen; Part I (Book II) ends in 4 on fol. 157v; fols 237–248 in 12, fols 249–258 in 9 of 10, Part II (Book V) ends in 8 on fol. 305, fol. 305v blank; copied from *pecie*: fol. 42v: *h. fi. xx. CI.*

PROVENANCE: Durham Cathedral since the at least 14th century; it is clearly integral with the other C.I group of manuscripts, though a largely erased ownership on fol. 2, *Iste liber . . .*, does not appear to be that of the De Insula brothers.

CONTENTS: Gregory IX, *Decretales* (3v-305); Innocent IV, *Novellae* (306–30v); Bernardus Compostellanus, *glossa*; Gregory X, *Constitutiones* (321–330); Garcia Hispanus, *glossa* (321–331v); Urban IV, *Constitutiones* (329v–332); Alexander IV, *Constitutiones* (332–342a); Nicholas III, *Constitutiones* (342b–347v); Garcia Hispanus, *glossa*; Clement IV, *Constitutiones* (347v–350); Garcia Hispanus, *glossa*.

TEXT: Bolognese, or Paduan, *c.* 1275–85.

The text and gloss are both in a broad *littera bononiensis*, moderately spaced; the gloss is more tightly spaced. The *Constitutions* forming the last section of the manuscript are in a different redder ink like the later additions to the gloss of the *Codex* (MS C.I.6, Cat. No. 12).

ILLUMINATION AND DECORATION: Bolognese, *c.* 1280/85, by two different workshops, with completions by an Anglo-French artist and the Jonathan Alexander Master.

Each of the books of the *Decretals* and the *Novellae* of Innocent was given a single-column frontispiece and a large initial opening the text, though the openings to each part (Promulgation, Book I and Book III) have been torn out. The added *Constitutions* have a large initial representing the pope.

Each title has an illuminated initial which is frequently figured, though more commonly foliate and accompanied by a marginal grotesque; these are generally extended by staves and foliate swags, which frame much of the text. Initial **I**s are generally treated as human grotesques. There are smaller foliate initials to each title in the gloss, including numerous subordinated chapters, making the borders frequently richer in decoration than the text itself.

The chapter capitals are alternately red and blue with contrasting elaborate early Bible-type filigree, set in the margin. It appears that the rubrication was generally executed after the illumination. In Part II, in particular, the illuminators' foliate staves frequently left insufficient space; narrow initials in a different purplish blue have been inserted by a Northern scribe, showing that the rubrication was unrealized in this part when the manuscript left Bologna. The clash of styles is particularly noticeable at the end of Book IV and in Book V.

A highly distinctive feature of the manuscript is the elaboration of some of the catchwords with pairs of painted animals that match from the end of the gathering to the beginning of the next. Their spirited drawing and painting suggests that the scribe was one of the illuminators: the coloured fish and birds are close in style to the opening of the *Volumen*, while the rather different hand responsible for the squatting man on fol. 73v appears to be the *Decretals* illuminator himself.

Fol. 3v, The Promulgation: The frontispiece has been torn out from the upper left column along with the first initial, **G**[*regorius*]; the initial to **R**[*ex pacificus*] is not illuminated.

Fol. 4, Book I: The leaf has been stolen except for the stump of an illuminated *bas-de-page,* suggesting that this page bore a separate

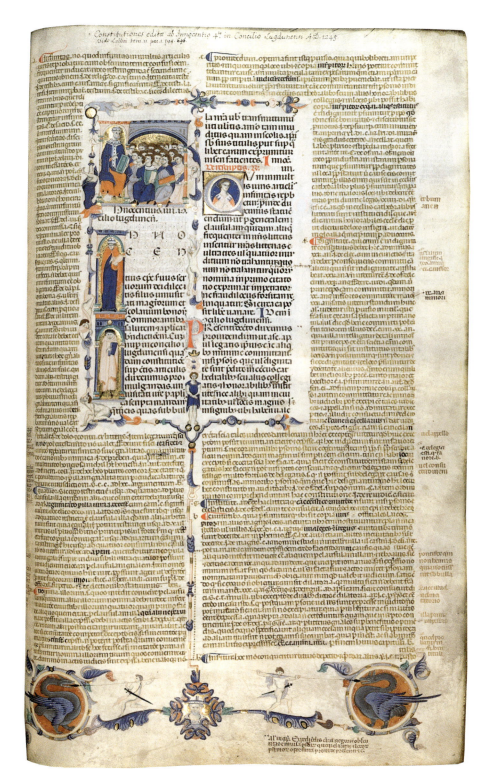

Pl. 13a. Durham Cathedral, Chapter Library, MS C.I.9, Gregory IX, *Decretales*, fol. 306: Innocent V, *Novellae*

Pl. 13b. Durham Cathedral, Chapter Library, MS C.I.9, Gregory IX, *Decretales*, fols 3v–4: the remains of the illuminated double opening

Pl. 13c. Durham Cathedral, Chapter Library, MS C.I.9, Gregory IX, *Decretales*, fols 13v–14: the catchwords between gatherings

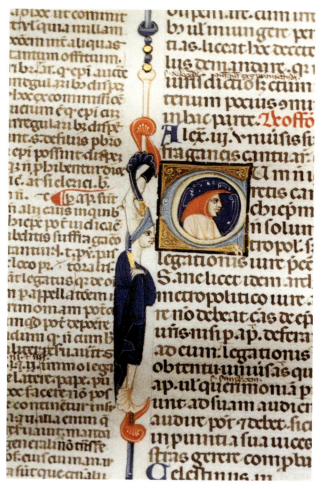

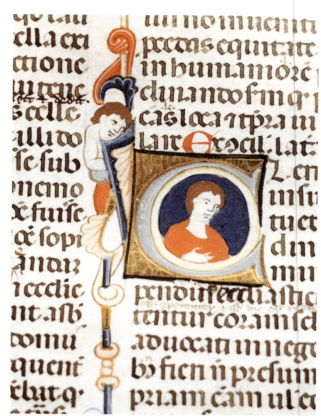

Pl. 13e. Durham Cathedral, Chapter Library, MS C.I.9, Gregory IX, *Decretales*, fol. 78: unfinished grotesques

Pl. 13d. Durham Cathedral, Chapter Library, MS C.I.9, Gregory IX, *Decretales*, fol. 68v: a figure in an exotic humanoid hat

frontispiece to Book I (Pl. 13b), a precocious double-frontispiece on the first opening like that in the copy illuminated by Jacopino da Reggio in the Vatican (BAV, Pal. lat. 629). The text is framed by foliate staves, accompanied by a cleric (3v) and a sprawling naked figure, that continue into the gloss below. In the restricted *bas-de-page*, two seated figures hold out scrolls towards a bare-legged clerical figure squatting in the centre, a scatological touch not untypical of Bolognese academic humour, though perhaps remarkable on the opening page of a canon law text.

The first gathering and the prologue page added before it are illuminated by the main artist, the *Decretals* Master. Marginal figures

include a bust of a priest, a naked half-length soldier with shield (5v), and a priest holding a similar shield (8v). The gathering is related to the next by a pair of fish painted in wash above the unframed catchword (13v–14, Pl. 13c).

Fols 14–43: The next three gatherings, illuminated by the *Decretals* Master, are similar, with numerous gold ground foliate initials and semi-clad grotesques. Notable grotesques include a blue eagle-headed swan-necked figure wearing a chasuble (20v); a bust of a youth and a bird-headed man in a cloak (39); a bald youth, possibly by an assistant (41); vermillion dog-headed figure in cloak (47); a naked man with a long neck in a blue cloak (48v); and a bald and bearded aged man accompanied by a naked

185

dog-head with shield (51v). Elaborated catch-words include a pair of blue birds in wash (23v–24); a pair of blue dragons (33v–34); and chickens with human heads and long ears (43v–44).

Fols 54–73v: The illumination appears to be by the *Decretals* Master himself: a priest hold-ing a book (55); a grumpy cross-eyed and bald-ing man looking from the initial at a near-naked tumbler (55v); a scholar or merchant with coif in profile and another below whose face has been redrawn (56); a youth in profile holding a book (57); a ginger-bearded man and soldier with shield (57v); a similar man with a blue dog-headed dragon (59); a blue bird-head, a youth, an old man and another figure grasping the foliage (59v); a warrior with tall helmet and buckler, a half-naked tumbler and a girl (60); a figure in an exotic humanoid hat, reflecting a scowling hooded figure in the initial itself (68v, Pl. 13d); and a half-naked trumpeter in the gloss initial (72v). Elaborated catchwords are horned dragons, probably drawn by the scribe (53v–54); another pair of calligraphic prancing dragons (63v–64); and a squatting bare legged figure with ass's ears and a hat, echoing the fig-ure on the opening page, but without a counter-part in the next gathering (73v).

Fols 74–83: This gathering introduces a number of blue dog-heads to the gloss, includ-ing a bird-head holding an axe with a dog-head alongside a youth in the initial (74v). The rest of the gathering is marked by unfinished illumina-tions in a particularly crisp drawing style dis-tinct from that of the main artist. Most pages have an illumination: a blue bird-head with a youth reading a book (77); a nude figure accom-panied by a youth (78, Pl. 13e); and a scowling lightly bearded man (81).

Fol. 88, Book II, On Judgements: The fron-tispiece is a three-arched composition with a priest in the centre responding to a lawyer on the left presenting his client and a group of onlookers; another cleric and a group of laymen react. The initial **D**[*e quod vult deo*] has a young woman with a wimple, and is held by a naked youth. These were inserted by a very different

Anglo-French artist along with the foliate fram-ing to the text. The foliate gloss initial is by a Bolognese hand.

The frontispiece falls within the gathering of fols 84–93; the following leaves of this gathering and the next are by a new hand, an assistant close to the Bolognese master. His style is char-acterized by faces with intense, small features and rougher drawing. Among his figures are a bishop or archbishop attended by a naked man (94); a fish-tailed priest with long over-sleeves and a book (96v); a dragon and a naked man, with spotted complexions added by a user (97v); a priest and a lawyer (99); and a half-naked trumpeter (123v).

Fols 124–157: A distinctively different artist or workshop illuminated these gatherings, con-tributing grotesques and foliate initials to the text with prominent white spreading lines in the leaves. Notable figures include a blue-grey dog-headed cleric and a pointing figure in an orange hood in the gloss (126v); animal-heads, vaguely snake-like, ending foliate staves (126v, 128v, 134); a vermillion dog-headed naked figure to the gloss (133v); and a blue-headed figure (134). Similar figures, along with an unusual snub-nosed man (142v), continue to the end of the book; fol. 157v is blank. The catchwords here are plain.

Fol. 157 bis, Book III: The frontispiece and opening initial have been stolen; a naked figure clambers up the remaining foliage stave. Other remaining illumination to the Book includes a naked trumpeter (158v); a tumbler brandishing a mallet and shield and a red-headed and legged dragon forming an **S** (159v); a little dog or bear forms an initial **I** in the gloss (161). The gather-ing is by the main artist again, perhaps assisted, ending with a pair of rabbits accompanying the catchword (166v, 167).

Fols 167–176: The following gatherings repeat the *Decretals* Master's repertoire of gin-ger-haired faces. The features are frequently pinched, suggesting the work of an inferior hand; however, the youths and characteristic plaited knots on fols 167v and 176 are of the artist's best quality. The gathering ends with

Pl. 13f. Durham Cathedral, Chapter Library, MS C.I.9, Gregory IX, *Decretales*, fol. 207: a bishop

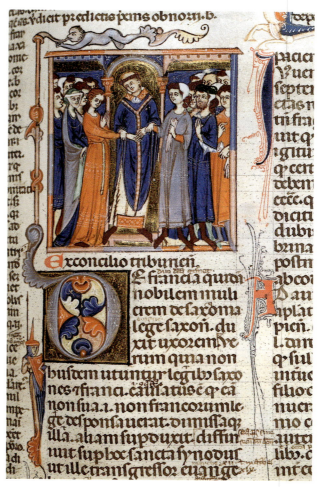

Pl. 13g. Durham Cathedral, Chapter Library, MS C.I.9, Gregory IX, *Decretales,* fol. 226: Book IV, On Marriage

lively uncoloured drawings of storks (176v–177).

Fols 177–186: The same *Decretals* Master's workshop, with variable quality, continued in this gathering. Faces with shading down the back of the cheek, a mannerism not typical of the main artist,[1] appear in the youth in profile of the gloss (177v), alongside lively nude figures (178, 178v, 182, 183). The figures have rather smaller faces and features than before (177v, 180v, 181v). Dragons also enliven the gloss (179, 181v). A foliate **T** with leaf antlers to the gloss and an undecorated catchword end the gathering (186).

Fols 187–206 reintroduce the second workshop that illuminated fols 124–157, here using

poorer pigments, such as a blue-green of less saturation perhaps indigo-based or a diluted azurite, and a vigorous and calligraphic treatment of foliage. The small triangular faces with curving cheek lines are also distinctive. A youth with a shield in the gloss (194v) is similar in drawing to the figure on fol. 142v. There is a series of bishops with triangular faces wearing triangular mitres, typical of this workshop or artist (198), including one accompanied by an unusually young dome-head (204).

Fols 207–216 are mainly by a third artist from an archaic workshop of the 1250s responsible for BAV, Vat. lat. 1412; he paints faces with distinctive pinched cheeks, and impoverished folded-leaf patterns, unlike the more cursive

187

foliage found in the previous pages.[2] Typical of this artist is the initial containing a bust of a bishop with furrowed features (207, Pl. 13f). Other figures include a man with naked legs and no body straddling an initial with a lawyer (208v); and a half-naked priest, illuminated by the main artist (208).

Fols 217–226v: The next gathering reintroduces the unfinished, small featured and sketchy work of fols 75–81, notably on fol. 222v. Fol. 223v has been damaged by water or erasure.

Fol. 226, Book IV, On Marriage: The frontispiece by the Anglo-French Gothic artist shows a priest joins the hands of a bride and groom, each with a family group (Pl. 13g). Most of the bride's party, apart from her wimpled mother, are male, like the groom's party, which is dominated by a man with miniver-lined coat, perhaps the groom's father. The initial is foliate; an armoured soldier is in the margin, and foliate staves surround the whole text. The gloss, however, has Bolognese illumination including a scowling profile face.

Fols 227–236, illuminated by the second workshop, have a series of the triangular-faced and mitred bishops, mostly with very long hooked fingers, including an unfinished version or an assistant's sketch (235), which direct the reader through matrimonial legislation from fols 229v–232v. Other images include a silver-haired figure with similar blue-green shading (233); an angry blue fish in an initial **S** (236v, Pl. 13h); and a bishop and a dragon head (241). The Anglo-French Gothic artist retouched an initial, adding a fine priest in profile and dragon-heads in the staves (241v).

Book V: The opening leaf between fols 248 and 249 has been stolen. Assistants of the main artist were responsible for most of the book, painting smaller heads and features and tighter foliage than the master's own work. The vivid imagery may occasionally reflect the topics of the book. A bishop in the initial to *De hiis qui filios occiderunt* (on those who kill their children) is accompanied by a semi-naked woman in a wimple and a military cloak (265v); a drag-on-priest addresses the foliate initial of *De infantibus et languidis expositis* (on the exposure of children and the sick), with a snake-headed man (266); a young lady accompanies *De crimine falsi* (on the crime of false testimony) (273v); and a man blowing a trumpet emerging from a dragon opens *De sortilegiis* (on witches and diviners) (274v). The *Delicti puerorum* (on the misdeeds of children) are discussed by a half-naked judge addressing a naked warrior wrapped in his shield, and a lawyer or layman is in the initial (275). A cleric and a hooded figure with a vase accompany the gloss, and the *bas-de-page* contains quacking grey geese; the gold bands across their wings match the bars on the staves, a design normally found on more important openings (281v). Other figures are a hooded man with a trumpet in the gloss and a judge or king in the text, taken from civilian iconography (286v); an unusual blessing Madonna in red and a man semi-clad in a coif and an academic cloak formed by foliage (289). On fols 289v–290 there are particularly notable clashes between the foliate staves and the capital letters of the left column along with a duck quacking at a half-naked priest, which has been covered by a capital **P**. The illumination of Book V is stylistically unified, with fussier foliage and smaller figures than those in the opening book by the Master; but the drawing becomes more open and the faces' expressions become sweeter in the course of the book.

Fols 298–305 were illuminated by the Anglo-French artist, generally confining himself to spare foliate initials with folded leaf designs perhaps inspired by Bolognese 'Second Style' rather than Academic Style models; he uses a similar purplish blue against contrasting pale yellow (300) or vermillion ground. Notable figures include a kneeling lawyer in academic robes to *De verborum significatione* (on the meaning of certain words), perhaps an emphasis on its legal nature but unlike Bolognese depictions of lawyers (300v); a series of colourful initials containing a dragon and a smiling trumpeter with a pointed hat in the gloss (301v). A naked figure closes the artist's work in the

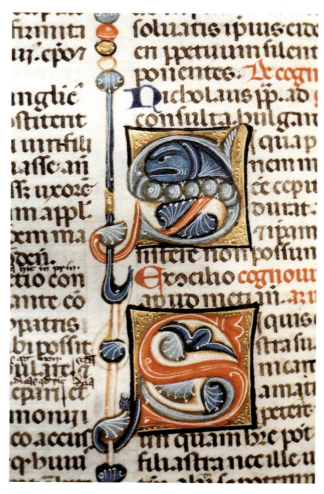

Pl. 13h. Durham Cathedral, Chapter Library, MS C.I.9, Gregory IX, *Decretales*, fol. 236v: an angry fish

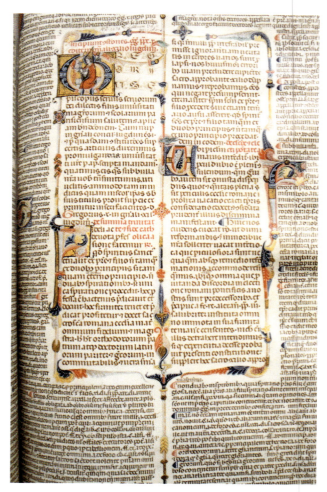

Pl. 13j. Durham Cathedral, Chapter Library, MS C.I.9, Gregory IX, *Decretales*, fol. 321: Gregory X, *Constitutiones*

gloss after a series of foliate initials; the text has the bust of a girl with a figure climbing the foliage beside her (305).

Fol. 306, Innocent V, *Novellae*, is illuminated by the *Decretals* Master. Its one-column frontispiece depicts the Pope addressing a congregation of laymen with a lawyer at the front (Pl. 13a). Pope Innocent is shown again in the initial of the text with a doctor of law below. The foliage staves are articulated by prostrate or tumbling semi-nude grotesques. The *bas-de-page* contains a bust of the Pope in knotwork, surrounded by tondi and birds speared by naked warriors, a conflation of classical, Christian and Siegfried imagery.

There are several characteristic initials by the *Decretals* Master with foliage or busts of young men, women and patriarchs. A notable illumination to *De iudiciis* (on judgements) shows a man in a short tunic *sans-culottes* wearing crumpled boots, carrying a building on his shoulders (309). The 'triangular bishop' artist contributed typical images of bishops or archbishops, wearing vestments adorned with his characteristic pearly roundels (314, 315).

The numerous *Consitutiones* which follow are unusual in their extent. They appear to have been added later with integral glosses, and a more modest iconographical programme than the original manuscript. Their illumination is

189

by the Jonathan Alexander Master, and while his imagery here is more restrained than in the *Codex*, he is still able to spread his mischievous vigour through the final pages. The scribe did not allow for full frontispieces to these, and generally provided small square spaces for the initials; however, the artist often maximizes the space by extending initials into the margin. The initials are typically foliate with figuration confined to the margins.

Fol. 321, Gregory X, *Constitutiones*: The artist emphasised the opening by expanding and extending the initial where Gregory X writes under the direction of Christ, who occupies the initial of the gloss (Pl. 13j). Text and central gloss margin are given a full framing in the artist's exuberant style.

Among the secondary illumination are profile leaf-masks, human faces and busts (322v, 325), and two scholars bitten by a lion head (326v). Academic debate intensifies on fol. 329, with a scholar brandishing a buckler and falchion at another.

Fols 329v–330, Urban V, *Constitutiones*: They are unglossed, with foliate initials; the second constitution has a soldier, a biting animal head and a leaf mask.

Fol. 332, Alexander IV, *Constitutiones*: The initial contains a bust of Pope Alexander blessing; extensive foliate staves enrich much of the text, which is unglossed. Staves contain numerous grotesques: a man blowing a horn (332v); dome-heads and leaf-masks (333, 334v); and a distinctive red-haired man (335v).

Fol. 342, Nicholas II, *Constitutiones*: The small initial holds the bust of a lawyer. Fol. 347 has a foliate initial and stave which ends in a lion wearing a fantastic humanoid cloak.

Fol. 347v, Clement IV, *Constitutiones*: The initial contains a bust of the Pope wearing a bishop's mitre and blessing, while a soldier rises from its background (Pl. 13k). Other illumination includes an unusual square quatrefoil initial and foliate stave topped by a long-beaked bird-head and ending in a dragon head (348); a woman with dragon wings (348v); a scowling solder with a shield and falchion (349).

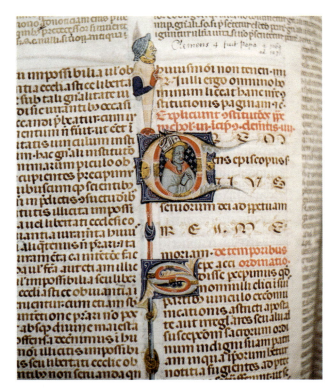

Pl. 13k. Durham Cathedral, Chapter Library, MS C.I.9, Gregory IX, *Decretales*, fol. 347v: Clement IV's *Constitutiones*

The manuscript's illuminators include two Bolognese artists not employed elsewhere in the set: the second hand of the triangular bishops' faces and blue-green foliage, and an older artist from the first stage of the Academic Style, the Vat. lat. 1412 Master or an assistant, responsible only for the gathering of fols 207–216. The *Decretals* Master also worked with at least one assistant absent from the other volumes of the set.

Altogether more important for its final appearance is the artist with a cursive High Gothic technique close to that in the early 14th-century English manuscripts influenced by French illumination, particularly the Queen Mary Psalter (London, BL MS Royal B II. 7) and associated manuscripts.[3] The overall symmetry of the compositions and the swaying figures with long trailing legs found in the frontispieces to Books II and IV of this manuscript have parallels in the portraits of saints in the

190

Hours of Alice of Reydon (Cambridge, University Library MS Dd.4.17). The flowing draperies and sketchy drawing of the figures give them a different appearance from Bolognese work. The decorative elements of this artist's page layouts match the overall design of the Bolognese ones, but he uses an emphatic brown ink outline and lighter colour washes, as well as simpler and broader foliage forms than those painted by the Durham Bolognese workshops.

Despite the loss of its major frontispieces, the iconography of the manuscript is almost as rich as the other volumes in the set; its decorative programme is arguably richer. The illuminated initials to individual Titles' are not usually related to their subject, but possible, though generic, exceptions occur in the ominous, naked or gender-relevant figures in some the of the criminal cases of Book V; none of these figures diverges from the general range of grotesqueries, however. This contrasts with the highly specific programmes in two of Jacopino da Reggio's copies contemporary with the later stages of this manuscript's illumination, Vatican City, BAV, Pal. Lat. 629 and Chantilly, Musée Condé MS XVIII E. 1. Even in its depleted state, however, MS C.I.9 is one of the most significant surviving copies of the *Decretals* before Boniface issued his *Liber sextus*, both for its texts and their lavishly enriched presentation.

RG

[1] Cf. Cat. No. 4 at n. 1.
[2] Kuttner and Elze, I, pp. 207–09; Gibbs, 'Development'. A related artist illuminated a *Codex* in Paris (BNF, lat. 4531); see Avril and Gousset, II, no. 100, p. 84, pl. XLVIII.
[3] Sandler, *Gothic Manuscripts*, nos 56–69, pp. 64–78, ills 137–81. Sandler justifiably challenges the customary emphasis on the French stylistic influence on this group. She considers that the relevant manuscripts of Morand's 'pre-Pucelle group' lack the fluidity of the main Queen Mary Psalter artist's work. The Durham illumination is as fluid but altogether less delicate than this artist.

Cat. No. 13.1 (*not exhibited*)
Durham Cathedral, Chapter Library, MS C.I.3

Justinian, *Digestum novum*
Accursius, *Glossa ordinaria*

Manuscript, parchment, 274 fols of which fols 3–274 are original MS, fol. 1 is an old contents list, possibly 15th century; the first folio of the text stolen, fol. 2 is an unfolded bifolio replacing the original first folio, from a smaller 13th/14th-century English MS; an inscription in an 18th-century hand on fol. 95v: *Excisum hic folium est/ i fine 5ᵗⁱ & initio 6ᵗⁱ libri*; 457 x 288/9 mm, written in 4 columns, 415 x 244 mm, the text in 2 columns, *c.* 200 x 140 mm, lightly ink ruled, with *lemmata* keyed alphabetically; in 10s, a few gatherings in 12s (151–161 in 11 of 12, fol. 159 stolen); Part I, Book VI, ends on fol. 110v in a bifolio, 109–110.

PROVENANCE: It is clearly integral with the other C.I. group of manuscripts and recorded in Durham Cathedral since 1391.

TEXT: Bolognese, or Paduan, *c.* 1280/85.

The text and gloss are in *littera bononiensis*. The Books are numbered I to XIII in the headers, but the rubrics, mostly lost, followed the numeration of the *Digestum* as a whole (D. 39–50, with the last title treated here as an extra book). Catchwords are framed in a cross of curled dash and colon dots on each axis.

ILLUMINATION AND DECORATION: Bolognese, *c.* 1280/85, with completions by the Jonathan Alexander Master.

The chapter initials are blue with simple linear red filigree; some include flying small circles. From Book IIII (D. 42) on the Jonathan Alexander Master overpainted the original capitals in those columns where he added illuminated initials and foliate staves with flag-shaped capitals, which seems to be an occasional feature of Toulousan manuscripts.[1]

The manuscript has lost all but one of its frontispieces, including two major pages opening each Part, together with most opening titles. The titles have figured or foliate illuminated initials; initial **I**s (*Iul.*) with human grotesques are rare in this text.[2]

Book I (D. 39): The first folio (which fell between fols 2 and 3) is lost; the opening gatherings are by the *Decretals* Master. A youth in the initial and a warrior with turban and shield accompany *De dampno infecto* (on anticipated injury) (6v); a man in the margin addresses a man in a military cloak in the initial **U** to *De aqua pluvialia arcenda* (on water and the preventing of damage by rainwater) (16); a cleric with a charter or a slab of stone (Pl. 131) at *De donacionibus* (on gifts) (23v); a youth in the initial and an eagle (26v).

Book II (D. 40): The frontispiece and most of its text have been stolen; fols 29–30 remain, with a crowned king or magistrate accompanying *De manumissis vindicta* (on manusmissions with the ceremonial rod) (30v).

Books III (D. 41)–VI (D. 44) are illuminated by the Jonathan Alexander Master.

Book III (D. 41): The opening frontispiece has been stolen; the rest of the Book continues on fols 31–53. The secondary illumination includes a foliate initial with a leaf-mask and stave (38v); a gold-crowned king, probably inspired by fols 30v on 49v; an initial transforming foliage into feathers and another with the bust of a fair-haired girl clearly Northern in character (52); foliate decoration and a dragon-head in the initial to *Pro dote* (usucaption on grounds of dowry) (52v–53).

Book IIII (D. 42): The frontispiece has been stolen from between fols 53 and 54, though the preceding rubric on fol. 53v survives: *incipit lib xlii de re iudicata*. Figures include a man with circlet (57v); a finely painted pseudo-classical profile with a face that grows up into a green dog-head biting at another face (58, Pl. 13m); an ass-headed man with a beak (58v); a Bolognese 'Second-Style' patera (60v); a soldier with a pointed hat and shield (62); a soldier in armour at *De separationibus* (on separations), perhaps

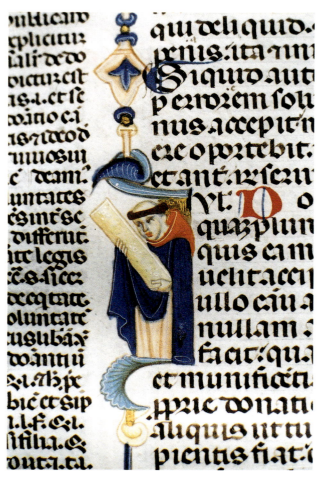

Pl. 13l. Durham Cathedral, Chapter Library, MS C.I.3, *Digestum novum*, fol. 23v: on gifts, a cleric with charter or slab of stone (*Decretals* Master)

Pl. 13m. Durham Cathedral, Chapter Library, MS C.I.3, *Digestum novum*, fol. 58: on those who admit liability, a pseudo classical profile

referring to c. 9, a son-in-power with military assets (63v); and a smiling bearded face whose travelling hat refers to the need for good guardians (65v).

Book V (D. 43): The frontispiece has been stolen from between fols 68 and 69. A man to *De ripa minuenda* (on building up a river bank) faces a king accompanying *De vi et vi armata* (on force and armed force) (76v), and an armed figure with a cat's head appears on fol. 86v.

Book VI (D. 44): The frontispiece has been stolen from between fols 96 and 97. On fol. 99v the foliate stave and initial are surmounted by a grotesque with a moon face emerging from his belly and a beaked ass-head holding a silver

wheel with rose-window or sun pattern, a motif found in the gloss of the *Codex*, fol. 34v, also by the Jonathan Alexander Master. On fol. 105v a soldier with bird-beak and ass's ears accompanies *De litigiosis* (on property subject to litigation), and an unusually dainty face, a girl or priest, opens *de actionibus et obligationibus* (on actions and obligations).

Fol. 110v bears the incipit to Book VII (D. 45) in the first column; the second is left blank to close Part I of the text.

Book VII (D. 45): The frontispiece has been stolen; fols 111–131v make up the rest of the book, which is illuminated by the *Decretals* Master. A double-folded leaf and a naked man

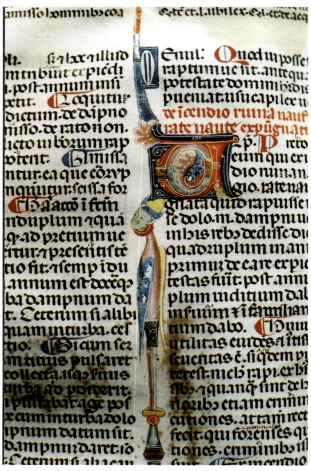

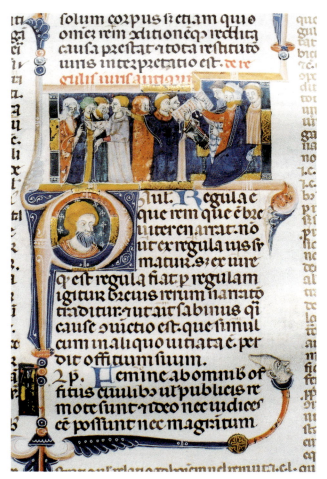

Pl. 13n. Durham Cathedral, Chapter Library, MS C.I.3, *Digestum novum,* fol. 175v: on fire, collapsing buildings or rafts and ships taken by storm, the head of a Mongol

Pl. 13o. Durham Cathedral, Chapter Library, MS C.I.3, *Digestum novum,* fol. 264r: Book XIII, on various rules of ancient law

climbing the foliate stave beside it is on fol. 128; a priest holding a book at *De stipulationibus* (on stipulations) is on fol. 129v.

Book VIII (D. 46): The frontispiece has been stolen from between fols 131 and 132; its first two gatherings (132–151) were also illuminated by the *Decretals* Master. His initials are accompanied by foliate staves. Remaining illumination includes a fair-faced man and a naked figure with a horse's head and cloak (138v); a youth in profile in the initial, a figure in a cloak and tall pointed hat, and a dragon or lion mask (141). The Jonathan Alexander Master illuminated the next gathering, mostly with foliate initials (152), including some with profile masks (153v, 154v).

Book IX (D. 47): The frontispiece between fols 159 and 160 has been stolen. Fols 169–170 have been cropped at the base. Figures include a bird with curved bill and a lion-headed soldier (169v–170), a turquoise-faced girl and a knight with coif (172), a man with coif and a stave that sprouts a pair of heron-heads (173v); a bird/dragon with the head of a Mongol illustrates *De incendio ruina naufragio rate naute expugnaitiva* (on fire, collapsing buildings or rafts and ships taken by storm) (175v, Pl. 13n); an ominous leaf mask with a beard and tall hat accompanies *De exordinariis criminibus* (on extraordinary crimes) (184); the head of a king opens *De sepulcro vioalato* (on the violation of a tomb) (184v); a soldier with broad helmet to *De concussione* (on

194

extortion with menaces) (185v); and a hooded man, perhaps also a soldier (186). The initials to *De furtibus balneariis* (on thieves lurking in baths) and *De crimine expoliate hereditatis* (on the plundering of an inheritance) have two snake-necked soldiers with weapons (186v–187). The other initials include a youth with braided hair; a pair of profile masks and a man in a coif; a soldier in pink with falchion and curved helmet (187v); and a turquoise leaf-mask (188). These are crimes punished 'by extraordinary process'.

Books X (D. 48)–XII (D. 50): The frontispieces have been stolen at fols 187 and 188, 219 and 220, and 237 and 238.

Book XIII (D. 51): The single surviving frontispiece (264) is to *De regulis iuris antiquae* (on various rules of ancient law). This is not standard; it is normally counted as title 17 to Book XII (D. 50), which may explain why it survived. The scene depicts a scholar addressing laypeople, and a priest with two companions approaching a doctor seated between a couple of clergy (Pl. 13o). The text initial has a bust of a bearded man, while the text is framed by foliate scrolls culminating in a gryllus on either side above and dome-heads below.

Despite the heavy plundering of this manuscript, enough remains to show that the two illuminators worked on separate gatherings. The Bolognese illuminator completed the first two Books along with the opening one and a half Books of Part II, and the Jonathan Alexander Master illuminated the rest in France or England. His distinctive reworking of the earli-er rubrication is more assertive than before and suggests his increasing control of the final state of the manuscripts. The division of labour, with the *Decretals* artist realizing the surviving elements of the opening gatherings to each Part, gives the impression that they were more elaborate and therefore more important than the rest, at least when originally created. Most of Book II is missing and other sections too.

The volume remains important for the high quality of the surviving illumination and the evidence that it brings for the set as a whole. The fact that the *Decretals* artist began the illumination of two of the four volumes as well as the presence of the Jonathan Alexander Master in three of them confirms that they belong together, and that the set embraced both codes of the *Ius comune*. It was presumably intended to embrace all the civil law texts and the canon law up to 1298; Gratian's *Decretum* and the other *Digest* volumes are no longer an identifiable part of it. It is possible that these were provided by older copies acquired from another student, perhaps including the earlier Bolognese Gratian now at Sydney Sussex College (MS 101, Cat. No. 1).

BIBLIOGRAPHY: Ker, *Medieval Libraries*, p. 69.

RG

[1] See note 3 in 'The Jonathan Alexander Master' in this volume.
[2] The titles begin with a citation from a major authority, Ulpian or Paul; Julian is not often the first authority to be given.

Cat. No. 14
Cambridge, Fitzwilliam Museum,
MS McClean 136

Gregory IX, *Decretales*
Bernardo Botone da Parma, *Glossa ordinaria*

Manuscript, parchment, I + 257 + I fols (Ib cut off), 422 x 245 mm, written in 4 columns 370 x 220 mm, the text in 2 columns, *c.* 210 x 120 mm, lightly lead ruled, in 12s, 15th–16th gatherings ending Part I in 10 + 9 of 10 (169–178, 179–187, of which 187bis cut off), the 22nd (248–255) in 8, ending in bifolio 256–257, fol. 257bis is a second thicker parchment guard sheet with index of titles.

PROVENANCE: The arms of the Earls of Cornwall, a shield argent, a lion rampant, gules crowned or within a bordure sable besanty, appear on fol. 1. Fols 187v and 257v have inscriptions recording ownership and the scribe: fol. 187v: *Decretum Dmni Vuillermi de Kirkos* (William of Kirkoswald?); *sum Robertus ego qui ma[nu?] scripta rogo*; fol. 257v: *sum Robertus ego qui ma[nu?] scripta rogo*. At the end of Book III the text has been annotated with a letter from Gregory IX to the Bishop of Orleans, and subsequently a Constitution of Urban V of 1367 in a French bastard hand has been inserted in the blank second column. James's claim that the manuscript is 'doubtless from a German monastery' presumably derives from the fine pigskin binding, stamped *ANNO 1749*, but this is clearly not its original destination, in view of the heraldry. It was bought from Olschki in 1893.

TEXT: Southern French or English, *c.* 1300.

The text and gloss are written in an unmistakable imitation of the broad round *littera bononiensis*. The writing is extremely regular, suggesting that the scribe, Robertus, may have trained in Bologna. However, it has a rather taller format than Italian manuscripts, is written in the French 12-leaf gatherings rather than the Italian 10 and has underlined rather than alpha-

196

betically keyed *lemmata*, a French practice, which are noticeably rare in the gloss. The catchwords for successive gatherings are set in rectangular boxes.

The preface presents the manuscript to the doctors and scholars of the universities of Paris and Bologna, demonstrating that it is not an Italian text.[1]

Each book of the text opens on a new page in this manuscript, a relatively distinguished design feature, though common in 14th-century illuminated copies. The main division of the manuscript is highly unusual in falling between the third and fourth rather than the second and third books, at fols 187 and 188. This stresses the short Book IV on marriage legislation rather than Book III devoted to the conduct of the clergy.

ILLUMINATION AND DECORATION: Southern French or English, *c.* 1300, by the Jonathan Alexander Master and a Southern French (Toulousan) illuminator.

The articulation of the text is unusual in having blue initial capitals to chapters throughout, rather than alternated red and blue as normal in Italian and Southern French canon law manuscripts.[2] They are placed in the margin, containing double line filigree in red, with circles outside letters rather than inside, a variant on the filigree of Bolognese academic manuscripts.

The illumination is in two very different styles: that of the Jonathan Alexander Master (Cat. Nos 12–13) and the rather coarse Italianate idiom of the Southern French artist. Single-column frontispieces open each book and the Promulgation, unlike the pair of scenes that open contemporary Italian manuscripts of this quality or the two-column scenes found in 14th-century French copies such as the Smithfield *Decretals* (London, BL Royal 10.E.IV) and the Fitzwilliam Museum's Marlay Cutting Fr. 2 (Cat. No. 15).[3] The text is partly framed by foliate staves and knots reminiscent of Bolognese design, which sometimes extend into full spirals occupied by figures in the *bas-de-page*. Books I, IV and V have spaces left free for three or four

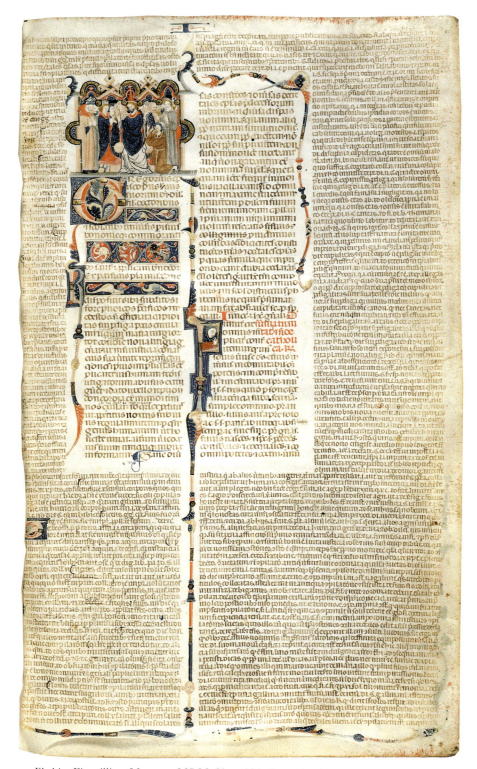

Pl. 14a. Fitzwilliam Museum, MS McClean 136, *Decretales,* fol. 1: Book I, Promulgation
and title 1, On the Holy Trinity and the Catholic Faith

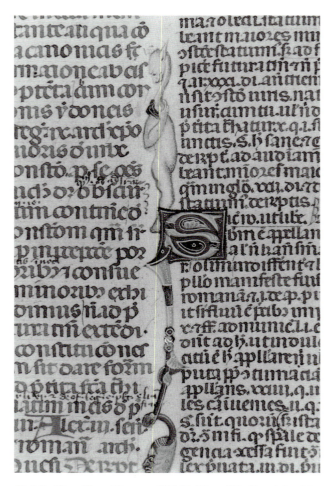

Pl. 14b. Fitzwilliam Museum, MS McClean 136, *Decretales*, fol. 4 (grotesque)

Pl. 14c. Fitzwilliam Museum, MS McClean 136, *Decretales*, fol. 32: grotesque

rows of decorative scroll work, often with fantastic animals like those found in metalwork or tapestry. This layout is quite common in late 13th- and 14th-century lawbooks, both Bolognese and French, though they are usually occupied by penwork flourishes rather than illumination.

Each title has an illuminated initial both to text and gloss, usually foliate but occasionally with a human bust; initial **I**s become human grotesques, and many of the initials are accompanied by foliate swags and humorous or grotesque figures. Most openings have illumination.

Fol. 1, Book I, Promulgation and title 1, On the Holy Trinity and the Catholic Faith, is by the Jonathan Alexander Master. The frontispiece shows Gregory IX seated and addressing a bishop among a throng of clergy and scholars (Pl. 14a). The two friars on the right, marked by their rope girdles as Franciscans, may represent an anomalous transformation of images of the Dominican Raymon de Peñyafort, the papal confessor who compiled the *Decretales* for Pope Gregory. He is frequently depicted with the Pope presenting or receiving the volume. The Friar in the brown habit holds up a volume to the Pope, while the one in grey seems to reach out for it. The centralized composition shown here became normal for both Gregory's *Decretales* and the corresponding scene in Justinian's *Codex* in the 1280s,

198

probably through the design of Jacopino da Reggio for his *Decretales* in the Vatican, BAV, Pal. lat. 629.

The arches and linear knotwork above the frontispiece are an unusual combination of forms, though the borders are part of the artist's typical vocabulary. The folded leaves of the initial are derived from the normal Bolognese foliage of the later 13th and early 14th-century, and its design has earlier roots in decorative art of the 12th century, particularly Mosan metalwork. The artist's distinctive treatment of foliage is often seen in human profiles wearing these leaves like a jester's hat or in blue figures evolving into these leaves. They recall the 'Green Men' of English gothic vault bosses and also the fringe of lobes surrounding church door-knockers, such as those at Durham Cathedral.[4]

Other characteristic figures of the Jonathan Alexander Master in the marginal decoration of the first gatherings include a man holding a falchion, whose dome-head evolves into a conical hat and a leaf stem (1v); a youth blowing two trumpets (2v); and a long-necked cleric with a blue ox-head accompanied by a man with serpentine neck and a cat's face (4, Pl. 14b). A knight composed of a shield, horse legs and flailing hands brandishing a dagger (11v) shows the influence of the Bolognese illuminator's disembodied limbs in the Durham *Codex* (C.I.6, fol. 99v; Cat. No. 12); the Jonathan Alexander Master himself created an abundance of such monsters in the Durham manuscripts.

The second, Toulousan, artist matched him with a human leg attached to a gaping fish-mouth (13v); a priest with a cross on his dome-head sticking out his tongue (32, Pl. 14c) and answered by a gaping bird-head; a priest with a long knotted neck and a winged head, a motif of heretical or ironic associations, illustrates *De filiis presbitorum ordinandis vel non* (on whether to ordain the sons of priests or not) (43v, Pl. 14d);[5] a swan-necked man with a shouting dome-head (45v, Pl. 14e); a cleric hunching his shoulders into his cowl accompanies *De offitio vicarii* (on the vicar's office) (49); a long-nosed cleric wearing a dunce's cap contemplates a blue cow-headed grotesque, similar to a motif typical of the Durham Bolognese *Volumen* Master and the third Lucca *Decretals* artist (64v, Pl. 14f).[6] A supporting cast of similar grotesques appears throughout his work.

Fol. 74, Book II, On Judgements, by the second artist, is much closer to Bolognese illumination in layout, though the unsteady linear rhythm of his foliage is definitely not Italian. The scene is framed by three segmental arches, a typical Bolognese Academic or 'First' Style setting. A judge sits in the central bay, wearing the miniver-lined hood of a lawyer, listening to a debate between two groups of clerics (Figs 20 and 33).

The asymmetry of the two musicians' figures in the *bas-de-page* distinguishes the border from genuine Bolognese work. A moon-face is unusually set in a diamond-shaped knot in the stave, and perhaps derives from the Durham *Volumen*, fols 34–37, 136 (Pl. 11c). The foliate staves of both Books II and III are notable for this Bolognese motif.

The frontispiece is an intervention in a gathering (73–84) otherwise by the Jonathan Alexander Master (Pl. 14 g). The Jonathan Alexander Master furnished a characteristic picture of a cross-legged knight, his shield gules a fess argent (79), and a typically bawdy squatting figure displaying his rear accompanies *De dilationibus* (on delays) (82v).

The Toulousan artist returns for the rest of the Book, illuminating grotesque clerics (85); a shouting leaf-dome-head (86v); a bird-headed leaf stem becoming splayed legs (93v); an innovative swan-neck with a profile moon-face (97v); a man whose nose becomes a penis (104v); and a celebrant sticking out his tongue while a bird displays his chalice (105v).

Fol. 137v, Book III, On the Life and Honesty of the Clergy, by the Toulousan artist, is another three-arch scene showing the celebration of mass (Fig. 58). The emphasis on excluding the laity from the vicinity of the altar is vividly expressed by the driving gesture of the acolyte and his admonitory expression. A

Pl. 14d. Fitzwilliam Museum, MS McClean 136, *Decretales*, fol. 43v: grotesque

Pl. 14f. Fitzwilliam Museum, MS McClean 136, *Decretales*, fol. 64v: grotesque

Pl. 14e. Fitzwilliam Museum, MS McClean 136, *Decretales*, fol. 45v: grotesque

lawyer and a layman in grey kneel in prayer within the *bas-de-page* spirals.

Notable grotesques include double-horned serfs (145v); a figure in tall hat, holding a censer (150); a distended corrugated dome-headed man (151); a soldier with a large battle-axe (155v), to which a woman brandishing another opposite (157) responds; a lawyer, perhaps, whose nose has become a trumpet (158v); and a grey stork contemplating naked semi-figures (162v).

Fol. 188, Book IV, On Marriage, by the Jonathan Alexander Master (Pl. 14h), is treated similarly to fol. 1, in its secondary illumination of animal grotesques. On the left a couple kneel before a priest who holds up an open book inscribed *DOMINUS VOBISCUM*; an acolyte holds up a wedding pall, and members of their families stand behind.

The figures are refined and their faces dainty but modelled in a light ruddy tone. The petite but rather squinting expressions of the married couple recall English royal illumination and painting of the 1270–80 period such as the Alfonso Psalter and the Westminster Retable: the groom's features are close in shape to the angel left of centre (or Virgin Mary) in the Retable.[7] The triangular faces of the marginal figures, larger and more heavily modelled, relate to the Douce Apocalypse and the Painted Chamber of Westminster Palace, the largely destroyed painting on the base of the Tomb of Edmund Crouchback, *c.* 1297, and the Sedilia of Westminster Abbey. These resemblances may be coincidental, given that this manuscript is surely Southern French. But in a closely related *Decretals* in Florence (Bibl. Laurenziana MS Edili 86), the hybrid creatures of the *Arbor Consanguinitatis* have been compared to English work by François Avril, and he considers that volume also to have originated in Toulouse or Montpellier; Simonetta Niccolini attributes its illumination to English and French illuminators.[8] Its frontispieces to Books II and III share the gold bars in their borders and in the initials; Book II, by a hand closer to the Durham manuscripts than that of Book III, also has the

pointed profiles of the Jonathan Alexander Master.

The rest of this gathering is full of characteristic inventions of the artist including an eagle with beak and wings extended to attack the text (192v); a minstrel playing a triangular lute; a spectacular attached pair of faces staring from between their legs (195, Pl. 14j); a dog-headed and snake-necked grotesque in a cope and a bird carrying off a bezant in the lower gloss (199).

Fol. 205, Book V, On Accusations and Inquisitions and Denunciations, is by the Toulousan artist, but the layout emulates that of Books I and IV, with four rows of grotesque animals, spirals and ivy-leaf scroll. The frontispiece has a three-arched design, using the same knotted round arches as Book III (Fig. 55). The pope is seated in the central bay and listening to a debate between two groups of monks.

A human profile is worked into a square niche in the stave, a variant on the idea of the moon-face. Two more faces blowing long horns under the ears of a lion mask provide a humorous touch to the very cramped *bas-de-page*.

The rest of the Book develops the vocabulary of the *bas-de-page*: a fish-headed cleric addresses a naked figure with winged hat to illustrate *De sortilegiis* (on witches and diviners) (228b); another fish-head addresses a snake-necked trumpeter at *De maledicis* (on those who speak ill) (229v). Nakedness and a long necks characterize the title *Clerico non ordinato ministrante* (of a cleric performing offices for which he is not ordained) (230v); and a termite-like dome-headed figure accompanies *Qui furtive ordinem suscepit* (on a cleric ordained in secret) (231). A closing flourish is provided by a lady with a long neck, a chicken leg and a shopping basket (253v) to *De verborum significatione* (on the meaning of words). While this artist's style is much coarser than that of the Jonathan Alexander Master, he is often just as able to communicate grotesque humour that generally reflects the nature of the text.

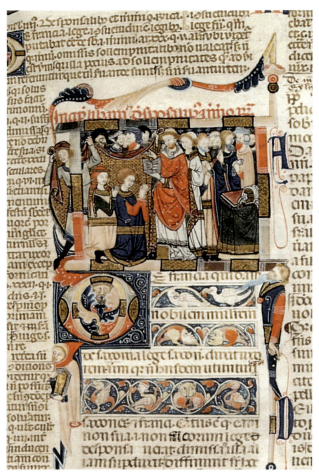

Pl. 14g. Fitzwilliam Museum, MS McClean 136, *Decretales*, fol. 73v: grotesque

Pl. 14h. Fitzwilliam Museum, MS McClean 136, *Decretales*, fol. 188: Book IV, On Marriage

The senior illuminator, the Jonathan Alexander Master, who completed several of Durham Cathedral's set of Bolognese law manuscripts (Cat. Nos 11–13), was responsible for illuminating the opening to each Part of the manuscript, Books I and IV. He illuminated the 1st and 7th gatherings, with the exception of the frontispiece to Book II, inserted into it by the other artist (even the rest of the bifolium, fol. 83, is by the Durham artist). He also carried out the whole of the 17th gathering.

His work in this manuscript is primarily linear, seen especially in the extremely sharp and elegantly defined outlines and draperies in the marriage scene of Book IV. The figures have smaller heads than in the Durham manuscripts and are taller in proportion, with Gregory

appearing as a rather tentative disembodied figure in the frontispice. Faces have small dainty features in the North French or English manner, painted over a smooth overall white impasto flesh tone with body colour added to model their cheeks and eyebrows. Eyes often have strong black pupils associated with the so-called Giottesque episode in English illumination of the 1340s and 50s.

The artist's familiarity with the goliardic spirit of Bolognese legal illumination is evident in the marginal imagery, though less extreme than in the Durham manuscripts. His extensive use of gold leaf is particularly striking in the frontispiece of Book IV, but also notable in the characteristic cross of gold bars that mark the axes of his capital letters and frequently break

up the dark blue and pale pink bars of his foliate swags. These are drawn directly from the Bolognese illuminators of the Durham lawbooks, most of whom use bars and bezants, though less consistently than this artist.

The second illuminator, working in a typical Southern French emulation of 13th-century Bolognese Academic Style, added the frontispiece of Book II to the 7th gathering, all the initials and marginalia to the 2nd–6th, 8th–16th, 18th–22nd gatherings and the frontispieces to Book III and Book V. Although the Jonathan Alexander Master's pre-eminence is clear given his responsibility for both major openings, they exchange roles at Book II, suggesting a systematic collaboration despite their very different styles. He draws moderately long

Pl. 14j. Fitzwilliam Museum, MS McClean 136, *Decretales*, fol. 195: grotesque

and thin forms in a thick and heavy outline, in complete contrast to the sharp, crisp line and rhythms of the Jonathan Alexander Master. His faces tend to be pointed and triangular with wide foreheads, large eyes, long square chins and tiny mouths. Draperies fall in simple essentially vertical folds and are painted in un-modelled body colour, predominantly brick red, a dark indigo(?) blue and blue-grey. The artist also uses verdigris green extensively. His foliage is narrow rather than slender and drawn in slow irregular curves lacking the rhythm of either Italian or French Gothic art.

James Marrow has pointed out artistic similarities to another *Decretals* given by Archbishop Jacques Gelu to the Cathedral of Tours but attributed to the South of France, *c.* 1280.[9] There are also similarities to a Gratian in Paris (BNF lat. 16899), tentatively attributed to Spain but copied by Martinus Olivier and Radulaius(?) for Gerardus de la Porta and once in the possession of the Parisian Dominicans.[10]

This is a manuscript which is clearly intended to stimulate the imagination of its users as well as to dignify the more formal occasions on which it might be consulted. It is at once imposing and beautiful at its major openings and creeping with wry humour, both aesthetic aspects derived along with the layout and calligraphy from Bolognese models. Its frontispieces present the usual iconography found in *Decretals* produced.

BIBLIOGRAPHY: James, *McClean*, pp. 283–85, as in a regular Bolognese hand, illuminated by 'Two artists, both Italian'.

RG

[1] Gregory IX seems to have sent the original copy contemporaneously to Bologna and Paris in 1239 with the form of address appropriate to each: see Chapter 1 in this volume.

[2] Good examples are provided by two manuscripts in the Vatican, BAV, Vat. lat. 1373 and 1374; see Kuttner and Elze, I, pp. 149–51, the latter manuscript wrongly given as Italian.

3 The Smithfield *Decretals* is frequently described as an Italian manuscript 'for French use' (Brown, *Western Historical Scripts*, pp. 124–25, pl. 48; Sandler, *Gothic Manuscripts*, no. 101, I, figs 256–58, II, pp. 111–12). However, its dedication to Paris alone is implausible in an Italian copy; its script is considerably less_regular than the McClean *Decretals*, the gloss is in a pointed hand close to *littera textualis*. The delicate filigree in red and violet is also typical of a body of Southern French manuscripts, perhaps from Toulouse, Avignon or Montpellier (see Cat. No. 8).

4 See Stone, pp. 49–50, pl. 28a, who drew attention to analogies with the Romanesque manuscripts of Durham's Bishop Carilef.

5 Cf. the drawing in the Sidney Sussex *Decretum* (Cat. No. 1); the motif becomes prominent in Jacopino da Reggio's highly influential copy of the *Decretals* in the Vatican, BAV, Pal. lat. 629.

6 See Cat. Nos 11–12.

7 Morgan, *Survey*, no. 153, pp. 141–45, figs 260–69; Sandler, *Gothic Manuscripts*, pp. 13–14, figs 1, 4; Binski, *Painted Chamber*; and Binski, *Westminster Abbey*, pp. 123–25, 152–66, for a current discussion and resumé of the material, including recent discoveries, and literature: comparative figures particularly relevant at pp. 161, 168–69, 173, 207, 209. The resemblance between the wide-eyed lost double profile cameo (*ibid.*, fig. 209) and the striking profile in the Durham *Digestum Novum*, C.I.3, fol. 58, is perhaps worth noting.

8 Fabbri and Tacconi, p. 125, pl. 33; S. Niccolini in *Duecento*, pp. 297–300. She considers the frontispieces to be by a single hand, but notes the presence of several others with an iconographic range for the title initials similar to the Durham manuscripts.

9 Drawing our attention to Holz, Lalou, Rabel, pp. 84–85.

10 Avril and Aniel, *Ibérique*, no. 104, pp. 90–91, pl. L.

Cat. No. 15
Cambridge, Fitzwilliam Museum, Marlay Cutting Fr. 2

Gregory IX, *Decretales*, Book III, *De vita et honestate clericorum*
Bernardo da Parma, *Glossa ordinaria*

Manuscript, parchment, a single folio, 474 x 309 mm, lightly or blind ruled, the written area in 4 columns, 366 x 240 mm, the text itself in 2 columns, *c.* 250 x 140 mm.

PROVENANCE: Charles Brinsley Marlay; bequeathed to the Fitzwilliam Museum in 1912.

TEXT: Probably Southern French, *c.* 1330–40.

It is written in a round gothic hand reminiscent of *littera bononiensis* and is extensively annotated; *lemmata* are occasionally underlined and not keyed alphabetically.

ILLUMINATION: Probably Southern French (Languedoc?), *c.* 1330–40.

Book III, *De vita et honestate clericorum* (On the Life and Morality of the Clergy), at what is in most copies the major division of the *Decretals*, deals with the proper conduct of religious services and, as its title indicates, the discipline of the clergy.[1] These were important concerns of canon law, particularly since the Church claimed exemption for the clergy from civil proceedings even for major criminal charges. The cutting illustrates the opening canon of the Book, which concerns the division of sacred space during the celebration of mass, stipulating that the laity should be separated from the area used by the clergy.[2]

The two-column frontispiece shows the celebration of the mass; the priest raises the host at the altar, aided by two kneeling acolytes; two clergy sing at a lectern; the laity, kneeling and standing behind, are structurally separated, though with a less clear architectural division than the text might suggest (Pl. 15). The large text initial contains the bust of a novice; its

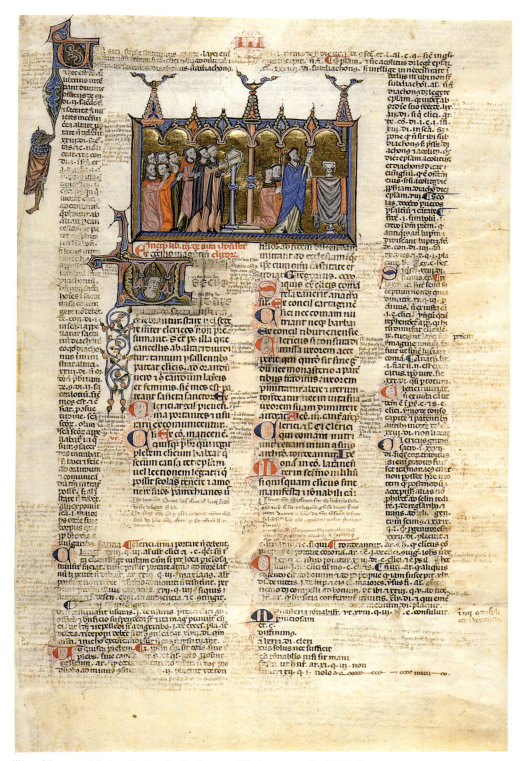

Pl. 15. Fitzwilliam Museum, Marlay Cutting Fr. 2, Gregory IX, *Decretales*: Book III, On the Life and Honesty of the Clergy

jagged blue and pink 'cabbage-leaf' framing, more typical of England or Northern France. The foliate initial to the gloss has a large Italianate leaf bitten by a sheep-headed grotesque wearing a chasuble. Inset major capitals to chapters are alternately in red and blue, with strongly contrasted strokes, very long serifs, and contrasting violet and red filigree found in a body of Southern French manuscripts, perhaps from Toulouse or Montpellier.

The church setting is a significant feature of this scene. Smaller copies or illuminated commentaries with a reduced version of this programme (e.g. Innocent VI's Apparatus, London, BL MS Royal 10. D. 3), limit it to the celebrant and an acolyte.[3] One of the most precise illustrations of the scene is by Jacopino da Reggio, *c.* 1280, in the highly influential Palatine *Decretals* (BAV, Pal. lat. 629), in which the different sections of the church and the separation of clergy and congregation are clearly defined. The Fitzwilliam *Decretals* (MS McClean 136, Cat. No. 14) shows the acolyte driving a laymen away from the altar, but with little reference to the building's internal divisions.

Several features of the cutting's illumination suggest a Southern French provenance. The denial of architectural logic, seen in the crockets of the spires, the ambiguous foliate centres of the smaller pinnacles and the knotted tops of the round arches, contrasts both with Italian painting and the crisp, pointed arches of Parisian design. However, it is a continuing feature of manuscripts that seem to have been illuminated in Southern France, and is already evident in the same scene of the Fitzwilliam *Decretals*.

The overall light tonality and palette of soft pinks, scarlets, lime greens and bright blues against the gold ground also suggest a Southern French origin of the second quarter of the 14th century, affected by recent Italian painting. There is no pictorial space in the scene: the figures stand on the frame. Their tall proportions and long flowing garments with strongly defined triangular folds are typical of French painting from 1240 to 1340. The tailored and tighter-fitting dress of the 1340s is not yet in evidence, nor the solid modelling of the 'Giottesque' Italian style affecting French art by 1350. The severely intense expressions distinguish the figures from the dainty elegance and smiling faces of North French work.

BIBLIOGRAPHY: Wormald and Giles, *Descriptive Catalogue*, p. 86.

RG

[1] Since the mid-13th century, Gregory's *Decretals* were divided between Books II and III; see Gibbs, 'Development'.

[2] '*Quum celebratur, divisus esse debeat clerus a populo*: From the Council of Mainz: That the laity should be away from the altar when the holy mysteries are celebrated, both for vigils and mass, and should not presume to stand or sit among the clergy, but that area separated from the altar by screens should be kept for the clergy. They should have access, however, for praying and communion to the *sancta sanctorum*. . . .' Bernardo Botone's gloss is clear, if surprising in its use of *sancta sanctorum*: 'The laity should not stay near the altar or in the choir while the mass is celebrated . . . they should not sit in the choir among the clergy when divine office is being sung. . . . Item, the church has two parts, the choir, which is divided by screens from the altar, and the *sancta sanctorum*, i.e. the lower part of the church, which is popularly called the nave'.

[3] Conti, *La miniatura*, p. 72, cited as a *Decretals*.

Cat. No. 16
Cambridge, Gonville and Caius College, MS 10/10

Justinian, *Digestum novum*
Accursius, *Glossa ordinaria*

Manuscript, parchment, notably varying in thickness, I–II cropped leaves with stubs + 283 fols + III–IV cropped leaves, 424 x 265 mm, written in 4 columns, 335 x 218 mm, the text in 2 columns, 200 x 115 mm, with strongly lead or ink-ruled verticals but the lines almost blind ruled, foliated in 14th/15th century arabic numerals to 33 with first leaves of gatherings foliated in pencil, in 12s, fol. 251bis robbed, fols 264–276 in 13 with fol. 271 inserted into gathering, fols 277–283 in 7 of 12, the last (blank) leaves cut out by the original binder. The MS has an early skin binding but has lost its clasps. It is not written in parts. The Books are numbered I–XII in the headings, xxxix–l in the rubricated incipits.[1]

PROVENANCE: The end folios have numerous *cautiones*, records of deposits for the use of the books, notably *Mr. W Elmham, Ric. Derham cuius principale liber sextus* and *William Somersham, ciste de neel. 1382, ciste de neel. pro iii li. et habet et supplementa ius infortiatum et unam peckam argenti cum quinque colchaibus 1390*, with further entries for 1387 or 1388. William Somersham was Master of Gonville College, 1412–d.1416. The manuscript was clearly already in the College in the later 14th century.

TEXT: Southern French, *c.* 1275–90.

It is written in a script close to *littera bononiensis*; the *lemmata* are not keyed to the text but underlined as in French academic production. The gloss has examples of triangular spaces left to fill out the column (e.g. fols 5 and 39). Catchwords are framed in varying irregular boxes of jagged line or oval form, sometimes enhanced in red.

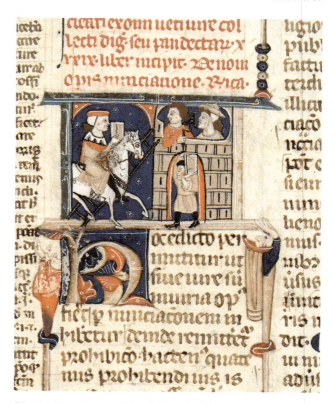

Pl. 16a. Gonville and Caius College, MS 10/10, Justinian, *Digestum novum*, fol. 1: Book I (D. 39), On the Notification of New Work

ILLUMINATION AND DECORATION: Southern French, *c.* 1275–90, close to the Jonathan Alexander Master at a previous stage of his evolution to the Durham manuscripts.

Each book appears to have had a single-column historiated frontispiece and an illuminated foliate initial opening its text, but many of the frontispieces have been robbed. The titles have larger square blue initials with elaborate palmette red filigree, only loosely related to Bolognese Bible style filigree; other initials, to the text of the citation rather than its author, are tall, narrow and blue with simple academic double line red filigree.

Fol. 1, Book I (D. 39), On the Notification of New Work: A judge approaches a city holding up a book to support his judgement; a mason with a trowel and his employer look on, while another mason carries out a block of stone (Pl. 16a). The page has suffered some fading and abrasion from repeated use.

Pl. 16b. Gonville and Caius College, MS 10/10, Justinian, *Digestum novum*, fol. 34v: Book II (D. 40), On Manumission

Pl. 16c. Gonville and Caius College, MS 10/10, Justinian, *Digestum novum*, fol. 66

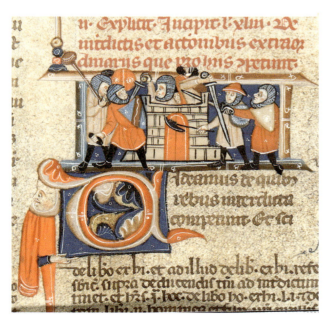

Pl. 16d. Gonville and Caius College, MS 10/10, Justinian, *Digestum novum*, fol. 102: Book V (D. 43), On Interdicts and Extraordinary Actions in Place of Interdicts

Fol. 34v: Book II (D. 40), On Manumission: A master or judge (dressed in a lawyer's hood but without a legal cap) lays a rod on the serf's shoulder to manumit him; two civilians and a bald man or tonsured priest are behind (Pl. 16b). A soldier grotesque holding a buckler and dome-headed masks are in the foliage *bas-de-page*.

Fol. 66, Book III (D. 41): The single-column frontispiece has been robbed, leaving a foliate initial to the text, a figure holding a huge trumpet and user's drawings (Pl. 16c).

Fol. 87v, Book IIII (D. 42): The single-column frontispiece has been robbed; only a cloaked youth and the foliage stave of the initial survive.

Fol. 102, Book V (D. 43), On Interdicts and Extraordinary Actions in Place of Interdicts: The single-column frontispiece shows the storming of a castle by a knight and armed men (Pl. 16d). A hooded figure in red accompanies the foliate initial. Italian manuscripts show a judge instructing officers for this Book. French manuscripts appear to show 'extraordinary actions' against a castle or town, such as that in a copy in Munich, Bay. Staatsbibl. Clm. 21, and a *Codex* in Tübingen, Univ. Bibl. Mc 294, whose Book VIII on the same subject has a bishop joining the fray.[2]

Fol. 125, Book VI (D. 44): The single-column frontispiece has been robbed; only a long-tailed bird remains.

Fol. 139, Book VII (D. 45), On Verbal Contracts: The single-column frontispiece, larger than the other surviving illuminations, shows a judge seated in the centre of a characteristic three-bay design (Pl. 16e). He addresses two clerics and a layman on the left and an artisan, wearing a short coat, accompanied by a cleric and a layman on the right. The former are presumably receiving a guarantee from the artisan or alleging his breaking of one. The foliate initial is accompanied by a half-length youth with shield who turns into the foliate stave below. The main scene is less lively than the other work in the manuscript but is by the main artist.

Fol. 164, Book VIII (D. 46): The single-column frontispiece has been robbed, and only the

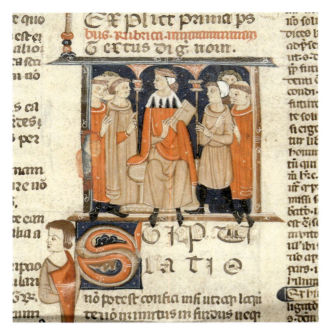

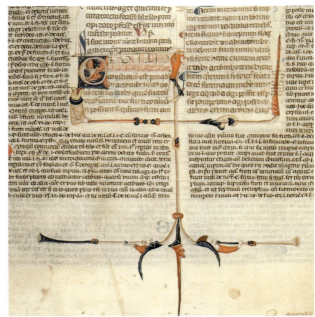

Pl. 16e. Gonville and Caius College, MS 10/10, Justinian, *Digestum novum*, fol. 139: Book VII (D. 45), On Verbal Contracts

Pl. 16f. Gonville and Caius College, MS 10/10, Justinian, *Digestum novum*, fol. 192v

grotesques remain: a priest for the opening foliate initial and a soldier in the fourth initial.

Fol. 192v, Book IX (D. 47): The single-column frontispiece has been robbed. Only grotesque half-length figures remain; trumpeters blow long horns in the *bas-de-page* (Pl. 16f).

Fol. 218v, Book X (D. 48): The single-column frontispiece has been robbed; a winged and hoofed priest accompanies the foliate initial, and a scholar holding a club is in the right margin. A shouting man clasps his hands to his ears in the *bas-de-page*.

Fol. 242v, Book XI (D. 49), On Appeals and Referrals: The single-column frontispiece is similar to Book VII but smaller. It shows a judge listening to three priests, while a priest and layman or novice responds on the left (Pl. 16g). A soldier with tall pointed hat and a falchion occupies the central column.

Fol. 256v, Book XII (D. 50): The single-column frontispiece has been robbed with part of the text. The initial with a fish has been cropped; a mourning priest remains.

The clerical emphasis of these trial scenes in a civil law manuscript is certainly alien to Bologna and evidence, along with style and codicology, for a Southern French origin. Most of the figures are short and squat, but with lively expressions formed by round eyes and a pointed little nose. The parchment is used as the flesh tone with some broad white strokes and dots of orange for cheeks and lips, and brown ink for pupils.

Artistically, this manuscript is close to the Jonathan Alexander Master's work in the Durham law books (MSS C.I.6, C.I.9, C.I.3; Cat. Nos 12–13.1) and the Fitzwilliam *Decretals* (MS McClean 136, Cat. No. 14). The distinctive slow spiral of a folded leaf wrapping the foliage stave (34v) and the firm drawing and architectural settings of Italianate character are all points of resemblance.

BIBLIOGRAPHY: James, *Caius*, pp. 8–10; Ker, p. 26.

RG

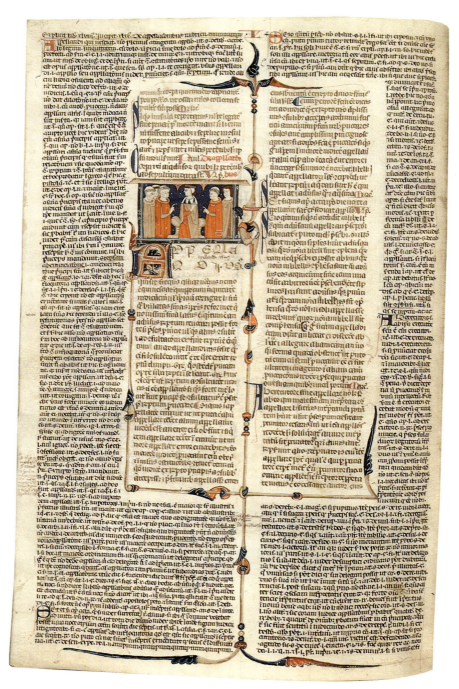

Pl. 16g. Gonville and Caius College, MS 10/10, Justinian, *Digestum novum*, fol 242v: Book XI (D. 49), On Appeals and Referrals

[1] It is common for the books of the second and third volumes of the *Digest* to be given their own numeration, particularly in the running headers; the rubrics generally preserve the original continuous sequence of 50 books (as in Cat. 13.1).

[2] For the manuscripts in Munich and Tübingen, see Ebel *et. al*, pp. 108–09, 142–43, who observe that the Church used the interdict in the 13th and 14th centuries as a major political weapon.

Cat. No. 17
Cambridge, Gonville and Caius College, MS 8/8

Justinian, *Digestum vetus*
Accursius, *Glossa ordinaria*

Manuscript, parchment, II + 398 ff + II, 447 x 270 mm; written in 4 columns, 410 x 253 mm, the text in 2 columns, 290 x 180 mm; foliated in pencil by quires (in 12s), old pagination in brown ink (784 pages); ruled in brown ink.

PROVENANCE: erased *cautio* on fol. 396v: *exposita ciste de neel . . . a.d. 1389 cuius supplementum parvum volumen.*

TEXT: Southern French?, early 14th century.

It is written in textura, in dark brown ink for text and gloss; catchwords are framed with wavy borders and decorated on the left-hand side with animal heads.

ARTICULATION: In the text, three-line blue pen-work initials, decorated with red filigree and placed in the margins, open the first word of text sections up to fol. 6v; after the first title the convention changes, now alternating red and blue initials that identify the authors of each text extract. The gloss is articulated with two-line blue penwork initials. Text titles are distinguished by three-line puzzlework initials in red and two shades of blue: a lighter, almost turquoise hue for smaller areas of detail and the standard darker blue for the puzzlework outline; red and blue sections are separated by a narrow uncoloured space, red filigree filling the bowl, red and blue filigree decorating the outside perimeter. Most initials have long J-band extenders running down the column, bands alternating red and blue. The filigree around the three-line initials is based on single spirals proceeding from a short straight or curved line. Some second letters of opening words after the penwork initials are executed in display lettering. *Lemmata* in the gloss are underlined in brown ink. Running titles in blue ink are placed at

upper margins, characterized by an **L** on the verso and the Roman numeral equivalent to the current book on the recto. Titles are written in brown ink at the lowermost margin of each page as a guide for the rubricator. Text and gloss end on fol. 396va, designated by *FINIS DIGESTA VETERIS* in display letters below the text; *Explicit lib. XXIIII ff. veteris* is written below the gloss.

ILLUMINATION: French or English, early 14th century.

This manuscript lacks most of its painted decoration. Of the twenty-four miniatures possible to the *Digestum vetus*, only two were executed and the second was excised; space was left by the scribe for the others, ranging from five to sixteen lines in height. Large painted initials directly below the miniature were planned for, but only executed at the Prologue and Book I. In most cases, display letters complete the first word after the large painted initial.

Folio 1a opens with the long Prologue rubric, followed by an 11-line, one-column miniature, framed with a narrow inside border of leaf gold decorated with simple dot punchmarks, and a wider outside border composed of alternating blue and pink bands, decorated with wavy white lines. Directly below the miniature is a 7-line initial **O**[*mnem*] executed in pink and orange, placed on a squared blue ground and outlined with a gold punched border; within the **O** against a pink ground are four acanthus leaf twists, terminating in dragon bodies with confronting male and female human heads. To the left of the initial, completing the word, are display letters in brown ink, with inner filigree forming vegetal and animal motifs. Along the centre intertextual margin runs a long bar of alternating pink and blue bands, scalloped at its upper section beside the miniature and topped by a dragon body; its course is studded with diamond-shaped motifs in leaf gold, painted in white with geometrical and flower designs. Pink filigree extenders run across the lower margin, bearing delicately painted birds at either corner.

Pl. 17a. Gonville and Caius College, MS 8/8, *Digestum vetus*, fol. 1

Pl. 17b. Gonville and Caius College, MS 8/8, *Digestum vetus*, fol. 3, grotesques

The opening miniature (Pl. 17a), representing the transmission of the newly reformulated body of law (*Omnem rei publicae*), is divided into two compartments, demarcated with a double arch in a winy red, and diaper-like backgrounds in different colours, pink and blue. At left a seated master, garbed in a red gown covered by a grey robe and wearing the pileus, lectures from the open book on a large bookstand and lifts one finger in a gesture of speech. In the right-hand section, seated around another bookstand with an open book, five coiffed students consider the words of their teacher. The foremost student seems about to comment on or question a point. This composition, portraying the use of the text itself in an actual classroom, is a variant on the more characteristic depiction of the Tribonian committee presenting to Justinian the recently reformulated law (see Chapter 5 for a description of this iconography). It may reflect the distinction accorded the *Digestum vetus* in Bologna, where it was considered the most important volume of the *Digest* and taught in the ordinary (morning) classes.

Book I opens on fol. 3a; although the 11-line miniature has been cut out, there are remains of the illuminated initial **I** on a gold ground, with blue and pink bars and scroll work, topped by a

hooded head. In the lower intertextual margin directly below the left-hand column, is a pair of facing hybrids holding shields and clubs, drawn in coloured inks and delicately shaded (Pl. 17b).

From this point on, miniatures and other painted illumination are in blank, although penwork and display lettering was executed. Book divisions are as follows: Book II begins on fol. 20va; Book III, fols 46vb–47a; Book IIII, fols 76b–76va; Book V, fol. 120a–b; Book VI, fol. 142b; Book VII, fol. 150va; Book VIII, fol. 170a; Book IX, fol. 185b; Book X, fols 199b–199va; Book XI, fol. 214a. The customary major division was observed at Book XII; the text of Book XI ends with a short quire (10 folios) at mid fol. 224va. The gloss scribe however initiated the gloss for Book XII on fol. 224vb, running ahead of the text, which initiates on fol. 225a, thus necessitating a gloss catchword at the lower margin of fol. 224vb to guide the scribe in his continuation of the gloss, mid-sentence, at upper fol. 225a. Despite the prioritizing of the opening to Book XII with a new quire, a comparatively small space was left for the miniature: nine lines, plus a 6-line initial **B** followed by executed display letters: *ENE EST*. A new penwork artist begins at this division, who provides more simple red filigree and

214

a different type of decoration for the large initials at titles: the red and blue puzzlework is maintained, but now the interior of initials is filled in with white vinescroll on solid red ground, peppered with tiny white dots. Book XIII begins on fol. 248v a, space left for an 8-line miniature, two lines of display letters beautifully executed in dark brown ink; Book XIV, fols. 261b–261va; Book XV, fol. 273a; Book XVI, fol. 284vb; Book XVII, fol. 294a; Book XVIII, fol. 309va; Book XIX, fol. 323va; Book XX, fol. 343va; Book XXI, fol. 352va; Book XXII, fol. 366va; Book XXIII, fol. 376a; Book XXIIII, fol. 389a.

This manuscript was carefully and clearly articulated to facilitate the readers' orientation through the text. Execution of the illustration programme may have been interrupted because the patron needed the text for immediate use, or to carry to a different location. There is a moderate number of added marginal annotations, dense in places, but largely limited to one or two lines.

BIBLIOGRAPHY: James, *Caius*, p. 8.

SL'E

Cat. No. 18
Cambridge, Gonville and Caius College, MS 11/11

Justinian, *Codex*
Accursius *Glossa ordinaria*

Manuscript, parchment, I–II with index on latter + 324 + II fols, the last bifolium smaller, filled with notes, 420 x 250 mm, written in 4 columns, 360/380 x 210/220 mm, the text in 2 columns, 250 x 125 mm, variously ink and blind ruled, in 12s; written in Parts, Part I ending in 12 on fol. 108va; the two Parts are clearly separated; the first Part concluding in a regular gathering on the last verso indicates scribal skill in fitting text to the space; foliated with titles in the header, top right, in the 14th century and paginated later.

PROVENANCE: The original or early owners had arms included on p. 9 and p. 608: a paly of 6 or and azure, a canton ermine (argent 3 pales azure, the dexter canton argent with an indistinct object: James), identified by Michael as the Shirle or Shirley family; the flyleaf has a French song inscribed *E dans joline*

TEXT: English or French, *c.* 1290–1320.

The text is in a rotunda script close to *littera bononiensis*, though the text block is rather irregular. The gloss is in a more vertically emphasized Northern hand, with underlined *lemmata* not keyed alphabetically as in Italian manuscripts. Catchwords are set in the lower right corner, mostly with a jagged ink frame closed on the left with a snarling animal or horned human face.

ILLUMINATION AND DECORATION: English, *c.* 1300–20.

Each book and the prologue had a single-column frontispiece; the first is larger, as those to Book I and Book VI may have been.

Each title has an illuminated foliate initial, sometimes accompanied by a grotesque (Pls 18c, 18d, 18e). The quality of the initials becomes coarser later in the manuscript, and the black outlining becomes more emphatic. The chapters have tall and narrow blue initials with very long red linear and scroll filigree not at all like Bolognese work except for the feathered angles. The palette is dominated by a rusty orange, pale copper green, deep dull pink and pale blues; the foliage is strongly highlighted in opaque white brushstrokes.

P. 1, Prologue: On the Composing of the New *Codex*: A single-column frontispiece depicts Justinian, enthroned, handing a book to a kneeling lawyer and a sword to a kneeling knight, while another knight and lawyer look on (Pl. 18a). This is a subtle play upon the normal frontispiece for a Gratian, the Distribution of Powers (see Pl. 5k), in which Christ hands the keys of the Church to the pope as St Peter's heir, and the sword of secular authority to the emperor as Constantine's. Italian manuscripts generally show Justinian issuing the *Codex* itself, not these more abstract symbols.

P. 9, Book I: The frontispiece has been cut out of the illuminated bar border (Pl. 18b).

P. 101, Book II, On Bringing an Action: The frontispiece shows a judge seated in the centre, addressed by an appellant holding a plea, while a companion and two others look on (Pl. 18f). The main parties appear to be tonsured but wear long hooded academic gowns rather than clerical habits; the appearance of clerics before a civil judge would be anomalous. A long-necked dragon with a human face forms the initial.

P. 155, Book III: The frontispiece has been robbed.

P. 213, Book IV: The frontispiece has been robbed; an opening foliate initial with the face of a youth at the end of the internal spiral remains.

P. 293, Book V, On Marriage: A smaller frontispiece illustrates a church from which two clergy in white emerge; the groom joins hands with the bride in the centre, while the bride's parents appear behind her (Pl. 18g). The presence of clerics but no lawyers contrasts with the

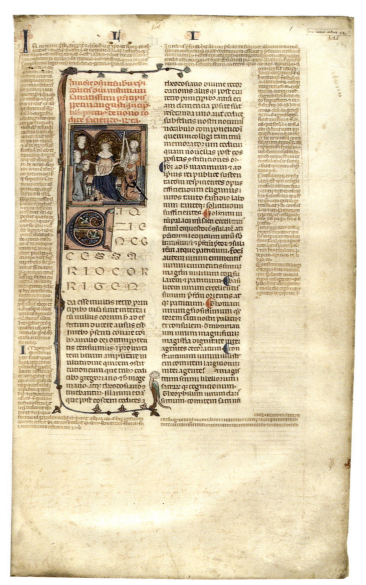

Pl. 18a. Gonville and Caius College, MS 11/11, Justinian, *Codex*, p. 1: Prologue, On the Composing of the New Codex

Pl. 18b. Gonville and Caius College, MS 11/11, Justinian, *Codex*, p. 9: the arms of Shirley

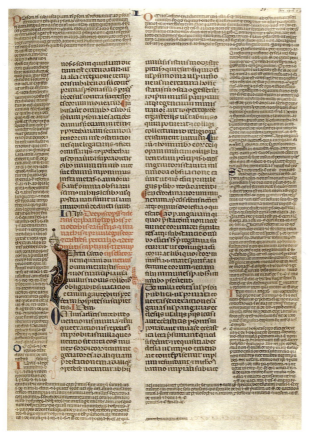

Pl. 18c. Gonville and Caius College, MS 11/11, Justinian,
Codex, p. 25

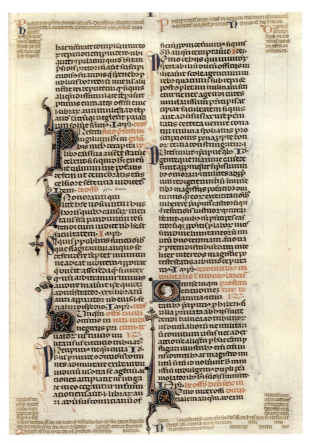

Pl. 18d. Gonville and Caius College, MS 11/11, Justinian,
Codex, p. 62

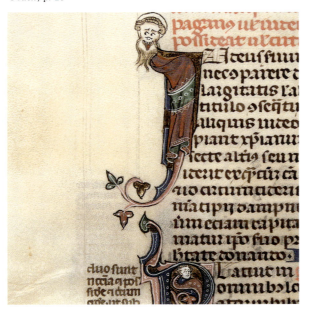

Pl. 18e. Gonville and Caius College, MS 11/11, Justinian,
Codex, p. 93

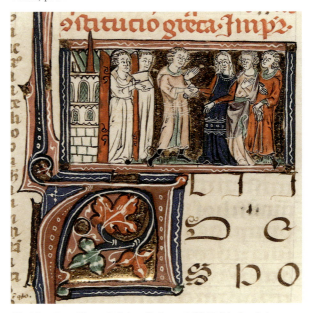

Pl. 18g. Gonville and Caius College, MS 11/11, Justinian,
Codex, p. 293: Book V, On Marriage

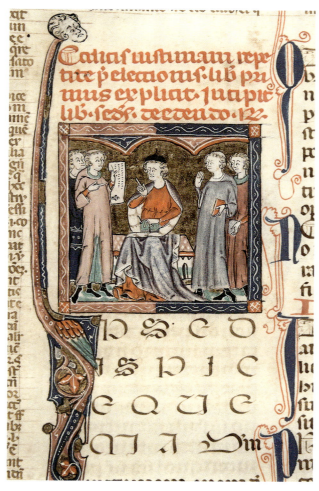

Pl. 18f. Gonville and Caius College, MS 11/11, Justinian, *Codex*, p. 101: Book II, On Bringing an Action

Pl. 18h. Gonville and Caius College, MS 11/11, Justinian, *Codex*, p. 608: the arms of Shirley

normal civil iconography of Italian and Italian-inspired copies. The initial is foliate.

P. 317, Part II, Book VI: The frontispiece has been robbed, but the daisies that remain from its corners are typical of 14th-century English illumination and distinct from any other European tradition.

P. 483, Book VII has been entirely robbed.

P. 549, Book VIII: The frontispiece has been cut out; a foliate initial to the text remains.

P. 608, Book IX: The frontispiece has been cut out; the arms of Shirley and another with a chequer of or and azure charged with argent fleurs-de-lys remain (Pl. 18h).

This appears to be a characteristic English manuscript in its illumination, which is less closely related to Italian or French models than most law books. It shows a knowledge of some aspects of continental iconography, though this is principally derived from canon law rather than civil law sources.

BIBLIOGRAPHY: James, *Caius*, pp. 10–11 as 'written in Italy, illuminated in England'; Ker, p. 26.

RG

Cat. No. 19
Cambridge, St John's College, MS A.4

Compendium on the *Liber sextus*
(The Brewes-Norwich Commentaries)[1]

Manuscript, parchment, 312 (123 + 84 + 22 + 83) folios (4 volumes bound into one); 404 x 253 mm, written in two columns of varying lines: Volume I in 82; Volume II with the text in two columns of varying size and gloss in 92 lines; Volumes III and IV in 80 lines. Written in quires of 12 folios. Early 17th-century brown calf, blind-tooled, rebacked and repaired by J. P. Grey and Son in October, 1970.

PROVENANCE: William of Gumthorp, Canon of Southwell Minster; bequeathed to Southwell Minster *c.* 1400 (*Sextus liber decretalium legatus capitulo de Suthwell per d. Will. de Gumthorp canonicum eiudem ecclesiae et prebendarium alterius prebendarum de Northwell vocat Palishall ad remanendum in libraria eiusd. eccl. ibidem perpetuo permansurus, qui quidem WillMS obiit xixo die Setembris apud Suthwell anno dni mill. cccc-mo qui allienaverit anathema sit*); given to St John's by William Marshall, Fellow of St John's College, 1625 and son of John Marshall of York, notary and Registrar of Southwell.

CONTENTS: Volume I: Guido da Baysio, *Apparatus in Librum sextum*;[2] Volume II: Boniface VIII, *Liber sextus*, with gloss of Johannes Monachus, *Apparatus in Librum sextum*; Volume III: Dinus de Mugello, *Apparatus in titulum de regulis iuris in Sexto*;[3] Volume IV: Johannes Andreae, *Glossa ordinaria in Librum sextum*.

TEXT: English, *c.* 1335.

It is ruled in brown ink and written in varying shades of brown ink; *lemmata* underlined in brown ink often overlaid with yellow wash, and in Volume II, some *lemmata* underlined in red ink. Catchwords at lower right-hand edge, near gutter – very interestingly, most were ruled for and lie framed by the ruling; many are decorat-

ed on the left in brown ink with human or animal heads and bodies. Illuminated initials substitute the usual penwork initials throughout the text. If there had been penwork initials they would probably have been blue; the paragraph markers that separate internal sections within the text are all blue. Running titles are in blue ink, **L**[*iber*] on versos, **VI** (for *sextus*) on rectos. Volume III – Dinus de Mugelo's commentary on the *regulis iuris* – is very distinctly laid out. Each rule of law is written in a large-sized script and occupies a space specially ruled for it in the left-hand side of the column, generally two or three lines in height. The commentary then begins alongside the rule on the right-hand side of the column, increasing to full-column width below.

ILLUMINATION AND DECORATION: English, *c.* 1335–50, by a group of artists loosely associated with the Tickhill Psalter workshop.

Egbert suggested that the manuscript was executed shortly before 1325, including it stylistically with the Tickhill group, while Lucy Sandler[4] observed that its cool, chalky palette, figure types and foliate borders were more consistent with work produced after 1335, and probably later. The primary decoration consists of nine rectangular miniatures and ten historiated initials. There are ivy-leaf borders and bars on miniature pages, some vinescroll details surrounded by gold grounds and other sections containing interlocking geometrical designs, diaper squares, figures and grotesques.[5] Two-line illuminated or inhabited (mostly by dragons) initials are placed at titles and paragraphs. When there are more than one initial in the same column they are connected by a narrow double bar, half leaf gold, half pink, that runs vertically along margin. Colours in the minor initial decoration are mainly orange and dark blue, with some touches of pink and winy-red. The first letter after an illuminated initial is generally a display capital, touched in yellow wash. The rules of law in Volume III are introduced by two-line initials on gold grounds, decorated with foliage, dragons and grotesques.

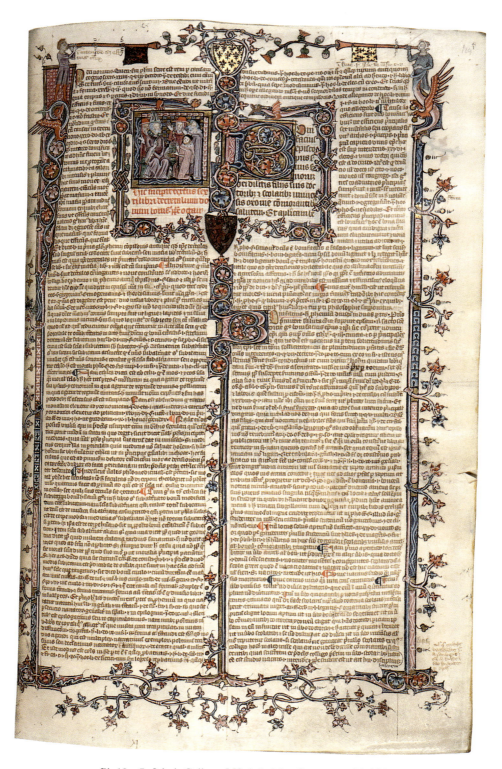

Pl. 19a. St John's College, MS A.4, *Liber Sextus* etc., fol. 124

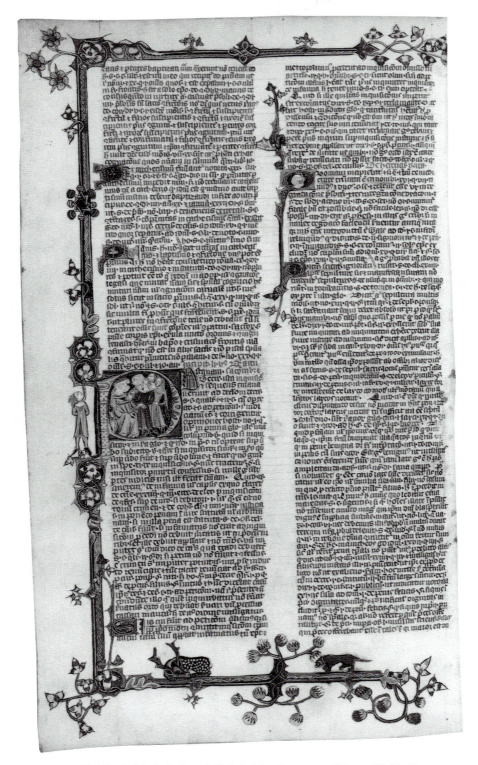

Pl. 19b. St John's College, MS A.4, *Liber Sextus* etc., Volume IV, fol. 61v

St John's College MS A.4 is plentifully supplied with heraldic evidence, including twenty-four shields and the arms of five different East Anglian families. Donald Egbert was convinced, as mentioned in Chapter 3, that it was executed to commemorate the marriage of Sir Robert Brewes and Katherine Norwich before 1325,[6] while Sandler felt this date was too early for the stylistic features of the illumination, and thought improbable that a manuscript of this sort would have been produced for such an occasion.[7] This manuscript in fact epitomizes a genre of texts assembled for comparative purposes, useful to a scholar of law, comprising a base text (here the *Liber sextus*) accompanied by four different commentaries. Significantly, the *Liber sextus* itself in Volume II is not surrounded by Johannes Andreae's *Glossa ordinaria* for Bologna – which comprises Volume IV on its own – but instead by the commentary of the French Cardinal Jean le Moine (Johannes Monachus, *c.* 1250–1313) that was taught as the *glossa ordinaria* at Paris, demonstrating yet another differentiating factor between law studies at the two universities. In addition, the *Liber sextus* is addressed to Oxford, implying that the manuscript was produced for an English market, closely tied with Paris in terms of curriculum.

The number of different texts brought together in this compilation is somewhat rare, although the idea of combining a series of *Liber sextus* commentaries seems to have been popular in this period, in England as well as on the continent. Egbert found the same four commentaries bound together in one 14th-century English manuscript,[8] and two other manuscripts containing all but Dinus de Mugello's apparatus.[9] It is more common to find, at the most, three of the different commentaries bound together, and more often two.[10] In the St John's collection each text is treated codicologically and visually as a separate unit. Just as the text of the *Liber sextus* is divided into five books, the commentaries were likewise formulated in five sections, and in all volumes but the third (Dinus de Mugello) each section is prefaced by a histo-riated composition, either a miniature or an initial.

The opening to the glossed *Liber sextus* in Volume II (Pl. 19a) featured in the exhibition, was given a layout and decoration typical for the period. Here a diminutive centre text block, ten lines in height, is surrounded by an immense quantity of gloss, both circumscribed by running frameworks of bars and foliage scattered with geometric and zoomorphic motifs. Heralds raising trumpets and accompanied by dragons face each other across the page at the upper outside corners of the gloss columns, standing atop the bands and foliage that form a full border around the text and fill the entire centre space between the text columns. Coats of arms punctuate the centre decoration, and heraldic devices decorate the banners hanging from the trumpets. Both text and gloss are introduced by large decorated initials, the gloss with a long **I**[*n dei nomine*] at upper left, and the text with the **B**[*onifacius episcopus*] that opens the papal address to the doctors and scholars of Oxford.

In the miniature, a bearded Pope Boniface VIII, flanked by red-hatted cardinals, is enthroned at left. Bedecked in a green tiara and violet robe, he receives the finished *Liber sextus* from the hands of a kneeling figure, perhaps representing the Cardinal Riccardo Petroni of Siena, who participated in the compilation of this decretals collection, along with William of Mandagot, Archbishop of Embrun, and Berengario Fredoli, Bishop of Beziers. This figure is portrayed as a civil lawyer, however, wearing the black pileus emblematic of his profession, as does his standing colleague. An interesting aspect of this manuscript's iconography is the prominence given to secular professionals, who exercise leading roles in the miniatures, supplementing or substituting the conventional ecclesiastical personnel. All surviving frontispieces (that to Volume IV was excised) include lay figures: in the frontispiece to Volume I the enthroned Boniface is also accompanied by two lay jurists in black pileus, in addition to the complement of cardinals, and the historiated initial that opens Volume III depicts a civil lec-

turer addressing a group of seated students. The historiated compositions for Books II, *De iudiciis* (On Judgements) and V, *De accusationibus, inquisitionibus et denunciationibus* (On Accusations, Inquisitions and Denunciations) in each volume eschew clerics entirely in their representations of court scenes, which are presided over by crowned figures or civil judges and attended by laymen and civil lawyers. As described and illustrated in Chapter 5, the historiated initial for Book V of Johannes Andreae's *Glossa ordinaria*, Volume IV (Pl. 19b), instead of the usual fleeing or expostulating cleric under accusation, pictures a poacher with bound hands and a stolen sheep tied around his neck, brought by laymen before a secular judge. The prevalence of secular protagonists might signify that the manuscript's original owner was a layman himself.

BIBLIOGRAPHY: James, *St John's*, no. 4, pp. 3–5; Egbert, pp. 117–20, 219–22; Sandler, *Gothic Manuscripts*, no. 113, pp. 126–27, ills 295, 296; 'Canon Law at Cambridge', p. xliv.

SL'E

1 This manuscript has been comprehensively described in Egbert, pp. 117–20 and pp. 219–22, so codicological details and description of iconography will here be kept to a minimum.

2 The Bolognese canonist Guido da Baysio (*c.* 1250–1313) produced his Apparatus on the *Liber sextus* in Avignon where he was serving Pope Clement V as *auditor*, finishing the work just before his death in 1313.

3 See Vatican City, BAV, Vat. lat. 1452, fols 131–156v. Dinus de Mugello (d. after 1298) was primarily a civil law commentator. He is thought to have been appointed by Boniface VIII to compile a list of 88 principles of law, assembled under the title *De regulis iuris*, to be inserted as a closing passage to the *Liber sextus* – in imitation of the closing title to the civil law *Digest*. Whether or not Dinus was actually responsible for the compilation, shortly after it came into use he composed his commentary on it, expressing the view that these general principles were the basis of and encapsulated all the written law. See Calasso, p. 403, 545; and Smith, p. 57.

4 Sandler, *Gothic Manuscripts*, I, no. 113, p. 126, ills 295, 296.

5 See the detailed descriptions of historiated, ornamental and heraldic decoration in Egbert, pp. 220–22.

6 Egbert, p. 118.

7 Sandler, *Gothic Manuscripts*, I, p. 126.

8 London, BL, Royal MS 11 D.V, with its *Liber sextus* addressed to Cambridge.

9 London, BL, Royal MSS 9 F.V and 10 E.I.

10 Gonville and Caius College MS 45, probably an Oxford production, contains the gloss of Johannes Monachus, the unglossed *Liber sextus* addressed to Oxford, and the *glossa ordinaria* of Johannes Andreae, written as three separate units; Pembroke College MS 165 comprises two separate sections: the *Liber sextus* enclosed by the gloss of Johannes Monachus, followed by the *glossa ordinaria* of Johannes Andreae; the Vatican Library's MS Vat. lat. 1393 contains the *Liber sextus* glossed by Guido da Baysio and followed by the Bolognese *glossa ordinaria*; Toledo, Bibliotecas y Archivos Capitulares MS 4-12 comprises the *Liber sextus* with the Bolognese *glossa ordinaria* and followed by Dino da Mugello's commentary on *De regula iuris*.

Niccolò da Bologna

NICCOLÒ DI GIACOMO Nascimbene da Bologna (active 1349–1403/4) was the most prolific illuminator of the Trecento, and his practice of signing his work enables us to follow its development in some detail. He probably learned his craft from the 'Illustrator' or perhaps a pupil or assistant of this artist, the 1346 Master. Niccolò's work reflects their figure types, modelled acanthus leaves in foliate letters and marginal decoration and taste for rich foliate backgrounds, but his figures have a wider range of characterization and more precise modelling than those of the two earlier artists. His first datable work, apart from some initials in the Roermond *Digest* (Gemeente museum MS 1/inv. 1855),[1] written in 1340 but surely illuminated some years later is the splendid little Kremsmunster Hours of 1349 (Stiftsbibliothek MS Clm 4).[2] In the next few years he developed dramatic representations of Giovanni d'Andrea teaching and of the Arts and Sciences for a new generation of legal texts: Vatican City, BAV, lat. 1456, lat. 2534 (1353), and Milan, Bibl. Ambrosiana B 42 infol. (1354).[3]

His mature style is well displayed in full-page illuminations of New Testament scenes in the Munich Missal (Bayer. Staatsbibl. Cod. lat. 10072) of 1374,[4] and many choir books in Bologna, while the massive figures of his late style are well represented in a set of civic bank records, the *Libri dei Creditori del Monte di Pubbliche Prestanze* (Bologna, Archivio di Stato, cod. min. 25–27), of 1394–95.[5]

Niccolò appears to have been a close friend of the leading painter of the period, Simone dei Crocefissi. Niccolò's nephew, Jacopo di Paolo, who practised both arts, was probably apprenticed to Simone, in whose household he is recorded on one occasion. The leading illuminator of the next generation, the Brussels Initials Master, who worked in Padua and at the court of Jean Duc de Berry, was clearly Niccolò's pupil.

RG

[1] Cassee, *Missal*, p. 117, fig. 119; Langenzaal, pp. 121–38.
[2] Schmidt, 'Andreas'; Cassee, *Missal*, esp. pp. 24–25, 115, attributes Andrea's work to the Illustrator (Gibbs, 'Recent Developments').
[3] D'Ancona, 'Nicolò da Bologna', esp. figs 6–7; Cassee, *Missal*, figs 8, 23.
[4] D'Ancona, 'Nicolò da Bologna', fig. 27.
[5] Medica, *Statuta*, pp. 100–01.

Cat. No. 20
Cambridge, Fitzwilliam Museum, MS 331

Johannes Andreae, *Novella in Decretales* (Lib. III–V), Book V

Manuscript, parchment, single leaf 445 x 280 mm, 2 columns (355 x 194 mm), 74 lines.

TEXT: Bologna, *c.* 1355–60, attributed to Bartolomeo dei Bartoli.

ILLUMINATION: Niccolò da Bologna, *c.* 1355–60.

MS 331, a single parchment leaf headed by a large miniature and two historiated initials (Pl. 20a) constitutes the frontispiece and opening folio to Book V of Johannes Andreae's *Novella in Decretales*. It was purchased from Sotheby's by Sidney Cockerell in 1932[1] with funds supplied by the Friends of the Fitzwilliam.[2] A sister leaf in the same sale, representing the frontispiece to Book IV of the same text, was acquired by Hirsch, later passing to H. P. Kraus and subsequently in 1958 to Lessing J. Rosenwald, who gave it to the National Gallery of Art, Washington, D.C., in 1961 where it was assigned the shelfmark MS B-22225.[3] The two leaves have attracted little attention up to now beyond the recognition that their illumination was executed by the most renowned 14th-century Bolognese illuminator, Niccolò da Bologna.

The Fitzwilliam leaf has a one-column frontispiece to illustrate its opening rubric, *De accusationibus, inquisitionibus et denuntiationibus* (On Accusations, Inquisitions and Denunciations), depicting a cardinal wearing the fur-lined *cappa* reserved to his rank, enthroned as a judge and conducting a hearing. He is addressed from the left by a soldier in green and a layman in red who press upon him a large scroll; at right a lawyer kneels with another plea. In the background, bystander groups of clerics and secular figures watch the court procedures. Below the cardinal, three lawyers write at a bench: a cleric in a white habit, and two doctors of law in miniver-lined hooded gowns, blue and pink. The

doctor in pink looks up reflectively; he wears a hat with side flaps often represented in academic scenes, and his long features are those associated with Johannes Andreae himself.[4] The initials to the first two titles are connected by a monumental treatment of the opening **P** set neatly into the entire left-hand text column and, like the miniature, laid on a rich gold ground outlined in black. A bishop reads within the bowl of the **P**; in the stem, a figure wearing ragged trousers serves as a caryatid to support the base of the bishop's *cathedra*; in the initial **S** at the foot of the text column is another representation of the pensive doctor in pink, presumably Johannes Andreae.

The National Gallery leaf (Fig. 18) also opens with a one-column miniature and a large historiated initial for its opening rubric, *De sponsalibus* (On Marriage). The miniature depicts a betrothal ceremony being conducted by a secular lawyer, who clasps the couple's shoulders as the groom places a ring on the bride's finger. Members of the wedding entourage cluster around the bride and groom, joined by musicians who enliven the festivities. The bride and groom embrace and kiss in the initial **P** directly below; further down in the initial **D**, a lone woman mourns the loss of her spouse.

It has recently been ascertained that both the Fitzwilliam Museum and the National Gallery of Art leaves originally belonged to MS M.747 at the Pierpont Morgan Library in New York. They were detached from their much-pillaged mother manuscript sometime before 1929, when it was presented to the Library as a gift of Junius S. Morgan. It is not known when or where he purchased the manuscript, but it was acquired strictly for its sixty-nine remaining historiated initials, beautifully executed by Niccolò da Bologna. The Morgan manuscript, of fifty folios, combines in one volume (in a 19th-century binding) fragments from two different commentaries by Johannes Andreae – his *Novella* on Books III–V of the *Decretales*, and the *Novella* on the *Liber sextus*. Six folios survive from the *Decretales* Book III, two of which are misbound between Books IV and V. There

226

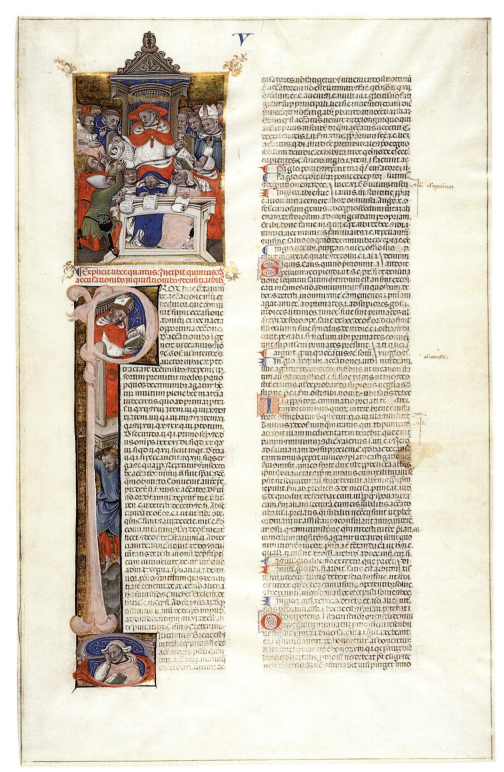

Pl. 20a. Fitzwilliam Museum, MS 331, Giovanni d'Andrea, *Novella in Decretalibus*, Book V

are eight remaining folios from Book IV, including the leaf that continues National Gallery MS B-22225, and ten from Book V, starting with the leaf that directly followed Fitzwilliam MS 331. The *Liber sextus* commentary continues in the same format, its twenty-six leaves distributed as follows: five from Book I, six from Book II, ten from Book III, three from Book IV and three from Book V. This text would most likely have had only one large opening frontispiece, which, along with the frontispiece for the *Decretales* Book III, is still missing.[5]

The *Novella* texts, even when commissioned as a set, were usually bound in separate volumes. Some examples are the Vatican Library's MSS Vat. lat. 2231 and 2233; Vat. lat. 1456 and 2534;[6] and the Toledo Cathedral Library's complete MSS 8-5, 8-7 and 8-10,[7] each set the work of a single scribe, and the last two sets also illuminated by Niccolò. Whether originally bound together or apart, the Morgan texts (including their detached leaves) were certainly executed as a set: all segments are written in columns of 74 lines and share scribe, rubricator and illuminator. Gerhard Schmidt attributed the fine script to a Bolognese scribe, Bartolomeo dei Bartoli, based on the affinity of its calligraphy with that in a Book of Hours in Kremsmünster, signed by him in 1349.[8] Schmidt dated the Fitzwilliam and Washington leaves to the later 1350s, however, as representing a later stage in the illuminator's stylistic development, compared with the 1349 Hours. This dating is convincing, particularly in terms of the contrast between the lighter orange-reds and lettuce greens used in earlier works – such as Niccolò's well-known frontispiece for the Biblioteca Ambrosiana's MS B42 inf. in Milan, dated 1354 – and the deeper reds and greens in the present manuscript. Here figure style, colours and dress are more compatible with the artist's surviving compositions in the Toledo MS 8-7, dated 1359 by the scribe.

At the secondary level of decoration, the sixty-nine remaining historiated initials in M.747 testify to the original richness of Niccolò's illustration programme for this set. Unlike his

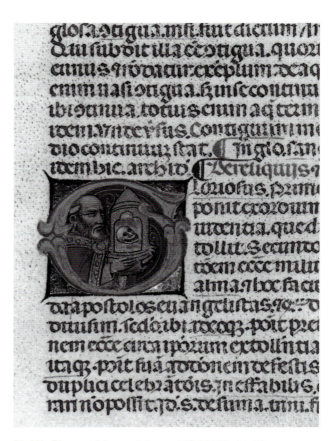

Pl. 20b. Pierpont Morgan Library, MS M.747, fol. 43v

Vatican, Toledo and Milan examples, whose initials at title divisions have foliate decoration or simple human busts, M.747's initials are all figured and often text-allusive. The integral decoration of these volumes would have represented a tremendous *tour de force*, since the *Decretales* has over 180 titles, and the *Liber sextus* 76. Such extensive secondary historiation in canon law manuscripts is very rare; among Bolognese works, two 13th-century *Decretales* (Vatican City, BAV, MS Pal. lat. 629 and Chantilly, Musée Condé MS XVIII E 1) have historiated titles executed by Jacopino da Reggio and his associates. Many of the examples in M.747 directly evoke the text they preface, such as the cardinal clinging to a moneybag at the rubric on simony (illustrated in Chapter 5, Fig. 48);[9] a pair of coffins bearing a male corpse and a skeleton, tucked into the initial **A**[*nimarum*] beside the rubric *De sepulturis* (On

Burial),[10] and especially the tonsured cleric in ceremonial robe, who holds up a golden reliquary containing a grinning skull within the initial **G**[*loriosus*], at the rubric *De reliquiis et veneratione sanctorum* (On Relics and Veneration of the Saints) on fol. 43v (Pl. 20b).[11]

The combination of elements – the regular and elegantly written script, use of a copious amount of gold leaf, execution of both primary and secondary illumination by a renowned artist – implies that the manuscripts were commissioned by or for an important (and wealthy) patron, who demanded and appreciated the best. Aside from correctors' marks and *pecia* indications at regular intervals, the fine vellum margins are clear of readers' commentary, and it is probable that the volumes were intended to be admired more than consulted.

BIBLIOGRAPHY *Annual Report of the Friends of the Fitzwilliam Museum*, 1932; Wormald and Giles, *Illuminated Manuscripts*, no. 61; Wormald and Giles, *Descriptive Catalogue*, pp. 320–21; Schmidt, 'Andreas,' pp. 63–64, figs 114–15; Vikan, no. 15, pp. 50–52.

SL'E

1. London, Sotheby's, 25 July 1932, lot 196, The Property of a Lady of Title. See Wormald and Giles, *Illuminated Manuscripts*, no. 61; Wormald and Giles, *Descriptive Catalogue*, pp. 320–21.
2. As evidenced by the Annual Report for 1932.
3. London, Sotheby's, 25 July 1932, lot 195. On the NGA leaf, see Washington, pp. 50–52, cat. no. 15, figs 15a–b.
4. See Gibbs, 'Images,' pp. 274, 276–77.
5. The frontispiece to Book III might have exploited the current popular trend of using an allegorical theme, like Niccolò's version for this book in MS B42 inf. at Milan's Biblioteca Ambrosiana, dated 1354, which features personifications of the Cardinal Virtues and the Sciences.
6. Kuttner and Elze, pp. 263–67. A complete set would comprise three volumes: the *Decretales* commentary in two, Books I–II, and Books III–V, the *Liber sextus* commentary in the third.
7. García y García and Gonzálvez, pp. 22–26. These three manuscripts were written in Padua by the scribe Andreas de Mutina in 1359, 1360 and 1363, while he was working in the household of his patron. The manuscripts were commissioned by Giovanni Placentini of Parma, a doctor of canon law from the University of Padua who pursued a career in the Church, beginning as canon in 1350, attaining high priest in 1360, elected Bishop of Cervia in 1364 and later appointed Bishop of Padua by the pope in 1370.
8. Schmidt, 'Andreas', pp. 63–64.
9. *Decretales*, Book V, title 3, fol. 15v.
10. *Liber sextus*, Book III, title 12, fol. 38v.
11. *Liber sextus*, Book III, title 21, fol. 43v.

Cat. No. 21
Cambridge, Fitzwilliam Museum, MS McClean 201.f.15

Matricola of the Bolognese Guild of the Cordwainers: De Quarterio Porte Ravennate (Quartiere de Porta Ravegnana)

Manuscript, parchment, a single detached folio, 350 x 250 mm, the text area 250 x 160 mm.

PROVENANCE: Frank McClean; bequeathed to the Fitzwilliam Museum in 1904.

TEXT: Bologna, 1378.

It is in a broad *littera bononiensis*.

ILLUMINATION AND DECORATION: Niccolò da Bologna, 1378.

This leaf originally belonged to the *matricola* (member register) of the Guild of the Cordwainers (*Cordovanieri*) in Bologna, who made fashionable shoes, particularly admired by university students.[1] The Fitzwilliam leaf is the opening for the list of members in the Quartiere de Porta Ravegnana, the last of the four quarters into which the city's populace was divided for all administrative purposes, and defined by the principal gates of the city (Pl. 21a). It can be associated with a leaf in Turin, and two leaves formerly in the Korner collection (discussed below). Together they make up the four principal openings of the register, each representing one of the quarters. There are slight variations in size between the leaves, undoubtedly due to different conditions of conservation: artistically and codicologically they are identical, and the survival of all four frontispieces confirms their original provenance from a single source.[2]

The regulation of Bologna involved considerable numbers of statutes, those by which the city itself was governed, as well as those of religious and professional societies, such as craft guilds, where Bologna's electorate and councillors were amongst the members. The city council controlled the statutes of the guilds, which

with their registers were important documents for the societies' administration. The date of this register, contemporary with the city's statutes also illuminated by Niccolò da Bologna, is of particular significance, since it follows the revolt against papal control in 1376 and the accord by which Bologna recovered virtual autonomy for a quarter of a century. New guild statutes, and the registers which accompanied them, were a natural part of such a change in government.

The opening folio to this register, now in Turin (Museo Civica d'Arte Antica, Inv. 926), features the city's patron saints (the Virgin Mary, Peter and Paul, Petronius, Ambrose, Francis and Dominic), to whom the register is dedicated along with the Holy Trinity (Pl. 21b).[3] Measuring 365 x 254 mm, it bears an original foliation, number **i**, in red in the upper right corner like the other three leaves. It is the most lavishly decorated of the frontispieces, as befits its introductory status. It depicts the Resurrected Christ rising from his tomb; directly below stands the Virgin Mary as the Madonna of Mercy, who shelters kneeling guild members in the folds of her voluminous blue cape. Her tunic is sewn with fleurs-de-lys, the colours of France and the Guelf allegiance, and may reflect decorative leatherwork. St Peter, the patron saint of the city's cathedral and the quarter represented by this leaf, is depicted as Pope, blessing the text and holding up keys, his chief attribute. The morse of his cope bears the arms of the Commune formed by a Bolognese shield, a red cross on white. Peter's depiction as the Pope is particularly significant since Bologna was legally subject to the papacy at this time.

In the lower foliate border are three large shields in roundels bearing the arms of the Comune of Bologna (a red cross on a silver ground, with a chief of the Guelf arms), of the Guelf allegience (the arms of Anjou and Naples: the French gold fleurs-de-lys with a red label in the chief) and of the Cordwainers' Guild (a leather-worker's knife, a shoe in profile and a sandal seen from above, in black on a silver ground). The silver grounds of the shields

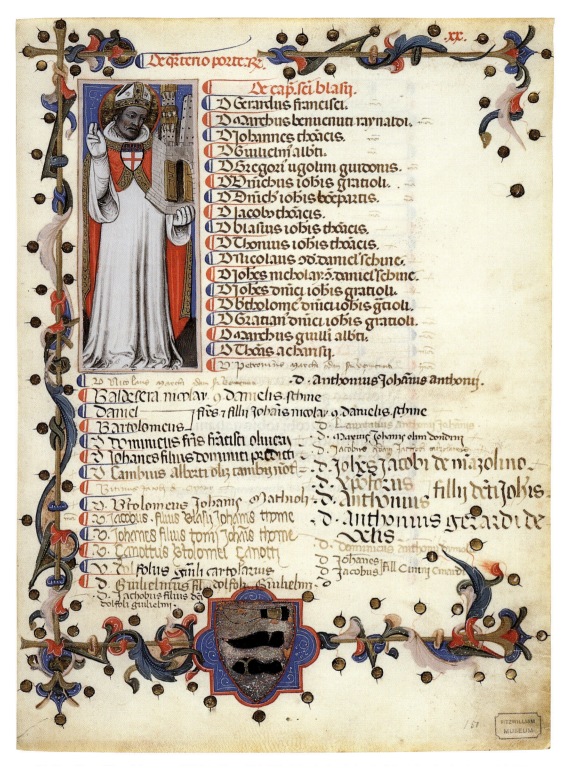

Pl. 21a. Fitzwilliam Museum, MS McClean 201.f.15, *Matricola* of the Guild of the Cordwainers, fol. XX
St Petronius representing the *Quartiere Porte Ravenate*

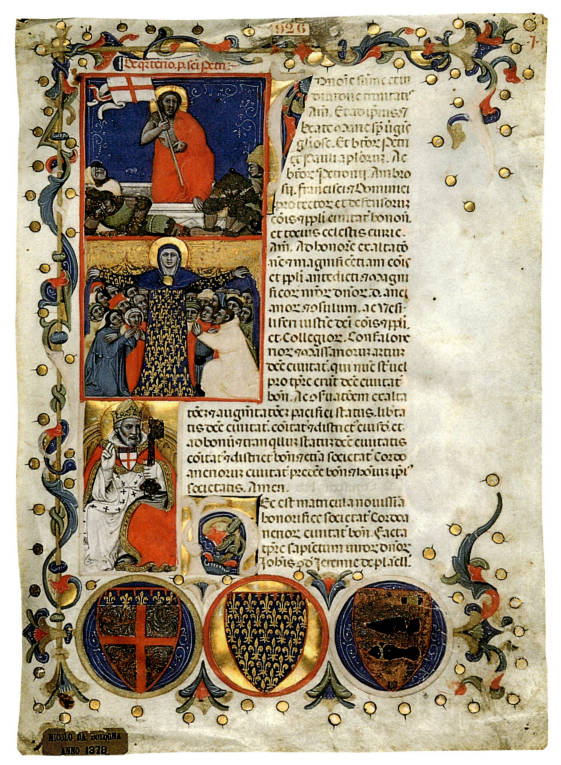

Pl. 21b. Turin, Museo Civico d'Arte Antica, Inv. 926, 386/M, fol. 1: Dedication of the Guild Register

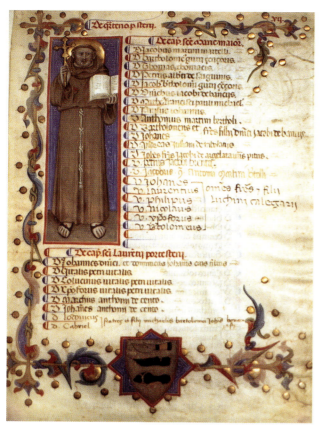

Pl. 21c. Niccolò da Bologna, *Matricola* of the *Cordovanieri*, 1378, fol. vii (formerly Korner Collection 22)

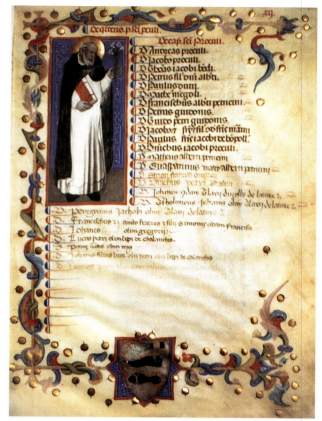

Pl. 21d. Niccolò da Bologna, *Matricola* of the *Cordovanieri*, 1378, fol. xii (formerly Korner Collection, then Breslayer)

are richly worked with silver foliate scroll derived directly from the gold foliage used by Bolognese illuminators as backgrounds for their illuminations.

The other three leaves of the register are illustrated more modestly, each with the patron saint of the quarter standing full-length in a tall, narrow miniature at the upper left-hand side and bordered by running vine-scroll and raised gold dots. The name of the quarter interrupts the top foliage stave, while the arms of the guild are centred in the lower margin. The guild members of the first parish of the *quartiere* to be recorded, active at the time the register was written appear alongside the saint, with later additions added below . Each leaf is ruled in 34 lines.

The leaf rubricated *De quarterio porte Sterii* (Quartiere de Porta Stiera), fol. vii, was former-

ly in the Korner Collection.[4] Measuring 350 x 245 mm, it shows St Francis stigmatized and holding up a gold cross and an open book (Pl. 21c). Guild members from the parishes of Sta. Maria Maggiore and S. Lorenzo di Porta Stiera are listed on the recto and those from S. Columbano and S. Feliciano on the verso.

The leaf rubricated *De quarterio porte sancti Proculi* (Quartiere della Porta S. Procolo), fol. xii, was also formerly in the Korner Collection and measures 350 x 248 mm.[5] It was named after the great Benedictine abbey of S. Procolo at the heart of the university, in whose parish Niccolò himself resided. It is represented by St Dominic (S. Domenico was the parish next to it) holding up two of his attributes: a stalk of white lilies and a large red-bound volume closed in his right hand (Pl. 21d). Guild members from the parish of S. Procolo itself are listed on

the recto, and those from the sub-parishes within S. Domenico and Sta. Caterina da Saragossa on the verso.

The Fitzwilliam leaf for the Quartiere della Porta Ravegnana is the last of the set, fol. xx. St Petronius, the saint most strongly identified with the city, is shown attired as a bishop with his cope closed by a morse emblazoned with the arms of the Commune and holding up and blessing a representation of the city with its characteristic leaning towers. The Ravenna gate itself, its doors ajar, is prominent in the wall that surrounds the two 12th- or 13th-century towers which are still Bologna's principal landmark: these stand right at the site of the gate. According to medieval legend Petronius set up four oratories and crosses at the gates of the wall, which he was supposed to have had built, and surviving Romanesque crosses lent continuing veracity to his legend, though the original wall was superseded by two later and larger ones. He was buried at S. Stefano, near the Ravenna gate. A decade after this register was illuminated the enormous basilica dedicated to him was built at the heart of the city which rivalled the cathedral of S. Pietro.

The names of the original guild members of the first parish of the quarter, S. Biagio (*Sancti Blasii*), introduced by the rubric at the top of the page, are laid out beside the saint's portrait, and paragraph signs for further names occupy the rest of the single column text space. The first twelve names represent members active at the time this register was written, and names of new members were added in subsequent years. On the verso are listed members for the parishes of Sta. Maria de Castro Britonum and Sta. Maria de Templo.

Each of the original guild members' names has been annotated '*mor[tem]*' as an indication for them to be remembered in the guild's prayers, while their successors, including sons of some of those in the original list, have been added. There appears to have been an exceptionally large activity of the Cordwainers' Guild in this parish in later decades, given the numerous names.

The figures in these leaves have a distinctive position in the development of Niccolo's style. They have a larger scale in relation to their compartments than in his earlier work, with a resulting sense of grandeur, yet they lack the exaggerated massiveness and coarse features that sometimes characterize his late illuminations. The standing saints still have sharp and rather straight contours; the colours of their mantles are pure rather than dominated by strong white highlight or contrasting shadows, such as those in the late registers of the 1394–95 *Libri dei Creditori del Monte di Pubbliche Prestanze* (Bologna, Archivio di Stato, cod. min. 25–27, and New York, Pierpont Morgan Library M.1056 [formerly Hirsch and Straus collections]). These *matricola* leaves are still much closer to the Munich Missal of 1374 (Bayer. Staatsbibl. Cod. lat. 10072) and the Treatises of Giovanni da Legnano of 1376 (Vatican City, BAV, Vat. lat. 2639) than to the late works with which they have been compared.[6] In making the comparisons to the Munich and Vatican manuscripts, Massimo Medica notes that the foliage of the *matricola* has the flat leaves of the earlier 14th century but considers it to be the work of Niccolò. It is likely, however, that this flat foliage style indicates a specialist decorator in Niccolò's workshop: his best foliage is usually modelled in the round and the secondary decoration of less luxurious manuscripts was frequently consigned to assistants who maintain the earlier tradition. The figures, however, are among his finest autograph work.

Niccolò's dominance of Bolognese illumination after 1350 is reflected in his illumination of most surviving statutes and registers from the *Statuti e Matricola dei Merciai* of 1360 (Bologna, Mus. Civ. MSS 635–636) to the registers of the *Creditori del Monte* of 1394–95. His development of this civic presentation of St Petronius in a series of statutes through the last quarter of the 14th century undoubtedly contributed to the city's own self-image and the cult of its main patron saint. By 1394 Niccolò shows in these works a great church and belfry, perhaps the cathedral or even the new basilica

the city had just begun to build in Petronius's honour, rising among the city's towers. Along with the image of the university doctor teaching, reflected in the next item of the exhibition, the Fitzwilliam Museum's MS 278a–b (Cat. No. 22), Niccolò's 1378 representation provides a powerful visual symbol for the greatest centre of medieval law.

BIBLIOGRAPHY: Bulgarelli, *Statuti*; James, *McClean*, p. 365; Medica, *Statuta*, particularly no. 21, pp. 64–66, 142–43; S. Castronovo in *Blu, Rosso e Oro,* pp. 131–32; De Winter, 'Bolognese Miniatures', p. 350; C. de Hamel in Korner, lots 16–17, pp. 44–47; Voelkle and Wieck, no. 71, pp. 46, 188–89; Günther, no. 24, pp. 137–40.

RG and SL'E

[1] See the essay by A. Pini in Medica, *Statuta*, pp. 31–37. In 1294 the guild boasted a membership of 1700, and later merged with the two other shoemaker guilds in Bologna, the *calzolai* and the *calegari*, in the second half of the Trecento.

[2] The registers of the Guild of the Cordwainers are consistently impressive: the frontispiece of the 1349 *matricola* is preserved in Paris (Musée Marmottan, Wildenstein Collection) with similar iconography to the opening leaf of this set. The illuminator is a highly refined painter close to Vitale da Bologna in style. See Medica, *Statuta*, no. 15, pp. 128–29, who convincingly suggests a possible connection with Jacobus (Jacopo Biondi?) responsible for the Joseph cycle at Mezzaratta.

[3] Medica, *Statuta*, no. 21, pp. 64–66, 142–43, tentatively associating the Korner leaves with the Turin frontispiece ('forse proveniente dalla medesima matricola').

[4] It was no. 22 in the Eric Korner Collection acquired from Heinrich Eisemann, sold at Sotheby's, London, 1990, lot 17, and purchased by Bruce Ferrini, subsequently listed and described in the 1993 Jörn Günther catalogue, although its present location is uncertain. Medica, *Statuta*, pp. 64–66, 142, is incorrect in assigning the Porta Stiera leaf to the Breslauer collection.

[5] This leaf was no. 21 in the Eric Korner Collection, also acquired from Heinrich Eisemann, sold at Sotheby's, London, 1990, lot 16; it was purchased by Bernard Breslauer.

[6] Voelkle and Wieck, pp. 46, 188–89, following De Winter, 'Bolognese Miniatures', p. 350, as 'circa 1386': the basis for De Winter's curiously specific date is not clear.

Cat. No. 22
Cambridge, Fitzwilliam Museum, MS 278a–b

Two Choir Book initials: *The Charity of St Nicholas* and *St Thomas Aquinas Teaching*

MS 278a: Manuscript, parchment, 315 x 275 mm, the principal illumination, 210 x 190 mm; the initial is mounted; the reverse is not currently readable.

MS 278b: Manuscript, parchment, 380 x 265 mm, the principal illumination on the recto, 315 x 207 mm; the staves show the choir books to be of a very large size, 57 mm each; the verso reads *[. . . et canden]s virgo fl[ore mu]ntitie bina [g/audet coro]na glorie.*

PROVENANCE: Bought by the Friends of the Fitzwilliam Museum in 1915 from Frank T. Sabin; in the collection of Captain Gilpin in the 19th century; and perhaps previously in a North Italian collection. A highly ambiguous note in the mount of MS 278b refers to the signature and to Gemona Cathedral, but in a confused manner: *Mastro Nicolo viveva circa 1132 seguato Master Nicolaus pintor me fecti nella fiacciata della Cattedrale di Gemona nel Frivoli.*

ILLUMINATION AND DECORATION: Bolognese, probably *c.* 1376, by Niccolò da Bologna or his workshop.

Bologna's status as an important centre for European law studies was reflected in most of its civic and religious artistic patronage, including the choir books of its friars and monks. The first of these two cuttings shows the radical transformation of a conventional subject to represent the unexpected distress that could befall even a wealthy legal family; the second depicts a great scholarly saint undertaking an academic duty.

MS 278a: *The Charity of St Nicholas*
In this scene St Nicholas, whose role as patron saint of Christmas gift giving derives from this

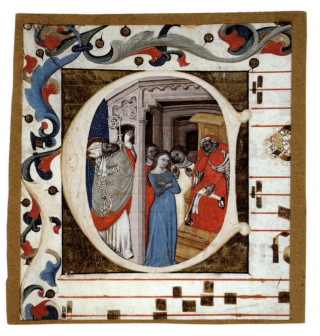

Pl. 22a. Fitzwilliam Museum, Museum MS 278a: *The Charity of St Nicholas*

story, is throwing a purse of gold coins into a house in which a father has fallen on hard times (Pl. 22a). He is lamenting that he cannot provide dowries for his daughters, who are in danger being reduced to prostitution. The distressed father is shown as a doctor of laws in a lavish miniver-lined suit, which may suggest a particular historical context. It may reflect the decline of the university or the upheavals in 1376 when the city rebelled against papal overlordship and as the result of which some wealthy legal families lost their important roles in civic government.[1]

The face and breast of the foremost daughter have clearly been repainted or very heavily retouched, and there is an almost certainly spurious and uncharacteristic signature: *nicholaus d. bononia fecit:-.* Niccolò used larger and more assured lettering for his numerous signatures, invariably majuscule rather than minuscule as here. It may, however, have been copied from an authentic signature elsewhere in the volume from which the initial is plundered. In this case the extension *da Bologna* would indicate that it was for a non-Bolognese church, since Niccolò

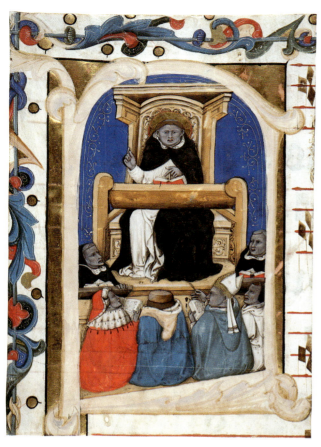

Pl. 22b. Fitzwilliam Museum, Museum MS 278b: *St Thomas Aquinas Teaching*

omitted this in manuscripts that were certainly for use in the city.

MS 278b: *St Thomas Aquinas Teaching*

The depiction of St Thomas Aquinas as a teacher is related to representations of him while preaching; both portrayals, as successive and distinct images, are common in Dominican choir books (Pl. 22b). The B 18 Master was responsible for at least three examples in the choir books of the friars of S. Domenico and the first Dominican nunnery in Bologna, Sta. Agnese.[2] Similar representations of Aquinas evolved as the characteristic commemorative image on the front of the Bolognese tombs of professors (*doctores*), the most harmonious and expressive being that of Giovanni d'Andrea (d. 1348). The Illustrator and Niccolò adapted

it in the 1340s and 1350s as a suitable frontispiece for texts by Giovanni d'Andrea, his *Novellae* on the *Decretals* and his biography of St Jerome.[3]

These two cuttings are almost certainly the product of Niccolò's workshop, but the small pinched features of most faces, the hunched posture of St Nicholas and the impassive figures seated before St Thomas suggest that he was not personally responsible for much of their execution. This is particularly evident in the flat tonsured head, which looks more like a cap, of the central member in Thomas's audience. The very dramatic and effective figure of the distressed doctor/father is characteristic of Niccolò's earlier work of the 1350s. These two fragments represent the calmer mood and more restrained colours of much of Niccolò's work in the 1360s and 1370s. However, such a range of style may be interpreted as a sign of workshop production.

BIBLIOGRAPHY: Wormald and Giles, *Descriptive Catalogue*, pp. 235–36.

RG

1 After the revolt of 1376, Riccardo da Saliceto, the most eminent and wealthy professor of civil law in Bologna, and his son Robert, were dispossessed for their role in its leadership. Riccardo da Saliceto owned the finest set of mid-14th-century Bolognese lawbooks: Vatican City, BAV, Vat. lat. 1409, 1425, 1430, 1436, 2514, of which three were illuminated by the Illustrator and the Paris Gratian Master. See Kuttner and Elze, I, pp. 204, 224–25, 231–32, 241–42, and II, pp. 88–89; Pace, *Saliceto*, pp. 75–86; Speciale, *Memoria*, pp. 208, 222, 233, 330–31; D'Arcais, 'L'Illustratore', pp. 27–41; Cassee, *Missal*, pp. 26–27, 74, 116, figs 16, 18, 19, 94; Conti, *La miniatura*, pp. 14, 88–91, figs 260, 264–65, 271–74.

2 Bologna, S. Domenico, cod. cor. 26; Venice, Fondazione Giorgio Cini 2032(33); Bologna, Mus. Civ. MS 516, fol. 229r and MS 545, fol. 77v. See Alce, *La biblioteca*, pp. 141–69; Canova, *Fondazione Cini*, no. 10, pp. 7–8, fig. 10; and Canova, 'Nuovi contributi', pp. 371–93, at pp. 383–87; Medica, *Libri miniati*, p. 10, fig. 10 and cover.

3 Grandi, *Dottori, passim*; Gibbs, 'Images' and Gibbs, *Tomaso*, pp. 35–38, 74–77, figs 19–20, 50–56.

List of Illustrations

Reproductions by the kind permission of the following:
Biblioteca Apostolica Vaticana
The Dean and Chapter of Durham Cathedral
The Dean and Chapter of Hereford Cathedral
Gemeente Museum, Roermond
The Master and Fellows of Corpus Christi College, Cambridge
The Master and Fellows of Gonville and Caius College, Cambridge
The Master and Fellows of St John's College, Cambridge
The Master and Fellows of Sidney Sussex College, Cambridge
Museo Civico d'arte Antica di Torino
The National Gallery of Art, Washington, D.C.
The Pierpont Morgan Library, New York
Staatsbibliothek Bamberg
The Syndics of the Cambridge University Library
The Syndics of the Fitzwilliam Museum, Cambridge

Note: Regardless of colour or black and white reproduction, all illustrations in the introductory chapters are termed 'figures' and those in the catalogue entries 'plates'.

FIGURES

Chapter 2

Chapter 3

Chapter 4

Chapter 5

PLATES

Cat. No. 1

Cat. No. 2

Cat. No. 3

Cat. No. 4

Cat. No. 5

Pl. 5g. Fitzwilliam Museum, Marlay Cutting It. 9
Pl. 5h. Fitzwilliam Museum, Marlay Cutting It. 10
Pl. 5j. Fitzwilliam Museum, Marlay Cutting It. 11
Pl. 5k. Biblioteca Apostolica Vaticana, Vat. Lat. 2492, fol. 1

Cat. No. 6

Pl. 6a. Fitzwilliam Museum, MS 183, fol. 1
Pl. 6b. Fitzwilliam Museum, MS 183, fol. 100
Pl. 6c. Fitzwilliam Museum, MS 183, fol. 174
Pl. 6d. Fitzwilliam Museum, MS 183, fol. 209v
Pl. 6e. Fitzwilliam Museum, MS 183, fol. 240
Pl. 6f. Fitzwilliam Museum, MS 183, fol. 253v
Pl. 6g. Fitzwilliam Museum, MS 183, fol. 310v
Pl. 6h. Fitzwilliam Museum, MS 183, fol. 312

Cat. No. 7

Pl. 7. Fitzwilliam Museum, MS 400-2000

Cat. No. 8

Pl. 8a. Fitzwilliam Museum, MS 262, fol. 1
Pl. 8b. Fitzwilliam Museum, MS 262, fol. 71
Pl. 8c. Fitzwilliam Museum, MS 262, fol. 71v
Pl. 8d. Fitzwilliam Museum, MS 262, fol. 86v

Cat. No. 9

Pl. 9. Fitzwilliam Museum, MS McClean 201.f.11b

Cat. No. 10

Pl. 10. Fitzwilliam Museum, MS McClean 139, fols i v–ii

Cat. No. 11

Pl. 11a. Durham Cathedral, Chapter Library MS C.I.4, fol. 4
Pl. 11b. Durham Cathedral, Chapter Library MS C.I.4, fol. 56
Pl. 11c. Durham Cathedral, Chapter Library MS C.I.4, fol. 136
Pl. 11d. Durham Cathedral, Chapter Library MS C.I.4, fol. 197v
Pl. 11e. Durham Cathedral, Chapter Library MS C.I.4, fol. 216
Pl. 11f. Durham Cathedral, Chapter Library MS C.I.4, fol. 236v
Pl. 11g. Durham Cathedral, Chapter Library MS C.I.4, fol. 246
Pl. 11h. Durham Cathedral, Chapter Library MS C.I.4, fol. 268

Cat. No. 12

Pl 12a. Durham Cathedral, Chapter Library, MS C.I.6, fol. 3
Pl 12b. Durham Cathedral, Chapter Library, MS C.I.6, fol. 44
Pl 12c. Durham Cathedral, Chapter Library, MS C.I.6, fol. 68v

Bibliography

Abate and Luisetto, *Codici e manoscritti*
Giuseppe Abate and Giovanni Luisetto, *Codici e manoscritti della Biblioteca Antoniana*, 2 vols, Fonti e studi per la storia del Santo a Padova, Fonti 2 (Vicenza: Neri Pozza Editore, 1975)

Abbey
Medieval Illuminated Miniatures from the Celebrated Library of the Late Major J. R. Abbey, Sotheby's, London, 19 June 1989

Alce, *La biblioteca*
P. V. Alce and P. A. D'Amato, *La biblioteca di S. Domenico in Bologna* (Firenze: Leo Olschki, 1971)

Alexander, 'Durham'
Jonathan J. G. Alexander, 'An English Illuminator's Work in Some Fourteenth-Century Italian Law Books at Durham', in *Medieval Art and Architecture at Durham Cathedral*, The British Archaeological Association: Conference Transactions for the Year 1977, 3 (London: The British Archaeological Association, 1980), pp. 149–53

Alexander, *Medieval Illuminators*
Jonathan J. G. Alexander, *Medieval Illuminators and their Methods of Work* (New Haven and London: Yale University Press, 1992)

Alexander, 'Iconography and Ideology'
Jonathan J. G. Alexander, 'Iconography and Ideology: Uncovering Social Meanings in Western Medieval Christian Art', *Studies in Iconography*, 15 (1993), 1–44

Arcangeli, *Pittura Bolognese*
Francesco Arcangeli, *Pittura Bolognese del '300* (Bologna: Grafis, 1978)

Ascheri: see *Lo studio*

Assisi. *Libri miniati*
M. Ciardi Dupre dal Poggetto, M. Assirolli, M.

Bernaba and G. Begalli, *I libri miniati di età romanica e gotica. Collana storica-artistica della Basilica e del sacro Convento di San Francesco*, Assisi, 7.I (Assisi: Casa Editrice Francescana, 1988)

Aston *et al.*, 'Alumni'
Trevor H. Aston, G. D. Duncan and T. A. R. Evans, 'The Medieval Alumni of the University of Cambridge', *Past and Present*, 86 (1980), 9–86

Avril, 'Un element retrouvé'
François Avril, 'Un element retrouvé du breviaire choral W.130 de la Walters Art Gallery', *The Journal of the Walters Art Gallery*, 55/56 (1997/98), 123–34

Avril and Aniel, *Ibérique*
F. Avril, J.-P. Aniel, M. Mentré, A. Saulnier and Y. Załuska, *Manuscrits enluminés de la péninsule ibérique* (Paris: Bibliothèque Nationale, 1982)

Avril and Gousset, II
François Avril and Marie-Thérèse Gousset, *Manuscrits enluminés d'origine italienne*, II: *XIIIe siècle* (Paris: Bibliothèque Nationale, 1984)

Avril *et al.*, *Dix siècles*
F. Avril, M.-T. Gousset and Y. Załuska, *Dix siècles de l'enlumineure italienne* (Paris: Bibliothèque National, 1984)

Barasch
Moshe Barasch, *Giotto and the Language of Gesture* (Cambridge and New York: Cambridge University Press, 1987)

Barzon
A. Barzon, *Codici miniati da Biblioteca Capitolare della Cattedrale di Padova* (Padua: Tipografia Antoniana, 1950)

Bauer-Eberhardt, *Die italienischen Miniaturen*
Die italienischen Miniaturen des 13.–16. Jahr-

hunderts, ed. Ulrike Bauer-Eberhardt (Munich: Staatliche Graphische Sammlung, 1984)

Bellinati, *Gaibana*
C. Bellinati and S. Bettini, *L'Epistolario di Giovanna da Gaibana* (Vicenza: Neri Pozza Editore, 1968)

Bellomo
Manlio Bellomo, *The Common Legal Past of Europe 1000–1800*, trans. Lydia G. Cochrane, Studies in Medieval and Early Modern Canon Law, 4 (Washington D.C.: Catholic University of America Press, 1995)

Bentini *et al*.
Jadranka Bentini, Rosa D'Amico and Elena Marcato, *Gli affreschi di San Vittore* (Bologna: Minerva, 2000)

Bergeron and Ornato, 'La lisibilité'
Réjean Bergeron and Ezio Ornato, 'La lisibilité dans les manuscrits et les imprimés de la fin du moyen âge: Préliminaires d'une recherche', *Scrittura e civiltà*, 14 (1990), 151–98

Berschin
Walter Berschin, *Die Palatina in der Vaticana: Eine deutsche Bibliothek in Rom* (Stuttgart and Zürich: Belser Verlag, 1992)

Bibliotheca Palatina
Bibliotheca Palatina (*Katalogue zur Ausstellung*), ed. Walter Berschin Mittler, Jürgen Miethke, Gottfried Seebaß, Vera Trost and Wilfried Werner (Heidelberg: Editon Braus, 1986)

Binski, *Painted Chamber*
Paul Binski, *The Painted Chamber at Westminster*, Society of Antiquaries of London Occasional Paper, n.s., 9 (London: Society of Antiquaries, 1986)

Binski, *Westminster Abbey*
Paul Binski, *Westminster Abbey and the Plantagenets* (London: Yale University Press, 1995)

Blu, rosso e oro
Blu, rosso e oro. Segni e colori dell'araldica in carte, codici e oggetti d'arte, ed. Isabella Massabò Ricci, Marco Carassi and Luisa Clotilde Gentile (Milan: Electa, 1998)

Boase
T. S. R. Boase, *English Art 1100–1216* (Oxford: Oxford University Press, 1958)

Bober, *Mortimer Brandt Collection*
H. Bober, *The Mortimer Brandt Collection of Medieval Manuscript Illuminations* (Memphis: Brooks Memorial Art Gallery, 1966)

Boskovits, *Martello*
Miklòs Boskovits, *The Martello Collection* (Florence: Centro Di, 1985)

Boyle, 'Canon Law'
Leonard E. Boyle, 'Canon Law before 1380', in *The History of the University of Oxford*, I: *The Early Oxford Schools*, ed. Jeremy I. Catto (Oxford: Oxford University Press, 1984), pp. 531–64

Bozzolo *et al*., 'Noir et Blanc'
Carla Bozzolo, Dominique Coq, Denis Muzerelle and Ezio Ornato, 'Noir et Blanc: Premiers résultats d'une enquête sur la mise en page dans le livre médiéval', in *Il libro e il testo*, Atti del convegno internazionale, Urbino, 20–23 September 1982, ed. Cesare Questa and Renato Raffaelli (Urbino: Università degli Studi di Urbino, 1982), pp. 197–221

Branner, '*Corpus*'
Robert Branner, 'The Copenhagen *Corpus*', *Konsthistorisk Tidskrift*, 38 (1969), 97–119

Branner, *Manuscript Painting*
Robert Branner, *Manuscript Painting in Paris during the Reign of St. Louis* (Berkeley: University of California Press, 1977)

Breveglieri
Bruno Breveglieri, 'La scrittura a Bologna nel Duecento' in *Duecento*, pp. 65–72

Brown, *Western Historical Scripts*
M. Brown, *A Guide to Western Historical Scripts from Antiquity to 1600* (London: The British Library, 1990)

BRUC
A. B. Emden, *Biographical Register of the University of Cambridge to AD 1500* (Cambridge: Cambridge University Press, 1963)

Brundage, 'Cambridge'
James A. Brundage, 'The Cambridge Faculty of Canon Law and the Ecclesiastical Courts of Ely', in *Medieval Cambridge: Essays on the Pre-Reformation University*, ed. Patrick N. R. Zutshi, The History of the University of Cambridge: Texts and Studies, 2 (Woodbridge: Boydell, 1993), pp. 21–45

Brundage, *Canon Law*
James A. Brundage, *Medieval Canon Law* (London and New York: Longman, 1995)

Brundage, 'Parisian Canonists'
James A. Brundage, 'From Classroom to Courtroom: Parisian Canonists and their Careers', *Zeitschrift der Savigny-Stiftung für Rechtsgeschichte, Kanonistische Abteilung*, 83 (1997), 342–61

BRUO
A. B. Emden, *Biographical Register of the University of Oxford to AD 1500*, 3 vols (Oxford: Oxford University Press, 1957–59)

Bulgarelli, *Statuti*
Gli statuti dei comuni e delle corporazioni in Italia nei secoli XIII–XVI, ed. S. Bulgarelli (Rome: Senato della Repubblica and Edizioni De Luca, 1995)

Burkhart, 'Die Dekretalhandschrift'
P. Burkhart, 'Die Dekretalhandschrift Vat. Pal. lat. 629 und die bologneser Buchmalerei am Ende des. XIII Jahrhunderts', in *Palatina-Studien*, ed. W. Bershin, Studi e testi, 365 (Vatican City: Biblioteca Apostolica Vaticana, 1997)

Cahn, 'Fragment'
Walter Cahn, 'A Twelfth-Century *Decretum* Fragment from Pontigny', *Cleveland Museum of Art Bulletin*, 62 (1975), 47–59

Cahn, *Romanesque Manuscripts*
Walter Cahn, *Romanesque Manuscripts: The Twelfth Century*, 2 vols, A Survey of Manuscripts Illuminated in France (London: Harvey Miller, 1996)

Calasso
Francesco Calasso, *Medio evo del Diritto*, I: *Le fonti* (Milan: Giuffré, 1954)

Camille
Michael Camille, *Mirror in Parchment: The Luttrell Psalter and the Making of Medieval England* (Chicago: University of Chicago Press, 1998)

Canova, *Fondazione Cini*
Giordana Canova Mariani, *Miniature dell'Italia settentrionale nella Fondazione Giorgio Cini* (Vicenza: Neri Pozza, 1978)

Canova, 'Nuovi contributi'
Giordana Canova Mariani, 'Nuovi contributi alla serie liturgica degli antifonari di S. Domenico in Bologna', in *La miniatura italiana in età romanica e gotica*, I, pp. 371–93

Cassee, *Missal*
Elly Cassee, *The Missal of Cardinal Bertrand de Deux* (Florence: Istituto Universitario Olandese di Storia dell'Arte, 1980)

Cassee, 'La miniatura italiana in Olanda'
Elly Cassee *et al.*, 'La miniatura italiana in Olanda', *La miniatura italiana*, II, pp. 155–74

Cassee and Langezaal, 'Miniatuurkunst'
Elly Cassee and Jacky Langezaal, 'Bolognese miniatuurkunst in Nederlands bezit', *Nederlands Kunsthistorisch Jaarboek*, 36 (1985), 71–101

CBS
Cambridge Bibliographical Society Transactions, III: *Handlist of Additional Manuscripts in the Fitzwilliam Museum* (Cambridge: Cambridge University Press, 1951)

Chartularium Studium Bononiensis
Chartularium Studium Bononiensis (Bologna: La Commissione per la Storia dell'Università di Bologna, 1909–87)

Chodorow, 'Law'
Stanley Chodorow, 'Law, Canon: After Gratian', in *Dictionary of the Middle Ages*, ed. Joseph R. Strayer *et al.* (New York: Scribner, 1982–89), VI (1986), pp. 413–18

Cobban, 'Theology and Law'
Alan B. Cobban, 'Theology and Law in the Medieval Colleges of Oxford and Cambridge', *Bulletin of the John Rylands Library*, 65, no. 1 (1982), 57–77

Cobban, *Medieval English Universities*
Alan B. Cobban, *The Medieval English Universities: Oxford and Cambridge to 1500* (Berkeley: University of California Press, 1988)

Conti, 'Problemi'
Alessandro Conti, 'Problemi di miniatura Bolognese', *Bollettino d'arte*, 64 (1979), 1–28

Conti, *La miniatura*
Alessandro Conti, *La miniatura Bolognese: Scuole e botteghe 1270–1340* (Bologna: Edizioni Alfa, 1981)

Coulton
George G. Coulton, *Life in the Middle Ages* (Cambridge: Cambridge University Press, 1929)

Dalli Regoli, 'La miniatura'
Gigetta Dalli Regoli, 'La miniatura, 3. Illustrazioni ed esemplificazioni nei codici giuridici', in *Storia dell'arte italiano*, pt III: *Situazioni, momenti, indagini*, vol. II: *Grafica e immagine 1. Scrittura, miniatura, disegno*, ed. Federico Zeri (Turin: Einaudi, 1980), pp. 157–83

D'Ancona, 'Nicolò da Bologna'
Paolo d'Ancona, 'Nicolò da Bologna miniaturista del secolo XIV', *Arte lombarda*, 14 (1969), 1–22

D'Ancona, 'Opere inedite'
Paolo d'Ancona, 'Di alcune opere inedite di Nicolò di Giacomo da Bologna', *La bibliofilia*, 14 (1912), 281–84 (plus plates)

D'Arcais, 'L'Illustratore'
Francesca F. d'Arcais, 'L'Illustratore tra Bologna e Padova', *Arte veneta* (1977), 27–41

D'Arcais, 'Le miniature'
Francesca F. d'Arcais, 'Le miniature del Riccardiano 1005 e del Braidense AG.XII.2: Due attribuzioni e alcuni problemi', *Storia dell'arte*, 30–33 (1977–78), 105–114

D'Arcais, 'L'organizzazione'
Francesca F. d'Arcais, 'L'organizzazione del lavoro negli scriptoria laici del primo trecento a Bologna', in *La miniatura italiana*, I, pp. 357–69

D'Arcais, 'Un'Aggiunta'
Francesca F. d'Arcais, 'Un'aggiunta al catalogo dell'*Illustratore*', *Miniatura*, 1 (1988), 65–73

D'Arcais, 'Manoscritti giuridici'
Francesca F. d'Arcais, 'Le miniature dei manoscritti giuridici trecenteschi nella Biblioteca Malatestiana', in *Libraria Domini. I manoscritti della Biblioteca Malatestiana: testi e decorazione*, ed. Fabrizio Lollini and Piero Lucchi (Bologna: Grafis, 1995), pp. 249–63

D'Arcais, 'Il "giottismo"'
Francesca F. d'Arcais, 'Il "giottismo" nella miniatura padovana del primo Trecento: proposte e ipotesi', in *Parole dipinte: la miniatura a Podova dal medioevo al Settecento*, ed. Giovanna Baldissin Molli, Giordana Canova Mariani and Federica Toniolo (Modena: Panini, 1999), pp. 459–64

Dearden, 'Ruskin'
James S. Dearden, 'John Ruskin the Collector', *The Library*, 21 (1966), 124–54

De Hamel, *Glossed Books*
Christopher de Hamel, *Glossed Books of the Bible and the Origins of the Paris Booktrade* (London: D. S. Brewer, 1984)

De Hamel, *Parker Library*
Christopher de Hamel, *The Parker Library. Treasures from the Collection at Corpus Christi College, Cambridge, England* (Cambridge: Corpus Christi College, 2000)

Destrez
Jean Destrez, *La pecia dans les manuscrits universitaires du XIII^e et XIV^e siècle* (Paris: Éditions Jacques Vautrain, 1935)

Devoti, 'Aspetti'
Luciana Devoti, 'Aspetti della produzione del libro a Bologna: il prezzo di copia del manoscritto giuridico tra XIII e XIV secolo', *Scrittura e civiltà*, 18 (1994), 77–142

De Zulueta and Stein
Francis De Zulueta and Peter Stein, *The Teaching of Roman Law in England around 1200*, Selden Society Supplementary Series, 8 (London: Selden Society, 1990)

Digest
The Digest of Justinian, Latin text ed. Theodor Mommsen and Paul Krueger; English trans. Alan Watson, 4 vols (Philadelphia: University of Pennsylvania Press, 1985)

Dix siècles
Dix siècles d'enluminure italienne, ed. Yolanta Załuska (Paris: Bibliothèque Nationale, 1984)

Dolezalek, *Repertorium*
Gero R. Dolezalek, *Repertorium manuscriptorum veterum Codicis Iustiniani*, 2 vols, Ius Commune, Sonderhefte 23: Repertorien zur Frühzeit der gelehrten Rechte (Frankfurt-am-Main: Vittorio Klostermann, 1985)

Dolezalek, 'La pecia'
Gero R. Dolezalek, 'La pecia e la preparazione dei libri giuridici nei secoli XII–XIII', in *Luoghi e metodi di insegnamento nell'Italia medioevale*, ed. Luciano Gargan and Oronzo Limone, Proceedings of conference held in Otranto, 6–8 October 1986 (Galatina: Congedo, 1989), pp. 201–17

Dolezalek, 'Les gloses'
Gero R. Dolezalek, 'Les gloses des manuscrits de droit: reflet des méthodes d'enseignement', in *Manuels, programmes de cours et techniques d'enseignement dans les universités médiévales* (Louvain-La-Neuve: Université Catholique de Louvain, 1994), pp. 235–55

Dolezalek, 'Research'
Gero R. Dolezalek, 'Research on Manuscripts of the *Corpus Iuris* with Glosses Written During the 12th and Early 13th Centuries: State of Affairs', in *Miscellanea Domenico Maffei dicata Historia – Ius – Studium*, ed. Antonio García y García and Peter Weimar (Weimar: Goldbach, 1995), I, pp. 143–71

Dolezalek and van de Wouw
Gero R. Dolezalek and H. van de Wouw, *Verzeichnis der Handschriften zum römischen Recht bis 1600*, 4 vols (Frankfurt am Main: Max-Planck-Institut für Europäische Rechtsgeschichte, 1972)

Dolezalek and Weigand, 'Das Geheimnis'
Gero R. Dolezalek and Rudolf Weigand, 'Das Geheimnis der roten Zeichen: Ein Beitrag zur Paläographie juristischer Handschriften des zwölften Jahrhunderts', *Zeitschrift der Savigny-Stiftung für Rechtsgeschichte, Kanonistische Abteilung*, 69 (1983), 143–99

Duecento
Duecento: Forme e colori del medioevo a Bologna, ed. Massimo Medica (Venice: Marsilio, 2000)

Ebel *et al.*
Friedrich Ebel, Andreas Fijal and Gernot Kocher, *Römisches Rechtsleben im Mittelalter* (Heidelberg: C. F. Müller Juristischer Verlag, 1988)

Egbert
Donald Drew Egbert, *The Tickhill Psalter and Related Manuscripts* (New York: The New York Public Library and The Department of Art and Archaeology of Princeton University, 1940)

Erbach Von Fuerstenau, A., 'La miniatura bolognese del Trecento', *L'arte*, 14 (1911), 1–12, 107–17

Errera
Andrea Errera, *Arbor actionum: genere letterario e forma di classificazione delle azioni nella dottrina dei glossatori* (Bologna: Moduzzi, 1995)

Fabbri and Tacconi
Lorenzo Fabbri and Marica Tacconi, *I libri del Duomo di Firenze* (Florence: Centro Di, 1997)

La fabbrica del codice
La fabbrica del codice, Paola Busonero, Maria Antonietta Casagrande Mazzoli, Luciana Devoti and Ezio Ornato (Rome: Viella, 1999)

Faranda, *Cor unum*
F. Faranda, ed., *Cor unum et anima una: Corali miniati della chiesa di Imola* (Faenza: Edit Faenza, 1994)

Filippini and Zucchini
Francesco Filippini and Guido Zucchini, *Miniatori e pittori a Bologna: documenti dei secoli XIII e XIV* (Florence: G. C. Sansoni, 1947)

Fliegle, *Blackburn Collection*
Stephen N. Fliegle, *The Jeanne Miles Blackburn Collection* (Cleveland: The Cleveland Museum of Art, 1999)

Francesco da Rimini
Rosa D'Amico, Renzo Grandi and Massimo Medica, *Francesco da Rimini e gli esordi del gotico bolognese* (Bologna: Nuova Alfa, 1990)

García y García and Gonzálvez
Antonio García y García and Ramón Gonzálvez, *Catalogo de los manuscritos juridicos medievales de la Catedral de Toledo*, Cuadernos del Instituto Juridico Español, 21 (Rome and Madrid: Consejo Superior de Investigaciónes Cientificas, 1970)

Garrison, *Italian Romanesque Painting*
E. Garrison, *Italian Romanesque Painting* (Florence: Leo S. Olschki, 1949)

Garrison, 'A Gradual'
E. Garrison, 'A Gradual of S. Stefano, Bologna, Angelica 123', *Studies in the History of Medieval Italian Painting*, 4, no. 1 (1960), 93–110

Gibbs, 'Recent Developments'
Robert Gibbs, 'Recent Developments in the Study of Bolognese and Trecento Illustration', *The Burlington Magazine*, 126 (1984), 638–41

Gibbs, *Tomaso*
Robert Gibbs, *Tomaso da Modena: Painting in Emilia and the March of Treviso, 1340–80* (Cambridge: Cambridge University Press, 1989)

Gibbs, 'Images'
Robert Gibbs, 'Images of Higher Education in Fourteenth-Century Bologna', in *Medieval Architecture and its Intellectual Context: Studies in Honour of Peter Kidson*, ed. Eric Fernie and Paul Crossley (London: Hambledon Press, 1990), pp. 269–81

Gibbs, 'Bolognese Manuscripts in Bohemia'
Robert Gibbs, 'Bolognese Manuscripts in Bohemia and their Influence on Bohemian Manuscripts', in *Il luogo ed il ruolo della città di Bologna tra Europa continentale e mediterranea*, Atti del Colloquio du Cornité International d'Histoire de l'Art, Bologna, October 1990 (Bologna: Nuova Alfa Editoriale, 1992), pp. 55–86

Gibbs, 'Camille'
Robert Gibbs, 'Michael Camille's *Braveheart Psalter*', *Apollo*, 457, CLI (March, 2000), 61–62

Gibbs, 'Development'
Robert Gibbs, 'The Development of the Illustration of Legal Manuscripts by Bolognese Illuminators between 1250 and 1298', *Juristische Buchproduktion im Mittelalter*, Proceedings of the Conference at the Max-Planck-Institut für Rechtsgeschichte, 25–28 October 1998, *Ius Comune* (2001, forthcoming)

Gordon, 'Calendar Cycles'
Olga Koseleff Gordon, 'Two Unusual Calendar Cycles of the 14th Century', *Art Bulletin*, 45 (1963), 245–53

Grandi, *Dottori*
R. Grandi, *I monumenti dei dottori e la scultura a Bologna* (Bologna: Istituto per la Storia di Bologna, 1981)

Greenwell and Hunter Blair
W. Greenwell and C. H. Hunter Blair, *Catalogue of the Seals in the Treasury of the Dean and Chapter of Durham* (Newcastle: Society of Antiquaries of Newcastle-upon-Tyne, 1911–21)

Günther
Dr Jörn Günther Antiquariat, Hamburg, *Mittelalterliche Handschriften und Miniaturen*, Katalog und Retrospektive, 1993

Hackett
M. Benedict Hackett, *The Original Statutes of Cambridge University: The Text and its History* (Cambridge: Cambridge University Press, 1970)

Harrison
F. Harrison, *Treasures of Illumination: English Manuscripts of the Fourteenth Century* (London: Studio, 1937)

Harrsen, Boyce
M. Harrsen and G. K. Boyce, *Italian Manuscripts in the Pierpont Morgan Library* (New York: Pierpont Morgan Library, 1953)

Helmholz
Richard H. Helmholz, *Roman Canon Law in Reformation England* (Cambridge: Cambridge University Press, 1990)

Hibbitts, 'Coming to our Senses'
Bernard J. Hibbitts, '"Coming to our Senses": Communication and Legal Expression in Performance Cultures', *Emory Law Journal*, 41 (Fall, 1992), 873–960

Hibbitts, 'Making Motions'
Bernard J. Hibbitts, 'Making Motions: The Embodiment of Law in Gesture', *Journal of Contemporary Legal Issues*, 6 (Spring, 1995), 50–81

Hindman and Bollati
Sandra Hindman and Milivia Bollati, *Medieval Miniatures*, Brisigotti Antiques Ltd, Les Enluminures and Longari Art SA, Catalogue 1 (London and Paris: BEL, 1996)

Holz, Lalou, Rabel
L. Holz, E. Lalou and C. Rabel, *'Dedens mon livre de pensee...' De Grégoire de Tours à Charles d'Orléans. Une histoire du livre médiévale en région centre* (Paris: Somogny Editions d'Art, CNRS, AGIR, 1997)

Jacob
Robert Jacob, *Images de la justice: essai sur l'iconographie judiciaire du Moyen Âge à l'âge classique* (Paris: Léopard d'Or, 1994)

Jacoff, Michael, 'A Bolognese Psalter of the Late Thirteenth Century and its Byzantine Sources' (unpublished doctoral dissertation, New York University, Institute of Fine Arts, 1976)

James, *Fitzwilliam*
Montague Rhodes James, *A Descriptive Catalogue of the Manuscripts in the Fitzwilliam Museum* (Cambridge: Cambridge University Press, 1895)

James, *Sydney Sussex*
Montague Rhodes James, *A Descriptive Catalogue of the Manuscripts in the Library of Sydney Sussex College, Cambridge* (Cambridge: Cambridge University Press, 1895)

James, *Peterhouse*
Montague Rhodes James, *A Descriptive Catalogue of the Manuscripts in the Library of Peterhouse* (Cambridge: Cambridge University Press, 1899)

James, *Trinity*
Montague Rhodes James, *The Western Manuscripts in the Library of Trinity College, Cambridge: A Descriptive Catalogue*, 3 vols (Cambridge: Cambridge University Press, 1902)

James, *Pembroke*
Montague Rhodes James, *A Descriptive Catalogue of the Manuscripts in the Library of Pembroke College, Cambridge* (Cambridge: Cambridge University Press, 1905)

James, *Caius*
Montague Rhodes James, *A Descriptive Catalogue of the Manuscripts in the Library of Gonville and Caius College*, 2 vols and suppl. (Cambridge: Cambridge University Press, 1907)

James, *Corpus*
Montague Rhodes James, *A Descriptive Catalogue of the Manuscripts in the Library of Corpus Christi College, Cambridge*, 2 vols (Cambridge: Cambridge University Press, 1912)

James, *McClean*
Montague Rhodes James, *A Descriptive Catalogue of the McClean Collection of Manuscripts in the Fitzwilliam Museum* (Cambridge: Cambridge University Press, 1912)

James, 'Inventory'
Montague Rhodes James, 'The Earliest Inventory of Corpus Christi College', *Proceedings of the Cambridge Antiquarian Society*, 16 (1912), 88–114

James, *St John's*
Montague Rhodes James, *A Descriptive Catalogue of the Manuscripts in the Library of St. John's College, Cambridge* (Cambridge: Cambridge University Press, 1913)

James and Jenkins
M. R. James and C. R. Jenkins, *A Descriptive Catalogue of the Manuscripts in the Library of Lambeth Palace* (Cambridge: Cambridge University Press, 1932)

Ker
Neil R. Ker, *Medieval Libraries of Great Britain* (London: Royal Historical Society, 1964)

Kocher, 'Sachsenspiegel'
Gernot Kocher, 'Sachsenspiegel, Institutionen, Digesten, Codex. Zum Aussagewert mittelalterlicher Rechtsillustrationen', *Forschungen zur Rechtsarchäologie und rechtlichen Volkskunde*, 3 (1981), 5–34

Kocher
Gernot Kocher, *Zeichen und Symbole des Rechts* (Munich: C. H. Beck, 1992)

Korner
Medieval Illuminated Miniatures from the Collection of the Late Eric Korner, Sotheby's, London, 19 June 1990

Kuttner, *Repertorium*
Stephan Kuttner, *Repertorium der Kanonistik (1140–1234)*, Studi e testi, 71 (Vatican City: Biblioteca Apostolica Vaticana, 1937)

Kuttner, 'Manuscripts'
Stephan Kuttner, 'Manuscripts and Incunabula Exhibited at the Inauguration of this Institute in May 1956', Institute of Research and Study in Medieval Canon Law, Bulletin for 1956, *Traditio*, 12 (1956), 611–15

Kuttner, 'Johannes Andreae'
Stephan Kuttner, 'Johannes Andreae and his *Novella* on the Decretals of Gregory IX', *The Jurist*, 24 (1964), 393–408; reprinted with

retractiones in Stephan Kuttner, *Studies in the History of Medieval Canon Law* (Aldershot: Variorum, 1990)

Kuttner, 'Revival'
Stephan Kuttner, 'The Revival of Jurisprudence', in *Renaissance and Renewal in the Twelfth Century,* ed. Robert L. Benson and Giles Constable (Cambridge, MA: Harvard University Press, 1982), pp. 299–323; reprinted with *retractiones* in Stephan Kuttner, *Studies in the History of Medieval Canon Law* (Aldershot: Variorum, 1990)

Kuttner, 'Tradition'
Stephan Kuttner, 'On the Medieval Tradition of Justinian's *Novellae*: An *Index Titulorum Authentici in Novem Collationes Digesti*', in *Estudios Jurídico-Canónicos*, ed. Antonio García y García, Bibliotheca Salmanticensis, Estudios, 141 (Salamanca: Universidad Pontificia, 1989), pp. 35–45

Kuttner and Elze
Stephan Kuttner and Reinhard Elze, *A Catalogue of Canon and Roman Law Manuscripts in the Vatican Library*, 2 vols, Studi e testi, 322 and 328 (Vatican City: Biblioteca Apostolica Vaticana, 1986–87)

Kuttner and Rathbone, 'Anglo-Norman Canonists'
Stephan Kuttner and Eleanor Rathbone, 'Anglo-Norman Canonists of the Twelfth Century', *Traditio*, 7 (1949–51), 279–358; reprinted with *retractiones* in Stephan Kuttner, *Gratian and the Schools of Law 1140–1234* (London: Variorum, 1983)

Kuttner and Smalley, '*Glossa*'
Stephan Kuttner and Beryl Smalley, 'The *Glossa Ordinaria* to the Gregorian Decretals', *English Historical Review*, 60 (1945), 97–105; reprinted with *retractiones* in Stephan Kuttner, *Studies in the History of Medieval Canon Law* (Aldershot: Variorum, 1990)

Leader
Damian R. Leader, *A History of the University of Cambridge,* I: *The University to 1546* (Cambridge: Cambridge University Press, 1988)

L'Engle
Susan L'Engle, 'The Illumination of Legal Manuscripts in Bologna, 1250–1350: Production and Iconography' (unpublished doctoral dissertation, University of New York, Institute of Fine Arts, 2000)

Le Goff
Jacques Le Goff, *Time, Work and Culture in the Middle Ages* (Chicago: University of Chicago Press, 1980)

Libraria Domini
Libraria Domini: I manoscritti della Biblioteca Malatestiana: testi e decorazioni, ed. Fabrizio Lollini and Piero Lucchi (Bologna: Grafis, 1995)

Libraries
The University and College Libraries of Cambridge, ed. Peter D. Clarke and Roger Lovatt, Corpus of British Medieval Library Catalogues (forthcoming). Documents edited in this volume are cited as UC plus the document number

Liotta, 'Appunti'
Filippo Liotta, 'Appunti per una biografia del canonista Guido da Baisio, arcidiacono di Bologna (con appendice di documenti)', *Studi senesi*, 76 (1964), 7–50

Logan, 'Sermons and Addresses'
F. Donald Logan, 'The Cambridge Canon Law Faculty: Sermons and Addresses', in *Medieval Ecclesiastical Studies in Honour of Dorothy M. Owen*, ed. M. J. Franklin and Christopher Harper-Bill, Studies in the History of Medieval Religion, 7 (Woodbridge: Boydell, 1995), pp. 151–64

Maffei, *La Donazione*
Domenico Maffei, *La Donazione di Constantino nei giuristi medievali* (Milan: A. Giuffrè, 1964)

Maffei *et al.*
Domenico Maffei, Ennio Cotese, Antonio García y García, Celestino Piano and Guido Rosii, *I codici del Collegio di Spagna di Bologna*, Orbis academicus, saggi e documenti di storia dell'università, 5 (Milan: Giuffrè, 1992)

Matthew Parker's Legacy: Books and Plate (Cambridge: Corpus Christi College, 1975)

Medica: see also *Duecento*

Medica, *Statuta*
Haec sunt statuta: Le corporazioni medievali nelle miniature bolognesi, ed. Massimo Medica (Modena: Fondazione Cassa di Risparmio di Vignola, 1999)

Medica, 'Miniatura'
Massimo Medica, 'Miniatura e committenza: il caso delle corporazioni', in *Statuta*, pp. 55–85

Medica, *Libri miniati*
Massimo Medica, *Libri miniati del Museo Medievale* (Bologna: Musei Civici, 1997)

Medica, *Pieve*
Massimo Medica, *Quattro corali bolognesi a Pieve di Cento*, Quaderni Pievese, 9 (Pieve di Cento: Comune, 1996)

Medica, 'Lando di Antonio'
Massimo Medica, 'Lando di Antonio, un miniatore del Trecento nella compagnia dei Lombardi', in *La compagnia dei Lombardi in Bologna: contributi per una storia di otto secoli* (Bologna: La compagnia dei Lombardi, 1992)

Medica, '"Miniatori–pittori"'
Massimo Medica, '"Miniatori–pittori": il "Maestro del Gherarduccio", Lando di Antonio, il "Maestro del 1328" ed altri. Alcune considerazioni sulla produzione miniatoria bolognese del 1320–30', in *Francesco da Rimini e gli esordi del gotico bolognese*, ed. Rosalba d'Amico, Renzo Grandi and Massimo Medica (Bologna: Nuova Alfa, 1990), pp. 97–123

Medica, 'Maestro delle Iniziali di Bruxelles'
Massimo Medica, Sull'attività bolognese del 'Maestro delle Iniziali di Bruxelles', in *Il cantiere di San Petronio* (Bologna: Nuova Alfa, 1987), pp. 166–92, 200–08

Meiss, *French Painting*
Millard Meiss, *French Painting in the Time of Jean de Berry*, 2 vols, 2nd edn (London: Phaidon, 1969)

Melnikas
Anthony Melnikas, *The Corpus of the Miniatures in the Manuscripts of the Decretum Gratiani*, Studia Gratiana, 16–18 (Rome: Studia Gratiana, 1975)

Mesini, 'Postille'
Carlo Mesini, 'Postille sulla biografia del "Magister Gratianus", padre del diritto canonico', *Apollinaris*, 54 (1981), 509–37

Millar, *Lambeth Palace*
E. G. Millar, *Les principaux manuscrits à peinture du Lambeth Palace à Londres* (Paris: [n. pub.], 1924–25)

Millar, *Honoré*
E. G. Millar, *The Parisian Miniaturist Honoré* (London: T. Yoseloff, 1959)

Miniatura a Brera
Miniatura a Brera, 1100–1422: manoscritti dalla Biblioteca Nazionale Braidense e da collezioni private, ed. Miklòs Boskovits, Giovanni Valagussa and Milvia Bollati (Milano: Federico Motta Editore, 1997)

La miniatura italiana, I
La miniatura italiana in età romanica e gotica, Atti del I° Congresso di storia della miniatura italiana, Cortona, 26–28 May 1978, ed. G. Vailati von Schoenburg Waldenburg (Florence: Leo S. Olschki, 1979)

La miniatura italiana, II
La miniatura italiana tra gotico e rinascimento, 2 vols, Atti del II° Congresso di storia della

miniatura italiana, Cortona, 24–26 September 1982, ed. Emanuela Sesti (Florence: Leo S. Olschki Editore, 1985)

Miniatures
Medieval and Renaissance Miniatures from the National Gallery of Art, ed. Gary Vikan (Washington D.C.: The National Gallery of Art, 1975)

Mordek, 'Gesetzgeber'
Hubert Mordek, 'Frühmittelalterliche Gesetzgeber und Iustitia in Miniaturen weltlicher Rechtshandschriften', in *La Giustizia nell'alto medioevo*, II, Settimane di studio del centro italiano di studi sull'alto medioevo, 42 (1995), pp. 997–1052 (plus plates)

Morgan, *Survey*
Nigel Morgan, *Early Gothic Manuscripts 1190–1250*, A Survey of Manuscripts Illuminated in the British Isles, 4 (London: Harvey Miller and Oxford University Press, 1982)

Mynors and Thomson, *Hereford*
R. A. B. Mynors and R. M. Thomson, *Catalogue of the Manuscripts of Hereford Cathedral Library* (Woodbridge: D. S. Brewer, 1993)

NCE
New Catholic Encyclopedia, 15 vols (New York: McGraw-Hill, 1967; Supplement, New York, 1974–)

Neske
Ingeborg Neske, *Die Handschriften der Stadtbibliothek Nürnberg,* III: *Die latenischen mittelalterlichen Handschriften: Juristische Handschriften* (Wiesbaden: O. Harrassowitz, 1991)

Noonan, 'Gratian'
John T. Noonan, 'Gratian Slept Here: The Changing Identity of the Father of the Systematic Study of Canon Law', *Traditio*, 35 (1979), 145–72

Nordenfalk, 'Review'
Carl Nordenfalk, 'Review of Melnikas's *Corpus of the Miniatures in the Manuscripts of the Decretum Gratiani*', *Zeitschrift für Kunstgeschichte*, 43 (1980), 318–37

Norris, Michael B., 'Early Gothic Illuminated Bibles at Bologna: The *Prima Maniera* Phase, 1250–1274' (unpublished doctoral dissertation, University of California, Santa Barbara, 1993)

Olivier-Martin, 'Manuscrits'
Félix Olivier-Martin, 'Manuscrits Bolonais du Decret de Gratien', *Mélanges d'archéologie et histoire*, 46–47 (1929–30), 215–57

Orlandelli, *Il libro a Bologna*
Gianfranco Orlandelli, *Il libro a Bologna dal 1300 al 1330* (Bologna: Zanichelli, 1959)

Orlandelli, 'Ricerche'
Gianfranco Orlandelli, 'Ricerche sulla origine della *littera bononiensis*', *Bullettino dell'Archivio Paleografico Italiano*, n.s. II–III (1956–57), pt II, pp. 178–214

Owen
Dorothy M. Owen, *The Medieval Canon Law: Teaching, Literature and Transmission*, Sandars Lectures in Bibliography, 1987–88 (Cambridge and New York: Cambridge University Press, 1990)

Pace, *Saliceto*
G. Pace, *Riccardo Saliceto. Un giurista Bolognese del Trecento* (Rome: I Libri di Erice, 1995)

Pächt and Alexander, II
Otto Pächt and J. J. G. Alexander, *Illuminated Manuscripts in the Bodleian Library, Oxford*, II: *Italian School* (Oxford: Clarendon Press, 1970)

Pächt and Alexander, III
Otto Pächt and J. J. G. Alexander, *Illuminated Manuscripts in the Bodleian Library, Oxford*, III: *British, Irish and Icelandic Schools* (Oxford: Clarendon Press, 1973)

Parkes, 'Influence'
M. B. Parkes, 'The Influence of the Concepts of *Ordinatio* and *Compilatio* on the Development of the Book', in his *Scribes, Scripts and Readers: Studies in the Communication, Presentation and Dissemination of Medieval Texts* (London: Hambledon, 1991), pp. 35–70

Parole dipinte
Parole dipinte: la miniatura a Padova dal medioevo al Settecento, ed. Giovanna Baldissin Molli, Giordana Canova Mariani and Federica Toniolo (Modena: Panini, 1999)

Peintner, *Neustifter Buchmalerei*
Martin Peintner, *Neustifter Buchmalerei* (Bolzano: Verlagsanstalt Athesia, 1984)

Pfändtner, *Die Psalterillustration*
Karl-Georg Pfändtner, *Die Psalterillustration des 13. und beginnenden 14. Jahrhunderts in Bologna* (Neuried: Deutsche Hochschuledition, 1996)

Pfändtner, *Illuminierte bologneser Handschriften*
Karl-Georg Pfändtner, *Illuminierte bologneser Handschriften der Staatsbibliothek Bamberg 1260–1340* (Bamberg: Bamberg Staatsbibliothek, 1996)

Piacenza
Il Duomo di Piacenza, Atti del Convegno di studi storici in occasione del 850° anniversario (Piacenza: Deputazione per la Storia Patria, 1975)

Pink, 'Decretum'
H. L. Pink, 'Decretum Manuscripts in Cambridge University', Studia Gratiana, 7 (Rome, 1959), pp. 235–50

Pirani, 'La miniatura bolognese'
Emma Pirani, 'La miniatura bolognese nella illustrazione del testo del "Decretum Gratiani"', in *Celebrazioni dell'VIII centenario del Decretum Gratiani* (Bologna: Università degli studi di Bologna, 1952), pp. 5–14

Pollard, 'The *Pecia* System'
Graham Pollard, 'The *Pecia* System in the Medieval Universities', in *Medieval Scribes, Manuscripts and Libraries: Essays Presented to N. R. Ker*, ed. Malcom B. Parkes and Andrew G. Watson (London: Scholar Press, 1978), pp. 145–61

Powitz and Buck
Gerhardt Powitz and Herbert Buck, *Die Handschriften des Bartholomaeusstifts und des Karmeliterklosters in Frankfurt am Main* (Frankfurt-am-Main: Vittorio Klostermann, 1974)

Quintavalle, *Miniatura*
A. C. Quintavalle, *Miniatura a Piacenza* (Venice: Neri Pozza, 1963)

Randall, *Images*
L. Randall, *Images in the Margins of Gothic Manuscripts* (Berkeley: University of California Press, 1966)

Rashdall
Hastings Rashdall, *The Universities of Europe in the Middle Ages*, ed. F. Maurice Powicke and A. B. Emden, 3 vols (Oxford: Oxford University Press, 1936)

Reynaud, 'Le recours'
Christiane Raynaud, 'Le recours à la juridiction de l'église (ms. 659 de la Bibliothèque municipale d'Avignon)', *Cahiers de Fanjeaux*, 29 (1994), 293–319

Rickert, *Painting*
M. Rickert, *Painting in Britain: The Middle Ages*, Pelican History of Art (Harmondsworth: Pelican, 1954)

Rickert, *Miniatura*
M. Rickert, *La miniatura inglese*, II (Milan: Electa, 1961)

Romans
Hubert de Romans, *Opera de Vita Regulari*, ed. J. J. Berthier (Rome: [n. pub.], 1888–89)

Rossi
Guido Rossi, *La summa arboris actionum di Ponzio da Ylerda* (Milan: Giuffrè, 1951)

Rossi, '*Arbor Actionum*'
Guido Rossi, 'Per una edizione dell'*Arbor Actionum*', *Studi e memoria dell'Istituto per la storia dell'Università di Bologna*, ser. 1, 18 (1944), 29–94

Rossi, 'Universitas'
Guido Rossi, 'Universitas scholarium et comune (sec. XII–XIV)', *Studi e memoria dell'Istituto per la storia dell'Università di Bologna*, ser. 2, 1 (1956), 173–266

Rouse and Rouse, '*Statim invenire*'
Richard H. Rouse and Mary A. Rouse, '*Statim invenire*: Schools, Preachers, and New Attitudes to the Page', in *Renaissance and Renewal in the Twelfth Century*, ed. Robert L. Benson and Giles Constable (Cambridge, MA: Harvard University Press, 1982), pp. 201–25

Rouse and Rouse, 'Dissemination'
Richard H. Rouse and Mary A. Rouse, 'The Dissemination of Texts in *Pecia* at Bologna and Paris', in *Rationalisierung der Buchherstellung im Mittelalter und in der frühen Neuzeit*, ed. Peter Rück, Elementa Diplomatica, 2 (Marburg-an-der-Lahn: Institut für historische Hilfswissenschaften, 1994), pp. 69–77

Rouse and Rouse, 'Wymondswold'
Richard H. Rouse and Mary A. Rouse, 'Thomas of Wymondswold', *The Journal of the Walters Art Gallery*, 54 (1996), 61–68

Rouse and Rouse, 'Wandering Scribes'
Richard H. Rouse and Mary A. Rouse, 'Wandering Scribes and Traveling Artists: Raulinus of Fremington and his Bolognese Bible', in *A Distinct Voice: Medieval Studies in Honor of Leonard E. Boyle, O.P.*, ed. Jacqueline Brown and William P. Stoneman (Notre Dame, IN University of Notre Dame Press, 1997), pp. 32–67

Rouse and Rouse, *Manuscripts*
Richard H. Rouse and Mary A. Rouse, *Manuscripts and their Makers: Commercial Book Producers in Medieval Paris 1200–1500* (Turnhout: Harvey Miller, 2000)

Rud
Thomas Rud, *Codicum manuscriptorum ecclesiae Cathedralis Dunelmensis catalogus* (Durham: F. Humble, 1925)

Ruskin and his Circle
Ruskin and his Circle (London: Arts Council, 1964)

Sandler, *De Lisle*
Lucy Freeman Sandler, *The Psalter of Robert de Lisle in the British Library*, 2nd edn (London: Harvey Miller, 2000)

Sandler, *Omne Bonum*
Lucy Freeman Sandler, *Omne Bonum: A Fourteenth-Century Encyclopedia of Universal Knowledge* (London: Harvey Miller and Oxford University Press, 1996)

Sandler, *Gothic Manuscripts*
Lucy Freeman Sandler, *Gothic Manuscripts 1285–1385*, A Survey of Manuscripts Illuminated in the British Isles, 5 (London: Harvey Miller and Oxford University Press, 1986)

Sayers
Jane Sayers, *Innocent III: Leader of Europe 1198–1216* (London and New York: Longman, 1994)

Schadt
Hermann Schadt, *Die Darstellungen der Arbores Consanguinitatis und der Arbores Affinitatis: Bildschemata in juristichen Handschriften* (Tübingen: Wasmuth, 1982)

Schilling, '*Decretum Gratiani*'
Rosy Schilling, 'The *Decretum Gratiani* Formerly in the C. W. Dyson Perrins Collection', *Journal of the British Archaeological Association*, 26 (1963), 27–39

Schlosser
Julius von Schlosser, 'Giustos Fresken in Padua und die Vorlaufer der Stanza della Segnatura', *Jahrbuch der Kunsthistorischen Sammlungen des allerhöchsten Kaiserhauses*, 17 (1896)

Schmidt, 'Andreas'
Gerhard Schmidt, 'Andreas me pinsit', *Wiener Jahrbuch für Kunstgeschichte*, 26 (1973), 57–73

Schmitt, 'Le miroir du canoniste'
Jean-Claude Schmitt, 'Le miroir du canoniste: à propos d'un manuscrit du Decret de Gratien de la Walters Art Gallery', *Journal of the Walters Art Gallery* 49/50 (1991–92), 67–82

Scott, *Gothic*
Kathleen L. Scott, *Later Gothic Manuscripts 1390–1490*, A Survey of Manuscripts Illuminated in the British Isles, 6 (London: Harvey Miller, 1996)

Scott, *Law*
Samuel P. Scott, *The Civil Law*, 17 vols (Cincinnati: The Central Trust Company, 1938)

Smith
J. A. Clarence Smith, *Medieval Law Teachers and Writers, Civilian and Canonist* (Ottawa: University of Ottawa Press, 1975)

Soetermeer, 'Origin'
Frank P. W. Soetermeer, 'The Origin of MS d'Ablaing 14 and the *Transmissio* of the Clementines to the Universities', *Tijdschrift voor Rechtsgeschiedenis*, 54 (1986), 101–12

Soetermeer, 'La terminologie'
Frank P. W. Soetermeer, 'La terminologie de la librairie à Bologne aux XIII^e et XIV^e siècles', in *Terminologie de la vie intellectuelle au moyen âge*, ed. Olga Weijers (Turnhout: Brepols, 1988), pp. 88–85

Soetermeer, 'Famille de copistes'
Frank P. W. Soetermeer, 'À propos d'une famille de copistes: quelques remarques sur la librarie à Bologne aux XIII^e et XIV^e siècles', *Studi medievale*, ser. 3, 30 (1989), 425–78

Soetermeer, 'La carcerazione'
Frank P. W. Soetermeer, 'La carcerazione del copista nel pensiero dei giuristi bolognesi', in *Studi belgi e olandesi per il IX centenario dell'alma mater bolognese*, ed. Anton Boschloo *et al.* (Bologna: L. Parma, 1990), pp. 121–39

Soetermeer, 'L'Édition'
Frank P. W. Soetermeer, 'L'Édition de *Lecturae* par les stationnaires bolonais', *Tijdschrift voor Rechtsgeschiedenis,* 59 (1991), 333–51

Soetermeer, *Utrumque ius in peciis*
Frank P. W. Soetermeer, *Utrumque ius in peciis: aspetti della produzione libraria a Bologna fra Due e Trecento* (Milan: Giuffrè, 1997)

Speciale, *Memoria*
G. Speciale, *La memoria del Diritto Comune* (Rome: I Libri di Erice, 1994)

Statuti
Statuti di Bologna dell'anno 1288, ed. Gina Fasoli and Pietro Sella, Studi e testi, 73 (Vatican City: Biblioteca Apostolica Vaticana, 1937)

Stelling-Michaud, 'Le transport'
Sven Stelling-Michaud, 'Le transport international des manuscrits juridiques bolonais entre 1265 et 1320', in *Mélanges d'histoire économique et sociale en hommage au professeur Antony Babel* (Geneva: [n. pub.], 1963), I, pp. 95–127

Stone
L. Stone, *Sculpture in Britain: The Middle Ages*, The Pelican History of Art (Harmondsworth: Pelican, 1955)

Stubblebine, *Guido*
J. Stubblebine, *Guido da Siena* (Princeton, Princeton University Press, 1964)

Lo studio
Lo studio e i testi: il libro universitario a Siena (secoli XII–XVII), ed. M. Ascheri (Siena:

Biblioteca Comunale and Protagon Editori Toscani, 1996)

Swarzenski and Schilling
Georg Swarzenski and Rosy Schilling, *Die illuminierten Handschriften und Einzelminiaturen des Mittelalters und der Renaissance in frankfurter Besitz* (Frankfurt-am-Main: Joseph Baer, 1929)

Talbot, 'Universities'
C. H. Talbot, 'The Universities and the Mediaeval Library', in *The English Library before 1700*, ed. Francis Wormald and C. E. Wright (London: Athlone Press, 1958), pp. 66–84

Tambini, 'Il Maestro'
A. Tambini, 'Il Maestro dei corali di Bagnacavallo', *Romagna arte e storia*, 12 (1992), 17–30

Thorndike, 'Final Jingles'
Lynn Thorndike, 'Copyists' Final Jingles in Mediaeval Manuscripts', *Speculum,* 12 (1937), 268

Thorndike, 'More Jingles'
Lynn Thorndike, 'More Copyists' Final Jingles', *Speculum,* 31 (1956), 321–28

Tietze
Beschreibendes Verzeichnis der illuminierten Handschriften in Österreich, V: H. Tietze, *Die illuminierten Handschriften in der Rossiana, Wien-Leinz* (Leipzig: Hiersemann, 1911)

Torriti, *Siena*
P. Torriti, *La Pinacoteca Nazionale di Siena* (Genoa: SAGEP Editrice, 1977)

The Treasury of Saint Francis
The Treasury of Saint Francis of Assisi, ed. G. Morello and L. B. Kanter (Milan: Electa, 1999)

Treuherz, 'Pre-Raphaelites'
J. Treuherz, 'The Pre-Raphaelites and Medieval Manuscripts', *Pre-Raphaelite Papers*, ed. L. Parris (London: Tate Gallery, 1984)

Ullmann
Walter Ullmann, *Law and Politics in the Middle Ages* (Ithaca, NY: Cornell University Press, 1975)

Van de Wouw, 'Textgeschichte'
H. van de Wouw, 'Zur Textgeschichte des Infortiatum und zu seiner Glossierung durch die früher Bologneser Glossatoren', *Ius Commune*, 11 (1984), 231–80

Veer-Langezaal, 'Een onderzoek'
Jacky de Veer-Langezaall, 'Een onderzoek naar geillumineerde Bolognese "Corpus iuris civilis": manuscripten, vervaardigd tussen 1250–1350', in *Middeleeuwse handschriftenkunde in de Nederlanden 1988 Verslag van de Groningse Codicologendagen 28–29 April 1988*, ed. J. M. M. Hermans (Grave: Uitgeverij Alfa, 1989), pp. 239–44

Vitzthum
G. Vitzthum, *Die pariser Miniaturmalerei von der Zeit des hl. Ludwig bis zu Phillipp von Valois* (Leipzig: Quelle & Meyer, 1907)

Vikan, Gary: see Washington

Voelkle and Wieck
W. Voelkle and R. Wieck, *The Bernhard H. Breslauer Collection of Manuscript Illuminations* (New York: Pierpont Morgan Library, 1992)

Von Euw and Plotzek
A. von Euw and J. M. Plotzek, *Die Handschriften der Sammlung Ludwig* (Cologne: Schnütgen-Museum der Stadt Köln, 1985)

Waetzoldt, *Kopien*
S. Waetzoldt, *Die Kopien des 17. Jahrhunderts nach Mosaiken und Wandmalereien in Rom* (Vienna and Munich: Schroll-Verlag, 1964)

Wallraf-Richartz, I
Vor Stefan Lochner, Die Kölner Maler von 1300 bis 1430 (Cologne: Wallraf-Richartz Museum, 1974)

Wallraf-Richartz, II
Vor Stefan Lochner, Die Kölner Maler von 1300 bis 1430, Ergebnisse der Ausstellung und des Colloquiums (Cologne: Wallraf-Richartz Museum, 1977)

Washington
Medieval and Renaissance Miniatures from the National Gallery of Art, compiled by C. Ferguson, D. S. Stevens Schaff and G. Vikan under the direction of C. Nordenfalk (Washington, D.C.: National Gallery of Art, 1975)

Watson, *A Supplement*
Medieval Libraries of Great Britain, ed. N. R. Ker, *A Supplement to the Second Edition*, ed. Andrew Watson (London: Royal Historical Society, 1987)

Weitzmann
Kurt Weitzmann, *Late Antique and Early Christian Book Illumination* (London: Chatto & Windus, 1977)

White, *Duccio*
J. White, *Duccio* (London: Thames and Hudson, 1979)

Whitman, 'Division'
James Q. Whitman, 'A Note on the Medieval Division of the Digest', *Tijdschrift voor Rechtsgeschidinis*, 59 (1991), 270–71

Wilson, 'Contents'
R. M. Wilson, 'The Contents of the Mediaeval Library', in *The English Library before 1700*, ed. Francis Wormald and C. E. Wright (London: Athlone Press, 1958), pp. 85–111

Winroth
Anders Winroth, *The Making of Gratian's 'Decretum'* (Cambridge: Cambridge University Press, 2000)

De Winter, 'Bolognese Miniatures'
Patrick M. De Winter, 'Bolognese Miniatures at the Cleveland Museum', *The Bulletin of the Cleveland Museum*, 70/8 (1983), 313–52

Wolfthal, 'Rape Imagery'
Diane Wolfthal, 'A "Hue and a Cry": Medieval Rape Imagery and its Transformation', *Art Bulletin*, 75 (March 1993), 39–64

Wormald, 'Monastic'
Francis Wormald, 'The Monastic Library', in *The English Library before 1700*, ed. Francis Wormald and C. E. Wright (London: Athlone Press, 1958), pp. 15–31

Wormald and Giles, *Illuminated Manuscripts*
Francis Wormald and P. M. Giles, *Illuminated Manuscripts in the Fitzwilliam Museum* (Cambridge: Fitzwilliam Museum, 1966)

Wormald and Giles, *Descriptive Catalogue*
Francis Wormald and P. M. Giles, *A Descriptive Catalogue of the Additional Illuminated Manuscripts in the Fitzwilliam Museum Acquired between 1895 and 1979 (excluding the McClean Collection)* (Cambridge: Cambridge University Press, 1982)

Zdekauer
Lodovico Zdekauer, *Su l'origine del manoscritto pisano delle Pandette Giustinianee e la sa fortuna nel Medio Evo* (Siena: E. Torrini, 1890)

Exhibition Catalogues

L'art au temps des rois maudits
L'art au temps des rois maudits Philippe le Bel et ses fils, 1285–1328, Paris, 17 March–29 June 1998 (Paris: Réunion des Musées Nationaux, 1998)

Decretum, manoscritti e incunabuli
Mostra di manoscritti e incunabuli del Decretum Gratiani (Bologna: Biblioteca Universitaria Bologna, 1952)

Die italienischen Miniaturen
Die italienischen Miniaturen des 13.–16. Jahrhunderts, ed. Ulrike Bauer-Eberhardt (Munich: Staatliche Graphische Sammlung, 1984)

Manoscritti e incunabuli
Mostra di manoscritti e incunabuli del Decretum Gratiani (Bologna: Biblioteca Universitaria Bologna, 1952)

Pfändtner, *Illuminierte bologneser Handschriften*
Karl-Georg Pfändtner, *Illuminierte bologneser Handschriften der Staatsbibliothek Bamberg 1260–1340* (Bamberg: Bamberg Staatsbibliothek, 1996)

Glossary

actions Proceedings in courts of justice, or lawsuits, by which individuals may demand or enforce their rights.

allegationes Used by the civil glossators to construct their glosses, they consist of citations of other texts in the *corpus* of civil law either relating to or conflicting with that being glossed. Used by civilians and canonists in their glosses, they consist of citations of other texts in civil or canon law either analogous to or conflicting with that being glossed.

apparatus A continuous set of glosses on a text.

Arbores **(Trees)** Tables of Actions, composed by the Bolognese Johannes Bassianus to classify the various types of civil lawsuit and of Consanguinity and Affinity to classify kinship and the degrees of relationship within which intermarriage was prohibited. The complex evolution and typology of the marriage trees have been classified by Hermann Schadt.

articulation The use of graphic devices on the manuscript page, of varying sizes and degrees of complexity, to identify the levels of text: part, book, chapter, law, question, paragraph, sentence.

bas-de-page A French term used to refer to the lower margin of the page, the site of catch-words, narrative or figurative images, and decorative motifs; in legal manuscripts it comprises the area below the lowest columns of gloss.

bifolium (pl. bifolia) A single sheet of support material vellum/parchment or paper folded in half to form two leaves (four pages) for writing.

calligraphic decoration Decorative elements on the manuscript page executed with pen and ink, rather than brush and paint; usually embellishing or developing from initials.

canonist A lawyer specializing in canon law.

catchword A word or phrase written in the lower margin of the last page of a manuscript quire, the verso of a folio, corresponding to the opening word or words of the following quire.

causa In Gratian's *Decretum*, a hypothetical case describing and discussing a point of law.

civilian A lawyer specializing in civil, or Roman law.

colophon A scribe's inscription at the end of a section of text, providing some but rarely all of the following information: title of the text, author, name of scribe, place of writing and date of completion, and sometimes a salutation to the reader, or personal information about the scribe himself.

Corpus iuris canonici The body of canon law, this title for canon law first assigned by the printer Jean Chappuis in his Paris edition of 1500.

Corpus iuris civilis The body of civil law; the texts of Roman law were assigned this collective title by the twelfth century.

decretal A papal letter issued in response either to a request for clarification on some point of canon law or an appeal for judgement on a particular case. In the plural, *Decretales*, it was used as the title of Gregory IX's compilation of current canon law (1239).

decretalist A commentator on decretals and decretal law.

decretist A commentator on Gratian's *Decretum*.

Decretum 'It has been decreed': the title of Burchard of Worms's eleventh-century compi-

lation of canon law; also commonly used as a short title for Gratian's *Concordance of Discordant Canons*.

density of the gloss The quantity of existing gloss corresponding to a particular passage of text, that should be physically positioned as nearby as possible to this passage, on the manuscript page.

dialectical method A scholastic approach popular in the early twelfth century for resolving contradictory statements on a particular issue, first by marshalling arguments for and against, and then finding a point of reconciliation.

display script Capital letters written in ink in a slightly larger and more decorative format than the main script; especially used for the first sentence at major text divisions.

exemplar A corrected, officially approved version of a text, to be copied into *pecia* format and rented out to scribes.

explicit The closing phrase of a unit of text.

gathering, quire, signature An established number of bifolia, folded and layered together to form an individual unit or booklet. A scribe would copy his text onto a series of these units, the sequence of which was maintained by the use of a catchword at the lower margin of the last page, corresponding to the first word of the next quire. Quires of ten folios were customary in Italian manuscripts; quires of eight or twelve were more common to Northern practices.

gloss A literary genre employed by professors and students of law to clarify and interpret legal texts. The smallest glosses were placed between the lines of the text they interpreted (interlinear gloss); longer expositions were placed in the nearby margins.

glossa ordinaria The standard exposition of commentaries on an entire text or texts of the *Corpus iuris*, synthesizing the previous accumulated body of glosses.

glossators Medieval teachers and doctors of law who studied, analysed, and wrote interpretative commentaries (glosses) on difficult passages in the texts of canon and civil law.

incipit The opening phrase of a unit of text.

lectura An extensive commentary on part of the *Corpus iuris canonici* or *Corpus iuris civilis*, usually circulated independently of the legal text.

lemmata Key words or passages in a legal text on which glosses commented.

palaeography The historical study of scripts and their different styles of handwriting.

pecia A standard segment of text, initially established in Bologna as a unit consisting of two bifolia containing sixteen columns, each of sixty lines, each line composed of thirty-two letters. An exemplar of each text was written into a set of number of these units, to be rented out in sequence to scribes for copying.

quaestio (pl. *quaestiones*) A type of legal literature, consisting of reports on disputations about specific problems of law.

quire see *gathering*

ruling Lines drawn on the blank manuscript page as guide to scribes and decorators, delimiting the areas of text and ornament, executed in blind, lead or ink.

siglum (pl. *sigla*) A letter, letters or some other graphic sign used in a passage of text, to (1) represent the name of an individual responsible for the passage as author or copyist, i.e., a teacher, glossator, scribe, notary or corrector; (2) advise the reader that similar passages may be found previous or subsequent to this one; or (3) serve as half of a matching pair of signs linking two

corresponding sections of text. See **tie-marks** below.

stationers Specially licensed booksellers.

summa A systematic treatise written on a text or a specific section of text from the corpus of canon or civil law.

tie-marks Special marks devised by scribes to link related sections of text on a manuscript page, such as text and gloss, written in pairs.

Index

G